MODERN ART AND THE MODERN MIND

MODERN ART
and the
MODERN MIND

J. P. Hodin

THE PRESS OF CASE WESTERN RESERVE UNIVERSITY
Cleveland & London
1972

To André Malraux

I believe in eternal man
because I believe in the ever-
lastingness of masterpieces.

André Malraux
The Walnut Trees of Altenburg

PREFACE

This selection of essays and papers, written between the years 1951 and 1967, is a continuation of the studies on art published in my book *The Dilemma of Being Modern*.[1] The problems dealt with in these two books complement each other. Thus, Part Two of this volume, "Psychology and Modern Art," which brings into the picture C. G. Jung and his relationship to art, is a counterpart to "The Cultural Psychology of Sigmund Freud" in *The Dilemma of Being Modern*. Comparing the ideas of Freud and Jung and focusing them on modern art suggests a new position which may perhaps clarify some of the doubts which confront us in the analysis of the creative impetus of our time. The questions discussed with Professor Karl Jaspers attempt to deepen the psychological approach to art into a philosophical one. The sections devoted to Oskar Kokoschka, Henry Moore, Julius Bissier, and others continue the conversations with leading artists that were presented in *The Dilemma of Being Modern* under the title "The Voice of the Pioneers." All these essays and papers have been elaborated in an effort to come to grips with the revolutionary and ambiguous character of the art of our time. Although each of them is self-contained and forms a literary entity, they are also to be regarded as preliminary studies to a major work, *The Enigma of Modern Art*, which has occupied the author for several decades. The inner link between the essays and papers is not only their preoccupation with modern art, but also their elaboration in different phases of the idea that scientific thought and methods have had a decisive impact on the formation of modern

[1] J. P. Hodin, *The Dilemma of Being Modern: Essays on Art and Literature* (London and New York, 1956).

vii

art. This is a *basic* idea: all the other ideas propounded in this book, the juxtaposition of reason and myth, unrest and beauty, dream and reality, the unconscious and the constructive, the visible and the visionary, and the timebound and the eternal, depend on it and its proper application. For the first time a definition of modern art is attempted in the context of this basic idea, and the question of its beginnings and its classification is critically examined. Special attention is paid to the social component in the interpretation of the function, the significance, and the style of a work of art in its relationship to the spirit of the epoch in its emergence (*Zeitgeist*).

I should like to take this opportunity of expressing my gratitude to the late Professor Karl Jaspers; the late Professor C. G. Jung; Professor Oskar Kokoschka O.M.; Henry Moore O.M.; Dame Barbara Hepworth; and the other leading artists for the penetrating and inspiring manner in which they illuminated vital aspects of the making of art and its meaning. The right comprehension of the struggle in which the modern mind is engaged, of the extent of the spiritual crisis in which we find ourselves, and of the emergence of new aesthetic, philosophical, and ethical values and the necessity of their acceptance—all this is dependent on the creative insight and the visionary imagination offered to their time by its great artists and thinkers.

My sincere thanks are due to Professor Thomas Munro, formerly of the Cleveland Museum of Art, for inviting me to read the paper "Art and Modern Science" at the Plenary Session, on September 5, 1965, of the Third International Congress of Aesthetics in Venice; to Professor Luigi Pareyson of the University of Turin, for his invitation to prepare the statement "Aesthetic Judgment and Modern Art Criticism" to be used as a basis for a discussion at the Simposio di Estetica (Venice, September 19, 1958), which took place within the framework of the International Congress of Philosophy in Venice and Padua; to the late President of the Association Internationale des Critiques d'Art, M. Paul Fierens, for his suggestion that I should prepare a paper on "Daily Life and the Values of Forms in Art" (here published under the title "The Timeless and the Timebound in Art: Thoughts on the Problem of Abstraction") for the Sixth International Congress of Art Critics in Naples and Palermo, 1957; to the President of the Fourth International Congress of Aesthetics in Athens, Professor P. A. Michelis, for asking me to read a paper, "The Empirical Approach to Aesthetic Problems of Modern Art," on this occasion (session of September 4, 1960); to the then President, the late Sir Herbert Read, and the Executive Committee of the British Society of Aesthetics, for their invitation to read the paper

"The Spirit of Modern Art" at the Society's meeting in London on February 1, 1961.

"The Future of Surrealism" was awarded the first prize for art criticism in an international competition organized by the Venice Biennale of 1954. "The Museum and Modern Art" was awarded the second prize in an international competition organized by the Galleria Nazionale d'Arte Moderna in Rome in 1956.

"The Philosophical Meaning of the Work of Art" was published originally under the title "Henry Moore's Challenge" in *Quadrum I* (Brussels, 1956). "The Future of Surrealism" appeared in French under the title "La Biennale et l'avenir du Surréalisme" in *Les Arts Plastiques, Numéro Special: La XXVIIe Biennale de Venise* (Brussels, 1954). "Symbol and *Chiffre* in Art" was published in *Quadrum III* (Brussels, 1957) under the title "Karl Jaspers Speaks to J. P. Hodin: Modern Art and the Philosopher," and in *Prism I* (New York: Prism Publications, 1962). "The Soviet Attitude to Art" was never published in its entirety; a selection from Professor Vladimir Kemenov's statement was printed in *Contemporary Review* (London), No. 1050 (June 1953); "The Museum and Modern Art" was published in *Art News and Review* (London), September 14, 1956; "Figuration and Abstraction" is a statement from the Introduction to the Catalogue of the Gaetano Marzotto Prize for Painting *(Figurative Painting in Europe)*, 1967; the paper "Art and Modern Science" was published in the *Proceedings of the Third International Congress of Aesthetics (Atti del III Congresso Internazionale di Estetica)*, edited by the Rivista di Estetica, Istituto di Estetica dell' Università di Torino, in 1957; "The Timeless and the Timebound in Art" was published in *The Journal of Aesthetics and Art Criticism* (Cleveland), Vol. 14, No. 4 (June 1958). The paper "Aesthetic Judgment and Modern Art Criticism" was published in the pamphlet *Il Guidizio Estetico, Relazioni,* by the Rivista di Estetica (Turin, 1958).

The research for the essay "What Is Modern Art?" was undertaken at the request of Professor G. C. Argan; part of the material was used, in different form, for the section "Europee Moderne Correnti" in the *Enciclopedia Universale dell'Arte* in Rome (*Encyclopedia of World Art,* New York); it was written during 1957 and 1958 and twice revised, in 1961 and 1967. "The Saga of Prometheus," which appears here in "Kokoschka on the Myth and Fate of Europe," was written in London in 1950, and "Thermopylae" in Villeneuve in 1954; a German version of these two essays was published under the title "Mythos und Schicksal Europas" in J. P. Hodin, *Bekenntnis zu Kokoschka* (Mainz and Berlin:

Florian Kupferberg Verlag, 1963). "Time and the Artist" was written in 1960. The first version of "The Hell of Initiation" was written in 1953; part of it was used as a lecture on "C. G. Jung and Modern Art" at the Institute of Contemporary Arts, London, in February 1954; the essay was only completed in 1959 and revised in 1960 and 1967. "The Problem of Jewish Art and Its Contemporary Aspect" was written in 1953 at the suggestion of the contemporary artists quoted at length in the essay. "Art and Sociology" was written in 1951 and revised in 1961 and 1967. "The Permanence of the Sacred in Art" was published in French under the title "Quand les artists parlent du sacré" in *XX. Siècle* (Paris), No. 24 (1964).

Only those papers and essays thus indicated have been previously published. I acknowledge, with thanks, the gracious permission of the various publishers to reproduce the essays in this new volume. The major part of the essays are here printed for the first time. The realization of this volume is due to the good offices of Professor Thomas Munro and the former Director of the Press of Case Western Reserve University, Howard R. Webber, for which I am most grateful.

J. P. Hodin

ACKNOWLEDGMENTS

The author makes grateful acknowledgment to the following:

Robert Graves, A. P. Watt & Son, and Collins-Knowlton-Wing, Inc., for permission to reprint an excerpt from *The Crowning Privilege*. Copyright © 1955 by Robert Graves.

College Art Journal (New York) for permission to quote from Oskar Kokoschka, "Edvard Munch's Expressionism."

Comprendre (Venice) for permission to quote from Bernard Berenson, "L'Art visuel et l'art abstrait."

Princeton University Press and Routledge and Kegan Paul Ltd. for permission to quote from *The Collected Works of C. G. Jung*, ed. G. Adler, M. Fordham, and H. Read, trans. R. F. C. Hull, Bollingen Series XX, Vol. 15: *The Spirit in Man, Art, and Literature*. Copyright © 1966 by Princeton University Press.

George Allen & Unwin Ltd. for permission to quote from Edward Glover, *Freud or Jung*.

The Museum of Modern Art, New York, for permission to quote from *Picasso: Fifty Years of His Art*, by Alfred H. Barr, Jr. Copyright © 1946.

Philosophical Library, Inc., for permission to quote from Naum Gabo, *Three Lectures on Modern Art*.

Routledge and Kegan Paul Ltd. and Philosophical Library, Inc., for permission to quote from J. E. Cirlot, *A Dictionary of Symbols*.

The Hogarth Press Ltd. and New Directions Publishing Corporation for permission to quote from Rainer Maria Rilke, *Selected Works: Prose*, trans. G. Craig Houston.

Random House, Inc., Chatto and Windus Ltd., and the translator's literary estate for permission to quote from Marcel Proust, *Time Regained*, Vol. 12 of *Remembrance of Things Past*, trans. Stephen Hudson.

Random House, Inc., The Hogarth Press Ltd., and the translator for permission to quote from Marcel Proust, *By Way of Sainte-Beuve*, trans. Sylvia Townsend Warner. Copyright © 1967.

Faber and Faber Ltd. and Random House, Inc., for permission to quote from "Musée des Beaux Arts," from *Collected Shorter Poems 1927–1957* by W. H. Auden.

Faber and Faber Ltd. and The Macmillan Company for permission to quote from Anne Ridler's "Piero della Francesca," from *Golden Bird* and *Selected Poems* respectively. Copyright © Anne Ridler, 1951, 1961.

Princeton University Press for permission to quote from Paul Valéry, "The Problem of Museums," in *The Collected Works of Paul Valéry*, Vol 12, *Degas, Manet, Morisot*, ed. Jackson Mathews, trans. David Paul, Bollingen Series XVI. Copyright © 1960.

Martin Secker & Warburg Limited and Doubleday & Company, Inc., for permission to quote from André Malraux, *Museum Without Walls*, from *The Voices of Silence*. Copyright © 1953.

Thames and Hudson and Horizon Press for permission to quote from Herbert Read, *The Origin of Form in Art*. Copyright © 1965.

CONTENTS

LIST OF ILLUSTRATIONS

All illustrations appear between pages 48 and 49.

Karl Jaspers
Leonardo da Vinci: *Self-portrait*
Henri Matisse: *The Young Sailor, II*
Vincent van Gogh: *Self-portrait Before Easel*
Marc Chagall: *Moses Receiving the Tables of the Law*
Roman, 4th Century A. D.: *Mary and Jesus*
Rembrandt: *The Agony in the Garden*
Titian: *Sacred and Profane Love*
J. P. Hodin in conversation with Marc Chagall, 1949
Oskar Kokoschka: *Thermopylae*. Left panel
Oskar Kokoschka: *Thermopylae*. Middle panel
Oskar Kokoschka: *Thermopylae*. Right panel
Oskar Kokoschka: *The Saga of Prometheus*. Left panel
Oskar Kokoschka: *The Saga of Prometheus*. Middle panel,
 left side
Oskar Kokoschka: *The Saga of Prometheus*. Middle panel,
 right side
Oskar Kokoschka: *The Saga of Prometheus*. Right panel
Oskar Kokoschka: *Herodotus*
Jacob Bornfriend: *Wedding*
Paul Delvaux: *The Sleeping City*
Endre Nemes: *Project for Tapestry*
Francis Bacon: *Lying Figure*
Sir Jacob Epstein: *Jacob and the Angel*
Ernst Josephson: *Portrait of Jeanette Rubenson*

PART I

PHILOSOPHY AND MODERN ART

1 • SYMBOL AND *CHIFFRE* IN ART

A Meeting with Karl Jaspers

We call great art the metaphysical art which reveals, through its visuality, Being itself. Fundamentally, just art and therefore skill bare of philosophic significance is the non-transcendental manner of representing, of decorating, of producing the sensuously attractive, in so far as it exists in isolation and has no metaphysical bearing.

<div align="right">

KARL JASPERS
Von der Wahrheit

</div>

I

IN HIS SEARCH FOR THE KEY TO THE ENIGMA OF MODERN ART, IN HIS attempts to solve the riddle of the ever-changing aspects of contemporary creativeness, the modern art historian can find basic certainties for his endeavor in the philosophy of Karl Jaspers.

There are two paths to the solution of the problems involved: the first is an investigation of science and its methods, and a consideration of its effect on modern life as the central event to which the essential changes in our contemporary scene can be traced. The second is a comparative study of art and culture to assess the meaning and value of the modern movement in art, related to the revolution in science, which, where it is original and honest, manifests itself increasingly in an unfamiliar, highly specialized, and abstract, but also figurative, conception of inner integrity and logic.

In a great majority of the works published during recent decades which deal with the problem of the spiritual crisis of our age the notion

3

of science has not been clearly defined and accepted as a fact of elemental importance, nor has serious consideration been given to the restlessness with which the modern artist strives for the crystallization of new organic concepts, a new inner order. The release of an unfrustrated, free artistic vision, often fed from subconscious sources—the human endeavor to come to grips again with the beauty and the mystery of creation, with the miracle of life—has been suspect. At the same time, the mechanistic-materialistic stage of science and its narrow rationalist interpretations have been confounded with the concept of science itself and its undogmatic and ever-changing thrust. This has released a critique of our age which is based in the main on prescientific values. Not only academicians[1] but some of the leading Christian philosophers,[2] and psychologists as well,[3] have proceeded in this way. When the classical concepts of physics were shaken by the quantum theory and the theory of relativity, a new view of the universe emerged that included notions, defined as "irrational" by Niels Bohr, which correspond to the philosophic approach termed metaphysical: for example, Max Born's idea of complementarity, or Werner Heisenberg's uncertainty principle.[4] The contemporary doctrines in philosophy generally referred to as logical positivism, such as Bertrand Russell's philosophy of logical analysis, the concepts of the Vienna Circle (especially Ludwig Wittgenstein), and those of the contemporary English school based on it (G. Ryle, A. J. Ayer, G. E. Moore), can be understood as representing a tendency to reject the traditional aims of philosophy and to give it a new foundation as a strictly scientific realm of knowledge (reducing it in fact to the science of logic, i.e., meaning).[5] In Karl Jaspers, however, we find a contemporary philosopher who not only has accepted modern science unconditionally and categorically as "a wonderful phenomenon of incomparable reliability, the deepest cleft ever carved into human history, the source of great dangers but even greater opportunities, and from now on the precondition of all human dignity,"[6] but, in so doing, has redefined philosophy as the urge for transcendental certainties. In a modern scientific world he has re-established the notion of the *philosophia perennis*, its aims, its truly human yearning for truth and a vision of the eternal.[7] Thus a tool has been created which can be used with great benefit for the critical penetration and the comprehension of modern art. Many contemporary literary works on art are proof that this cannot be achieved in a satisfactory way without a philosophy and a comparative study on a world scale of art and culture.

My efforts to interpret modern art led me to the philosophy of Karl Jaspers. Here I found the confirmation of some of my working hypoth-

eses and an analogy of thought which was a most exciting experience. Apart from some general statements which enter into his system of philosophy, Jaspers has rarely written on art. He touches upon contemporary art, in his role as a psychiatrist, in an analysis of the late work of van Gogh—that is all. And so I was anxious to discuss art with him. Our meeting took place on June 2, 1956, at his home in Basle. Before recalling this meeting, let me say a few words about Jaspers' ideas on art in general and his attitude to van Gogh, that is, to Expressionism, and the enhancing effect of schizophrenia in ensuring for art freedom from rational interference and from the inhibiting factors presented to the consciousness by unbearable contemporary pressures and by tradition, i.e., established formative concepts.

In investigating the difference between philosophy and art, Jaspers goes back to existence itself, which brings forth both philosophy and art. In its origin art is to him "the illumination of Existence by an assurance which visually presents Being as a tangible reality. While in philosophy Being is comprehended as something conceivable, in art it is comprehended as something capable of representation." Only in metaphysical speculation, as representing the attempt at a rational reading of the *chiffre*-writing of Being, does he see an analogy to art:

> The urge of man's metaphysical thinking is towards art. His mind opens up to that primary state when art was meant in earnest and was not mere decoration, play, sensuousness, but *chiffre*-reading. Through all the formal analyses of its works, through all the accounts of its world in the history of the mind, through the biography of its creators, he seeks contact with that something which perhaps he himself is not but which as Existence questioned, saw and shaped in the depth of Being that which he too is seeking.[8]

This is a high concept of art, worthy of a time which is in the course of recreating its idea of life and culture on the basis of new conditions and trying to measure it by values established by tradition. These traditional values have been shaken by the role played by science as a means of conceiving truth:

> It is the problem of our present situation that the last foundations of existence have been undermined. Our time compels us to reflect upon ultimate questions and presses us to most immediate experience. As a result of the condition of our whole culture, our souls have become accessible to unfamiliar things in an unexpected manner in so far as they appear to us as being genuine and existential.

Thus Jaspers wrote in his study on van Gogh. He sees the "striking fact that to-day a number of high-minded people who have become schizophrenic exert an effect through works of their schizophrenic period" in this light: "If we go back in Western European history to the 18th century, we do not find any schizophrenics whose cultural significance for their time is comparable to that of van Gogh and others." In van Gogh's later work it is

> as though a last source of existence had become temporarily visible, as though hidden depths of all realities had here exercised their influence. . . . It all evokes a questioning, an appeal to one's own existence, which has a beneficial effect by setting off a transformation.[9]

In his speculation, Jaspers performs the act of thinking out of the necessities dictated by his own time, by the situation into which he has been born. We recognize in his urge for the reconquest of fundamental values of thought a phenomenon which is also an essential element throughout the development of modern art.

II

I visited Karl Jaspers at his home at 126 Austrasse, a small but nobly designed house in a quiet residential quarter of the old town of Basle. Jaspers was appointed professor of philosophy at the famous University of Basle in 1948, even though, by his concept of direct philosophical thinking and by his following of Nietzsche and Kierkegaard, he repudiated the old academic notion of philosophy as being but an editing of texts and an interpretation of established systems. He wished to think directly, creatively. (Similarly, the modern movement in art resisted all academism.) The citizens of Basle, with their feeling for quality and the dignity of learning—what other town can pride itself on having had among its teachers men such as Nietzsche, Eucken, Burckhardt, Bachofen?—had the good sense and the courage to call upon him to instruct their youth. A most imposing figure, yet unassuming and friendly, the septuagenarian received me in his study, surrounded, as one would expect, by books stacked up to the ceiling. I observed him attentively. Only once or twice did I seem to notice a routine reply, as if he were quoting directly from his books. Throughout most of our conversation there was an element of surprise, arising from the nature of the topic and the pleasure which he seemed to derive from it. He

was involved in a process of immediate thinking and of careful formulation of his answers. This was reflected in his eyes. I have never seen a face with two eyes of such different action. The left eye was, as it were, turned inward; tranquil and deep like a lake, it seemed to meditate with a Yogi-like detachment. The other eye, wide open, darted rays of energy. I experienced these rays as lines of force, as perceptible links of communication, so vivid was my impression.

"Speaking of artists: apart from van Gogh, I only wrote on Leonardo, as you may know," he said in a resonant voice.

> At that time, however, I was more interested in the philosopher. Leonardo was always spoken of as the *uomo universale*, the artist, the scientist, the engineer. That he was a philosopher was scarcely mentioned and mostly ignored. Already in my youth I had a great love for Leonardo the artist. You may have noticed the picture outside on the wall.

(In the antechamber of his study, which was also lined with books from floor to ceiling, there hung a reproduction of Leonardo's famous self-portrait as an old man, drawn in red chalk, which is now in the collection of the Palazzo Reale in Turin.)[10]

> When I wrote on Strindberg and van Gogh, my approach was purely psychological. Strindberg was especially alien to me; for van Gogh I felt more. In 1912 I saw the large Sonderbund exhibition in Cologne, where the whole of modern art from Moscow to Madrid was represented. There were more than a hundred pictures by van Gogh. The impact they made on me was very strong, unlike anything—I felt it distinctly.

Remarking that Edvard Munch was also represented with a large collection in the same exhibition, I tried to draw his attention to the Norwegian master. "Munch was a great artist," he murmured, "but he cannot be compared to van Gogh. At least that was how I felt. Van Gogh was schizophrenic, an outspoken mental case."

To the suggestion that van Gogh's different biographers are not in agreement with regard to the diagnosis of his illness—the French, for instance, spoke of epilepsy—he retorted that according to the new classification this label is not correct. He added,

> The terminology of psychiatry is very much a matter of fashion. For the concept of van Gogh, only that which goes beyond the

psychiatric facts is important. Not until later did I realize what it meant for a work to reach such greatness, growing, as it were, out of the soil of such a psychic process. This impelled me to study Hölderlin for comparison. His *Hymns* made the deepest impression on me, especially those written at the beginning of his illness. Without the mental illness a work of such agitating metaphysical emotion would not have been possible. This was a great revelation to me. As a psychiatrist I noticed that at the beginning of the schizophrenic process even those patients express metaphysical thoughts who ordinarily are not open to philosophical speculations. This book on Strindberg and van Gogh is a work of my youth. It was written as early as 1914, but I could not bring it out until later, owing to the outbreak of the war.

To the question whether other modern artists, such as Klee perhaps, had made a similarly deep impression on him, he answered, "No. You could name them all, one by one; they interest me as contemporaries, my questioning mind is focused on them. I can say that a Picasso fascinates me in a strange way. I recognize his creative capacity, but I do not register any emotional reaction."

Did this answer astonish me? I do not know, but I should like to think so. It was in exactly the same way that, a few years earlier, C. G. Jung had answered a similar question of mine. It may be significant that he too approached modern art from the point of view of the psychiatrist—with this difference, that the case which he investigated was Picasso, who is not schizophrenic but whose work reveals a schizoid tendency. Suspecting that Jaspers, who in his study on van Gogh had included a chapter on "Schizophrenia and the Culture of Our Time" (a similar tying-up of both was suggested by Prinzhorn in his work *Bildnerei der Geisteskranken*),[11] might also be inclined to treat the whole modern movement as a parallel to, or symptom of, mental derangement or, at best, as an expression in art of the spiritual crisis of our age (Jung did both), I asked him about it.

> In the first instance, I must question the phrasing of the question itself. I regard as humanly ruinous the reduction to generalizations of spiritual phenomena such as art, and the investigation of these phenomena in one's own time as historically completed. It is as if the seriousness of the issue were done away with by way of reflection. Nowadays many artists produce theories. They not only provide us with the art but also with the interpretation. I have read with interest letters of Franz Marc. But I did not find in them any relationship to his work whatsoever. When reading Malraux's *Psychologie de l'art*,[12] on the other hand, I believe I

have experienced the author's expansive vision of the millennia, something eternal which stands above all ages. I agreed with it completely, whilst in our age Spengler's subsumptions must be considered to be the last echo of a trend of thought which started with Hegel, made its impact on the world through Marxism, and extinguished man in favour of history. Sometimes one wishes that Malraux would develop an idea more elaborately; one would like to see more consistency in the formulation: nothing constructive for the philosophical mind seems to emerge from it. But there is always a great wealth of deep insight; one feels the vigorous personality, the poetic grip. Take Haftmann,[13] on the other hand: I glanced through his book . . . idle talk, if you permit my saying so. The same old trot, above all the trends, nothing but a chronological grouping of the artists into schools and generations, that's all it is.

He shrugged his shoulders.

"Malraux's work has been attacked again and again. Art historians declared that it was not art history, psychologists that it had nothing to do with psychology: in one word, it was not science."

"It is not science: it is more," he responded.

Anxious to get to the bottom of the problem of modernism, I asked, "What does contemporary art mean to you?"

He shot a sharp glance at me. Then the general calm and mildness of his personality returned, closing over us again like a benevolent wave:

This question cannot be answered in one sentence. I want to say that my contemporaries have always priority of interest. "Because it happens to-day, it is my concern" [here he quoted Goethe]. That I acknowledge the seriousness and the toil, the struggle and the artistic gift, and that I cannot look upon the era of modern art as one uncared-for, that is certain. But—now comes the *but*: since I am not an artist or a poet myself, art and poetry reach me only as one who listens, who comprehends. I do not feel deeply satisfied unless a truly great artist speaks to me. Again and again I take up books, filled with the wish that they may bring back to my mind what I have seen in museums, exhibitions, and elsewhere, that they may bring it nearer to my appreciation. Rembrandt, Michelangelo, Titian, Leonardo!

He shook his head. And then:

This is not a judgment, but the expression of an essentially basic attitude. In art, what counts is transcendental content rendered

visible; but, curiously enough, this happens only with the rare, truly great artist so that for the few hours left for it, it is rewarding to look at them. In considering art I think one has to draw a sharp line. I spoke with Wilhelm Furtwängler about it—it was in 1925. But he rejected it as completely wrong. I said to him: "In art there are two layers; one is metaphysically sincere; the other, while showing vital creativeness, can at best please but it cannot impress itself in an essential manner. This sharp division cannot be made with objective certainty, but I consider it of such fundamental importance that without it I could not make any statement on art at all." Furtwängler disagreed. Even the humblest musician, the most insignificant little tune, so he maintained, originates in one indivisible source, which is art.

Speaking about the relationship of art and science and the attitude of modern artists who adopted either a pro-scientific or a contra-scientific attitude, Jaspers seemed to find fault with both.

I like to look at some of Matisse's paintings. I once had the opportunity—it was in the house of a friend of mine—to live for some time with a work of Matisse's. [This was *The Young Sailor II*, formerly in Mr. Hans Seligman Schlirch's collection in Basle and later in the collection of Mr. and Mrs. Leigh Block in Chicago.] Seeing it every day brought me nearer to it. Then one day I read a statement by Matisse against theories.[14] It was a defiant statement against all kinds of theories. Matisse paints pictures which do not move me, it is true; but I agree with Matisse in his rejection of theories coming from the artist. Such theories emanate mostly from wrong presuppositions. The Renaissance artist was a scientist as well. His studies of perspective, of anatomy, were scientifically based. Because they were predominantly artists, however . . .

"They had a surety of taste . . . " I continued.

No, taste is not the right word in this connection. Because they were artists, the artistic truth prevailed. The Renaissance artist had enough sensibility to deviate from science when he felt the need for it. The same is true of the old Greeks. Take the Doric style: it has always been maintained that the Greeks of that age proceeded in a scientific manner. But when you measure from decisive points this will prove incorrect—in a scientific sense. A plane is not a plane, but [is] bent, and so on. The struggle for art, for form and expression, is one which cannot be solved like a

mathematical problem. Science at that time was used as a means, no more. Today, however, artists indulge in the same mischief as some philosophers by borrowing concepts from modern science which they pass off as a world view. The case of the modern artist is this: he says modern science has done away with the notion of reality. What is left are mathematical formulae—non-reality. This is nonsense, it is dilettantism. What is true, however, is that natural science works with utmost pregnancy. Newton is not superseded but included in a more comprehensive picture. Planck said: Reality is what is measurable. This measurable quantity exists—somewhere. This reality has remained—but it is infinitely less than what really is. What these artists do is the same kind of nonsense that has been repeated throughout the centuries: the establishment of a metaphysical absolute. It is the beginning of every development in natural science. I do not consider what is being explored now as constituting the deepest division in natural science. This division lies with Galileo and with Newton. It was an immense world-historic division, the turning point of thought on which the present development has meaningfully built further. The technological effects of it have a significance which is basically different from that of a hundred years ago. Today the destiny of mankind is at stake. It is not certain, and we cannot know whether there will be people in existence in a hundred years from now. Take the contamination of the earth's atmosphere. That this is possible is new technologically but not as a concept. The present situation resembles in some ways that of early Christianity. The early Christians expected the end of the world; we fear the contamination of our planet. That is not exactly the same. Similar fears have entered the mind of the artist. They have left their traces on his work. Science has been reproached for these disgraceful consequences. One should rather reproach the morality which allows science to be used in this way. Such a dreadful necessity should not be imposed on an age when the real need is to make people use their reason.[15]

Confronted once more with the problem of modern art when speaking of the *chiffres* of being—the *Gestalten* of reality itself can be seen as *chiffres*, as hieroglyphics, of an unknown transcendental reality, and the *chiffres* in artistic creation as the ever-changing human aspects of this transcendental reality—he said that

> the invention of such *chiffres* is great art. The step to be taken is from the symbol to the *chiffre*. The artist creates symbols as visible appearances and recreates them in order to achieve the

chiffre. The symbol itself is less than the *chiffre*. Historically the artist represents man living out of the metaphysical ground, whose creative spiritual power brings forth both the notion and the visuality of the *chiffre*. In the first centuries of the Christian era there did not exist any Christian art; what we find there is a degenerate antique art. Christian art began with the great mosaics. The powerful artists who created these works were Christian artists. The Christian artist was not he who merely knew the Bible but he who created from the depth of its spirit. But first there had to be one to do it. That is why we find Rembrandt so unique. In 1925 I visited Rembrandt's house in Amsterdam. My wife, who is Jewish, was surprised that she could not tear me away from these narrow streets and squares, which seemed to me to have changed very little since the days of the master. There was the same bustle and movement which we recognize in many of his pictures; everything happens outdoors in the street. There was much noise and no manners, but suddenly one would notice a head here and a face there which he too had noticed and painted. He did not reflect, he did not make a program. Rembrandt rediscovered the Jewish soul; he painted the Jewish soul in innumerable figures. It fascinated me so much that I suggested one day—it was during the Nazi regime—to the art historian Grisebach in Heidelberg that he embark with me on a book. The plan was that he should write about Rembrandt, on the discovery of the Jewish soul in art, and I would write about Nietzsche, on the discovery of the Jewish soul in philosophy.

Responding to the question in my eyes, he said: "If one adds up all the statements which Nietzsche has made on this subject, the quality of his insight becomes obvious." He went on:

> Let us return to Rembrandt. He discovered the Jewish soul by painting the Bible, by painting Jesus, the Prophets, the Apostles—all of them magnificently. This is an artistic accomplishment based on Biblical faith. It is a powerful intuition which reveals his faith in man, bringing it to life by means of pictures. It is free of dogma and so great that one longs to see such a picture in one's dying hour. And there are not many things one wishes to see when dying.

I interposed, "Since Rembrandt, only Chagall has interpreted the imagery of the Bible with such genuine intuition."[16]

> I can believe that. I do not know his Bible illustrations. But he has something so childlike, an Eastern quality which is convinc-

ing. . . . In general, however, one must say that the modern artist does not possess that foundation of faith, that religious conviction. Such a faith can be truly rendered only through one's own existence. In most cases the modern artist is either violent or cool and conscious. A process of self-galvanization has taken place, but there is no metaphysical truth. Of modern artists I am inclined to believe mainly in men such as Matisse. Their work gives pleasure.

I was reluctant to accept Matisse as an individual case only. On the other hand, I could understand Jaspers' reasoning. I therefore tried to draw his attention to the currently accepted axiom that nothing truly contemporary can any longer be expressed by way of the traditional concepts and images which originate in the Greco-Christian era. They all seem to the artist dead. He replied,

> I am convinced that there are many believers in our time, people who live in sincerity and are ethically correct. Yet it is true that their world is not creative. A friend of mine, a Catholic priest, once said to me, "Perhaps never before has there been a time when the average Catholic priest attained such a high moral level, yet he is completely unproductive. There is no longer any life in the work on the dogma. That is all left to the Pope and the cardinals, who provide it whenever they consider it necessary." These priests are trained Thomists; everything goes very smoothly and they are generally better equipped than other philosophers. Will there be a creative recovery? To prophesy would be foolish. Many deny it. Our reason always sees only decline. The creative faculty can give birth, reason cannot. And I need not emphasize that I appreciate reason to a high degree. If reason could foretell coming developments it could also create. That, however, is not given to it. There is a factor of unpredictability . . .

"Professor Toynbee's work seems to present us with a different outlook."[17]

> Professor Toynbee is a man of weight in these days. Here again it is a matter not only of differing viewpoints but of a fundamental difference in the conception of Biblical faith in mankind, if you wish. Toynbee is far more Christian than I am. In fact, I am not a Christian. In his forecast of a universal Christianity of the future there is much of Hegel's and Spengler's mind. I do not share it because I consider such a forecast to be wrong. My involvement with the idea of the unity of mankind is different from Toynbee's. That is why I found in the concept of an axis-time, in the very

medium of scientific exploration—that is, in history—a means of investigating this unity of mankind.[18] I worked it out during the years of barbaric racial hatred when I was working in solitude in the Germany of the Third Reich. Already in 1934–35, in my despair, I occupied myself with the translation of works from Chinese and Indian literature and I studied history to reassure myself of this spiritual unity. It was my only consolation in those days, that with one's mind one could take refuge in the unity of mankind, that one was not tied to any particular place. My book on history was the result.

Among contemporary artists there are many who are concerned with metaphysical phrases. I shall give you an example. In my academic lectures, long before 1933, I explained what it means when people speak of "the daemonic." After all, one must know what one speaks about. If one operates with daemonic powers much in real life, the world goes to the bottom. It became very common in Germany to quote Goethe on the daemonic. Now, they said Hitler was daemonic. When one says such things one is already for him, even if one is his enemy. There was nothing daemonic about him, everything was calculated. The mood in pre-Hitler Germany—and to a large extent the artists and the writers had helped to create it—became a bog, and in the confusion of emotions and ideas the world sank into catastrophe. It was fortunate that modern art was proclaimed degenerate. This saved it from taking part in the process. The position of modern art in Russia is analogous.[19]

Again I was struck by the similarity with Jung's approach to the same problem. Not only did he speak to me in an identical manner about the daemonic powers having been exorcized; in one of his books he also thoroughly propounded this aspect of the Second World War.[20] Jung's attitude is also similar to Jaspers' in that many of his notions, such as the concept of the archetypes or the collective content of the subconscious, the subconscious unity of mankind, can be used very profitably in the interpretation of modern art, although Jung himself does not favor such an art.

If, apart from what has already been stated in a general way in the first part of this essay, we apply Jaspers' idea of the relationship between art and science to all the different aspects of abstract art; or apply the use of metaphysical concepts and the notion of *chiffre* to the work of Klee, or Miró, or Masson; or apply the presence of dread, of *Angst* and *Sorge*, and the emergence of daemonic trends of thought to

certain aspects of Expressionism, or contemporary sculpture, or Sur-
realism; and finally, if we realize that an age cannot be judged con-
clusively until it is over, or the art of an age evaluated while it is still in
progress—that we cannot expect an art to reach maturity while only in
its early stages (as with early Christian art), and that truly great artists
are and always have been rare—then we shall find that Jaspers' philoso-
phy, supplying as it does some fundamental viewpoints for the critical
apparatus required for its evaluation, can contribute much to an under-
standing of modern art.

NOTES

1. Thomas Bodkin, *An Approach to Painting* (London, 1945); Lionel
 Lindsey, *Addled Art* (London, 1946); Bernard Berenson, *Seeing
 and Knowing* (London, 1953).
2. Bernard Champigneulle, *L'Inquiétude dans l'art d'aujourd'hui*
 (Paris, 1930); Wladimir Weidlé, *The Dilemma of the Arts* (*Les
 Abeilles d'aristée*) (London, 1948); Hans Sedlmayr, *Verlust der
 Mitte* (Salzburg, 1948); Nicholas Berdyaev, *The Meaning of the
 Creative Act* (London, 1955).
3. C. G. Jung, "*Ulysses*-Picasso," in *Wirklichkeit der Seele* (Zurich,
 1952); English version: "*Ulysses*," in *Nimbus*, Vol. 2, No. 1 (Au-
 gust 1953); "Picasso," in *Nimbus*, Vol. 2, No. 2 (Autumn 1953);
 J. P. Hodin, "C. G. Jung and Modern Art, A Conversation" (Lecture
 given to the Institute of Contemporary Arts, London, February 18,
 1954).
4. Max Born, "Physics and Metaphysics," The Joule Memorial Lec-
 ture, 1950, in *Science News* (London: Penguin Books, 1950); E. A.
 Burtt, *The Metaphysical Foundation of Modern Science*, rev. ed.
 (New York, 1955); Werner Heisenberg, *Philosophic Problems of
 Nuclear Science* (*Wandlungen in den Grundlagen der Naturwis-
 senschaft*) (London, 1952); Erwin Schrödinger, *Nature and the
 Greeks* (Cambridge, 1954).
5. Bertrand Russell, "The Philosophy of Logical Analysis," in *History
 of Western Philosophy* (London, 1946); Ludwig Wittgenstein,
 Tractatus Logico-Philosophicus, with an introduction by Bertrand
 Russell (London, 1922); A. J. Ayer et al., *The Revolution in Philos-
 ophy*, with an introduction by Gilbert Ryle (London, 1956).
6. *Philosophie und Wissenschaft* (Basle, 1948), in *Rechenschaft und
 Ausblick: Reden und Aufsätze* (Munich, 1951); *Philosophy and
 Science* (London, 1950).

7. *Philosophie,* 2d ed. (Berlin-Göttingen-Heidelberg, 1948); Karl Jaspers, *Von der Wahrheit.*

8. "Philosophie und Kunst," in *Philosophie,* pp. 282–92, and "Kunst als Sprache aus dem Lesen der Chiffreschrift," in *Philosophe,* pp. 840–46.

9. *Strindberg und van Gogh: Versuch einer pathographischen Analyse unter vergleichender Heranziehung von Swedenborg und Hölderlin* (Bremen, 1949; 1st ed., 1922).

10. *Lionardo als Philosoph* (Berne, 1953). In a letter dated July 6, 1956, Professor Jaspers wrote to the author as follows: "Of Leonardo I brought with me in 1902 from my first journey to Italy a reproduction of his self-portrait (the original drawing is in Turin) and an Anderson photograph of Titian's so-called *Earthly and Heavenly Love* which then hung in the Casino Borghese. Both pictures have since that time accompanied me, first in my student rooms and later, the self-portrait only, in respective studies, whereas the photograph of the Titian painting hangs still today in another room." Of the Titian painting Professor Jaspers wrote in a later letter (July 14, 1956) that "it represents two female figures, one a nude, the other dressed, sitting on a fountain with a wonderful landscape as background. The title of the picture is nonsense. What it represents has never been discovered. Once it was called *Persuasion to Love,* even this not very satisfactorily. That is however of no consequence. The picture seems to unveil a scene which nevertheless remains unknown. It makes an impression on me as if in the depth of things peace can be found."

11. "Das Schizophrene Weltgefühl und unsere Zeit," in *Bildnerei der Geisteskranken: Ein Beitrag zur Psychologie und Psychopathologie der Gestaltung* (Berlin: 1st ed., 1921).

12. (Geneva, 1948–50), 3 vols.; new rev. ed. in *Les Voix du silence* (*The Voices of Silence*), (Paris, 1951).

13. *Malerei im 20. Jahrhundert* (Munich, 1954).

14. *Notes d'un peintre.* Originally published in the *Grande Revue,* (Paris), December 25, 1908.

15. Two years after this conversation Karl Jaspers published *Die Atombombe und die Zukunft des Menschen: Politisches Bewusstsein in unserer Zeit* (Munich, 1958), for which he was awarded the Nobel Peace Prize.

16. Marc Chagall, *Illustrations for the Bible* (*La Bible*), *Verve* (Paris), Vol. 9, No. 33/34 (1956). Also: *Bible* (Paris: Ed. Tériade, 1956), 2 vols. See: *Le Message Biblique de Marc Chagall.* Donation Marcel Valentine Chagall, Catalogue, Musée du Louvre (Paris, 1967).

17. *A Study of History* (Oxford, 1934–54).

18. In his book *Vom Ursprung und Zeil der Geschichte* (Munich, 1949), Karl Jaspers developed the idea that all mankind, independently of race and place, reached in the epoch between 800 and 200 B.C., with approximately 500 B.C. as the axis of world history, that height of moral and contemplative maturity, that notion of man in a religious and philosophical sense which is still the basis of modern man's personality.
19. Alfred Rosenberg, *Der Mythus des 20. Jahrhunderts* (Munich, 1930), Book Two: *Das Wesen der germanischen Kunst;* J. P. Hodin, "The Soviet Attitude to Art," in *Contemporary Review* (London), June 1953.
20. C. G. Jung, *Aufsätze zur Zeitgeschichte* (Zurich, 1946).

2 • KOKOSCHKA ON THE MYTH AND FATE OF EUROPE
Thoughts on the Philosophy of a Humanist Culture

THE SAGA OF PROMETHEUS*

With the World War a time has dawned in which things happen of which hitherto we only dreamed. Indeed, the very idea of war between cultured nations was looked upon as something absurd. . . . And what followed the war was a real witches' Sabbath of anarchy and ruin.

C. G. JUNG

Will Europe remain what it appeared to be, that is: the precious part of the earthly Universe, the pearl of the Spheres, the brain of a vast body?

PAUL VALERY

A FEW YEARS BEFORE THE OUTBREAK OF THE FIRST WORLD WAR, OSKAR Kokoschka was painting portraits which earned him the enmity of the conservative *Neue Freie Presse* of Vienna and the admiration and help of a man of vision and understanding, his friend the architect Adolf Loos. (Referring to these pictures almost four decades later in London at a moment when he was deeply shaken by the events of the Second World War, the artist exclaimed: "Even then I felt it. Suddenly, intuitively, I knew that the whole of humanity was smitten with an incurable disease.")

* This and the following section, "Thermopylae," are translations from my *Bekenntnis zu Kokoschka: Erinnerungen und Deutungen,* published by Florian Kupferberg Verlag in Mainz in 1963.

18

Then the First World War broke out, and in 1914, with the vision of the hecatombs of the dead in his mind's eye, Kokoschka designed a crematorium. It was a fantastic building suggestive of the architecture of ancient Egypt, and on its inner walls was to be painted a frieze depicting life and death. Only two drawings and a watercolor of this project are preserved. In them a vision of the tragic discords of our time is combined with the artist's own urge to create on a monumental scale.

The artist's work was exhibited in Basle soon after the war, and he was able to take stock of it and orient himself anew. The mature work that arose out of his further meditations was the legend of Prometheus, depicted in a triptych, the first monumental painting of the artist to attain completion. Wiser through experience and inspired by a pure vein of mystic thought, Kokoschka set before the eyes of a sick Europe the image of its own culture. It was like a call to us at the eleventh hour to return to the source of our spiritual tradition. And it sounded a warning against mass man, ready to throw away a noble inheritance for the enjoyment of the false temporary gains which science, dialectical materialism, and technology so temptingly held before his narrow field of vision. The call was not that of "back to the Greece of antiquity," which Nietzsche had sounded when he laid the axe to the age-old stem of Christian ideology, and which in reality—our reality—sought to set biology in the place of ethics and to smother the human consciousness of culture under Darwinism. Nor was Kokoschka's call one of "back to Primitivism," to sensual thinking, to the brutality of André Gide's *acte gratuit*, to the negation of culture, to the mentality of Dadaism. No: it was a call, rather, to the visionary in man, proclaiming that God is none other than a leap into space, and that to seek God is man's only worthy aim. If anything can be called virile, it is this, in Kokoschka's view: just this, and not a deed of arms. If man aims low, if he aims at sexuality alone, at power, at the values of the marketplace, at pleasure, these will form the standard of measurement for the ideal he follows. The more powerful man becomes in the mass, the less his real value; and the fate that now threatens us is to lose our identity in the raw material of life. At this point, however, we reach the domain where the mothers rule; and hard as the trial will be for us and the generations that follow us, here we shall escape the final danger. Whoever descends into the realm of the mothers will find certainty in the origin of all experience to light the way for the next phase of human destiny. It is here that Kokoschka's Promethean saga begins. It is the saga of the male and the female principle, out of which sprang the glorious tree which bore such

magical fruits: those of antiquity, with its cosmic wisdom and vision of earthly beauty, those of Judaism, with its sense of divine creation and divine justice, and those of Christianity, with its gospel of love and its hope of eternal life. Will the flowers of modern science, which have been dazzling the eyes of all humanity for more than a hundred years, ripen into fruit whose poison will destroy us all? Will they prove to be the fruit of which the ancient legend says that man may not eat, that the day upon which he shall taste of the fruit he shall surely die?

In the left-hand panel of Kokoschka's triptych we see the realm of the eternally feminine, on the right that of the creative and destructive male spirit, the spirit of the daring and suffering Prometheus. The middle panel displays, as in a panorama, the vision of European culture and the danger that threatens it.

The realm of the mothers is bathed in moonlight. It is that side of existence which signifies love and the mystery of organic growth, and hence is also the womb of life and culture. Demeter, Persephone, and Hades are here represented. It is the myth of the seed corn that must first be buried in the earth to germinate before it comes into the light again, transforming death into life. The Greek myth tells of the rape of Persephone, the beautiful virgin daughter of Demeter, by Hades, the god of the underworld. Blue dominates here, the color of night, of distance, of longing; whereas on the right, in the Prometheus picture—where the principle of thought, of organization, takes the place of germination, where the will takes precedence over the pulse of life, and day takes the place of night—the dominant color is yellow. Thus both poles of human existence have their part in this eternal, preordained movement of ebb and flow, of alternating joy and sorrow, building and destroying, now with the male, now with the female principle in the ascendant, here blessing, there condemning.

Whoever saw Kokoschka at the time when he was painting this mythical poem and knew the suffering out of which he forged the unique instrument of art that he is, whoever followed the *katabasis eis entron,* his descent into the underworld, where knowledge at its original source was granted to him, will understand why he painted himself as Hades, who with one mighty arm seeks to hold back Persephone from flight while the other arm rests on the head of the Gorgon. The Gorgon too belongs to the picture. She is the symbol of horror and terror to which so many contemporary artists have fallen victim, forgetful that the winged Pegasus sprang from the blood of Medusa when she was slain by Perseus.

"I belong to the underworld," said Kokoschka in the room, shadowed by leaves, where he was painting the triptych at the time.[1] "I belong to the mothers, and that" (he pointed to the picture) "is my real head." Out of his body springs Persephone, the goddess of death and love (in the Indian mythology, Kali), bursting out of the picture as well and falling, as it were, toward the beholder. Demeter, goddess of fertility, without whose aid nothing can prosper and ripen (for which reason she stands in Kokoschka's picture in a wide arch between the upper and the lower world) is met with also in other figurations. She is the fleeing mare pursued by the stallion between the moon and the fathomless night; the quails in the corn field are sacred to Demeter; so also is the fig tree standing before the grotto, the entrance to the underworld. The ray of moonlight seems to bless the hand of Hades, the hand that grasps and carries off beauty and eternal life into the underworld: a grandly constructive conception. In the background of the principal theme, another motif invades the middle field: the standing female figure, emptying an urn over a figure in the act of rising, is a further variation of the mother goddess bringing the dead to life. She causes life to germinate, and she also revives the dead. It is a version of the libation, the ancient drink offering, which has its place also in the Catholic Mass as a promise of eternal life. For the living person is born spiritually dead, and is brought to life for the first time in baptism with water, and for the last time through the Holy Sacraments, thus being endowed with eternal life both at entering the world and at leaving it.

The mother motif continues along the lower edge of the middle field. All the female figures there, mothers, those of the Old Testament and those more ancient still, pour water out of vessels or fill urns with water from the sea. And so throughout the whole composition we are made to feel that all culture proceeds from the mothers who revere Gea, the earth (a further metamorphosis of Demeter), the most ancient of them all. She is depicted in the middle of the composition surrounded by water. Behind the ancient women are monsters (centaurs) hiding in clefts of rock on the hillside upon which, to the left of the middle field, figures symbolizing the unfolding of European culture have their place. Kokoschka said to me:

Water brings forth life. The womb is also water. Out of the womb of Gea, the womb of earth, comes the first man, Adam. He is elemental man, heavy as a clod of the earth on which he lies outstretched. He belongs more to the clay than to the spirit. Above him appear the individual phases of European culture, those of

the Old and of the New Testament and of the Pantheon: Cain and Abel, the bloody transition from a nomadic to a settled existence; David sings holy psalms to the music of the harp; in the cave is a broken idol. The golden calf is not Mammon, it is vice. Virgil with his goat—the *Bucolica* and *Georgica*—looks at David playing and singing, he himself chanting the golden age, the coming kingdom. Above the caves are the prophets, the seers and the witnesses foretelling the coming of the Savior, the Deliverer. At the highest point is the Cross.

The deepest wisdom of European cultural history, its innermost soul, is expressed in the Greek dictum that "man is the measure of all things." The crucifix too is a man.

The Four Horsemen of the Apocalypse come storming through the night, threatening this human creation of culture with extinction. Magnificent Baroque horses they have, wildly rearing! "The horse too comes out of the sea." When Poseidon struck the earth with his trident he brought forth the horse which has become his symbol.

In Boeotia and Thessaly we find the oldest known European cult of the horse; and there too rose the myth of Demeter. When the animal breeders changed over to agriculture and a settled existence they began the worship of Demeter. Death also comes out of the life-giving sea, and is here interpreted as one side of a unified process. On the right Aeneas is shown bearing his old father Anchises out of the wreck of the city of Troy. Rome and our own world stem from Aeneas.

A mild afternoon in late summer. All is quiet; only occasionally is a bird's song to be heard out of the thickly interwoven branches of the old trees. Kokoschka gazes for a long while out of the open window. "Nemesis," he said, "will always be lying in wait, threatening life. Again and again the children will be offered to her—youth will be sacrificed. They survive the storm of the Apocalypse, however, as if by a miracle. A new world rises out of the deluge. Gea brings forth new life again and again."

The apocalyptic riders come through from the right, the side of Prometheus, with whose representation they are formally bound up. Might one not surmise, then, for nothing here is left to chance, that they represent the male principle in its destructive aspect? It is well, in this connection, to remember that the young Kokoschka, for a long

time after the First World War, refused to give his hand to men in greeting for the reason that their hands might be stained with blood. But the destructive is an aspect of reality and belongs to it as shadow to light. Man cannot be thought of as exclusively creative, or solely a complement to the female principle of generation and the fundamental instincts; when the spark of the spirit enters, even the evil urge to destruction attains its positive side. Germs thrive in decomposition, and out of ruins springs new life.

If in our rationalistic age Prometheus can be interpreted as the bringer of the dark light of that knowledge which threatens with destruction all that we hold most dear—our ancient European civilization—he may also, when we contemplate in Kokoschka's picture the violent Baroque foreshortening of his body chained to the rock and torn by the vultures of the earth ruler, be held to represent suffering mankind, tortured by its thirst for wisdom and its inner unrest; the human race, which for thousands of years has been punished for having stolen the spark of knowledge, the eternal flame from heaven. He may also be seen as the original father of all craftsmanship, as the creative artist: for according to the old Greek legend, it was Prometheus who made man and breathed into him the breath of spiritual life, thereby drawing upon himself the eternal enmity of Olympus. Out of this breath of spiritual life sprang also the attributes of culture which are represented symbolically in Kokoschka's picture: social order and honor by the crown, justice by the scales. After justice has spoken, judgment appears in the shape of the fasces with the axe. Judgment can be just or unjust; when unjust, it transforms freedom into slavery— hence the chains. And so it is left to man to turn to the good or to the evil; this is his real freedom. "For every man is in this sense a god; in this life he may shape himself for light or wrath." So spake Jacob Boehme, and Kokoschka, the last master of the Baroque and heir to the great mystical tradition, pronounces likewise.

In the right-hand corner, near the edge (where so much always happens in Kokoschka's pictures), sits an owl, symbol of the goddess of wisdom, the last of the incarnations of the mother goddess in this great picture. And above the night bird is the flaming torch which Prometheus threw into the world to bestow upon it fire as well as light, the art of the smith and the liberal arts, and all that might be of service to man. This dramatic legend is set in a summer landscape with the fiery sun at its zenith, the left side is set in a moonlit landscape, and the two are a rounded whole.

THERMOPYLAE

Who knows nowadays what Europe is?

<div align="right">UNAMUNO</div>

What we call a way is hesitation.

<div align="right">KAFKA</div>

Kokoschka was hardly settled in Switzerland in the autumn of 1953, in a region intimately connected with the beginning of his artistic career (it was by the lake of Geneva under the majestic sign of the Dent du Midi), when he began to make preparations for the execution of yet another monumental painting. He completed it in the summer of 1954 in the studio of his house in Villeneuve near Montreux, not far from the Château de Chillon. This painting is also in the form of a triptych, and represents Thermopylae.[2]

It was after the Second World War, when "the uneasy peace was scattering its seed," as Céline put it, that I listened to Kokoschka talking in his London apartment about present-day man, who is bewildered by science and technology. Misled by the mass psychosis of socialism and the spirit of industrialization, he has no understanding of his great European inheritance and casts it away. Kokoschka said:

> A world of ideas of inestimable value is passing away, and we are the witnesses of its passing. These ideas are in direct opposition to all cold intellectualism and all analytical processes. I am no pessimist. My roots are deep in the soil of European culture. But I do know that a long period of desolation is in store for us, a period of sterility after this last outbreak of Satanism. There is no progress in life; on the other hand there is a life substance, a life force. As in some huge earthworm, parts die off behind and new ones grow in front. The organism remains the same.

He broke into praise of the Catholic Church (though not of Christianity, for as he says, today everybody calls himself a Christian). The Catholic Church is, for him, the only worldwide organization of our time that builds upon spiritual values and can look back on a tradition of almost two thousand years. In this body, the oldest Christian and even pre-Christian wisdom and rites are fused, together with the spiritual inheritance of Greece and Israel, into a living power. The rationalist spirit, together with the particularist aims of nationalism,

have threatened to fragment the Catholic Church. But woe to Europe if it fails to bethink itself in time of the *unio catholica*—of the spiritual bond that binds all things together!

In January 1954 Kokoschka began work on the mural in which the situation that threatens the Europe of today is clothed with a historic garment. If his painting of the Prometheus legend was a pictorial rendering of the spiritual inheritance of Europe, this triptych of the Battle of Thermopylae is a representation of the political and humanist *condition humaine* of the present day. Three main ideas are embodied in this composition: the sense of history, of humanism, and of mankind in its critical decision; these culminate in a divine vision as their eternal reincarnation. On the left-hand side of the center panel, the largest of the three, Herodotus is depicted, his massive face turned toward us with the visionary gaze of the seer, meditating on the present and the past, gathering the story together and writing it down with power. The book of *Histories* on his knees, Herodotus, traveler, historian, and poet, appears as a mighty figure. It was his achievement to have composed the first great prose work of European literature, a work in which he describes, among other happenings, the heroic and successful struggle of small and disunited Greece against the mighty Persian Empire. This episode in the life of a little nation has always had a deep significance for Europe, and one that is particularly apposite today: it brings into high relief the conflict between two essentially different ways of life—the absolutism of the East and the free institutions of the West, the latter being based on the Jewish concept of divine justice, on Christian ideals, on Roman law, on Greek myth, and on the arts which they engendered. (These are also to be conceived as modes of spiritual order.) It is in fact the culture of the Mediterranean world, whose fate is once more in the balance. There is, too, another clash of forces conveyed in Kokoschka's picture, though indicated more subtly. It is the struggle of the man of culture against the crowd, whether governing or governed, against the materialists, the cynics, and those intellectuals who deny the soul and who are wholly given over to aggression or dread or inferiority complexes: in short, against the mob instincts within us and around us, the swarm of all-devouring locusts threatening the harvest of Europe.

Karl Jaspers says in his study *Die geistige Situation der Zeit*:

> If a man is singled out as a hero for holding his ground against odds which gather against him in a manner peculiar to any given time, then today the hero will be seen holding his ground against

the impalpable masses. Today the masses are sanctified against all questioning; and the individual if he wants to live in the world has to submit and suffer in silence or endure martyrdom at the hands of these despots who can destroy quietly and without leaving a trace.

To those who have given expression to the heroic spirit of resistance of the individual in his struggle against this amorphous mass and in defense of our European inheritance, while others were floundering in the morass of national prejudice and social compassion or withdrawn into ivory towers of introspection—to such men as Karl Jaspers, Miguel de Unamuno, Ortega y Gasset, Paul Valéry, Alexis Carrel, J. Huizinga, and Martin Heidegger—must be added Oskar Kokoschka. His vision was as strong and proud as that of Herodotus when he wrote: "Did not Xerxes lead all the peoples of Asia against Hellas? Were not all the waters too small for the host to drink, save only the great rivers?"

"It is always only a handful of people who really matter. It is always the individual that counts," said Kokoschka.

> Take Leonidas, the hero of Thermopylae. I represent him as a simple man, a peasant. When the access to the pass was treacherously given away by the perfidious Ephialtes, and it was hemmed in on all sides by the Persian invasion force, he held out the whole day with only three hundred warriors against an overwhelming weight of numbers, and finally shared the bloody sacrifice that befell them all. Leonidas and his little band of heroes who covered the retreat of the main Greek army, inflicting great losses on the enemy, did for the glory of Greece even more than the victors of the Battle of Marathon.

This Leonidas is seen on the left-hand side of the picture. He holds his helmet in one hand and in the other his shield, on which is painted an enormous and terrifying eye. He is taking leave of his wife. To her left, symbolizing peace and civilization, are a nurse and a child, a woman kindling a fire, a boy playfully grasping at a skin, and, farther back, a path in the warm, mountainous land of Greece, winding between cypresses and olives, past a temple and the figure of a god, with Bacchus riding on an ass led by Eros: all this is painted in subtle fluid color as if breathed onto the canvas.

> The helmet is so heavy that the wicked metal can be felt. It is the mask of war. Leonidas takes the curse upon himself of his own free will. The skin is that of a sacrificial ram, an animal I always

liked. The composition is built up out of vertical and horizontal lines. The one exception is that of the figure of Leonidas' wife. It expresses the grief of leave-taking.

With one hand she points to the child and with the other toward the sky, to where in the middle field, above Herodotus, the figure of Apollo appears, "the divine immortal in the bloom of youth. He is in my picture still almost a child." The young Apollo with the rainbow, in whose web of color the mountain landscape is lit up—this is again and again the miracle of life. Again and again a pair of open eyes and out of these comes the future. Apollo's hand pushes back the dark thunder-cloud, and the rainbow shows that the storm, the evil power, is over-come. The storm cloud, blood-red, the strongest color accent in the whole picture (which otherwise is kept in a scheme of pastel hues: rose, warm ocher, light green, and light blue) hangs heavily over the right half of the middle panel where the battle itself is taking place. This is the battle of which Herodotus so simply records that it began on a summer day in the year 480 B.C. For a while Greece stood united in face of the common danger. The record of this war, which lasted more than forty years and ended with a Greek victory, is a warning for a disunited Europe. The individuals, the handful of those who are con-scious of the danger, have not yet made the sacrifice of Thermopylae. The victories of Salamis and Plataea are yet to be won.

European man stands hesitant. He does not know which way to turn. His power of decision is paralyzed, for only yesterday he thought he had performed his great human duty by throwing all that he had into the balance in favor of liberty, equality, and fraternity, in the name of reason and science; and now, half stupefied, he is called upon to recognize that man is born not to be free but to act according to his duties and responsibilities. He has to learn that there is only one possible equality, and that is the equality of the lowest, and that fra-ternity does not mean lowering the level of culture so that everybody can feel comfortable on the same mental plane; but that, on the con-trary, it means aiming high, so that each and all strive for a worthy goal, and through their striving aid Europe to remain what it has hitherto always been—the salt of Western civilization. This man at the parting of the ways, "who cannot make up his mind whether to run away and give everything up or to stand his ground," who is depicted there with his fingers to his lips, as the sentries of old Greece were obliged to stand guard so that they might not fall asleep, is the central figure in Kokoschka's composition, the main axis around which every-thing moves. He stands there like a shadow, lance in hand, half sleep-

ing, half thinking. Ephialtes, the traitor at Thermopylae, creeps like a foul reptile at his feet, waiting for the moment when he can pounce upon the falling lance. Ephialtes belonged to one of the best families of Attica, one which had made its fortune out of supplies in the first Persian war; Ephialtes, the vulgar war profiteer, is the traitor. And now the invasion is here again (in the right-hand panel of the picture), the eternal invasion. And the figure on the right edge of the center panel, a man hurling down a heavy stone, that again is Leonidas, dying, this time painted in blue. He is the solitary individual on whose resolution and heroism everything depends. Above, there is a wild battle of men on horseback. "How many horsemen are there?" Kokoschka asked me, with a sly smile. There are only two horses there, and four or five figures indicated, and yet the whole gives the impression of a fierce battle.

> That is the power of the imagination, the art of creating an illusion; there is no reality. There is only a dull realism, and that by the way is also false. Old photographs give a different picture of reality from those today. In any case there is no such thing as progress, although there are fools living today who believe that they are in the van of it. A Chinese master of the fourteenth century once said of himself: "I can make a surface of two inches look like a distance of thirty miles, and on thirty inches I can paint infinity."

Between the man at the parting of the ways and the dying Leonidas a horseman brings a dead warrior out of the battle. How tired the horse looks, and how heavy the dead man! And how significantly the spear points in the direction of the mob with their coarse faces, the formless faces of the mass! Only about seven are sketchily represented, with the masterly art of characterization and the astonishing virtuosity of brushwork of which Kokoschka's vast experience has rendered him capable. He reminds us of the composer of a fugue, working with many voices in different keys, using counterpoint, modulation, episode, stretto, pedal, and coda, so that the music finally rages like a storm, and again becomes calm like sea waves, meditative; the parts and the whole are one because they are the overflow of an inspired soul. Kokoschka worked on this painting day by day for six months, with one short interval forced upon him by a journey to London. Between whiles, and for the purpose of relaxation, he wrote a volume of short stories.

Spatial depth, as ever with this master, is strongly emphasized. In each particular panel and in the whole the Baroque S-line is evident.

It bends away from the beholder leftwards with the path into the peaceful Greek landscape, then stretches through the middle plane of the composition till it turns again suddenly to the right toward the beholder in the fleeing figure of a woman (Liberty). In the center panel, between the death raven in the foreground, coming from the battlefield, and the appeasing hand of Apollo there is space in both the sense of the visual and the imaginary. There is space also at the back of the mob, one of whom brutally holds up the body of a child spitted on a spear. In the background, above the mob, there is a picture of a naval battle painted in the manner of the old masters, in which small vessels surround some large Persian warships—a vision of the naval victory at Salamis. This pictorially narrative element, embracing past and future in the present, this synchronicity, is also a protest against the mechanistic conception of time. Here is the leave-taking of Leonidas, and there the ensuing battle and his death. And here, again, is the final victory, with its frightful ruins which rise up into the dark sky of the present, against which the naked figure of Liberty stands out in stark relief. Following upon her heels are three bloodthirsty hounds—three heads like Cerberus, "the eternal police dogs."

"Neither time nor the spirit of the time!" So Kokoschka rejected any imputation of such ideas:

> What you see here is no *Zeitgeist*. "Modern" has always meant to me what other people were doing. Klimt to begin with, then Picasso, the Surrealists. What they achieve with their hatred of ability and order and with their communistic devaluation of art tradition is to hasten the time when people will reach the level of *these* hordes. This modern ideal of art that everybody worships! It certainly does not come out of Spain. It lacks entirely the full Spanish character with its sense of the sadness of knowledge. It is mere hatred, destruction, and wit. What I wanted to do here was certainly not to paint a battle-piece (I leave that to the sterile Social Realists) but the sadness of war. The conception of Europe is thousands of years old. Everything, whether in life or art, is a matter of human feeling; and that is just what the artists of today want to eliminate. Every object, every action in my picture, is the outcome of a human idea. There is no neo-classicism about it. Formally, it all had to be invented. The same humanistic principle determines the distribution of light and shade. The full light is to the left with the sun and the kindling of the fire; over the battle-field the light is diminished. But the human element has no longer any place either in art or life, and for that very reason humanity

must make up its mind. For that reason too my central figure con-
tains all directions in itself, that leading down to Ephialtes and
that leading upwards to Apollo with its relationship to the mass
behind it and its look into the past.

José Ortega y Gasset, in his *Revolt of the Masses*, demands that man-
kind of our generation shall learn and make its choice between a noble
and worthy life and a life of flat mediocrity.[3] And it is just this act of
choosing that makes the problem of modern man's spiritual destiny so
painfully acute.

The shock administered to the modern consciousness by the cata-
strophic consequences of the Second World War, said Jung, has as its
inner counterpart the shock to our faith in ourselves.[4] Paul Valéry, de-
scribing in *La Crise de l'esprit* modern European man as a Hamlet
who looks upon millions of ghosts, says that he meditates on the life
and death of truths. He has as phantoms all the objects of our great
controversy, and exclaims ironically: "Adieu phantoms! The world
does not need you any more. A certain confusion is still reigning but in
a short while all will be clear; we will at last see emerge the miracle of
an animal society, a perfect and final ant heap!"[5] And with reference
to a poem of Rilke ("If out of the trader's hand the scale goes over to
that angel who calms and steadies it in the heavens with the balance
of space . . . ") Heidegger complains that "the usual life of the man
of today is the quite common one of making his way on the unpro-
tected market of the money changer. Handing over the scale to the
angel is on the contrary uncommon; it is indeed already half forgot-
ten."[6]

Consciousness, however, stands on the threshold of the deed. Has
not Alexis Carrel alluded in his *Réflexions sur la conduite de la vie* to
that *"culte aveugle de la liberté"* with which the present phase of the
struggle is being carried on against those rules of life to which our
forefathers subjected their conduct?[7] Moderation, honor, truthfulness,
responsibility, purity, self-governance, love of one's neighbor, heroism:
these are the impulses of that cultural tradition which Renan defined
as having in common a famous past and a common striving in the
present; there are great deeds behind us and within us the will to do
more. In the past an inheritance of fame and sacrifice, and the same
program for the future. Our existence is an act of decision daily re-
peated.[8] Huizinga says: "We know it—incontestably: if we want to pre-
serve culture, then we must go ahead and produce it."[9] For Unamuno
also every idea and every thought is an inheritance. Why do we find
it so hard to make a decision? The Spanish thinker, who has much in

common with Kokoschka, says that in place of a spiritual existence as his aim, man has set himself the goal of progress, reason, and science, and this has become embodied in the form of a scientific or pseudo-scientific vulgarization.[10] He has tried to destroy the spirit of the *unio catholica* in Europe, that spiritual bond which André Malraux also defends, the tradition of classic and Christian humanism which is for him sacred: "We have cast off that within us which was the beast, and we want to find man again wherever we find that which crushed him."[11] A proud and thoughtful word, and as profound as Unamuno's, when he asks angrily: "Are not exceptions necessary, at least as examples? Are not racehorses bred to preserve the purity of draught and saddle horses? Are we not entitled to an ethical luxury as well as to any other? The monastic order that gave an Eckehart, a Seuse, a Tauler, a Ruisbroek, a St. John of the Cross, a Catherine of Siena and a St. Teresa, has justified itself fully." Kokoschka is of a similar opinion. "When I become more mature and knowledgeable, I shall perhaps venture one of these days to paint an apotheosis of the Catholic Church."[12]

NOTES

1. It was in the home of Count Antoine von Seilern in London, where the painting later on covered the ceiling of one of the rooms. It is at present fixed to a wall.
2. The triptych is now in the aula of Hamburg University.
3. *La Rebelión de las Masas*, 1930 (London, 1951).
4. *Aufsätze zur Zeitgeschichte* (Zurich, 1946).
5. In *Paul Valéry, History and Politics*. Vol. 10 of the *Collected Works*, published as Bollingen Series XLV (New York, 1960).
6. *Holzwege* (Frankfurt am Main, 1950).
7. (Paris, 1950).
8. *L'Avenir de la science, Pensées de 1848* (Paris, 1890).
9. *Im Schatten von Morgen: Eine Diagnose des kulturellen Leidens unserer Zeit* (Bern-Leipzig, 1936).
10. *A Tragic Sense of Life in Man and in Peoples* (London, 1921).
11. *Les Voix du silence* (Paris, 1951).
12. Since these essays were written, in 1950 and 1954 respectively, my book *Bekenntnis zu Kokoschka* (Berlin and Mainz: Florian Kupferberg, 1963) was published containing these two essays in German, under the joint title *Mythos und Schicksal Europas*. In 1967 my biography *Oskar Kokoschka: The Artist and His Time* was published by Cory, Adams & Mackay (London) and the New York Graphic Society.

3 • THE PHILOSOPHICAL MEANING
OF THE WORK OF ART

PHILOSOPHY IS THE URGE TO UNDERSTAND THE REALITY AND THE MEANING of life. It is as old as man himself. It is as strong a drive as hunger and thirst and sex. It begins as an indefinable quality and it ends undefined. Science can never replace it but can embrace it to become ennobled, a truly human endeavor.

Philosophy is not a study of systems and the work of ancient or modern philosophers. Nor is it a memorizing of texts or an accumulation of scholastic knowledge. Philosophy is a primary and creative activity of the mind, an irresistible impulse. It is the child's burning question—why? It is youth's unceasing yearning to know the answer, not only the question. It is the sage's contention that the road itself is the goal.

The intellectual does not know the wounds which thought can inflict; he does not share the delights of spiritual conquest. His thinking is not directed toward the center. It moves on the periphery. The academician is concerned with the history, the interpretation of philosophy—not with thinking itself. He alone who longs for self-knowledge will meet with dignity those who, throughout the centuries, have pursued the perennial quest to remove the veil from the secret of the obvious. He alone can value tradition as everlastingly present, whose roots reach into the consciousness of the miracle of Being. Not the specialist. Not the theoretician. The thinker will recognize in the quest of the artist the pulsating life of the searching soul. In the formative will of his search, there is query and answer. There is *simile*. There is symbol, there is life itself. There can be no true art without the palpability of the child's, the youth's wondering. There can only be production. True art is philosophy in paint, in stone, in tone, in rhythm.

From philosophy and from shaping comes man's answer to cosmic questions, comes *human* creation, growth, blossoming, an appeasing of tortuous curiosity; comes courage to carry on with the task of bridging the gap between past and present; comes confidence in the power of nature, and in the power of man—when the way seems lost. Comes unrest.

There is art in philosophy. For how could a man speak of experiencing the world as God's language, how—without being a poet—could he find the words: "Out of his despondency grows man's task and chance, emerges the comprehension that modern man, by applying the false loftiness of aesthetic images, is easily misled to avoid facing his real situation" (Jaspers)?

Rest and inner certainty are the aims of all philosophy. But with the monstrous destruction of age-old values in our day, when thought apprehends itself as spiritual youthfulness in the pain of leave-taking, rest can be searched for only by a perpetual stirring of our unrest. Thus Jaspers recognized the philosophic quest. Those who, like Kierkegaard and Nietzsche, have shaken yesterday's moral and ontological truths have expressed the dread and the courage with which man now faces the new scientific reality. In spite of all shocks and destruction we are still in danger of living and thinking as though nothing significant had happened. And yet, science is the deep spiritual incision in the history of man, a new beginning comparable to the invention of the first tools or the discovery of fire-making. Only unrest, urging us back to the roots, back to the sources of life, can give us new certainties, can satisfy us mentally. Restfulness, in the present situation, is deceitful, for it rocks us to sleep when vigilance and creative pioneering work are needed. The same philosophy is valid in art. In art and thought we stand on common ground: modern man in the making of a new world.

UNREST AND PERFECTIONISM IN ART:
A Conversation with Henry Moore

In the course of our conversation held on November 13, 1954, at Henry Moore's home near Much Hadham, Moore made several attempts to characterize his art, citing examples which were not limited to our own time: Masaccio, Michelangelo, Rembrandt, Cézanne. What he found to be common to all of them was a disturbing element, a distortion, giving evidence of a struggle of some sort. On the opposite

side he pointed to Hellenistic art, Botticelli, the Seicento, Raphael. But even in Raphael's art he found some of the quality of the former group:

> If you look at details, the face of Plato or that of Aristotle in *The School of Athens* at the Vatican, for instance, there it is again. The classicist trend has a pleasing quality; the static is emphasized. In England, both Ben Nicholson and Barbara Hepworth adhere to it. Rembrandt, on the other hand . . .

"And van Gogh!"

"Van Gogh is another matter. His art, great as it is, grows from a weakness, we have to admit it; it is panicky when compared to Rembrandt."

I realized that Moore wanted to bring out a further quality besides that of Expressionism. Expressionism to him seemed a manifestation less of strength than of irritation.

> Masaccio's art, the late art of Michelangelo and of Rembrandt, have an infinitely stronger bearing on life than has classicism. Rembrandt had an indisputable success as a portraitist of the Amsterdam burghers. But it did not satisfy him; he wanted something deeper. He wanted to achieve the impossible. Here the disturbing element comes in. It is instructive to know that Rembrandt copied Mantegna, whose art is the extreme opposite of his own. Why did he do so? Because he was conscious that his art lacked the classical element. He was aware of the opposite and that makes him greater. Cézanne, too, wanted to do the impossible. His art was always disturbing, but he ended by copying Rembrandt. The picture is now in the National Gallery. When we ask ourselves whether Cézanne really underwent a change, the answer must be No. His *Bathers* have still the disturbing quality which we find already in the large romantic Baroque compositions he began with. One cannot change one's nature. Artists try to debate all the time what they do instead of seeing that there is something in the opposite. No one really knows anything unless he knows also the opposite.
>
> I personally believe that all life is a conflict, something to be accepted, something you have to know. And you have to die, too, which is the opposite of living. One must try to find a synthesis, to come to terms with opposite qualities. Art and life are made up of conflicts.
>
> I think really that in great art—that is, in the art I find great— this conflict is hidden, it is unsolved. Great art is not perfect.

Take the Rondanini *Pietà*, one of the greatest works of Michelangelo. It is not a perfect work of art. There is a huge arm remaining from the other statue into which the *Pietà* was later changed. It has nothing to do with the composition. Nevertheless, it was left there. Impact and method in this work are the absolute opposite of the classic. Michelangelo had aimed at something else; but he had not enough stone for what he wanted to do. The strong feeling, the intention which obsessed him comes through—you feel the mark of his hand on the chest!

The *Slaves* in Florence are different. They are simply unfinished. The Rondanini *Pietà* couldn't be finished. There was no stone . . . although something powerful urged him on.

By the disturbing element, I mean struggle. By struggling, I mean being impelled to solve something.

Perfectionist art does not move me. Chinese painting is unsatisfactory to me. I can appreciate it, of course, and find it very pleasing and decorative, but something is missing. At the Chinese exhibition in Venice in 1954 I realized, more strongly than ever before, the conscious aesthetic and effectivist point of view which determined these works and which empties them of conflict. Try to compare, in your mind, some of the late Chinese works with Rembrandt. Rembrandt never started from this. His aim was not the perfect brush stroke, or to arrive at it by continual perfection. For me this is just where the difference lies between art and craft.

All that is bursting with energy is disturbing—not perfect. It is the quality of life. The other is the quality of the ideal. It could never satisfy me. The crystal which is an ideal in life can hardly change this general rule.

Moore, in his direct way of thinking, has come to conclusions similar to those of Karl Jaspers, who, more deeply and more consistently than any other contemporary philosopher, has explored what is the basic tension of life. Jaspers has said,

We search for the unity of the world. We search for relationships beyond the cleavages by exploring how, within the disruption of things, one reacts upon the other.

The leap from dread to inner harmony is the most prodigious man can perform. That he succeeds must be due to reasons beyond the existence of his self-being. . . . It is but dread taking the leap to inner harmony which is capable of seeing, unreservedly, the reality of the world. Bare dread, or inner harmony alone, however, veil reality.[1]

Why does the conjunction of opposites, of which the philosophy of old was so conscious, once more dominate the modern mind? The Atharvaveda had known this truth, and so did the Iça Upanishad; but it was lost in idealism, Greek and Christian. It is the face of reality itself, the Face of faces, as Nicholas of Cusa once said when, in the early fifteenth century, he coined the term *coincidentia oppositorum:*

> In all faces is shown the Face of faces, veiled and in a riddle. Howbeit, unveiled it is not seen until, above all faces, a man enter into a certain secret and mystic silence, where there is no knowing or concept of a face. This mist, cloud, darkness, or ignorance, into which he that seeketh thy Face entereth, when he goeth beyond all knowledge or concept, is the state below which thy Face cannot be found, except veiled; but that very darkness revealeth thy Face to be there beyond all veils. Hence I observe how needful it is for me to enter into the darkness and to admit the coincidence of opposites, beyond all the grasp of reason, and there to seek the Truth, where impossibility meeteth us.[2]

And Heraclitus, the dark one, as he was called by the Greeks, saw this reality more clearly than any classic philosopher after him:

> From the living comes death, and from the dead, life; from the young, old age; and from the old, youth; from waking, sleep; and from sleep, waking; the stream of creation and decay never stands still. . . . Construction and destruction, destruction and construction—this is the norm which rules in every circle of natural life from the smallest to the greatest. Just as the cosmic itself emerged from the primal, so it must return once more into the same—a double process running its measured course through vast periods, a drama eternally reenacted.[3]

This *enantiodromy,* nature's exertion toward the opposites, recognized that it is these, not sameness, which bring about the accord, the unity. This, in turn, is how C. G. Jung, by studying the symbolism of polarity and unity, could establish the bipolar character of human nature, for the obsolete idealistic conceptions are exploded and the naked face of life is staring at us again.[4]

"It is the same quality of disturbance," Moore continued, "which makes one distrust things too easily achieved. I always have a distrust of something I can do easily. This may have satisfied X. . . . X once showed me a picture and remarked with pride: "I did it in half an hour." If I had done something as easily as that, I would have felt unhappy."

This conflicting quality finds a new formulation in some of Moore's later works. In his *Warrior*, the head is a formal invention, the body more traditionally felt. There seems to be a conflict of style, and I pointed out that this was cited in criticism against it: "We don't hold to that, there is no unity." Moore responded:

> But could we not say the same of Chartres, or of many primitive works? In Chartres Cathedral, the bodies are like columns and the heads are realistic. No one reproaches them for disunity of style. I willingly accept what I try to bring together. In the heads of the *King and Queen* or in the head and body of the *Warrior*, some mixture of degrees of realism is implicit. But we got used to it in Chartres and shall get used to it now. I do not suggest that I have intentionally done it. I did not say: Now, I'll make the head different—but: I'll make a whole figue in which the head will express what I want the entire figure to represent.
>
> A bull-like, docile, battered being, suffering—the cleft down the middle—yet he is resigned to it. That is part of the whole idea the figure is about. If the figure has to have its meaning, it means all the more because the head is contrasted to the natural structure of the rest. It is only these contrasts which do it.
>
> It is the mutilation which disturbs the average person. The average person does not want to be disturbed by art. What he asks from art is the entertainment value of the cinema. When the modern artist turned away from his entertainment function, he found himself isolated. The Greeks, up to the fifth century, did not want to please. The Parthenon sculptures are not perfectionist sculptures. If you put a Parthenon figure against one of the fourth century, you'll find that they are of the same spirit. Compare it with a work of a hundred years later, and one realizes what a wealth of content the Parthenon still had. Not the sweetness and emptiness into which [Greek sculpture] degenerated later on.
>
> All primitive art is disturbed, or an experience of power, not perfectionist. You may come to certain periods when the primitive, the primary element, is attenuated until it disappears altogether. But even in a Piero della Francesca, in spite of his sophistication and conscious mastery of art, there is also a disturbing element. It is present in all true art, as it is in life. Classical detachment doesn't try to solve anything.
>
> This disturbing quality of life goes hand in hand with the disturbing quality of our time. The timely emphasizes the perpetual. People do not understand the basic character of their age. They want to escape. Many of them expect of art perfect craftsmanship, artifacts. They are used to other standards through education. One tries to prove that one isn't the only person who

does not know of it. Never once did I want to make what I thought of as a "beautiful" woman. People would say, of course: "How beautiful!" This does not mean that there is no beauty in what I do. Beauty is a deeper concept than perfection, or niceness, or attractiveness, sweetness, prettiness. To me, "beautiful" is much more than that. Just as a bull is more beautiful than a frisking lamb ("How beautiful!"), or a big fleshy beech tree trunk more beautiful than an orchid.

One does not limit oneself to surface. Surface is not and cannot be a full expression of form, of what the shape of a thing is. Surface comes last, not first. In Hellenistic times [surface came first], maybe. But not for Phidias. Surfaces [come] last—unless you give the relief.

After Surrealism nobody should be upset that a head on one of my sculptures is different from the rest.

I do not really want to play the role of the disturber. This bogeyman business I leave to the Grand Guignol, to Dali. The crime and comic line is theirs. . . . I don't want to produce shocks.

THE CROWNING PRIVILEGE

Similarly, Henry Moore boldly rebukes perfectionism and idealism in assessing the artist's position in society:

Many of my contemporaries, even some great ones, want to produce a perfect world in life. They see it as an ideal at which life has to aim. To me, it is a life which I do not want. Consequently, I do not consider our age to be worse than others. I would not want to transplant myself to another period. I could not even imagine it. For life, every period is a terrible period. Many people argue and would probably say that the artist today is in a deplorable position. We are sorry for the poor fellow! There is no unified structure in society for him to fit in. Because they think that life and thought were unified in Gothic times, therefore every artist of the Gothic era necessarily produced great works of art. They did not and they could not. Only a few are great. Works of art are not done easily. I do not believe that the really important contributions were done easily by anybody. Besides, what is valid for the visual arts must be equally valid for music and poetry. There is Shelley in the nineteenth century, or Beethoven, but there are no painters. One cannot say that society did not produce great painting but produced great poetry and music. Society is bad for all or for none.

I do not believe in crying out at the artist's lot. I do not believe in decrying conditions today. ("My goodness, if only we had lived in the past, we would have done much better!")

No art has ever existed, and no artist has ever created, out of despair. To be an artist is the opposite of being in a state of despair. To be an artist is to believe in life.

I asked, "Would you call this basic feeling a religious feeling?"

Yes, and in that sense an artist does not need any church and dogma. We all think that art and society are torn apart. But I believe that in other periods, the relationship was an individual relationship; it was not based on state decree. If you can admit that a novelist can produce a great novel without being commissioned, say Dickens, Tolstoi, Flaubert, Stendhal—if one admits that these are works of art, why should one accept the case for the visual arts to be different? Of course, the present conditions are not better than before; in fact, they could be worse. Before, the visual arts had been more easily recognized. Perhaps this is so. Cézanne had everything against him. He had some money to be able to go on modestly, but no commissions. We must say, however: Perhaps it was better that he was not commissioned. If he had been, we might not care for Cézanne.

Then, again, they say that great works of art need a religious belief. This was the unifying bond in former times and it is gone. Today you can base your art only on life itself. All right. When did Rembrandt create his greatest works? When he was old and cut off from society. And Goya's boldest fantasies were produced in isolation, in protest, when he was deaf and sick. Either the society argument is valid (then a Rembrandt, a Goya, etc., cannot happen), or it is bunk. The artist is a human being. He has to live, that is understood. We have to live in this world. This fact does not change my argument.

So Henry Moore's voice joins that of the poet Robert Graves, who proclaimed that

a poet's public consists of those who happen to be close enough to him, in education and environment and imaginative vision, to be able to catch both the overtones and the undertones of his poetic statements. . . . And what is all this nonsense about poetry not paying? Why should it pay? . . . Poets today complain far too much about the economic situation; they even expect the State to support them. What social function have they? They are

neither scientists nor entertainers, nor philosophers, nor preachers.
... If a poet is obsessed by the Muse and privileged to satisfy her
demands when he records his obsessions in poetry, this in itself
should be sufficient reward. I doubt whether he should even
bargain with the public.

For Graves the "crowning privilege" of the poets' profession is

the desire to deserve well of the Muse, their divine patroness,
from whom they receive their unwritten commissions, to whom
they eat their solitary dinners, who confers her silent benediction
on them, to whom they swear their secret Hippocratic oath, to
whose moods they are attentive as the stockbroker is to his
market.[5]

This statement concerning poets and the difference between their pro-
fession and others, their general privilege of always being free to enjoy,
of not being formally enrolled, their insistence that if, in most profes-
sions the size of a man's income is a fairly reliable criterion of worth,
with them the income test works in reverse, so that to make a comfort-
able living by writing poems is to risk being treated with derision—all
these are also part and parcel of Henry Moore's philosophy of the free-
dom of creation from democratic prejudice.

"Society, the public," Moore insists, "cannot have any say in art.
Because they cannot work it out. It is a mystery, what happens there.
It disturbs, it is interesting. In poetry there is something which is not
easily explainable. If it were, it would be like the public monuments
in squares—one passes and does not look at them."

NOTES

1. *Von der Wahrheit* (Munich, 1947).
2. Jakob Hommes, *Die Philosophische Gotteslehre des Nikolaus Ku-
 sanus in ihren Grundlehren* (Munich, 1926).
3. Hermann Diels, *Die Fragmente der Vorsokratiker, Griechisch und
 Deutsch*, 3 vols. (Berlin, 1956-59).
4. *Mysterium Coniunctionis*, 3 vols. (Zurich, 1955-57).
5. *The Crowning Privilege*, The Clark Lectures, 1954-55 (London,
 1955).

4 • TIME AND THE ARTIST
Containing Some Statements by Julius Bissier on Contemporary Art

To what extent is the work of art an expression of its time? This is a question that has lately come very much to the fore. Works of a very extreme character predominated in the Documenta II Exhibition in Kassel, in 1959, and it was in his introductory lecture to this exhibition that Werner Haftmann spoke strongly in favor of the *Zeitgeist*.[1] Wilhelm Pinder had already on a previous occasion exalted the time factor to the level of a style determinant valid for the whole history of art: "In the normal course of things artists are fixed in their time. In other words, the time of their birth determines the unfolding of their being.... Artists are grouped with reference to this fact. A generation is normally unitary in character, and its problems are peculiar to itself. Generation determines style."[2]

But just that notion of *Zeitgeist* is one of the vaguest in the whole history of art.

Works that are disquieting, crazed, depraved, uninhibited, and provocative, works that proclaim the superiority of chance to law, that exalt material and process against content: such works have dominated the scene during the last decades under the banners of *Art informel*, Tachism, Action painting, *Art autre*, *Art brut*, Abstract Expressionism or Impressionism, Pop, Op, or Minimal art—all of them being direct expressions of the circumstances of the time and bearing witness to it. From other quarters, in particular from American theorists, we hear that the artist is in advance of his time and in his own medium often anticipates scientific discovery. They speak of a "cognitive" element, which seems to indicate a confusion of concepts between art and science.[3] A further circumstance must be taken into account, that the taste of a given age is often decades behind that of the creative artist,

so that a long period must elapse before his art is accepted at its true value. Thus it is only now, when Picasso has to give up his leading position among the artists, that he is accepted as the leading artist of our day by the public, who certainly never accepted him as such in the time of his "analytical Cubism" of 1907–14, or of his "convulsive Expressionism" of the year 1929, or of his "Neolithic" period of violent distortions of 1930–31. (The physicist Erwin Schrödinger puts forward a similar argument for science when he says: "There is a lapse of time between the views of scientists and the views of the general public about those views of the men of science. I do not think that fifty years can be reckoned an exaggerated estimate of this period of time."[4]

But then, if the artist is to be on the one hand in advance of his time, and on the other the expression of the spirit of his age, i.e., the expression of what his contemporaries, in an unformed fashion, think and feel, we seem to be faced with a *contradictio in adiecto*, which can be solved apparently only by assuming that the artist, thanks to his more sensitive fingertips, possesses a *Zeitgeist* which is all his own: one, that is, with a temporal shift into the future. This, however, contradicts the simplest logic: either the artist is an expression of the spirit of the age or he is not. But let us assume that he is such an expression but only to a certain degree. To support this assumption we should have to introduce new elements of thought into the matters we are considering, and first of all the element of personal temperament. How far can the lyrical artist be the expression of our age, riddled as it is with crises, torn with wars and revolutions, and adrift from spiritual moorings? How can the lyrical artist be the expression of an age of abysmal emptiness, as is ours when we compare it to earlier epochs (this point will be amplified later), an age of dread, of hopelessness, of brutalities, of mental disintegration? And Julius Bissier, of whom we are going to speak, is a lyrical artist. It may be said that the artist, by reason of his temperament, either falls a victim to his time, or that, like a prophet of harmony and spiritual order, he runs before it showing it where healing powers and inner peace may be found. Strangely enough, hardly a single artist of this latter kind exists in our age; and the belief that an idea is a force which, when called into being and given shape and substance, can work upon life to guide and change it seems entirely foreign to us. And yet this belief was common to the art of early Christianity, to Gothic art as well as to the art of other periods.

There is an important aspect of our argument that has not yet been touched upon. It is this: if the artist is the expression of the spirit of

his age, in the sense intended by Haftmann and Pinder, then his work must dispense with that promise of immortality which has hitherto been regarded as the prerogative of all great art. The power with which a work of art is endowed, which enables it to outlive its own time and to rise again, ever new, after periods of neglect or oblivion; the power it possesses to inspire, to be a guiding star, a well of beauty and spiritual renewal: this power cannot have its source in the ephemeral and the time-bound. Time-bound it may be in its origin, but never in its ultimate significance; or, to be more specific, it may be time-bound in its attitudes, its materials, and its technique, but never in its spirit. For if it were bound up wholly with the spirit of its age it would be mercilessly swept away with that age as a newspaper article is swept away, without daring to make a claim to be a work of art. Nevertheless, the artist can come to grips with the spirit of his age, as Oskar Kokoschka did in revolting against it in his earlier work. His later development took him over it and beyond it.

Edvard Munch made this significant statement: "In art there are no schools; there are only tasks. Just now it is the turn of the shadows."[5] This dictum, coming directly out of the artist's workshop, is the expression of a thought formed in the process of work. And because in art, in spite of what psychoanalysts and depth psychologists have said, it is the artifact, the work of art itself, that counts, and not the work of art as "expression" (Wilhelm Worringer) or as "case history" (Lehel), Munch's words have for us a quite special importance.[6] As a factual statement we will set them against purely historically and theoretically based views, as we set authentic history against legend. Every artist is born into an artistic situation. He does not work like a spider spinning its web "out of itself," as some artists would have us believe in order to exalt the individual and personal value of their work, but he picks up this and that, here and there among what his time offers him according to his spiritual and temperamental bent, and with the matters so selected he builds his art. André Malraux very finely expresses a similar thought: "The young artist cannot choose between his teacher and his way of seeing things. His only choice is between his teacher and another teacher, between pictures and other pictures. If his way of seeing things were not that of another or of many others he would have to invent the art of painting over again."[7]

Let us now turn our attention to Julius Bissier. He was represented in the Documenta II Exhibition with works which were outstanding for their modest format, as well as for their content. Is he a contem-

porary artist? Without a doubt. Is his work an expression of his time? Yes, but only if one disregards time and sees through it to what is permanent. He, too, was born into his situation. Paul Klee appealed to him, as did also the "timeless" quality of Chinese art. His works are poetic statements of the greatest simplicity and sincerity. There is joy in them and the love of life and things, and of color and brushes and painting. There is a deep intimacy in his work which seizes us and prevents us from saying: "Ah yes, evolution of calligraphy, Chinese brushwork, we know all about that." Bissier's work is too humble, too genuine, too quiet to provoke such a reaction. It is as natural as the moon, the water, and the wind, and it will not change at the dictates of any political manifesto, or any new scientific research, or even at the instance of a new fashion launched by art dealers.

I put a few questions to Bissier about the chains which are said to bind art to its time, suggested by a lecture by Werner Haftmann at Documenta II:[8]

Q. Is the substance of a modern work of art to be sought in its formal order (as if through art's becoming abstract its content had become fugitive and impalpable)?

A. The formal problem alone is not the substance of modern art, merely its appearance.

Q. Is the reason for its extremist quality to be sought in the artist's exclusive preoccupation with his problems of form and representation? Or is it in the reality which has confronted this generation born after 1900, a reality whose horrors have far outstripped the worst nightmares of world history (two wars, and in the interval between them the misdeeds of *homo politicus*)?

A. The reason is not to be sought in the artist's exclusive preoccupation with his problems of form and representation. As to the "reality" into which this generation was born: we should not forget that the art of the Middle Ages had also to contend with a reality surpassing "the worst nightmares" of the human race. To be broken on the wheel, torn to pieces, or flayed alive is no less destructive of the legend than the reality of our own wars and their aftermath. It is a very moot point how much effective support the flayed person got out of his faith.

Q. Have, then, the civilized worlds of humanism, of Christianity, of idealism become so enfeebled that they have lost all their power to inspire the artist?

A. Yes, it may be that the old legends and prototypes have lost some of their power to attract. But in the meanwhile we are still free to believe or not to believe in the force of "unalterable law," even if belief and unbelief have lately become more or less anonymous.

Q. Today the artist no longer stands under the guardianship of these ideas. Standing, as he thinks, before his own reality, he has of his own will freed himself from the necessity of such a shield. He looks upon religious affiliations and attachments as no longer possible for him. Is that so?

A. This is covered by the answer to the previous question.

Q. In his work, therefore, there are overtones of horror and an abstract frenzy. These pictures often face us with threatening gestures. They represent a tumult of violently conflicting forms. The painter's canvas often looks like a place where an adversary lies hidden; and so the action of the painting resembles blows being struck, something being hurled, or pushed, or violently thrown. And then there are dark, earthy pictures that look like walls on which mysterious signs have been scrawled. Is there a connection between this fact and the two questions above?

A. The overtones of horror you speak of are by no means a recent phenomenon. And to speak of abstract frenzy is tantamount to reproaching the artist with a lack of wisdom. This is just where character reveals itself in its entirety, in its degree of insight, its fundamentally productive or unproductive nature. Horror, frenzy, and such effects, including irony or the Surrealist placing of sense and nonsense on an equal footing, are for me questions of second or third importance in connection with the origins of modern art.

Q. The supporters of the *Zeitgeist* theory find a binding moral force in these latest productions, whose basic impulse, they maintain, proceeds from *freedom* and *love* (the antithesis of what modern reality offers humanity). Freedom to realize one's own personality and the longing for a new brotherly community.

A. Freedom and love are certainly operative as fundamental impulses. But they have their place in that region which the Greeks called "*Logos*," the Taoists "Being," and Christendom "Providence" or "Divine Law."

Q. Do you think that the feeling for a new truth has taken the place of the Christian, the humanist, the idealist ways of thinking? The new truth I have in mind is one in which the relationship of man to his world is no longer conceived as a dualism (God-man) but

as a whole of vast breadth and depth, in which man has his being. Is this the prospect opened up to us by modern science?

A. Being absorbed in the breadth and the depth (though not in that which is disclosed by science) is the real, the factual, way to art, whether the art of today or that which is to come.

Q. And is it for this reason that modern art is no longer interested in the outward appearance of nature but occupied rather with the processes that lie behind nature? Are modern art and the new conception of reality in agreement?

A. That the artist turns away from the outward face of nature is merely an accompanying phenomenon, never the essential. "The essence of the matter, now as always, lies in a movement of heart and mind having its source in that which is itself immovable" (Plato).

NOTES

1. Haftmann's lecture appeared in abridged form under the title, "On the Content of Contemporary Art," in *Quadrum VII* (Brussels, 1959).
2. *Das Problem der Generation in der Kunstgeschichte Europas* (Berlin, 1926).
3. M. de Zayas and P. B. Haviland, *A Study of the Modern Evolution of Plastic Expression* (New York, 1913). See also Eugène Veron's *L'Esthétique;* George Santayana's *Reason in Art*, etc.; and Guido Morpurgo-Tagliabue, *L'Esthétique contemporaine: Une Enquête* (Milan, 1960).
4. *Science and Humanism: Physics in Our Time* (Cambridge, 1951).
5. J. P. Hodin, *Edvard Munch, Der Genius des Nordens* (Berlin and Mainz, 1963).
6. Wilhelm Worringer, *Abstraktion und Einfühlung: Ein Beitrag zur Stilpsychologie* (Munich, 1908); François Lehel, *Notre Art dément: Quatre Études sur l'art pathologique* (Paris, 1926).
7. *Les Voix du silence* (Paris, 1951).
8. They were answered by the artist on August 21, 1959, at Hagna.

5 • FIGURATION AND ABSTRACTION

THE LAST FIVE DECADES IN THE DEVELOPMENT OF MODERN ART HAVE BEEN marked by the emergence, the unfolding, and the decline of abstract art. Although figurative, representational, objective-visual art never ceased to exist in this period, nevertheless the accent was decisively on experimental art, which was proclaimed as the art of our scientific age. This notion of "experiment," of "research," was clearly derived from science, and its formal elements, insofar as they were novel, from technology, which in its manifestations meets our eyes everywhere: in the buildings of our age and their style, which is defined by the new building materials and the spirit in which they are used; in the machines which dominate our lives and the speed and the noise, the restlessness and meaninglessness of mechanization, which seem to have dried up the faculties of our souls, so that, looking backwards, we can only mock at the past, distort it, and finally destroy its image and background of mythical, aesthetic, and humanistic values. Was that not, after all, the Luciferian function of Dada and of Surrealism, which, although remaining within the figurative, gave it a psychoanalytical emphasis, leading finally, in its new phase, to the brutality, the cynicism, the sexualism, the journalistic artistry of Pop and all its variations? Only ten years and it was achieved—the *tabula rasa*. What first presented itself philosophically as nihilism, as Existentialism, and as depth psychology evolved into the supermarket, the headline mentality in art. Banality and entertainment value triumphed; only surprise and novelty counted. Never before has art sunk so low, and never before in the history of art has it been exploited in such a cold and calculated manner. Art has been commercialized through and through, and with all its experiments and research into the uses of new materials and new effects it has become sub-

47

ordinated to the publicity management of business and industry in the service of mass production. Art, if one may still call it that, is dominated by the public relations function of success. The cheapness of the performance is its hallmark. There is no inner depth, there is no message. The art of the last decade has become the art of a highly materialistic society, shedding all allusions to life's interpretation and meaningful comprehension. No hierarchy is admissible: it is all at the level of the ant heap. Shallow pleasure against the background of threatening disaster, even annihilation, the phosphorescence of decay pretending to be joy—that is the mental trend. There are more "art" schools at present, more people are trained to become "artists," than in any high period of art, whether in Italy, France, or the Netherlands. The shock technique of the Surrealists, in their dialectical attempts to shatter any belief, has become our daily bread—no one can be shocked any longer. Either we have given up our sensibilities or we are apathetic to it all. Only the young seem to enjoy it still. Youth has become a value in itself, a merit for its own sake, youth which has vitality but no wisdom. Our artistic culture has become teen-age.

With such conditions prevailing, the Gaetano-Marzotto prize was established, in 1967, to draw attention once again to the technique and the art of painting; for in all the experimenting and research the technique of painting has been superseded by other techniques and by gimmicks: collage, accrochage, assemblage, objects, formal or informal happenings, *haute pâte*. The danger had to be envisaged that one day the technique of painting might be forgotten altogether. And why? Because, in not aiming at "expressing" anything, the age-old, fine technique of painting and drawing, the technique of Giotto and Masaccio, of Giorgione and Piero della Francesca, of Mathias Grünewald and Frans Hals, of Rembrandt and Velasquez, El Greco and Goya, of Cézanne, of Monet, and of Bonnard, might be condemned to disappear —and with it the notion of art and its hierarchies; art in the service of human values; art that renders and interprets life, the miracle of Being, and the mystery of the human mind (not the intellect); art as a means of cognition; art as the crowning privilege of *Homo sapiens*; poetic, revelatory art; art as a witness to creation; art as the image of the wholeness of life (not of its atoms, its elements); art as formative will in the sense intended by Goethe:

> The great works of art are at the same time the greatest works of Nature produced by men according to true and natural laws. Everything arbitrary and illusory collapses. There is necessity!

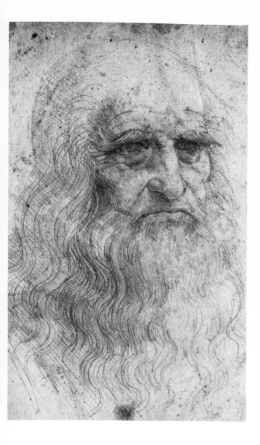

Karl Jaspers, 1956.
Photo: Fritz Eschen.

Leonardo da Vinci: *Self-portrait*. Red
Chalk, c.1510–13. Turin Library.
Photo: Anderson, Rome.

Henri Matisse: *The Young Sailor,
II*. Oil on canvas, 1906. Collection of Mr. and Mrs. Jacques Gelman, Mexico City.

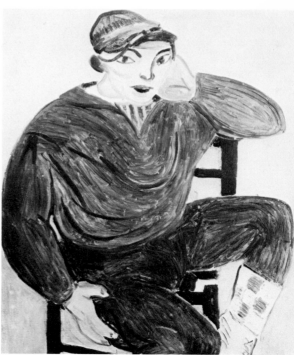

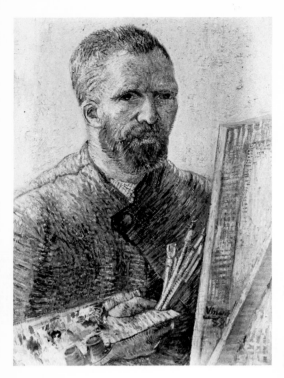

Vincent van Gogh: *Self-portrait Before Easel*. Oil on canvas, 1888. The Vincent van Gogh Foundation, Amsterdam.
Photo: Arts Council of Great Britain, London.

Marc Chagall: *Moses Receiving the Tables of the Law*. Oil on canvas, 1950–52. Private collection, France.
Photo: Giraudon, Paris.

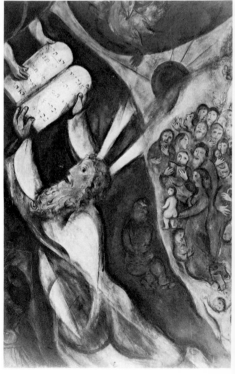

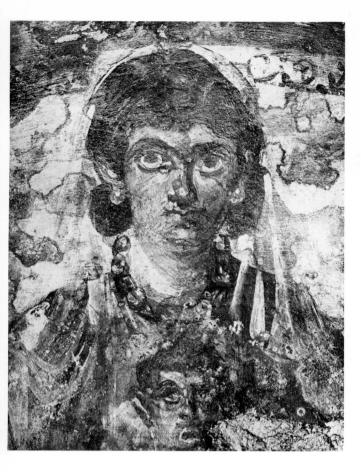

Roman, 4th Century, A.D.: *Mary and Jesus*. Mural. Coemeterium Maius. Photo: Anderson, Rome.

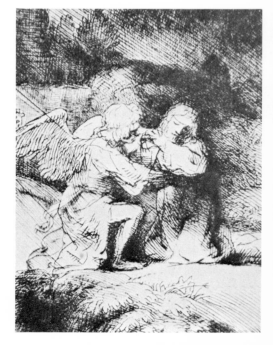

Rembrandt: *The Agony in the Garden*. Etching, c. 1653. British Museum, London.

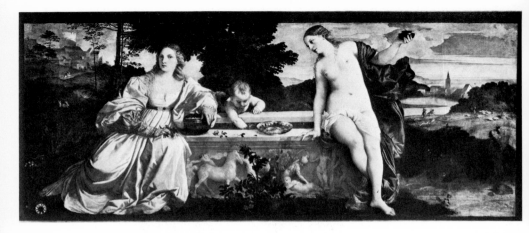

Titian: *Sacred and Profane Love*. Oil on Canvas, c. 1516. Borghese Gallery, Rome.
Photo: Anderson, Rome.

J. P. Hodin in conversation with Marc Chagall, 1949.
Photo: James S. Mosley.

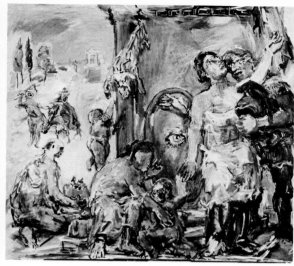

Oskar Kokoschka: *Thermopylae.* Tempera on canvas, 1954. Left panel, representing Leonidas taking leave of his wife, with symbols of peace in the background. Hamburg, University.
Photo: Schwitter, Basle.

Oskar Kokoschka: *Thermopylae.* Middle panel, representing Herodotus, Apollo, Ephialtes, and the battle.
Photo: Schwitter, Basle.

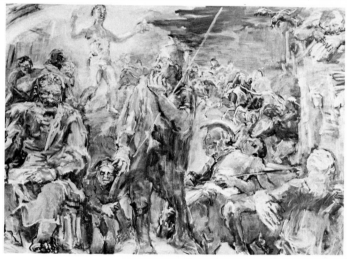

Oskar Kokoschka: *Thermopylae.* Right panel, representing the fleeing goddess of Liberty and the Battle of Salamis.
Photo: Schwitter, Basle.

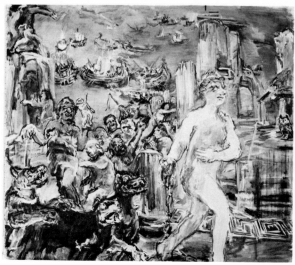

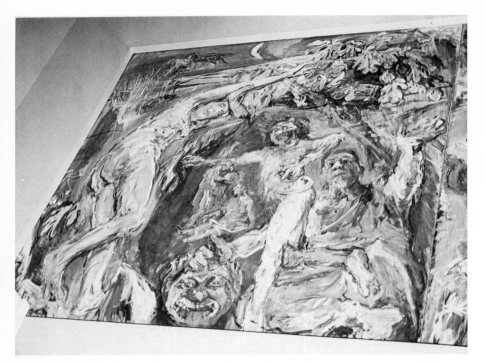

Oskar Kokoschka: *The Saga of Prometheus*. Tempera on canvas, 1950. Left panel, representing Demeter, Persephone, Hades, and the Gorgon's Head. Collection of Count Antoine Seilern, London.

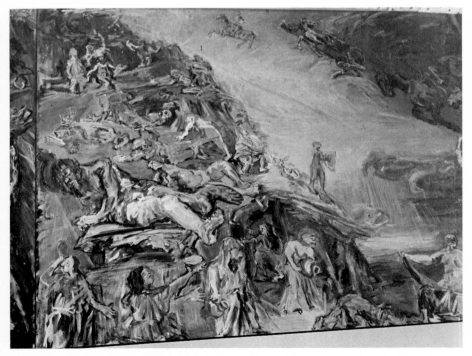

Oskar Kokoschka: *The Saga of Prometheus*. Middle panel, left side, representing symbolic figures of Greco-Christian culture.

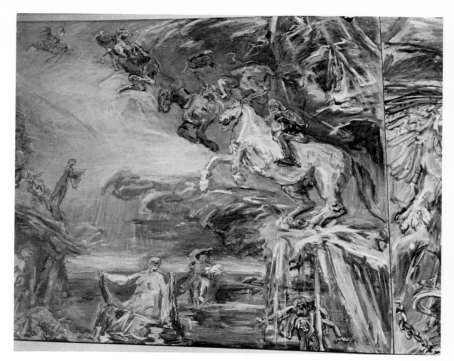

Oskar Kokoschka: *The Saga of Prometheus*. Middle panel, right side, representing the Horsemen of the Apocalypse.

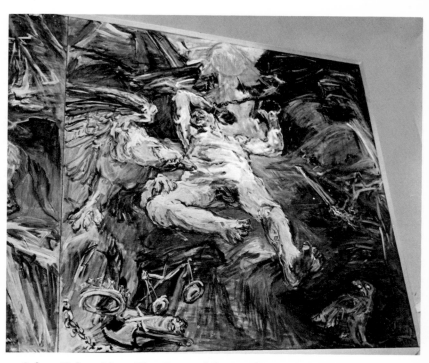

Oskar Kokoschka: *The Saga of Prometheus*. Right panel, representing the fettered Prometheus.

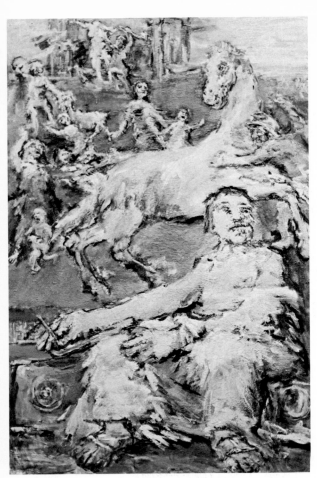

Oskar Kokoschka: *Herodotus.*
Oil on canvas, 1964. Collection, the artist.

Jacob Bornfriend: *Wedding.*
Oil on canvas, 1943.

Paul Delvaux: *The Sleeping City*. Oil on canvas, 1938.
Collection of Stephen Higgons, Paris.
Photo: Ferruzzi, Venice.

Endre Nemes: *Project for Tapestry*. Oil and tempera, 1945.
Photo: Atelier Bernhard, Stockholm.

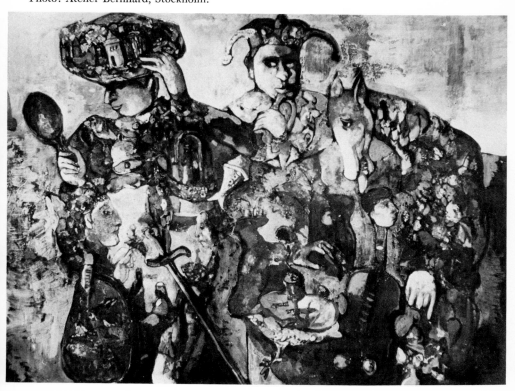

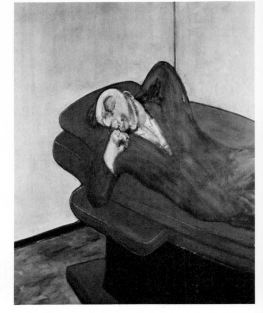

Francis Bacon: *Lying Figure*. Oil
on canvas, 1958. Städtische Kunst-
galerie, Bochum.

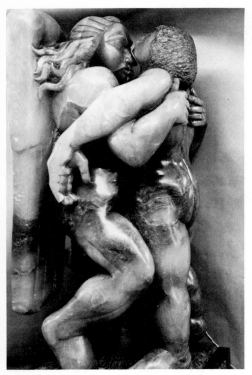

Sir Jacob Epstein: *Jacob and the
Angel*. Alabaster, 1940. Private col-
lection, England.
Photo: Hans Wild, London.

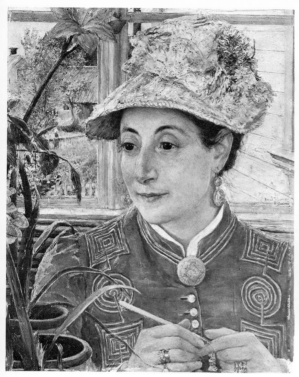

Carl Gustav Jung, 1955.

Ernst Josephson: *Portrait of Jeanette Rubenson*. Oil on panel, 1883. Konstmuseum, Gothenburg.
Photo: Arne Karlsson, Gothenburg.

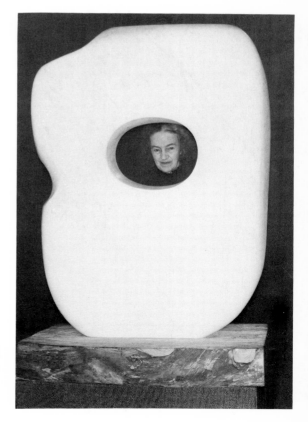

Barbara Hepworth looking through her work *Pierced Form*, 1963. Pentelicon marble.
Photo: Sport and General Press Agency, London

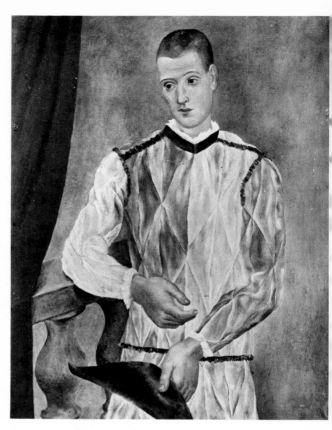

Pablo Picasso: *Harlequin*. Oil on canvas, 1917. Museo Picasso, Barcelona.
© by S.P.A.D.E.M., Paris, 1971.

Pablo Picasso: *L'Evocation* (or *The Burial of Casagemas*). Oil on canvas, 1901. Musée du Petit Palais, Paris.
Photo: Clichés des Musées Nationaux, Paris.

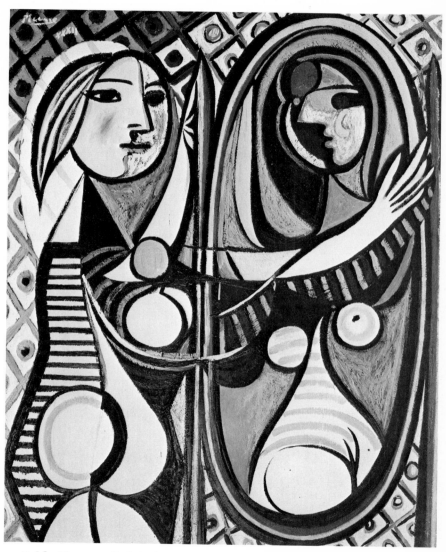

Pablo Picasso: *Girl Before a Mirror*. Oil on canvas, 1932. Museum of Modern Art, New York. Gift of Mrs. Simon Guggenheim.

Pablo Picasso: *The Poet*. Oil on canvas, 1911. Peggy Guggenheim Collection, Venice.
Photo: Giacomelli, Venice.

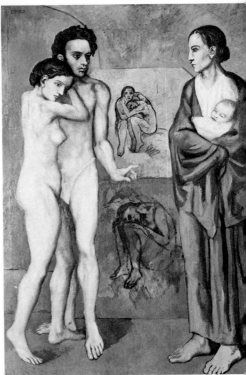

Pablo Picasso: *La Vie*. Oil on canvas, 1903. The Cleveland Museum of Art.

Pablo Picasso: *Crouching Woman*. Oil on canvas, 1902. Private collection, Stockholm. Photo: Giraudon, Paris.

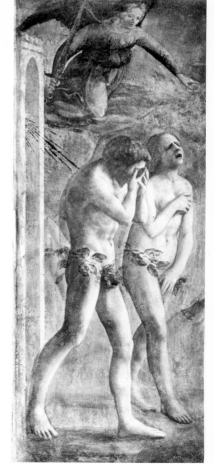

Masaccio: *Adam and Eve Driven from Paradise*. Fresco, 1426–27. S. Maria del Carmine, Florence. Photo: Scala, Florence.

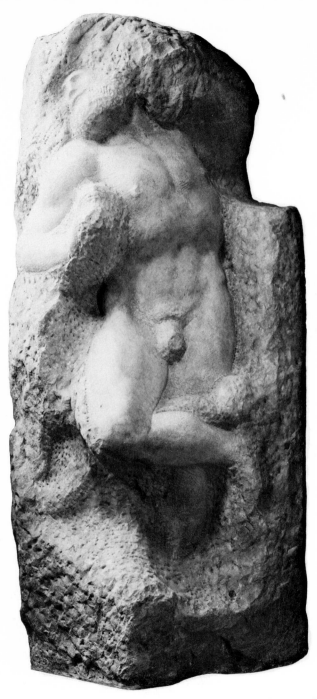

Michelangelo: *Slave. Carrara Marble*, c. 1513. Academy, Florence.
Photo: Alinari, Florence.

> There is God! . . . I suspect that the Greeks acted according to the laws by which Nature herself acts; and I am on the track of them.

But, he complained:

> No one will realize nowadays that the highest and sole operation of Nature and art is *Gestaltung* [the formative process], and that the *Gestalt* [the final shapes in which life and being manifest themselves] is the specification needed before each thing may become, be, and remain a particular and significant entity.[1]

It is from the full conviction that when art dies humanistic man dies too that the Gaetano-Marzotto prize for figurative painting aimed at encouraging painters of Europe not to give in to the futile although strong contemporary pressures, but to fulfill their mission as artists expressing human values. For it is this expression which is at the summit of the hierarchy of art—every other aspect of art, including the decorative, takes its organic place as we see it in the Romanesque or Gothic cathedral, in the Greek temple, etc.—the expression, not only of the artist's personality, but of man's relationship to eternity, to the tragic sense of life (i.e., the realization of the conjunction of opposites), to his dignity and spiritual aspirations. After all, Kokoschka is still working among us, and Picasso. Picasso stands at the border between art and non-art, because it was he who through his daring broke down the dykes, so that all the inhibitions inherent in our cultural responsibilities and consciousness, and above all the sense of a living tradition, were abandoned; yet, having let loose the Devil, he has himself remained an artist in his integrity, leaving it to others to make fools of themselves. They, to avoid his strong influence, abdicated into "abstraction." He had genius but he introduced into art the "democratic" principle, the leveling-down principle of our days, the rubbish-heap attitude of mechanized civilization toward art. Yet it was he who, even in 1923, said that

> the idea of "research" has often made painting go astray, and made the artist lose himself in mental lucubrations. Perhaps this has been the principal fault of modern art. The spirit of research has poisoned those who have not fully understood all the positive and conclusive elements in modern art and has made them attempt to paint the invisible and, therefore, the unpaintable.[2]

Kokoschka insists on being a "seer." It is he who always taught the young the art of "seeing"—not of "peeping" into the subconscious only or of shutting one's eyes before life's objective manifestations, but of seeing the wonders of life which still exist in spite of our reaching to the moon, of our surpassing the speed of light, of our splitting the atom, of our threatening the world with destruction, with the extinction of all life. If this is to be the fate of man then it will be the fate of blinded scientific man. There is, however, still the artist, in the highest sense, as Kokoschka sees his role through his life and through his work. He was aware, even during the war, of the danger that mankind might lose not only the faculty of creating art but even the faculty of "seeing." "Since the Reformation," he once said to me, "the link with nature has been undermined, the way to life cut off. The Renaissance still had a means of communication through sight; since then logical intercourse has dominated."[3]

It was a fallacy indeed to believe that, as the theory of matter was replaced by the theory of energy, life and its forms could be replaced by abstractions. That is what Karl Jaspers once pointed out to me.[4]

That is also why Kokoschka wrote, in his essay on Edvard Munch's Expressionism:

> We turn to a future, when in our time—a time of ravaged rubble and stagnant land, an epoch that exhausts itself in experimenting with forms without the appearance of any meaning—the artist rises in the background like a statue with lowered torch. . . .
>
> Today eternity has become almost a distressing concept for us, we who have no time in our savagely devastated existence barely to notice fresh-picked flowers still smelling damp from the earth. An existence that is merely a period of waiting, which we condemn ourselves to spend in the most intense impatience, while progress calls for insane haste. . . .
>
> In a timid renunciation of what we perceive through the senses, and consequently the elimination of personal experience, there is a search for some means to get away from fate, which chains the actor to the scene he composed and inspired. . . .
>
> With due astonishment, however, we must view the fact that the artists feel themselves obliged to break a lance for modern science. The theory of so-called non-objective art postulates a theoretical system, analogous to the scientific hypothesis, which is detached from the world of visual perception. This artistic theory finds approval in the entire compass of technical civilization with surprising speed. . . .

Inasmuch as non-objective art entails the disappearance of man, it shrouds the mirror that reflects the image of our time. For a long time already we have despaired of being the image of those gods that we created. . . . Yet we are striving just as much to free ourselves from pessimistic materialism; that is why we are beginning again to dream of a "beyond." Thus there may be seen a certain logic when the creative artist today entirely breaks the mirror that can but throw back at us damnation in the face of the murderer, of the suicide, in our own face. . . .

To the Russian painter Wassily Kandinsky . . . belongs the fame of having been the first to think of a purely "spiritual" style of painting that sought to be understood only as a structure analogous to the formulistic language of mathematics or of the theory of music. . . .

The ability to see consciously is sacrificed in Kandinsky's program as an innate legacy of the past. In this he is a pioneer. The future will tell whether his influence, which today is dominant in modern art, is likely to do more harm than good.[5]

With the problem of abstraction and figuration we find ourselves in the midst of an old philosophical problem, that of Platonism and Aristotelianism. Is reality to be found the world of "ideas," or is reality experienced by the senses, which are part of an indivisible whole? Abstractionism is the contemporary form of Platonism in art. What we have to aim at is the realization of the wholeness between the world and man's perceptions of it. No jet plane, no nuclear power can change anything in this morphological unity.

The conclusions reached by André Gide when contemplating the work of Poussin are still valid for us and will be valid in the future:

To attach supreme merit to the craftsmanship of the artist is to deprive art itself of all spiritual value. It has led to the greatest artists of our day taking care to appeal only to our senses, and has reduced their functional equipment to the level of an eye and a brush. This voluntary impoverishment will, I believe, be recognized as characteristic of our age, an age without standards of value. For this, future ages may judge us severely. . . . That idea and feeling should be banished from the plastic arts; that painting should have renounced the great domain of expression (a domain which is its own and inalienable) will be a source of astonishment to future ages.[6]

There is only one point to which I would like to take exception in this statement of André Gide's. Where he speaks of mere craftsman-

ship he seems to have forgotten, maybe under the pressure of con-
temporary criticism, that when his lines were written Bonnard was
still alive, and Matisse, Picasso, Braque, Miró, Giacometti, and Ko-
koschka were at the height of their activities. There were Chagall,
Beckmann, Nolde, Morandi, Diego Rivera, Siqueiros, Permeke; there
were the Surrealists, and sculptors such as Marini and Manzú.

I cannot believe that there is no possibility of finding a new synthesis
for a pictorial language which is directly and immediately understand-
able to the human eye. Just as Picasso appeared on the scene—thinking
to explode academic art and in fact bringing art, in its highest, its meta-
physical, sense, into danger of losing its very existence—so a yet un-
known artist may one day appear and change the whole course of
modern art, continuing and fulfilling the European tradition. The im-
mense success of the retrospective exhibition of Bonnard's works is
indicative of the mentality of the ordinary man, of his truthfulness to
himself. Each of us is convinced that our present art is the art of a
transitory period of bewilderment, and that Bernard Berenson saw the
situation only too clearly when he wrote:

> A leaning towards abstract art has always been considered
> characteristic of periods regarded as primitive, periods in which
> man has not yet become fully conscious of his position in the
> universe; or of certain periods of transition wherein man is pain-
> fully aware of the fragile nature of the relationship of the human
> creature to the surrounding world. As soon as man feels that he
> knows the meaning of life and his own purpose in it the geo-
> metrical forms and the abstract diagrams give place to representa-
> tions of the human body as proof of his confidence in himself and
> in his capacity to establish harmonious relations between himself
> and the world around him. In other words, he no longer thinks of
> the world of things as a hostile world, as is the case today, but,
> instead, feels himself capable of mastering his environment. And
> he is inspired by the hope of vanquishing death to immortalize
> his own image, giving his own forms to his expectations of a
> future life.[7]

And so the circle may close once again, for was it not at the begin-
ning of our European tradition, the tradition of our art, of our philos-
ophy, of our religion, of our concept of history and science, which all
have their roots in the Mediterranean, that Protagoras proclaimed man
to be the measure of all things?[8] This is the only measure which can
make him feel at home on earth and at peace with himself.

NOTES

1. J. P. Hodin, "Goethe's Succession," in *The Dilemma of Being Modern* (London, 1956).
2. Alfred H. Barr, *Picasso: Fifty Years of His Art* (New York, 1946).
3. J. P. Hodin, "The Expressionists," in *The Dilemma of Being Modern* (London, 1956).
4. See the conversation with Karl Jaspers in this volume, pp. 6–15.
5. "Edvard Munch's Expressionism," *College Art Journal* (Cleveland), Vol. 12, No. 4 (Summer, 1953).
6. *Poussin* (Paris, 1945).
7. "L'Art visuel et l'art abstrait," in *Comprendre: Revue de Politique de la Culture* (Venice), 17–18.
8. Hermann Diels, *Die Fragmente der Vorosokratiker*, 3 vols. (Berlin, 1952–56).

PART II

PSYCHOLOGY AND MODERN ART

1 • THE HELL OF INITIATION

An Essay Prompted by a Conversation with C. G. Jung

FREUD AND JUNG

ON NOVEMBER 13, 1932, AN ARTICLE ON PICASSO BY C. J. JUNG APPEARED in the Swiss newspaper *Neue Zürcher Zeitung.*[1] It is the only paper Jung ever wrote on modern art. At the time of his article he had already developed the fundamental ideas of his psychology, which, as he has declared on many occasions, is based on experience and is therefore empirical, and from that point of view may claim the status of a science.

Jung's breach with Freud occurred as early as 1913. It was caused by Jung's opposition to the conception of man's inner life, both in its normal and in its disturbed states, as centered in the sexual instinct, the conception that sees the conscious part of man's psyche, the ego, as merely a differentiated surface layer of the id, the unconscious part. From this theory it follows that it would not be possible to expect that the ego can be equipped with any instincts other than those which are present in the id.[2] Translated into terms of culture, the subject that concerns us here, this means that all culture is a sublimation of the sexual instinct. It means that the sexual instinct calls into existence all man's aggressive tendencies, his neuroses, his morbid psychic states, his feelings of guilt and anxiety, his death instinct and destructive impulses, and that on the cultural plane we meet all these things again, only this time transformed, metamorphosed, sublimated in the guise of religion, art, and philosophy, and tolerated, approved, even acclaimed, by society.

The logical tendency of this line of thought is to explain religion, art, philosophy, or mystical experience in terms of individual neurotic

symptoms which, when multiplied on a mass scale, acquire significance for society. In the field of art Freudianism occupied itself mainly with acquiring personal data about the individual artist, a procedure which seems to me quite inadequate for any interpretation of the artist's product. There is a tendency in Freudian psychology toward evolution, but this tendency seems not to have affected its fundamental concept of sexual mechanism. This fixity, this rigidity, was typical of all science in the nineteenth century.[3]

In this connection it seems apropos to recall the question formulated by A. N. Whitehead: "What is the sense of all this talk about a mechanical explanation when you do not know what you mean by mechanics?"[4] Similarly, we may ask: Are we to accept the notion of libido in the sense of Freud or in the sense of Jung? The few attempts Freud made to interpret works of art, as in his *Jensen's Gradiva* or his *A Childhood Memory of Leonardo da Vinci,* generally consist in allusions to phenomena in the life of the artist. On general culture, as in *The Future of an Illusion,* which concerns religion, or on war and peace (*Why War?*, an exchange of letters with Albert Einstein), or in his *Totem and Tabu,* Freud's work bears the hallmark on the one hand of his clinical approach, conditioned by his studies of neuroses, and on the other hand of his firm belief in rationalism. This stamps him as a representative of the Victorian era, and at the same time as a destroyer of Victorian prejudices and illusions, with one notable exception—the illusion of rationalism. An early statement of Freud on art and the artist is contained in his *Introductory Lectures on Psycho-Analysis.*[5] Speaking of the return of the libido to fantasy as an early step on the way to symptom formation—a process for which Jung has coined the appropriate term "introversion"—Freud discusses a side of fantasy life of very general interest. There is to him a path from fantasy back again to reality, and that is—art. The artist has an introverted disposition and is urged on by instinctive moods: "He longs to attain to honour, power, riches, fame, and the love of women; but he lacks the means of achieving these gratifications." Unsatisfied, he turns away from reality and transfers all his interests to the fulfillment of his wishes in the life of fantasy. Freud mentions that there are three factors which prevent this from becoming the whole outcome of his development. According to him, the artist's constitution is endowed with a strong capacity for sublimation and with a certain flexibility in the repressions determining the conflict. How is the way back to reality formed by the artist, and where is the precondition for his success to be found? The artist is not the only one who has a life of fantasy; all people adopt fantasy for their

comfort and consolation. But to those who are not artists the gratifica-
tion offered by fantasy is very limited. An artist, on the other hand,
understands how to elaborate his daydreams, so that their personal
origin is not easily detected. He also has the ability to shape his material
so that it is capable of expressing the ideas of his fantasy; he attaches
to this elaboration of his fantasy life a stream of pleasure strong enough
to dispel the repressions, at least for a time. In doing so he shows to
others the way back to the comfort and consolation of their unconscious
sources of pleasure, for which they admire and also reward him: "Then
he has won—through his phantasy—what before he would only win in
phantasy: honour, power, and the love of women."

This is a conception of art and the artist which, one feels, cannot be
accepted today, not for reasons connected with the prestige of art or
arising from any kind of frustration, but simply because it so obviously
reflects a very time-bound pattern of thought, all too familiar to us in
the shape of dialectical materialism. The Marxist sees culture and
spiritual life and all that these may include only as superstructure
reared upon the economic conditions and the real factors of production;
similarly, for Freud everything has its roots primarily in the sexual and
social ambitions of the individual—whether they are sublimated or
suppressed does not matter here. In spite of the antipathy of Freudians
to all "culturistic" deviations in modern psychology (which are
identified by them as a distorted return to magical thinking and to the
contrast of body and soul), it is obvious to the unprejudiced observer
that the human being is not only a social and a sexual being but that
besides his relationship to society, a relationship which has been over-
emphasized in our age for very natural reasons, there is another
primordial relationship of man to the realities of life and to the existence
of the universe. If this is true, then it is false to assert that for a thought-
ful youth, the contemplation of the beauty and the mystery of being has
but a subordinate role in his violent response to the other sex or to his
fear of death. Neither sociology nor physiology is capable of explaining
this other relationship in a satisfactory manner. Here, it seems to me,
we may look for the roots of Jung's own thought. To Jung, Freud is a
representative of the enlightenment of the nineteenth century. With the
help of rationalism Freud fought the repressive tendencies of his time,
the anemic ideals and morals of the respectable bourgeoisie. Art,
philosophy, and religion seemed to him to be questionable. This nega-
tive attitude toward recognized cultural values is historically condi-
tioned. He was prejudiced by the materialistic trend of thought in the
science and philosophy of his age.[6]

Jung's position is fundamentally different. A great part of his work is devoted to the symbols and archetypes of the collective unconscious, thus giving us, from a psychologist's point of view, a history of the human spirit throughout the ages, or, as he himself entitles it, "contributions to the historical development of thought" (*Beiträge zur Entwicklungsgeschichte des Denkens*), or "studies in the history of symbols" (*Untersuchungen zur Symbolgeschichte*). In addition, his recognition of the ineffable quality in all art, religion, and philosophy—and, let us add, also in science and therefore in psychology—is a much more acceptable view for our purpose. Jung accords a particularly important place to the creative activity of the imagination, even assigning it a category of its own; and this he does because in his opinion the imagination cannot be included in any of the four fundamental functions of the psychic totality, that is, thought, feeling, sensation, and intuition, although it partakes in a measure in all of them: "True productivity is a spring that cannot be stopped up. Is there any trick on earth that one could have whispered to Mozart and Beethoven and so have kept these masters from producing? Creative power is stronger than man."[7] And:

> The mystery of creativity, like that of the freedom of the will, is a transcendental problem which psychology cannot solve but only describe. Freud thought he had found in the shape of the personal experience of the individual artist, a key to unlock the door of this mystery. But every creative personality is a duality or a synthesis of contradictory qualities. On the one hand, he is individually human; on the other, he is an impersonally human process. As a person he may have his own impulses and desires and follow his own bent, but as an artist he is "human" in the higher sense of the word. He is the collective man, the bearer and form-giver of the unconsciously active soul of humanity. For this reason the great work of art is objective and impersonal, and moves us to the depth of our being.[8]

To acknowledge the ineffable in art and even in the sciences is today an accepted practice. We wish to stress here the conclusions reached in this respect by the scientists themselves. Has not Professor Niels Bohr used the term "irrational" to describe the new features of the physical world discovered by Planck?[9] Did not Professor Werner Heisenberg proclaim the uncertainty principle in nuclear physics,[10] and is not Professor Max Born, in accepting the idea of complementarity, on the border line between physics and metaphysics? "Even in restricted fields," Born says,

a description of the whole of a system in one picture is impossible. There are complementary images which do not apply simultaneously but are nevertheless not contradictory and exhaust the whole only together.... The fact that in exact science, like physics, there are mutually exclusive and complementary situations which cannot be described by the same concepts, but need two kinds of expressions, must have an influence—and I think a welcome influence—in other fields of human activity and thought.[11]

Professor George Boas, speaking in his presidential address to the American Society for Aesthetics in Durham in 1950 on "The Defense of the Unintelligible," said:

It is true that the nineteenth century now seems in many ways to have been incredibly optimistic; its leaders thought that they had finally understood all problems and that there were no *terrae incognitae*. Well, the twentieth century has suddenly changed all that and there seem to be more worlds to conquer than our fathers dreamed of. The universe has grown in many ways more mysterious rather than less.... [12]

ANTAGONISM TO MODERN ART

A stylistic description of a work of art, together with an iconographic and formal examination and a biographic and historic interpretation, do not produce a complete answer to the question, What is a work of art? The poles of interest to be studied are many: the artist himself; the work itself; artist *and* work; work *and* material; work *and* technique; work *and* tradition; work *and* time; work *and* beholder; beholder *and* time. Special difficulties arise in dealing with the modern work of art. When we study a sequence of analytical Cubist pictures, we must admit that without an interpretation which goes beyond the accepted analysis they remain puzzling and even disquieting. And this is so not only because of an ambiguity inherent in them, but also because of the prevalence of a traditional way of looking at works of art, an attitude which will acknowledge only past values and rejects any new approach to artistic problems. The physicist Erwin Schrödinger spoke, in his *Science and Humanism: Physics in Our Time,* of a time lag between the views held by learned men and those of the average person, which he estimated at about fifty years.[13] It seems to us that an academic art historian, for reasons inherent in his subject matter, requires an even

greater length of time before he can approach the works of his own age. What absurd judgments have been offered to us by scholars of different disciplines! Let us take the art historians first. Thomas Bodkin condemns, in *The Approach to Painting*,[14] everything that is called modern art:

> There was method in the madness of many of these modern painters who gathered rewards which they could never have hoped to gain by the exercise of their own talents unaided. Their day might be short, but it was sunny while it lasted. There is no need to weep for them in their subsequent eclipse. The sober truth is that most of them were bad in every sense of the word.
>
> They were bad as artists, because they were ignorant of the craft of their calling. They shirked the labour that alone brings competence. They despised the delicate tools, the beautiful material that true artists have always delighted in handling. . . . They were bad as men, because they had no sense of reverence nor respect for authority. Debauched, drunken, drugged, depraved creatures throng the ranks of "modern" painters.

(Later on, though, Bodkin acknowledged the merit of the Impressionists, artists who were attacked as senselessly in their own day as he attacks all modernism; in twenty years, perhaps, the truth will dawn on every academician that even Picasso may be a great artist.) Sir Lionel Lindsay also sees himself as a St. George fighting the dragon of modernism:

> I would never have used up a portion of the little time left to me, to make this book, if I had preferred my comfort to my duty. But I saw art undefended, threatened everywhere by the same aliens, the same corrupting influences that undermined French art, both supported by powerful propaganda. Rembrandt himself could not have commanded such advertisements, simply because modern art has passed, in the currency of journalism, from the casual stunt to the inviolable holy of holies—sensation. Between the years 1926 and 1935 I studied this phenomenon in Europe. Puzzled at first by its revolutionary and anti-traditional character, I came gradually to see its purport and the means by which it had been forced on a defenseless public. It did not win its way by honest fighting but was written into existence by hireling critics, corrupted in most instances by interested dealers. . . . I am convinced that modern art (self-styled) will die the death, for it has no roots in tradition, no evolutionary scope, no contacts with the soul of man. But in the meantime, art is distracted and must con-

tinue to suffer until such time as the Dragon of Imposture is be-
headed.[15]

Equally negative was Bernard Berenson[16]—whose viewpoint was
shared by Benedetto Croce, who told me in June 1952 that modern art
does not exist, since the art has evaporated from modern work. But
even modern artists themselves have attacked modern art.[17]

In England in the forties Sir Anthony Blunt was the only professor
of art history wholeheartedly to recognize the genius of post-Impres-
sionist art—at any rate in the person of Picasso. Other university
teachers remained cautiously aloof—seemingly objective, but in fact
lacking in the spirit of adventure which this age of great changes de-
mands, the courage or the interest to throw aside safety and penetrate
into the new realms of experience along with the scientist and the
artist. These academic interpreters, when they did not ridicule modern
art, characterized it as "experimental." Thus, they revealed an attitude
halfway between full recognition and the wholehearted acceptance of
nothing but the past, where everything, so long as it be old enough,
is honored irrespective of value (E. H. Gombrich). At the same time,
however, there were academics—Lionello Venturi and George Boas
were two of them—who had a more positive and constructive attitude
toward modern art. "As knowledge of the external world dissolved
into a series of equations," Boas wrote,

> so the perceptions of that world hardened into a cluster of as-
> sociations some of which took on a new and strange, and, for that
> reason alone, horrible significance. It is noticeable that the hostile
> critics of what is called modern art are not left cold and un-
> touched by it. . . . So long as the human eye was simply a retina
> on whose passive surface the light-rays made their impressions,
> pictures were easily enough painted and understood. But now
> we know that between the retina and the paint-brush lies an
> enormous complex of hate and longing and dread and hunger, of
> fears emerging from infancy and childhood, of desires to placate,
> to annoy, to kill, to create. What folly then to preach an aesthetic
> creed based upon an obsolete psychology.[18]

We can see that the days are numbered when modern art is regarded
as merely experimental. Suzanne K. Langer, in her book *Feeling and
Form: A Theory of Art* (a development of her *Philosophy in a New
Key*),[19] accepts fully Picasso's statement "I have never made trials or
experiments. Whenever I had something to say I said it in the manner

in which I have felt it ought to be said." She accepts it as seriously as any academician accepts a statement of an artist of past times. Moreover, Miss Langer bases a significant conclusion on this statement:

> What these critics (some of whom are serious theorists) fail to see is that such "values"—meant are formative values—are not the stuff of literature at all, but devices for making the true elements that constitute the poetic illusion.... The cardinal principle is that every artifice employed must be employed to a poetic purpose, not because it is fun, or the fashion, or a new experiment, to use it.

Thus, the art historians and aestheticians. Now for some other observers. Oswald Spengler declares, "What is produced as art today is impotence and lies—the music after Wagner as well as the painting after Manet, Cézanne, Leibl, and Menzel."[20] Following Spengler's footsteps, Toynbee pronounces a similar judgment:

> The prevailing tendency to abandon our artistic traditions is not the result of technical incompetence; it is the deliberate abandonment of a style which is losing its appeal to a rising generation because this generation is ceasing to cultivate its aesthetic sensibilities on the traditional Western lines.... Our abandonment of our traditional artistic technique is manifestly the consequence of some kind of spiritual breakdown in our Western civilization and the cause of this breakdown evidently cannot be found in a phenomenon which is one of its results.[21]

Now, the less pessimistic thought of a sociologist, Pitirim Sorokin:

> We are seemingly between two epochs: the dying sensate culture of our magnificent yesterday (600 years) and the coming ideational culture of the creative tomorrow.... The night of the transitory period begins to loom before us, with its nightmares, frightening shadows and heartrending horrors. Beyond it, however, the dawn of a new great ideational culture is probably waiting to greet the men of the future.[22]

Let us consider the significance of this "transitory period" for the arts. The psychiatrist Hans Prinzhorn developed at length the idea of the "schizophrenic world feeling" in our time and of the anxieties caused by the decay of the traditional "world feeling." Adapting it to the realm of art he pointed to the "very close relationship between

schizophrenia and other deranged states of mind and modern art. Modern art in its urge towards intuition and inspiration is well aware of certain spiritual attitudes—strives towards them and seeks to reach them—a result which schizophrenia arrives at by force of its obsession."[23] Similarly, C. G. Jung said nine years later of Joyce's *Ulysses* that it is

> no more a pathological product than modern art as a whole. It is "cubistic" in the deepest sense, because it resolves the picture of the actual into an immensely complex painting whose dominant note is the melancholy of abstract objectivity. Cubism is not a disease but a tendency to present the actual in a certain way—it may be a grotesquely realistic or a grotesquely abstract way.[24]

Let us now also listen to those who formulate their ideas on modern art from a religious (mainly Catholic) viewpoint, such as Bernard Champigneulle, Wladimir Weidlé, and, we may add, Nicholas Berdyaev, together with those German art historians influenced by them, like Hans Sedlmayr, Wilhelm Hausenstein, and Otto H. Förster, who are all mainly negative in their outlook on modern art.[25] "Art has always responded to a desire, a thirst in man. But then it was a thirst for expression, for total incarnation and not merely a strictly limited need, of the practical or aesthetic order." So judges Weidlé. They all agree with Baudelaire that the first condition necessary to give us a healthy art is a belief in integral unity. Or, with St. Augustine: *Omnis pulchritudinis forma unitas est.* Weidlé feels that the only thing that can save art and the whole life of the spirit is a power capable of spiritualizing the masses. Such a power, under whatever form it may show itself, can never arise except from a common religious experience. One wonders, however, if this must not necessarily mean a return to dogma. What Jung thinks of all this we shall hear later. So much for the antagonistic criticism of modern art in general.

SCIENTIFIC THOUGHT AND ART

We know that we have to accept science in the way that Karl Jaspers does:

> As opposed both to the superstitious belief in science and the contempt for science, philosophy stands unconditionally on the side of modern science, which it considers a wonderful phenome-

non of incomparable reliability, the deepest incision ever made into human history, the source of great dangers but ever greater opportunities, and from now on, the condition of all human dignity. . . . [It is] the genuine, imperturbable, never-failing scientific attitude which, precisely because it is conscious of its limitations, leaves room for every other source of truth in man.[26]

We also know the influence which science and technology have exercised on modern art. But we (even the artists) have to go beyond science as it was known in the past to achieve a new vision of the whole. "We are witnessing," said Werner Heisenberg,

a change in the external features of the world. The struggle for its reshaping is carried on with all our resources and absorbs all our powers. . . . A fundamental and lasting change which has gradually matured in some fields of intellectual activity, can also have universal importance in shaping our future. It appears that the various branches of science are trying to fuse into one great entity. . . . [27]

Let us quote a few more instances of the definition of twentieth-century science. Max Born declared:

Long years of neglect have not deleted the deep impression made in my youth by the age-old attempts to answer the most urgent questions of the human mind: the question about the ultimate meaning of existence, about the universe at large and our part in it, about life and death, truth and error, goodness and vice, God and eternity. . . . Getting old, I feel . . . the desire to summarize the results of the scientific search in which, during several decades, I have taken a small part, and that leads unavoidably back to those eternal questions which go under the title of metaphysics.[28]

And Albert Einstein proclaimed: "The most beautiful thing we can experience is the mysterious side of life. It is the deep feeling which is at the cradle of all true art and science. In this sense, and only in this sense, I count myself amongst the most deeply religious people."[29] We find Jung following similar lines of thought. Jung represents a stage in psychology which is as typical of our era as Freud was of his; even if we think that his later work tends sometimes to be overgrown by a medieval and Oriental mythological imagery, as it tries to grasp the evolving universal image of the powers which form man, it remains representative of its own age. In its cultural research it influenced

Freudianism; only a synthesis, not a mere polemic, can lead us to greater clarity. "True expression is formative intuition," Jung himself says.[30] The direction of thought in Jung's philosophy is similar to that followed in Madame Blavatsky's Theosophy, Rudolf Steiner's Anthroposophy, the Gurdjieff-Ouspensky school, and lately in the trend toward Zen Buddhism. Heidegger's question *Was ist Metaphysik?* was answered by a *Meta-Metaphysik*, that is, by penetration beyond the accepted doctrine of metaphysics to the roots of being itself.[31] Did Aldous Huxley's *The Perennial Philosophy* not aim at a similar goal in mystical thought?[32] This same direction, dictated by an inner need, was also followed by poets such as Robert Graves and by Hermann Hesse and Thomas Mann.[33] And T. S. Eliot, in his notes on *The Waste Land,* confesses to an analogous influence of Christian and pre-Christian imagery in his own work:

> Not only the title but the plan and a good deal of the incidental symbolism of the poem were suggested by Miss Jessie L. Weston's book on the Grail legend, *From Ritual to Romance.* . . . To another work of anthropology I am indebted in general, one which has influenced our generation profoundly; I mean *The Golden Bough.* I have used especially the two volumes Adonis, Attis, Osiris. Anyone acquainted with these works will immediately recognize in the poem certain references to vegetation ceremonies.[34]

Edith Sitwell also acknowledges this influence in her poetry.[35] The author of *The Golden Bough,* J. G. Frazer, who wished to demonstrate the evolutionary theory of man's spiritual life from magic ritual to religious myth, has influenced the post-Victorian generation only by the wealth of his imagery, which is strange, secret, and deeply symbolic, fascinating and horrifying at the same time.[36] Jung's thought has, incidentally, a striking similarity to that of Frazer. Take Frazer's idea of the comparative method, the literary form which was not a systematic development of an argument:

> He collected, compared and classified the facts about man's earliest beliefs, institutions and practices, the way of life both of contemporary savage or primitive peoples and of the earliest ancestors of civilized peoples of whom we have records. To these he added the survivals of those which are to be found in the beliefs and practices, the folklore and superstitions of the more advanced peoples. In bringing these three sets of phenomena together he assumed not only that the human mind is essentially

similar in all men, and that the ancestors of civilized peoples passed through the stages at which contemporary primitives now are, but also that there is the same essential similarity between the customs, traditions, and institutions in which the human mind finds expression among different peoples who are at the same stage of cultural development. Similar customs, traditions, and practices, whenever and wherever found, could therefore [Frazer believed] be used to throw light on one another, and on the motives and beliefs which gave rise to them.

We need only to project these social-anthropological findings onto the realm of depth psychology to recognize Jung's notion of the Collective Unconscious. There is another similarity:

> The fact is that even today social anthropology is not a fully fledged science in the sense of a systematic and growing body of knowledge in which every problem is considered from a common point of view and dealt with by the same method. It is rather the name for a group of problems more or less intimately connected; and the aims of those who investigate them and the methods which they find useful in solving them are different from one another.[37]

Nevertheless, *The Golden Bough* will remain one of the great literary masterpieces of our language, not only an inexhaustible mine of anthropological facts, but also a spectacular work of constructive imagination.

How many contemporary artists, such as Kokoschka, Beckmann, Klee, Ernst, Masson, Brauner, have derived inspiration and inner certainty from studying the mystics, mythologies and cosmologies, anthropology, magic, alchemy? It may be that Cyril Connolly, as editor of *Horizon*, misjudged the thought of his time when he asked Dr. Edward Glover to write an essay against Jung. The controversial book was published under the title *Freud or Jung*. Connolly's letter to Glover is quoted in the preface. "I feel," wrote Connolly,

> that Jung's reputation has grown out of all proportion in the last few years because of that aspect of his work which is really a distortion of Freud's ideas, by the injection into them of unscientific mystical feelings which make them popular, but which are antagonistic to the whole Freudian conception of psychology as a science. It seems to me that only a really profound Freudian can unravel in the work of Jung those elements in which Jung's

own desire for a religious, rather than a scientific conception exists. I am also alarmed at the popularity of Jung's ideas in the Catholic Church and among my literary friends who confuse the inspirational value of much of Jung's thought with the basic accuracy required of such thinking.[38]

Is this not, translated into the terms of the history of modern art, like demanding a defense of those purely rational principles of Cubism or geometric art in order to stop the tendency growing amongst artists ever since Gauguin and van Gogh toward the undefinable in life and art, and as a protest against a purely scientific attitude? "Science," as understood by Connolly and subsequently by Glover, appears to us to be used in a restricted and rather antiquated sense.

Dr. Glover writes: "Speaking of the scientific approach to creative art and in particular of the influence of rationalism on programmatic Surrealism, Mr. J. P. Hodin remarks (Horizon, January 1940) that this is a case of the shadow of psycho-analysis falling on art. . . . He continues that "particularly in the case of Surrealism, it is not the shadow of psycho-analysis that has fallen on art, but the shadow of the Jungian Collective Unconscious." This statement is not only misleading, it is wrong. The uses of psychoanalysis in modern art (apart from its own brand of interpretation) are: (1) the method of automatism, with the aim of excluding the interfering and controlling conscious mind from artistic activity. This is a direct imitation, used by André Breton, of psychoanalytical clinical procedure; (2) the introduction of an often psychotic dream world for pictorial representation with an overemphasis on parasexual symbolism, with its shock-and-surprise formulas of alogical and chance situations; (3) iconographically, the reintroduction into art of the subject matter as an element of first importance; and (4) formally, the reintroduction of photographic, even academic, realism—for, to depict dream situations in their often terrifying, airless spaciousness, sharp outlines, three-dimensionality, and meticulously rendered details are a necessity. Automatism led in the visual sphere of Surrealism to the rediscovery (rediscovery, because the principle was already known to Leonardo da Vinci) of automatic processes such as frottage, collage, and decalcomania, and of the range which objets trouvés offer to the active Surrealist fantasy. In such instances we can find the direct impact of Freudianism on the arts/ It is well known how deeply Freud has influenced literature also. In the case of Jung we can speak rather of a parallelism of thought and vision between the aims of Symbolism, Expressionism, Neo-Primitivism, or Fantastic art and his complex psychology.

Jung deduces, from his conception of the Collective Unconscious and of the archetypes inherent in it since the beginning of time, the secret of the artistic effect. To him the creative process consists of an activation of the timeless symbols of humanity resting in the unconscious and their acquisition of a tangible reality through the completed work of art. The artist speaks in primordial images, speaks as with a thousand tongues. He grips and overpowers, and at the same time he elevates that which he treats out of the individual and transitory into the sphere of the eternal; he exalts, and therewith he releases in us, too, all those forces that have ever enabled humanity to secure itself from whatever distress and to live through even the longest night. Jung makes it quite clear also that only that part of art which consists in the process of artistic formation can be the subject of psychology— not that part which is the peculiar essence of art. This second part, posed as the question What is art in itself?, can never be the subject of psychological but only of aesthetic-artistic inquiry.[39]

PICASSO AND JAMES JOYCE'S *ULYSSES*

All these preliminary statements have been necessary to indicate my own position with regard to the problems concerning Freud and Jung, the changing concept of science in the twentieth century, and the impact of this on modern art. Being decidedly of the opinion that the ineffable quality is a *sine qua non* of all art, and that the notion of a human science is a basic notion of our century, I nevertheless find myself critical toward Jung's ideas on modern art.[40] The following paragraphs will show why.

At this juncture we shall take up the analysis of Jung's study on Picasso. A relatively short essay, about two thousand words, it cannot claim to be an early exposition of the meaning of Picasso's work. The exhibition on which Jung based this study was the retrospective exhibition of Picasso's work held at the Kunsthalle in Zurich (September 11 to October 30, 1932), displaying 436 items, including paintings, drawings, watercolors, and sculpture dating from 1898 to 1932. Only thirty-two works were actually illustrated in the Zurich catalogue. It seems obvious, however, that Jung must have studied some other works of Picasso, too, as certain indications in his reasoning cannot be traced back to the Zurich catalogue.

Jung has written this essay with some reluctance:

> Had it not been suggested to me on good authority, I should probably not have taken up my pen on the subject. It is not that

this painter and his strange art seem to me too slight a theme . . . on the contrary, his problem has my undivided interest; but it appears too wide, too difficult, and too involved, for me to hope that I could come anywhere near to covering it fully in a short article. If I venture to express myself on the subject at all, it is with the explicit reservation that I have nothing to say on the question of Picasso's "art," but only on its psychology. I shall therefore leave the aesthetic problem to the art critics and shall restrict myself to the psychology underlying this kind of artistic creativeness.

Picasso's psychic problems, insofar as they find expression in his work, seem to Jung strictly analogous to those of his patients. He approaches his theme like Freud, from a clinical angle, but he works from other premises and therefore arrives at different conclusions. It is evident from the foregoing that Jung is going to treat Picasso—and with him all modern art—as representative of the time, of the strains and sufferings and frustrations of a time which is on its way to elaborating new scientific, metaphysical, and religious symbols, which has lost its hold on the age-old inner certainties and truths, and which, to a great degree, is in conflict with its symbol- and myth-creating abilities because of a one-sided tendency toward the rational. Such an analysis of our situation is not new. It has its roots already in the philosophy of Bergson, in the revival of Catholic philosophy in France, and in the phenomenology of Husserl, and it has found its expression too in Ludwig Klages, Oswald Spengler, and others. Bergson may have influenced Jung's coming to look upon Freud's libido more as the *élan vital* itself.[41] This is a much wider concept than the Freudian, and is one which Jung tried to establish on the basis of his clinical experience. And so Jung has made it clear, both for his patients and for our whole age, that before the reintegration of the personality is achieved—a reintegration in which all the faculties of the soul given to man will take part in their effort of experiencing and expressing life: not merely the rational and physiological, but the religious, artistic, and meditative faculties as well—no balance of mind can be reached.

It is significant that in the same year, only a few months earlier, Jung was confronted with a literary parallel to Picasso in Joyce's *Ulysses*. His *Ulysses* study is five times the length of the Picasso essay. Jung is obviously more at ease when he is analyzing literary rather than visual works of art. His "*Ulysses*" is a dramatic study, revealing the intense effort he made to penetrate to the inner core of this strange literary work until at last he could arrive at some reasonable conclusions which find a natural order in his own system of thought. One is at first in-

clined to say that only the projection of his own ideas onto the work of Joyce and Picasso through association—in the case of Picasso it was the picture *Evocation* which brought about this reaction—gave him satisfaction and rest. But we shall see that such an interpretation does not contain the whole truth. How deeply and logically Jung felt the inner connection of different symptoms can be seen when recollecting his statement: "Like Nietzsche, like the World War, so is Freud, and so also is his literary counterpart, Joyce—an answer to the sickness of the nineteenth century."[42] In fact, it is by analogy that Jung arrives at his image of man's spiritual life. He arrives at it by adopting the comparative method which is used in anthropology and anatomy, and also in psychiatry. This Jungian psychology is rooted in Ernst Haeckel's biogenetic principle, according to which the individual organism during the course of its embryological development passes through the main stages in the evolution of its species.[43] (Freud had expressed the same thought when he said that the principle that ontogeny repeats phylogeny must apply also to the inner life of man.) The primitive is in everyone; it is not only an evolutionary factor, but an inner power of considerable strength in modern man which, when repressed, claims its rights forcefully. So too does the symbol-creating faculty, which is the only reliable way for man to grasp the mystery of life and the universe, and which is rooted in the Collective Unconscious. We again encounter an analogy in the history of art. The modern artist, confronted with a sterile traditionalism and academism, revitalizes art at the sources in going back to the fundamentals of both sensation and formal experience. This return to the archaic is not to be seen negatively, as a regression, but as a step undertaken from inner necessity. It is a proof of the artist's vitality, honesty, directness, and truthfulness. The conclusions at which Jung arrives in analyzing Picasso are not final; they cannot be. They are rather hypothetical; they keep all eventualities open, even that of madness: "What quintessence will he [Picasso] distil from his heaped up garbage and decay, from half-born and prematurely dead potentialities of form and colour? What symbol will appear as the final cause and meaning of all this dissolution? As to his future, I would rather not try my hand at prophecy, for this inner adventure is a dangerous affair."

It is advisable to study the *Ulysses* essay together with the *Picasso* article, because it is in the former that Jung seems to arrive at more definite—at least for that time more definite—conclusions. Jung's starting point in his reasoning on Picasso is, as already mentioned, the picture *Evocation* (1901), an allegory of life and death, of love and

motherhood and youth and hope. It is above all the pictures which can be interpreted in a literary sense that produce the first links in Jung's reasoning; they also give the main direction to the metaphysical trend of interpretation he adopts. Once he comes to Cubism or other formal aspects, which in themselves have a deep meaning that also needs to be transposed into words, his arguments become more general, emphasizing the time factor and basing themselves on the experience of a psychiatrist. Nevertheless, Jung is one of the few psychologists who introduced the formal as well as the thematic viewpoint in his argument. Confronted with Picasso, he is at first puzzled. He experiences merely a sensation of strangeness, and of a confusing diversity. Only the comparative study of several series of pictures offers him a possibility of understanding. Because of their lack of artistic imagination, the pictures of patients seem to him simpler and therefore easier to understand. Speaking of two groups of patients, neurotics and schizophrenics, Jung states that the first group produces pictures of a synthetic character based on an underlying unity of feeling; the second group, on the other hand, produces pictures which immediately reveal their estrangement from feeling:

> From a purely formal point of view, the main characteristic is one of laceration, which expresses itself in so-called "fractured lines"—that is, a kind of psychic "faults" [in the geological sense], which goes right through the picture. The picture leaves one cold, or terrifies by its lack of concern for the spectator. This is the group to which Picasso belongs.

Both groups have one thing in common, symbolic content:

> Its meaning is implied. Whereas the neurotic searches for the meaning, and for the feeling that corresponds to it, and takes pains to transmit it to the beholder, the schizophrenic shows no such inclination. Nothing goes out towards the beholder, everything turns away from him. The horrible, the sick, the grotesque, the incomprehensible, and the banal are sought out in order to obscure. The whole thing is quite pointless, like a spectacle that can do without an audience.

It is doubtful to me whether this psychiatric picture, however intriguing it may sound, really carries conviction.[44] What Jung can certainly claim is that, as we are here confronted with symbol-images from the Collective Unconscious, Picasso cannot possibly be aware of

them. It also seems to me that Jung's analysis does not correspond to the facts. Does Picasso really *not* search for the meaning and for the feeling that corresponds to it? And does he *not* take pains to transmit it to the beholder? Is it not rather that the novelty of his achievement has bewildered his audience, but that his meaning reveals itself after some study? It is certain that his intentions evolve from one stage to another, until they reach a solution from which point they do not interest the artist any more and he drops them. Where else can we find such an intense representation of the magic of sleep as in the sleeping nudes painted in 1932? And have we not to go as far back as Mathias Grünewald to find such a violent expression of suffering, its meaning and the feeling which corresponds to its meaning, as in the *Guernica Postscripts?*

Let us now turn to the *Ulysses* essay, where we shall find a more definite viewpoint.

> In a sick man, the botching of beauty and meaning through grotesque reality or equally grotesque unreality is a result of the destruction of personality; in the artist, however, it is creative purpose. . . . This being so we can ascribe a positive creative value and meaning not only to *Ulysses*, but also to that art in general to which it is spiritually related. . . . In its attempt to destroy the criteria of beauty and meaning that have held until today, *Ulysses* accomplishes wonders. It insults all the conventional feelings, it brutally disappoints one's expectation of sense and content, it turns all synthesis to ridicule. Everything abusive we can say about *Ulysses* bears testimony to its peculiar quality, for our abusiveness springs from the resentment of the unmodern man who does not wish to see what the gods graciously veil from his sight.

Jung speaks here of creative destruction, which corresponds in the work of Picasso to his analytical Cubist period, and adds, astonished: "There must exist a community of moderns who are so numerous that since 1922 they have been able to devour ten editions of *Ulysses*. The book must mean something to them or even bring them the revelation of something that they did not know and feel before." Again he stresses his idea of the artist as the unwitting mouthpiece of his time, through whom it tells the secrets of its soul. The artist is as unconscious as a sleepwalker. He supposes that it is he who speaks, but the spirit of the age is his prompter and whatever this spirit says is so, for it is a fact of contemporary consciousness. Jung seems suddenly to realize that we

do not know to what extent we ourselves still belong in the deepest sense to the Middle Ages.

In his Picasso essay Jung says that with neurotics one can define what they are trying to express, and with schizophrenics, what they are unable to express. In both cases, the content is full of secret meaning. A series of images of this kind

> begins as a rule with the symbol of the Nekya, the journey to Hades, the descent into the unconscious, and the leave-taking of the upper world. What happens afterwards, though it is still expressed in the forms and shapes of the day-world, intimates a hidden meaning, and is therefore symbolic in character. Thus Picasso starts with the still objective pictures of the Blue Period—the blue of night, of moonlight and the waters, the Tuat-blue of the Egyptian underworld [*Celestine*, 1903].[45] He dies, and his soul rides on horseback into the beyond [*Evocation*, 1901]. The day-light clings to him, and a woman with a child steps up to him warningly [*La Vie*, 1903]. As the day is woman to him, so is the night; psychologically speaking, these are called the light and the dark soul (anima). The dark one [*Femme assise*, 1903; *Femme aux bras croisés*, 1902] sits waiting, expecting him in the blue twilight, and stirring up morbid presentiments. With the change of colour, we enter the underworld [*Femme maquilée*, 1901]. The world of objects is doomed to death, as the horrifying masterpiece of the syphilitic and tubercular adolescent prostitute makes plain [*La Femme au chignon*, 1901]. The motif of the prostitute commences with the entry into the beyond, where he, as a departed soul, encounters a number of others of his kind. When I say "he," I mean that personality in Picasso which suffers the underworld fate—the man who does not turn towards the day-world, but is fatefully drawn into the dark; who follows not the accepted ideals of goodness and beauty, but the demoniac attraction of ugliness and evil. It is these anti-Christian and Luciferian forces that well up in modern man and engender an all-pervading sense of doom, surrounding the bright world of day with the mists of Hades, infecting it with deadly decay, and finally, like an earthquake, dissolving it into fragments, fractured lines, discarded remnants, debris, shreds, and inorganic units [*Accordionist*, 1911]. Picasso and his exhibition are a sign of the times; just as much as the 28,000 people who came to look at these pictures.

When the man who meets with such a fate belongs to the neurotic group, he usually encounters the unconscious in the form of the "dark one," a Kundry of grotesquely horrible, prehistoric ugliness, or of infernal beauty. Corresponding to the four fe-

male figures of the Gnostic underworld—Eve, Helen, Mary and Sophia—we find, in the case of Faust's metamorphosis, Gretchen, Helen, Mary and the abstract "eternal Feminine."

In his descent Picasso transforms himself and appears in the underworld-form of the tragic Harlequin [*Arlequin,* 1909, 1918, etc.] motif which persists through numerous pictures: like *Faust* in Part II, he is caught up in murderous happenings and reappears also in changed form. It may be remarked in passing that Harlequin is an ancient chthonic god.

The descent down to ancient times is associated, ever since Homer's testimony, with the Nekya. Faust turns back to the primitive world of delusion of the *Blocksberg* witches' sabbath, and to a chimera of classical antiquity. Picasso evokes the crude, earthly shapes of a grotesque primitive [*Two Nudes,* 1906; *Les Demoiselles d'Avignon,* 1907], and resurrects the soullessness of ancient Pompeii in a cold, shimmering light—an evocation unsurpassed even by Giulio Romano! Seldom or never have I had a patient who did not go back to neolithic art-forms or launched out into an evocation of antique Dionysiasm. Like Faust, Harlequin wanders through all these forms, though sometimes nothing betrays his presence but his wine, his lute, or at least the colourful pattern of his jester's costume [*Fireplace with Guitar,* 1915; *Three Musicians,* 1921]. And what does he experience in his wild journey through man's millennial history? . . . The Nekya is no aimless, purely destructive and titanic fall into the abyss, but a meaningful *Katabasis eis entron,* a descent into the cave of initiation and secret knowledge. The journey through the psychic history of mankind has as its object the re-establishment of man as a whole by the awakening of the recollection of the blood. The descent to the Mothers enables Faust to raise up the whole, sinful man—Paris and Helen—that man who was forgotten whenever the present went astray and became one-sided. . . . It is he who at all times of upheaval has caused the tremor of the upper world, and will always cause it again. This man stands in opposition to the man of the present, because he is the one who ever is as he was, while the latter is what he is only for the present. Correspondingly, with my patients, the period of *Katabasis* and *Katalysis* is followed by a recognition of the bi-polar character of human nature, and of the necessity of the conflict-fraught pairs of opposites. . . . Hence, after the symbols of the experience of madness during the period of dissolution, there follow images which represent the coming together of the pairs of opposites: light-dark, above-below, white-black, male-female, etc. In Picasso's latest pictures [i.e., in 1932], the motif of the conjunction of opposites is seen very clearly in their direct confrontation. One pic-

ture (though it is transversed by a number of fractured lines) even contains the conjunction of the light and dark anima [*Girl Before Mirror*, 1932]. The strident, unambiguous, even brutal colours of the latest period correspond to the tendency of the unconscious to master the conflict of feelings by violence (colour =feeling).

In a patient's psychic development, this state of things is neither the end nor the goal. It merely represents a broadening of his outlook, which from now on comprehends the whole of man's moral, bestial, and spiritual nature, without as yet shaping it into a living whole. Picasso's "*drame intérieur*" has progressed to this last height before the climax.

We have stressed already that modern art is in need of an interpretation which goes beyond the purely formalistic, stylistic, or otherwise "theoretic" aspects. We have also expressed our incertitude over whether to accept Jung's interpretation as valid. We can without doubt speak of a widening of the scope of methods and "objects" of representation discernible in the aims of the modern artist, which cannot be resolved by a depth-psychological approach. The question of *how*— how did Picasso solve the problem of space or composition or of pictorial content?—has to be combined with the question of *why*—why did he solve it as he did? Why Cubism, why abstraction, why the return to Neolithic or other primitive forms?

To answer these questions in the most direct way possible, let us adopt the position taken by the physicist Erwin Schrödinger:

> We feel clearly that we are only now beginning to acquire reliable material for welding together the sum total of all that is known into a whole; but, on the other hand, it has become next to impossible for a single mind fully to command more than a small specialized portion of it. I can see no other escape from this dilemma (lest our true aim is lost forever) than that some of us should venture to embark on a synthesis of facts and theories, albeit with second-hand and incomplete knowledge of some of them—and at the risk of making fools of ourselves.[46]

Here the emphasis is on what is known, not on what is subconscious. Let us now proceed to the evidence of art history.

When studying the metamorphoses of Picasso's art and recording them objectively as art historians do, we are summing up facts which are important as a basis for more comprehensive studies, but which do not directly touch upon the problem of their meaning.

In Paris in 1900–1901, so we read in Barr's *Picasso*,[47] the artist

> studied the work of the vanguard, Gauguin, van Gogh, Toulouse-
> Lautrec, Vuillard, Denis, and the older men, Carrière, Degas,
> Renoir, and the Impressionists. During his early years in Paris
> he went often to the Louvre to study the old masters and also
> the rooms of Egyptian and ancient Mediterranean art which may
> have encouraged some of the archaisms which appear rather
> casually in his work of this and the next year or so.

In June 1901, Picasso was criticized as an imitator of Lautrec, Stein-
len, van Gogh!

> Toward the end of 1901 Picasso began to use a pervasive blue
> tone in his paintings which soon became almost monochrome.
> Just why Picasso came to use so much blue over so long a period
> has never been convincingly explained. It has been suggested
> that Picasso used a blue monochrome because he painted at night
> by a weak lamp which made it difficult to use colors, that he was
> too poor to buy a variety of colors and therefore used only one;
> that he was, perhaps unconsciously, influenced by the prevalence
> of blue prints which were widely used at the time by amateur
> photographers as a cheap substitute for other and more perman-
> ent positives. Gertrude Stein says the Blue Period was the re-
> sult of Picasso's return to Spain in 1902 when the monotony and
> sadness of Spanish coloring influenced him after his Paris so-
> journ. She . . . ignores the fact that Picasso began to paint blue
> pictures in Paris in 1901 before he went back to Barcelona. Many
> of Cézanne's late paintings were saturated with blue; Matisse had
> painted several large figure studies in blue just before the turn
> of the century, though these were probably not known to Picasso;
> and Carrière, whose work Picasso did admire, used a gloomy
> monochrome, though it was grey not blue. Some Catalan critics
> insist upon the influence of Isidro Nonell, whose dejected figures
> do at times closely resemble Picasso's, but Nonell was in Barce-
> lona during 1901 at the very time Picasso's Blue Period was ma-
> turing in Paris. Whatever its source—and it was probably from
> within Picasso himself—the lugubrious tone was in harmony with
> the murky and sometimes heavy-handed pathos of his subject
> matter—poverty-stricken mothers, wan harlots with femme fatale
> masks, and blind beggars.

A sociologist may remark that these themes, which are given such
an outstanding significance in Jung's interpretation, can be explained

not only by Picasso's own hungry years in Paris at the beginning of the century but by the fact that the whole era was disturbed by the social problems and unrest preceding the outbreak of the First World War. The theme cycles of the harlot, the café, the bohemian artist, the ballet, the circus, all depict the fringes of society, a milieu which has its attraction and poetry and beauty, its promise of freedom as well as its suffering. These theme cycles can be studied in the work of many artists and authors of the time. The Symbolist ideas so powerful in those days, with their emphasis on the irrational, can be defined as a revolt against a narrow scientific and utilitarian spirit. There was Odilon Redon, there was still Gustave Moreau (among whose pupils were Matisse and Rouault), and there was the influence of Puvis de Chavannes. There was Böcklin, von Marées, Edvard Munch. Are not these stimuli sufficient to explain the position of the artist? Why do we need the archetypal imagery used by Jung, which stretches far back into the mythological past and seems so far-fetched?

Before we enter into this discussion, let us continue with our art-historic facts:

> Gradually the mannerism of 1904 gave way to the more natural style and melancholy sweetness of the long series of circus people —acrobats, clowns, *saltimbanques* and jugglers in harlequin tights—done during the early months of 1905. Color, too, while still subdued, grew more varied and subtle in harmony with a new delicacy of drawing and sentiment. . . . As 1905 passed, Picasso gradually left behind him his nostalgic, introspective mood and emaciated figures. During the second half of the year his work began to assume a classic breadth and repose.[48]

Then came the influence of El Greco, the Iberian influence, the influence of Cézanne, of African Negro sculpture, and finally what every conservative interpreter calls the complete breakdown of the traditional image—Cubism.

Now, what was Cubism? Not an earthquake engendered by anti-Christian and Luciferian forces, dissolving the bright world of today into fragments, fractured lines, discarded remnants, debris, shreds, and inorganic units, but rather the deliberate and courageous effort to find ways of organizing the space of a picture inside its frame other than those derived from tradition (even from primitive tradition); it was an act of will which challenged the existing laws of composition as powerfully as modern science, aiming at a new vision, challenged a

world view based on pre-scientific axioms. That in the process conventional aspects of art were discarded or neglected (Picasso took them up again repeatedly later on) was only due to the intensity of the effort. This is something quite different from going back, or going back exclusively to the primitive. If, however, the going back of modern art to the primitive—the sources—can be interpreted, as by Jung, as a going back to the unconscious to regain the vitality and the balance necessary for a sound conduct of life and art, we should now find ourselves in the middle of that process which Jung himself calls the integration, or reintegration, of man into a harmonious whole. This was, indeed, an ideal which has animated those artists who have consciously fought their inheritance of mechanistic-materialistic thought and opened their minds to new forces of spiritual growth: the Symbolists, the Expressionists, the Neo-Primitives, Fantastic artists such as Chagall and Klee. But it was not the case in the development of modern art as a whole. The branch based on Picasso's revolutionary, "Cubist" thinking—ironically, it was this branch which developed abstraction to avoid his powerful influence—has since then gone to one extreme after another, with *Art autre* and Action painting, Tachism, and *Art informel* leading to complete chaos and disorientation. Now the artist felt really "free," without inhibitions. Now he could take his hysteria, his Existentialist misery, as the only aim of art, entirely losing sight of the function of art and its message. Of this later development Jung did not know when he wrote on Picasso, but he summarily repudiated all those artists who were one day to speak his own language. We wonder why the modern artist has been so misunderstood by Jung, why Jung saw in him the destroyer of old and possibly time-bound images, but not the creator of new ones. We for our part affirm that for the first time in the history of man a development is taking place which will sum up man's artistic achievement, irrespective of time and place, and that Picasso in his own way is a living example of this global development. André Malraux expressed these ideas with great ingenuity in *Les Voix du silence*.[49] In this belief we affirm too that modern art in some of its historically established aspects is more than an experiment, more than a protest against the shortcomings of its own time. We understand it as the symbol of man's eternal struggle to come to terms with evolution, marked in our case by the advance of science. If Jung's definition of the effect of the work of art is correct, it should hold for modern art. But he says: Nothing goes out toward the beholder, everything turns away from him. The effect of the modern work of art is not as of speaking with a thousand tongues. If Jung's explanation had

universal validity it would *eo ipso* exclude modern art as art. As we have to repudiate this conclusion, it is left to us to abide by our own conclusion, and that is that Jung, like Arthur Schopenhauer and Adolph Hildebrand, is convinced of the exclusive validity of a single ideal of art, that of the High Renaissance and of Periclean Greece, a view which is untenable today. Starting from the Collective Unconscious (which we do not want to debate here, although Freud already considered the use of this term superfluous), "whose content and functions are of an archaic nature"—not pseudo-archaic, but in the nature of a relic, as Jung explains, adding that the artist's images are "archaic" when they have mythological parallels which are unrecognizable to him—it is well to consider anew the main points of Jung's analysis.

Evocation and *La Vie* are allegories of the kind much in vogue in the age of Symbolism, expressing general ideas about life and death. No Collective Unconscious is needed to convince us of the facts of life, death, and love. Picasso was in those days very much occupied with the themes of death, love, pregnancy, and motherhood. This preoccupation had its personal motifs also. The picture *Evocation,* for instance, was always known to Picasso's friends as *The Burial of Casagemas.*[50] Carlos Casagemas was a young painter who accompanied Picasso from Barcelona on his first visit to Paris in 1900. Their stay ended abruptly, the main cause of the return to Spain being, according to Picasso, his companion's despair. Casagemas had fallen in love with a girl in Paris who in spite of all his efforts showed no interest in him. Believing that the sunshine of Andalusia might have a good influence on him, Picasso hastened his melancholy friend to Malaga by way of Barcelona. The result was negative. Casagemas, absorbed by his unyielding misery, returned to Paris and shot himself in a café in 1901.[51] The subject matter of *Evocation* is therefore more than symbolic (Jung: "He [Picasso] dies, and his soul rides on horseback into the beyond"). The ideology of the picture recalls El Greco's famous *Burial of Count Orgaz* of 1586.

Interestingly enough, Jung brings the pictures *Evocation* and *La Vie* into close relationship with each other ("The daylight clings to him, and a woman with a child steps up to him warningly"). This connection is defined by Penrose in general terms only, as consisting in a "symbolism" which links the two pictures. Penrose also mentions that in a preliminary drawing the man's face is clearly a self-portrait. When I visited Picasso for a second time in December 1954 to question the artist about Jung's interpretations, I was told that the picture *La Vie* contained no symbolism, that it represented reality. The man was

definitely Casagemas. In Penrose the self-portrait drawing is said to have been changed by the artist into the likeness of "one of his friends" for the painting. But it represents Casagemas, and any interpretation which takes no account of this fact must be misleading.

Let us consider the description of the painting first:

> A naked woman leaning her body against a man is balanced by the draped figure of a woman carrying a child at whom the man points enigmatically. In the background between the figures two studies of nudes are propped up as though in a studio. The figures in both are huddled up and apparently in great distress . . .

And now the interpretation:

> The allegory which is intended is not easily understood and critics have sometimes been content to discuss it as a "problem picture." The rigid pose of the three figures suggests that they are intended to expound some principle such as the incompatability of sexual love and life.[52]

There is nothing more compatible than sexual love and life. But love may become a problem as it was in the case of Casagemas. There he stands with the girl who refused him, pointing to his own unattainable desire: unity with her and the sweet fruit of his love, a child. (Picasso had already painted the maternity theme in 1901. There the mother looks more peaceful and relaxed, although the theme of poverty comes into the picture too.) The face of the mother in *La Vie* is stern; it has also became the face of life which refused to Casagemas the fulfillment of his love. The figures in the background accentuate the tragic feeling.

The Dark One can be interpreted as a portrait, the macabre quality of which may be explained from the model itself, and the reason why Picasso was attracted to it is to be sought in his state of mind in those difficult early Paris years. *The Prostitutes* are simply prostitutes, and syphilis was simply syphilis. In those days prostitutes were considered a poetic, antibourgeois theme. They were accepted by artists as favored models and friends, like the circus people: Degas, Seurat, Bonnard, Chagall all painted them. The change of color which Jung considers the signal for the entry into the underworld is significant rather for the change of theme from the cafés, prostitutes, and poverty to the more subtle circus motifs.

Picasso's *Harlequin* may come directly from impressions of the circus or from Cézanne's picture *Mardi Gras*. Mardi Gras is the last day of the Carnival, the eve of Ash Wednesday. It is a day of pleasure and joyful celebrations. On Ash Wednesday, the first day of Lent, the priests place ashes on the foreheads of the faithful to remind them that they come from the earth and that they will return to it. The etymology of the term *harlequin* is most controversial. The German dictionary of the brothers Grimm quotes a mythological interpretation which tries to establish its connection with *Helle-Unterwelt* (hell-underworld).[53] The Italian Alichino seems to be a diabolic personage. Dante has in his Hell a devil called Alichino. Similarly Rühlman points to *Erlenkönig* (elf-king) and *Höllen-Kind* (child of hell).[54] Otto Driese quotes also some instances of mythological sources in ancient plays of Harlequin.[55] In old French works he is interpreted as a spirit of the air, deriving thence his invisibility and his characteristically light and airy whirlings. In French folk literature he appears as early as 1100; he had already become proverbial as a ragamuffin of demonic appearance and character; it was not till much later that the French Harlequin was transformed into the Italian Arlecchino.[56] Other interpretations trace the name back to a Greek clown with wand and mask representing the rustic Athenian. Very illuminating is the story of the particolored and spangled dress of the Harlequin of the Italian village of Bergamo, of which Arlecchino has become as typical as Pantaloon for Venice and Scapin for Naples. Harlequin was the principal character in countless comedies, pantomimes, and comic operas of the seventeenth and eighteenth centuries, based on the Commedia dell'Arte, as a person privileged to tell unpleasant truths in jest, and his costume has remained one of the most popular of the Carnival. Apart from the visual and symbolic attraction which it may have exercised on Cézanne, Derain, Picasso, Hofer (the artist in modern society feels like a Harlequin), the image of Harlequin is still part of our experience, although his origins are obscured by contradictory statements from story and tradition. (The most extensive collection of these is to be found in Larousse.)[57] Neither in the pictures of Cézanne nor in those of Derain, Picasso, or Hofer is Harlequin the gay figure or gourmand of some literary interpretations. On the border line between Carnival and Lent, he assumes on the canvases of these masters—and in the famous painting by Watteau—an ambiguous air; he is slender and agile, but charged with the guilt feelings, the melancholy, the repentance usual after a violent spell of freedom, the shadow of death in life, spiritual consciousness after uninhibited sensualism.

But besides the melancholy *Harlequin* Picasso has painted also a melancholy *Pierrot* and the tragic couple of *Saltimbanques* as variations on the Harlequin motif. Picasso has painted his little son Paul several times as Pierrot as well as Harlequin and as a torero, and although the number of Harlequin compositions may outnumber those of his other personages, we feel that Harlequin and Pierrot, bullfighters and circus people, all had the same fascination for Picasso and that Jung's exclusively mythological interpretation remains an unproved hypothesis.

The strong colors in Picasso's paintings around 1932 were developed from the Fauvism of Matisse but were not used by Picasso in his Cubist period, when he was occupied with structural problems. This may be due simply to the law of change—a natural law which Edvard Munch pointed out in a conversation with me when speaking about Picasso's *Guernica*.[58] *Girl Before a Mirror*, alluded to by Jung as the picture of the conjunction of light and the dark animal, "is one of the most elaborately designed and sumptuously painted of Picasso's pictures. Its magnificent colour, heavy dark lines, and diamond-patterned background call to mind Gothic stained glass."[59] It represents a girl and her image in the mirror; it is also a poetic rendering of a woman in which are used all the new means Picasso had developed in his art. There are the Fauvist pattern and line and color, the Cubist representation, surpassing the stereotyped perspectivist one-sidedness of the Renaissance tradition and thereby liberating modes of expression which were known to the art of the Primitives—superimposition, transparency, X-ray viewing: and these means are used to give a direct vision of the beauty and mystery of womanhood, a vision in which Picasso as a great artist and poet participated.

We cannot share Jung's view of Picasso as exemplifying the disrupted world view of modern European man. Not all of his work expresses this aspect of life. Nor is he the only representative of his time. There is Bonnard, there is Renoir, both very Greek and positive in their *joie de vivre*, who achieved harmony. But they may be placed as representatives more of the nineteenth than of the twentieth century. Klee, however, definitely belongs to the twentieth century. He was very positively searching for new means of artistic expression which would match the need of a new world view based on science and technology and humanism—and his search had its reward in works of a new beauty and harmony. If the inner climate attributed by Jung to Picasso as the representative of his time is supported by the outlook and problems of the Expressionist school of art, yet we must also note, to complete the picture, that Braque created his balanced and classic art in the same

period, and that this art is as representative of our time as Picasso's. Picasso's art, more dramatic, has its roots deep in the soil of Spanish mentality: the mentality of the Inquisition, of El Greco, Ribera, and Goya, not of the modern age in themselves, but entering into a strange affinity with it in the work of Picasso.

We feel also that the hell of initiation of which Jung speaks in connection with Picasso is much more strongly expressed in such works as *Woman in an Armchair* or *Acrobat* (very close to some apocalyptic visions of the eleventh century), or even in *Crucifixion*. There are pictures of the so-called Surrealist period, painted between 1925 and 1930, which also admit of such an interpretation. There is no need to read an unconscious "content" into these works, which have been condemned by Jung as symptoms of the horrible, the sick, the grotesque, the incomprehensible, and the destructive. Picasso himself does not believe in Hell, except in the hell of life. When during my visit in May 1952 I wished to detect a religious symbolic meaning or image in his *L'Homme au mouton*, he brushed it aside. "It is not religious," he said, "it is human." *L'Homme au mouton* was sculpted at about the same time as the death's head: life-death. It is a direct experience: the man carrying the sheep, caressing it, protecting it. Man and animal: man and death. This happens everywhere. It is a primary image. I then saw the statue in the marketplace in Valouris. It seemed to have stood there for a thousand years, much longer than the church nearby. I understood it for what it was, no more and no less. If the primitive, the direct, the going to the source, the beginning anew of the modern artist means anything at all, it means that he does not want to be interpreted by analogy or in a traditional way, from the point of view of either religion or mythology. The historical and erudite outlook are not creative. They can become a curse. They kill the spark of life. They change everything into reflection. The man carrying the sheep is not the symbol of the Savior, nor is it an image from the old Greek tradition: it is an experience lying beyond them.

The artist creates his images directly from his experience of life without knowledge of history or anthropology, and he does it here and now. This is his eternity, his presence, and reality. The rest is education. We not only forget old imagery and its meaning; we also outgrow the states of mind from which such old imagery sprang. Anybody who reads *The Golden Bough* must experience it. Phylogeny in biology does not mean that we still are or wish to return to the stage of amoebas or reptiles; and phylogeny in the life of the mind (the mind reflects life, they are one: "What is without is within," said Goethe) cannot

mean such an absurd thing either. It may be so in an abnormal mind, but not in a normal one. The light and the dark anima are only images of a content which has to be consistently reformulated. The different images of that content in different times can be compared with each other, but they cannot be made dependent on each other. There is a common process of experiencing throughout the ages, but not more— perhaps a changing process even. Picasso is not Harlequin the chthonic god. If an artist wishes to express such things he does it directly, as Blake did. The thought and the effective means come to him spontaneously. But Picasso does not want to express any such thing. As any world view or view of life is dependent on actual knowledge of the world, religious and scientific knowledge, so the imagery is dependent on it too. The old images such as the Nekya were, after all, formulated directly as what they are. They were not veiled in symbols of the unconscious—they were believed in as existing realities. I wonder why these old images should be of such great importance for us. We ought not to underestimate the power of the psyche to create new images.

THE MEETING WITH JUNG

My doubts made me approach Professor Jung personally. I hope he forgave my disagreement with him, for he was a great man. I knew well his antipathy to antiquated conceptions of science. I remembered it was he who said:

> Under the influence of scientific materialism everything the eye could not see or the hand touch was doubtful or, worse still, disreputable, for metaphysics was under suspicion. Today the voice of him who cries in the wilderness must take on a scientific ring if it is to catch the contemporary ear. One has to convince one's time that it is science alone which renders any results possible, for science alone brings a measure of conviction with it.[60]

I was also aware of the note with which Jung prefaced the studies which we have analyzed here when reprinting them in *Wirklichkeit der Seele*:

> This literary essay ["*Ulysses*"] does not pretend to be a scientific treatise any more than does the *aperçu* about Picasso which follows it. If in spite of that I include it in the *Psychologische Abhandlungen*, it is because *Ulysses* is an important "human document" characteristic of our times, and therefore my expression

of opinion on it is a psychological document demonstrating the practical application to a concrete subject of ideas which have played a not inconsiderable part in my work. My essay is completely innocent of any scientific pretensions or didactic intentions. That is why the reader should approach it merely with the interest which is due to a subjective and in no way binding expression of opinion.

I visited Jung on June 17, 1952, at his home in Küsnacht on the Zurich Lake. The jasmine was in flower, and I picked a few blossoms as a souvenir. In a small study, its windows opening on the garden and the lake beyond it, Jung awaited me: a writing-desk in one corner, bookcases, a few insignificant pictures of small size in dark frames on the wall—landscapes, figures. Jung bade me welcome and asked me to be seated in a chair near the window. He was over medium height, had a strong frame which suggested peasant stock, and walked with a rather heavy gait. The soundness of his shape was matched by his strong gaze. His hair and moustache were white, but he seemed younger than his years although he was, he told me, just recovering from one of the illnesses which assail old age. That is why, when I mentioned in passing an incident from the life of the aged Swiss poet Hermann Hesse, Jung spoke of having many times lately thought of *Freund Hein,* which is a German expression for death. But he must have embarked on one of his most ambitious works, the *Mysterium Conniunctionis* (published 1955–57), at about this same time.

He listened attentively to my objections. When I mentioned that in England his psychology had again and again been attacked as unscientific, he was at first indignant. Only later followed an even stream of evidence. "In comparative anatomy," he said,

> we speak of morphological phenomena in man, of organs which resemble the organs of animals. We know, for instance, that man has lived through early stages of development in the course of his evolution. We know the complete genealogy of the horse dating back millions of years, and on these facts the science of anatomy is founded. There is also a comparative morphology of psychic images. Folklore is another field of research into motivation. What I have practiced is simply a comparative phenomenology of the mind, nothing else. If someone has a dream and we find that dream in identical form in mythology, and if this constantly repeats itself, are we not justified in saying with certainty: We are still functioning in the same way as those who created that mythological image?

Take the Eucharist. A god is slain, pierced with a spear, is dismembered, eaten. To this day, the piercing of a loaf of bread with a silver spear is a ritual of the Greek Church. In the Aztec rites, Kuiziopulti is slain, pierced with a lance. His body consists of a dough made from the seeds of plants just as the Host is made of white flour, and the pieces are distributed and eaten. The undivided and the divided God. Think of the use made of the cross in Yucatan. It is the same as our adoration of the Cross. Or the myth of Dionysos.

And Jung gave several other examples which are dealt with at length in his works.

The psychiatrists, in treating their cases, know that these things happen in the soul of the patients. There are countless ideas, images of the unconscious, which have been compared to mythological concepts, because they proved to be identical. There is only one method: the comparative method. Comparative anatomy, the science of comparative religion. Why not then comparative psychology? If we draw a circle and divide that circle into four equal parts and think of it as a philosophical idea, and the Chinese does the same thing, and the Indian too—do you think that it is something different when I do it? Unscientific! There are only a few heaven-inspired minds who understand me. In America it was William James. But most people are ignoramuses. They take no pains to find out the essential things about themselves. It requires too much Latin and Greek!

I asked him if he had any inclination to interpret works of other modern artists—Paul Klee, for example. I had just come from Berne, where I had visited Klee's aged sister and his son Felix and had seen very early works of this artist. "No," he said,

I cannot occupy myself with modern art any more. It is too awful. That is why I do not want to know more about it.[61] At one time I took a great interest in art. I painted myself, sculpted and did wood carving. I have a certain sense of color. When modern art came on the scene, it presented a great psychological problem for me. Then I wrote about Picasso and Joyce. I recognized there something which is very unpopular, namely the very thing which confronts me in my patients. These people are either schizophrenics or neurotics. Neurotics smart under the problems of our age. They smart under the conditions of its time. Art derives its life from and expresses the conditions of our time. In that sense art

is prophetic. It speaks as the plant speaks of nature and of the earth, of ground and background. My patients make similar pictures. When they are in a chaotic state, all forms dissolve. Then panic grips them. Everything threatens to fall to pieces and we are in a state of panic—though it is an unadmitted panic. What does this art say? This art is a flight from the perceptible world, from the visible reality. What does it mean, to turn one's eye inward? The first thing people see there is the debris of destruction, and the infantilism of their own souls. That is why they imitate the tyro. People admire the art of the primitives. True, it is art, but it is primitive. Or one imitates the drawings of children. The schizophrenics do that too. To the extent that it is a manifestation of a yearning for the primary it may have a positive value. But dissolution demands synthesis. And I am always concerned with the pile of wreckage, with the ruins of that which has been, with infantile attempts at something new. The fact is we have not yet reached the point when things can be put together. And we cannot reach it yet, because the world is cut in two. The iron curtain . . .

I interpolated: "A political factor. Has it anything to do with it?"

I should think it has! It hangs over our lives like the sword of Damocles. Since 1933 we have witnessed uttermost destruction. First it was the Nazis. On two occasions they almost got here. If they had, I should have been put against the wall. Well, I had settled my accounts with the next world. If the Russians come we shall have the "pile of wreckage," for even if we are the victors, we know very well that we shall do the same thing as they do and with the same methods. In America, when they want to cope with the gangsters, they do it with the help of G-men. That means we become like them. I am pessimistic about the pile of wreckage. A new revelation from within, one that will enable us to see behind the shattered fragments of infantilism, one in which the true image appears, one that is constructive—that is what I am waiting for. We have to visualize this image empirically, as at once an idea and a living form, the ground for which has long been prepared historically. I have always pointed it out. The alchemist called it the Round. It is the idea of completeness. The Chinese call it Tao—the unity of opposites in the whole. Psychologically seen, the process takes place in the center of the personality which is not the "I," but another center, the greater man in us. For this too the ground has been prepared psychologically. I see it as form, or, if you like, as an idea. Except that an idea without living form is merely intellectual. My idea which

is also form is like a man who has a body. If he has no body, we should not see him. It must be visible form and idea at the same time.

To the question whether he considered science to have had a negative influence on modern man, Jung replied:

Science is only one source of the evil. Besides science there are technology, religion, philosophy, art. Modern art preaches the same fatality. The destructive role of the intellect, of rationalism, not only of science, must share the guilt. Everything that should represent the irrational and fails to do so is responsible. *"La Déesse raison a ses raisons"* [the goddess of Reason has her own reasons]. This doctrine took the stage as a mass movement in the French Revolution, and it is the same revolution which we are still experiencing, because we have raised Reason to a seat above the gods.

What Jung meant by this, I felt, was not God or gods as objective realities. As a psychologist all he says is that God is an archetype of what is to be found in the soul of man and which may be called the image of God.

I misunderstood him intentionally in order to make him express himself more specifically, and suggested that modern man could not reconcile himself to dogmas, and that this was understandable if viewed historically.

"Dogmas," he muttered,

dogmas would be all right. They are symbols. One could not do it better. But they [that is, theologians] rationalize them. We only interpret it psychologically, this drama of the Heavens. Theology is one of the causes of soullessness. Science, because it claims exclusiveness; the priest, when he subordinated himself to the intellect; art, which has all of a sudden lost its belief in beauty and looks only inwardly where there is nothing to be found but ruins, the mirror of our world: they all want to descend into the realm of the mothers without possessing Faust's key. In my own way I try to get hold of a key and to open closed doors with it.

There is an inscription over the gate to Jung's house which reads: *Vocatus atque non vocatus Deus aderit.* It is the Latin version of a Delphic oracle which the Lacedemonians received when they were

about to go to war with Athens. Freely translated it means: "One way or another, it is extremely risky." We wish to apply this inscription to our own purpose. The conclusions to be drawn from my conversation with Jung, conclusions which are significant for the inquiry into whether a work of art can be validly interpreted in terms of the Collective Unconscious, are indicated in this oracular inscription. Equally, in the words of Jung about the problem of creativeness in general: "The secret of creativeness, like that of free will, is a transcendent problem which psychology cannot answer but only describe."[62]

My position regarding Jung's statement on modern art is that it must not be considered an absolute rejection. Today, thirty-five years after his essay on Picasso—thirty-five years of strange and extraordinary artistic activity, of syntheses and climaxes in the art of Picasso—we need not worry about this aspect of the matter. Picasso, and with him modern art in general, has passed through many metamorphoses since 1932. And the ideas working in some artists have undergone changes—changes which have been in the direction of Jung's and other thinkers' general concepts of the need for a reintegration of personality and culture. I also understood Jung's attitude in the light of the fact that, at the age of seventy-five, he had the wish and the well-earned right to put the finishing touches to his work and did not want, therefore, to enlarge upon modern art any more. He had seen and pointed out its significance as a symptom of a disturbed state of mind, and he left it to us to recognize in it the promise of a new integration. He himself was then mainly concerned with the positive aspect of the recovery. He was tired of the negative aspect, the "pile of wreckage." Everything in him now strove toward rounding off his work into a whole. Besides being a psychologist, Jung was a poetical mystic whose ambition it was to become a teacher of modern man in search of his soul, not only the doctor for his neurotic patients that he had so successfully been up to about 1944. And surely, notwithstanding its abundance of erudite, versatile intellectuals and meticulous specialists, what our age needs most is the wisdom of men who know that only in the dynamic union of opposite life forces and the reconciliation of reason and soul lies the future of man. But in saying that "we moderns have no alternative but to reexperience the spiritual impulse, and that means going back to primary experience; this is the only way to break through the magic circle of the biological process,"[63] did not Jung in fact express the very thing for which he castigated the modern artist? And is not the modern psychologist also "introverted," like the modern artist, in that he seems to replace philosophical and religious thinking and feel-

ing and artistic experiencing by a far too specialized "psychological" approach? As though man were the be-all and end-all of things, and the universe not a reality but only a reflection of a reality? Strangely enough, the system which Jung has evolved, with its mixture of psychiatry, psychology, mythology, anthropology, education and the interrelation of works of mysticism, alchemy, and poetry, brings to mind the utopian dream of Jan Amos Comenius, the universal knowledge called Pansophia, conceived during the time of the Thirty Years' War—a time of great physical, moral, and spiritual distress.

NOTES

1. Reprinted in his book *Wirklichkeit der Seele* (Zurich, 1934). An English translation was published in the review *Nimbus* (London), No. 2 (1953).
2. Otto Fenichel, *The Psychoanalytic Theory of Neuroses* (New York, 1945).
3. Examples of this rigidity may be found in Eckart von Sydow's *Primitive Kunst und Psychoanalyse* (Berlin, 1927) or in Ernest Jones' study *Hamlet and Oedipus: A Classic Study in the Psychoanalysis of Literature* (New York, 1955). In recent years fruitful attempts have been made to break through this fixed and seemingly unchangeable position. In this respect the studies of Adrian Stokes are remarkable ("Form in Art," in *New Directions in Psycho-Analysis* (London, 1955); *Michelangelo: A Study in the Nature of Art* (London, 1955); *Greek Culture and the Ego: A Psycho-Analytical Survey of an Aspect of Greek Culture and of Art* (London, 1958); *Reflections on the Nude* (London, 1967); *The Invitation in Art* (London, 1965). Also Anton Ehrenzweig's *The Psycho-Analysis of Artistic Vision and Hearing* (London, 1953); and *The Hidden Order of Art: A Study in the Psychology of Artistic Imagination* (London, 1967); Hanna Segal, "A Psycho-Analytical Approach to Aesthetics," in *New Directions in Psycho-Analysis* (London, 1955); Marion Milner, "Psycho-Analysis and Art," in *Psycho-Analysis and Contemporary Thought* (London, 1958). Even Gestalt psychology has tried its hand at the problems of art (Rudolf Arnheim, *Art and Visual Perception: A Psychology of the Creative Eye* [London, 1956], and *Towards a Psychology of Art* [London, 1967]). The Gestalt psychologists come nearest to the concept of form, but they are more concerned with perception than with creation. That Jungian psychologists would attempt to enlarge upon the narrow ground secured for the subject of art by Professor Jung himself is

only too understandable. It led either to superimpositions of archetypal terms upon thematic and sometimes even formal facts (G. W. Digby, *Meaning and Symbol in Three Modern Artists—Edvard Munch, Henry Moore, Paul Nash* [London, 1955]; *Symbol and Image in William Blake* (London, 1957]), or to generalizations of a philosophical, mythological, and psychological character combined (E. Neumann, *Art and the Creative Unconscious: Four Essays* [London, 1959]).

4. *Science and the Modern World* (Cambridge, 1926).
5. (London, 1929).
6. "Der Gegensatz Freud und Jung," in *Seelenprobleme der Gegenwart* (Zurich, 1931).
7. *Psychologie und Erziehung* (Zurich, 1946).
8. "Psychologie und Dichtung," in *Gestaltungen des Unbewussten* (Zurich, 1950).
9. C. F. Weizsäcker and J. Juilfs, *Physik der Gegenwart* (Göttingen, 1958).
10. *Philosophic Problems of Nuclear Science* (London, 1952).
11. "Physics and Metaphysics," in *Science News*, No. 17 (Harmondsworth, 1950).
12. *The Journal of Aesthetics and Art Criticism* (Cleveland), June 1951.
13. *Science and Humanism: Physics in Our Time* (Cambridge, 1951).
14. (London, 1945).
15. *Addled Art* (London, 1946).
16. *Seeing and Knowing* (London, 1953).
17. Giorgio de Chirico, *The Italian Renaissance and the Present-day Painter* (London, 1949); Wyndham Lewis, *The Dawn of Progress in the Arts* (London, 1954).
18. *Wingless Pegasus: A Handbook for Critics* (Baltimore, 1950). See also E. H. Gombrich, *The Story of Art* (London, 1950); Lionello Venturi, *Lezioni di Storia dell'Arte Moderna* (Rome, 1955).
19. (New York, 1953).
20. *Der Untergang des Abendlandes*, Vol. 1 (Munich, 1917).
21. *A Study of History*, Vol. 13 (Oxford, 1954). The defenders of the idea of the decline of the West cannot acknowledge the fact that the foundations are being laid for a new worldwide civilization. They still work with the notions of local, national, and continental culture units. The revolutionary facts of science and technology are breaking through the conception of the cyclic theory. Professor Toynbee applies the evolutionary theory to the realm of art. We cannot maintain it in the sphere of sensitiveness or expressiveness. We have only to compare the paintings in Paleolithic caves with the representations of animals in the art of any high civilization to realize this.

22. *The Crisis of Our Age: The Social and Cultural Outlook* (Sydney and London, 1942).

23. *Bildnerei der Geisteskranken* (Berlin, 1923).

24. *"Ulysses,"* in *Wirklichkeit der Seele* (Zurich, 1934). English translation in *Nimbus* (London), No. 1 (1953).

25. Bernard Champigneulle, *L'Inquiétude dans l'art d'aujourd'hui* (Paris, 1939); Wladimir Weidlé, *The Dilemma of the Arts* (London, 1948); Nicholas Berdyaev, *The Meaning of the Creative Act* (London, 1955); Hans Sedlmayr, *Verlust der Mitte: Die bildende Kunst des 19. und 20. Jahrhunderts als Symptom und Symbol der Zeit* (Salzburg, 1948); Hans Sedlmayr, *Die Revolution der Modernen Kunst* (Hamburg, 1955); Wilhelm Hausenstein, *Was bedeutet die moderne Kunst* (Munich, 1949); Otto H. Förster, *Grundformen der deutschen Kunst* (Cologne, 1952).

26. "Philosophy and Science," in *World Review* (London), March 1952.

27. From a lecture delivered on November 26, 1941, at the University of Leipzig on "The Unity of the Scientific Outlook on Nature," published in *Philosophic Problems of Nuclear Science* (London, 1952).

28. "Physics and Metaphysics." See also Max Born, *Physik im Wandel meiner Zeit* (Braunschweig, 1958).

29. *Comment je vois le monde* (Paris, 1934).

30. "Der Gegensatz Freud und Jung."

31. (Frankfurt am Main, 1949).

32. (London, 1947).

33. Robert Graves, *The White Goddess: A Historical Grammar of Poetic Myth* (London, 1948); Hermann Hesse, *Aus Indien* (Berlin, 1913), and *Weg nach Innen* (Berlin, 1931); Thomas Mann, *Joseph und seine Brüder* (Stockholm, 1956).

34. *The Waste Land and Other Poems* (London, 1945).

35. "Some Notes on My Own Poetry," in *Collected Poems* (London, 1957).

36. *The Golden Bough: A Study in Magic and Religion*, 3d ed. (London, 1911–1918).

37. Alexander Macbeath, "The Author of *The Golden Bough*," *The Listener*, February 4, 1954. A new stage has been reached lately in anthropology by the method of structuralism (*anthropologie structurale*) by Professor Claude Lévi-Strauss (*Tristes Tropiques* [Paris, 1955]; *La Pensée Sauvage* [Paris, 1962], and *Mythologiques* [2 vols., 1964 and 1966]).

38. (London, 1950).

39. "Über die Beziehungen der analytischen Psychologie zum Dichterischen Kunstwerk," in *Seelenprobleme der Gegenwart* (Zurich, 1931).

40. On human science, see Alexis Carrel, *L'Homme, cet inconnu* (Paris 1945):

> The Sacrifice which modern civilization has made to the materialistic spirit was a mistake. . . . The stupidity and dreariness of the present civilization are due, at least in part, to the suppression of the elementary forms of aesthetic pleasure in everyday life. . . . The spirit of mystery has gone out of most religions. Its very meaning has been forgotten.

And he demanded: "We must evolve a truly human science. There is a greater need for it than for the mechanical, physical, and chemical sciences."

41. Henri Bergson, *L'Évolution créatrice* (Paris, 1908).
42. "*Ulysses.*"
43. *Die Lebenswunder: Gemeinverständliche Studien über Biologische Philosophie* (Stuttgart, 1905).
44. Picasso's own comment on the Jung study was not very complimentary (letter from Dr. C. Giedion-Welcker to the author).
45. Jung's Picasso study does not give any titles of pictures.
46. "The Physical Aspect of the Living Cell," in *What Is Life?* (Cambridge, 1944).
47. Alfred H. Barr, Jr., *Picasso: Fifty Years of His Art* (New York, 1946).
48. Ibid.
49. (Paris, 1951). English translation, *The Voices of Silence* (London, 1954).
50. Remark of Jaime Sabartès to the author.
51. Roland Penrose, *Picasso: His Life and Work* (London, 1958).
52. Ibid.
53. *Deutsches Wörterbuch von Jacob und Wilhelm Grimm* (Leipzig, 1877).
54. *Etymologie des Wortes Harlequin: Dissertation* (Halle, 1912).
55. *Der Ursprung des Harlekin: Ein kulturhistorisches Problem* (Berlin, 1904).
56. *Encyclopedia Britannica.*
57. *Dictionnaire du XIXe siècle* (Paris, 1866).
58. J. P. Hodin, *Edvard Munch: Der Genius des Nordens* (Stockholm, 1948).
59. Barr, *Picasso.*
60. *Wirklichkeit der Seele.*
61. I did not give up the idea that he might one day change his mind, and perhaps produce a piece of writing of a more positive character on modern art. But a letter which he wrote me on September 3, 1955, convinced me of the contrary:

. . . and I regret to tell you that I cannot fulfill your wish to write something on Kokoschka. I would first have to familiarize myself with the *oeuvre* of this artist and this would be too troublesome a task for me. My capacity, unfortunately, is very limited. Nor do I pretend to have very much to say about modern art. Most of it is alien to me from the human point of view and too disagreeably reminiscent of what I have seen in my medical practice. If I were to write something in the nature of what you have in mind, I would want to come to grips with the subject by way of a critical inquiry. Art is, after all, intimately connected with the spirit of the times, and there is a great deal in just this spirit of the times to which one could take exception. I cannot say that such a task would not attract me, but I am afraid it would go beyond my strength.

62. *Gestaltungen des Unbewussten* (Zurich, 1950).

63. "Der Gegensatz Freud und Jung."

2 • THE FUTURE OF SURREALISM

THE BIENNALE EXHIBITIONS IN VENICE HAVE A DEFINITE TENDENCY TO GIVE a retrospective view of the historic "isms," those pillars of the modern movement in art, in such a way as to enable us to arrive at an estimate of their significance. In 1952, for instance, Expressionism had its turn, while in 1954 Surrealism was the star of the Mostra Biennale Internazionale d'Arte. In the end, it is the great artist, the one who cannot easily be made to fit into a theory or an ism, who is decisive, and it is also he who gives birth to every new aspect of art in the modern movement. His work, apart from the talent it displays, will throw light upon the initial impulse that led to an ism. It is through our interpretation of isms that we are able to analyze the ideas they contain, and even the fundamental needs to which they are a response: such needs as lie, for example, in the spiritual and material situation of our time; in the human condition; in the crisis of the old religious, ethical, and philosophic values; in the formation of new values; and in the search for a soul at a time when science dominates the world of thought and technique—in short, in the world of modern man.

Art historians who try to define modern art are conscious of the fact that none of the modern movements can satisfactorily be classed as a style, in the sense in which that term has been used hitherto. A style does not come into being with the speed of an ism, nor does it proceed solely from the specialized field of technical research or from the selection of a certain subject matter. It is always the expression of the formative will of an entire epoch, and gives in visible images the essence of the whole—the unity of a world. This cannot be said of the modern isms. Nevertheless, it would be an error to limit their existence to that extent of time lying between their appearance and

their end as a particular school. The great Surrealist exhibition in Paris in 1947 left on the visitor the impression that he had before him only the decline of a remarkable movement which had given a sensational shock to its time; but as a matter of fact the ideas of which Surrealism was the issue, those subterranean currents of conscience which gave it birth, are by no means inoperative today. As long as the spiritual crisis of Europe endures, the thesis, as the term was used by Hegel (so much admired by André Breton), will be the Antique-Christian (Mediterranean) culture, its antithesis is the destructive impact of the exact sciences upon it, and the synthesis is as yet uncertain. We are in the midst of a process of reassessment and reinterpretation of hitherto accepted values, in the course of which we are led back to our human beginnings, but this process will bring to the man of the future a knowledge, solidly based, of science and its limitations, and with it a new myth, a new poetry, and a new art—in all probability classic in character. As long as this crisis endures (or rather, metamorphosis, for its origins lie as far back as in the Renaissance, and even farther, with the philosopher-scientists of classical Greece),[1] there will always be a reason for works of art born of the same spirit as and fundamentally identical with those of Surrealism. Whether Surrealism will continue to exist is a question which was asked at Venice in 1954. Those who know how to read the signs will receive a clear answer from them.[2]

2. A decade after this essay was written a new wave of Dadaist, Surrealist, uninhibited imagery swept through the art world and found an outlet in Pop art.

The question whether Surrealism will or will not continue to exist arises from the erroneous idea that an ism is dead and done with when it is eclipsed in the eyes of the public by another ism; in our case, no doubt, the new ism would be abstract art, or rather kinetic and optical art. But the inquiry into the inner being of man which characterizes Surrealism is still a principal preoccupation of our time, which seems to have abandoned myth, religion, and metaphysics in favor of depth psychology, sociology, and anthropology.[3] In doing this modern man has certainly turned his attention to a matter of fundamental importance, namely, to mind as perception, but he has done so to the neglect of the other side—the reality of the world and the substance of Being (as distinct from Existence), both of which are nevertheless needed to form the Image, the Myth, the Truth—in a word, the Whole. We should be grateful to philosophers like Husserl, Kierkegaard, Heidegger, Jaspers, and Sartre, as well as to writers

like Malraux and Camus, who understood this problem and saw it as the existential problem of our time, ignoring Substance, that notion which so haunted the imagination of the past. But the eclipse of Substance is only temporary, for man is a many-faceted being forever working toward a knowledge of "Man, the Unknown" (Alexis Carrel), and he will fashion anew the image of Substance. This effort will lead not only to a new humanism, to a new conception of man, but also to a new conception of religion and a new aesthetic imagery. We owe much to psychoanalysis, to depth psychology, to the experimental psychology of perception, the Gestalt psychology, as we do also to modern psychiatry, through which a scientific exploration of the human psyche and the intricate machinery of the brain—the organ, maybe, of the imaginative processes—has been attempted. It is a fact that Surrealism has its origin in Freud, and it is also a fact that Existentialism has its roots in the same soil: mistrust of a reality seen as objective fact, refusal to accept present conditions as permanent, striving toward a complete knowledge of the human psyche. We can thus claim with certainty that a movement that has a past must also have a future.[4] It remains to be seen, however, whether that future is to be a petrified repetition of one of the stylistic stages of Surrealism or whether it is to be a renaissance corresponding to the interior needs of man, needs which will create ever new modes of questioning the supernatural, new regions for the imagination and the dream, new knowledge of the subconscious, new freedom for the irrational and the instinctive. In the first case one may safely predict that the old phase of Surrealism has no future at all, although some of its masters are still active and although it still has a second and third generation of followers in many countries. That phase was a historical event, and for that reason it has its importance. Apart from that, it is of academic interest only. On the other hand, there is not the slightest doubt that a new phase of Surrealism would amply justify its existence.

In awarding the principal international prizes to the initiators of the Surrealist movement, or to those who had deep roots in it—Max Ernst, Miró, Arp; by inviting these artists to exhibit in rooms specially reserved for them in the central Italian pavilion, the organizers of the Biennale of 1954 wished it to be understood from the beginning that these prizes should be considered as historical awards, as prizes awarded for a historically established fact in the modern movement. This historical manifestation of Surrealism has set criticism the task of determining whether there is still something vital in that movement. Professor Rodolfo Pallucchini's introduction to the catalogue

suggests that the opinion of the organizers of the Biennale was posi-
tive on this point, and the exhibition itself revealed the justification
of that opinion. The art that explores the surreal, finding therein its
main subject matter, and the psychology that is inseparable from that
art have both developed since the beginnings of Surrealism. We re-
member the twenty years of antagonism between the theories of Freud
and those of Jung, between pansexualism in psychology and the con-
ception of archetypal ideas. But we remember also a stage in the
progress of scientific knowledge in which the rationalist, materialist,
and mechanistic attitude (Freud was basically a representative of
that phase of science) had to surrender its privileged position to a
newcomer. It was shaken in its beliefs by the discovery of the un-
certainty principle in modern physics, a principle that has opened
wide metaphysical perspectives in science, and one that the modern
physicist cannot afford to ignore.[5]

A RETROSPECTIVE GLANCE AT SURREALISM

It is only after Ernst that we can speak of a Surrealist painting that
has developed its own particular means and its own methods of ex-
pression.[6] There are two facts that strike the student of Max Ernst's
work: the first (and the most important for the appreciation of the
artist himself) is that no Surrealist theory can do justice to the artis-
tic value of the painter; for it is above all his aesthetic qualities, his
invention of new imaginary forms and techniques, his feeling for color
that strike the beholder and convince him that Max Ernst is in the
first place a painter, and only to a secondary degree a Surrealist. This
is in fact the most positive judgment that can be pronounced on him.
The period in which the Freudian subconscious and the practice of
automatism for the purpose of materializing the subconscious domi-
nated this artist's intentions is exemplified by works like *The Elephant
of Celebes*, while in those pictures where the technique of frottage is
imitated in paint and combined with his typical visions of birds, the
purely pictorial means and the psychoanalytical attitude are well
balanced. But the climax of his achievement seems to lie in the paint-
ings in which he attains an authentic poetry of expression. They repre-
sent dream seas or dark forests towering aloft like mountainous
islands and standing out against an unfathomable depth, under a sun
or a full moon varying in form from a circle or a circular plane to a
ring. These are descendants of the lyrical spirit that inspired the

moonlight pictures of Edvard Munch or the *Isle of the Dead* of Arnold Böcklin.

The early works of Max Ernst bear witness to influences from different sources: Cubism, de Chirico, Constructivism, Klee (particularly in designs with long poetic titles), the *papiers collés* of Braque and Picasso, to mention only a few contemporary influences. However, once this is said, let us not forget the great impulse that the creative and revolutionary talent and intelligence of Max Ernst gave to contemporary art. In his later works color plays a dominant part. It was after 1934 that his palette lightened and brightened, becoming often fluorescent but above all richer, as well as calm and confident. The idea of the interpenetration of colored planes, a device handled with so much mastery by Picabia and Masson, seems to have been a major preoccupation with Max Ernst for some time. Some pictures manifest an obsession with sculpturesque, monumental forms presented in strong earthy colors. A tendency toward geometrical abstraction of a celestial order, combined with Surrealist elements, is strongly marked in certain of his later works, whereas a photographic realism, an indispensable element for the Surrealist in expressing his world of dreams and his biological thought, dominated his earlier pictures.

The second fact that strikes the student contemplating the work of Max Ernst is that the modern artist is an uprooted and solitary individual. He is deprived of his place in well-organized society, and also of that humanistic and religious universe which so effectively sustained the art and the artist of other days and which has suffered so severely from the progress of technology. Indeed, Max Ernst, shaken in his idealism by the events of the First World War, fell a victim to the nihilism of the Dadaist movement. As a supporter of Dada, he was obliged to look upon humanist and religious conceptions as vicious inventions of the bourgeois spirit of his time. He rid himself of those conceptions as of a burden; and the Surrealist Max Ernst was left with an inner world emptied of the ethical, aesthetic, and universal ideas with which men have always striven to comprehend life and to interpret it by means of symbolic images, and bereft of that human order which is analogous to the order of creation. Naturally, the result was that he was thrown back upon the representation of purely biological reactions, upon the recording of primordial instincts: thus, on the psychological plane, presenting not the whole image but only its shattered fragments, with all their inevitable horror and confusion. Without the complications resulting from the war and the revolution, Max Ernst would have been in fact what he fundamentally is—a

romantic painter of the type of Casper David Friedrich, the greatest
of all landscape painters of German Romanticism.

All the new methods invented by Ernst (collage, frottage, etc.) are
methods of psychic automatism. As defined by Breton they are meth-
ods through which the real functioning of thought can be expressed.
In their totality they are a way of thinking freed from all control by
the reason and from all moral or aesthetic preoccupations. Surrealism
is founded upon the belief in the superior reality of associations,
neglected hitherto; upon the omnipotence of dreams; upon the un-
inhibited play of thought itself.[7] Other methods of automatism were
developed later.[8] What we should like to stress here is that automatism
is no new thing, and that Max Ernst was well aware of the researches
of Leonardo da Vinci in this field.[9] The only difference is that in his
case nothing remains of the aesthetic and scientific mysticism which
inspired and guided the researches of Leonardo. For trains of asso-
ciation (which are not necessarily subconscious) are not the sole
product of automatism. Automatism serves also a philosophy of the
cosmos and of harmony in which chance plays a leading part. And
the philosophy of chance is fundamentally skeptical, even nihilistic.

From Ernst to Dali we pass from psychology to psychiatry. Dali's
practice of paranoiac criticism was defined by him as a systematic
and violent outbreak of human desire in the world, as a spontaneous
method of producing the irrational associations of delirium.[10] They
reveal also his greatest ambition: that is, to reconquer the technique
of the old masters to express his conception of the nuclear age. A
large exhibition of Dali's work was held in Rome, in May 1954, in the
Casino del'Aurora (Rospigliosi-Pallavicini palace). The exhibition in-
cluded oil paintings, watercolors (of which 102 were illustrations to
the *Divina Commedia),* drawings, and jewelry, and attracted the
attention of the public both to the work and to the theatrical attitu-
dinizing of the artist himself. This representative collection showed
clearly that to *épater le bourgeois* is no longer a sufficient program,
although it was in large measure that of Dadaism, of the early Sur-
realism, and of Futurism. In these movements a clearly revolutionary
and political *parti pris* took the place of the purely artistic applica-
tion of the old slogan as it was used at the end of the last century.
Without Dada the art of Ernst, of Dali, of Arp, of Klee, and of Miró
is historically unthinkable. Dada, born of the crisis of the First World
War, was hailed in Paris as a "means of salvation." It was a monster
that could create the necessary void; it was an offensive arm of ad-
mirable potency.[11] Out of Arp's Dadaism, his automatic drawings,

his collages, and his reliefs in cardboard and wood, his art of pure organic form was born. There is a direct connection between his inventions and Henry Moore's work, which also has its roots deep in the soil of Surrealism. Miró, who felt for a long time the attraction of Surrealism, was fascinated also by popular art and was influenced by Klee. Above all, however, he was influenced by the signs and symbols of the pictographic and ideographic stage of the art of writing, and it is these elements that constitute Miró's contribution to modern art.

Masson is just as astonishing an individualistic artist as Miró; he is inventive, personal, penetrating. He makes his strongest impact as illustrator of his own philosophic texts, while Miró is a completely unliterary painter. Masson is more the metaphysician; Miró is the more simply human artist and is full of humor. Masson is heavy with the weight of tradition; Miró is lighthearted, as at a carnival. Masson is esoteric. Miró is popular in content, though in manner extremely subtle; he speaks of his art as the art of the future.[12]

There is a fantastic, a mystical, element at the back of Klee's supernatural, superreal revelations. He makes use of a number of modern technical devices, or adapts these procedures to his purposes. "Sometimes," wrote Klee,

> I dream of a work of vast scope covering the whole range of pictorial elements—subject, content, style. That will certainly remain a dream, but it is good at times to imagine the possibility, unsubstantial as it is in our day. Nothing can be hurried. The work has to grow, always gaining in stature, and when its time comes, well, we shall be glad to see it. We must try for it and work for it. In part it is already here, but not yet the whole.[13]

In opposition to the pure doctrine of Surrealism Klee's aim was always art, whereas Breton proudly proclaimed that the Surrealists are simple recording machines, in no way participating in the motives they depict, and that as machines they serve perhaps a nobler cause, thus making an honest use of the talent lent to them.[14]

THE FREUDIAN AND JUNGIAN PHASES OF SURREALISM

Here we must pause for a moment; for we are about to state two arguments which should aid us in establishing our own personal point of view. The first is that Surrealism is like a tree that has struck deep roots in the soil of psychoanalysis, and whose powerful trunk and

strong branches have borne fruit in the shape of works of art such as those of Ernst, Dali, Tanguy, and Magritte. The second is that only the trunk and several branches can be considered as bearing Surrealist fruit according to the strict definition of Breton. These branches are represented by works of Carzou, Coutaud, Labisse, Goerg, and the earlier paintings by Brauner; by the Germans Ende, Cremer, Schlichter, and Zimmerman; by Lucien Freud in Great Britain and Savinio in Italy. The Belgians, apart from Magritte and Delvaux, have a score of secondary contemporary masters of fantastic Surrealist art,[15] showing how deeply this stylistic trend has made itself felt in the country of Hieronymus Bosch, Peter Huys, and A. J. Wiertz. It is the school of de Chirico, Ernst, Dali, Magritte, and Klee, and the tradition of James Ensor, Felicien Rops, F. Khnopff, Odilon Redon, Chagall, Duchamp, Picabia, and Giacometti, but in general it is the influence of the first five named that we find, together with their vocabulary.

With Arp, Miró, and Klee, with Delvaux, and later with Francis Bacon (Great Britain); with Appel (Holland) and de Kooning (United States); with Hundertwasser (Austria), Guiette and Keunen (Belgium); and also with Wols, Dubuffet, Michaux, and Bryen something different is growing at a distance from the old Surrealist soil. This expansion, which has led to a complete change of attitude and technical methods, reminds us that Surrealism is only one of the modern art tendencies turning to the irrational for its motifs. This same obsession with the irrational is at bottom also the reason for the interest now taken in children's art, in the art of the mentally deranged, in Neo-Primitivism; it is the reason for the study of archaic and primitive art forms, and of any fantastic art (of which Surrealism, with its insistence on an alogical principle, on surprise, on the shock and the marvel, is only one branch), of the Metaphysical school and of Expressionism. The *act gratuit* of *Les Caves du Vatican* by André Gide, *The White Goddess* by Robert Graves, *A la recherche du merveilleux* by Gourdjieff-Ouspensky, *Aion* by Jung, the *Holzwege* by Heidegger, and *The Doors of Perception* (the apotheosis of mescalin, i.e., of drugs) by Aldous Huxley; what do these mean if not an effort to break the chains of rationalism in order to provide man with a greater field of sensation and inner experience, and so to pave the way to a deeper vision of life?

With Bacon we have before us a man stripped of all illusions and of all sentiment of human dignity, howling with anguish in his Existentialist void. The various circles of this nihilistic hell are depicted with a neurotic zeal, like film sequences, revealing a world reminiscent of

Kafka, a world of refined masochism, of a debased humanity, a world abandoned without the refuge of faith or hope, if not for man at least for God—which was the extreme limit of Kafka's belief. The visions of Bacon display in cold process man's inner dread, his slow and endless dying, his madness, his fear of solitude. We say in cold process because that process was not born of a despair of the heart, as it was with Soutine, but from a cruelty of the brain. Bacon's painting, however, is not cold in the way that paintings by Dali or Magritte are cold, that is to say, in its execution: it is cold in its conception. There is fear in it, but the fear that is provoked by a surgeon with a plainly sadistic urge. This is the state of mind of modern man when he contemplates the horror and destruction wrought by atomic war. It is the state of mind existing in a nightmare. It is the alter ego, the "shadow" of the artist's "I," that is here at work. There is no question of a program, as is the case with Magritte. It is a state of mind which might interest both the psychologist and the humanist, for in these pictures humanity is represented as being in a most pitiable condition. Man in all his splendor (the Pope!) is more miserable than even the animal, in that he is cursed by his knowledge and by the blackness of his soul. He has fallen from grace, and he lacks the power to dominate his humiliating and destructive urges. The influence of Bacon on Graham Sutherland and Reg Butler, together with his world reputation, prove that his inspiration is authentic. The challenge he throws down makes him without doubt the strongest of the new Surrealists, but at the same time it evokes in the beholder a resistance of inner forces to such a conception of humanity. For many it is becoming more and more certain that the world of the unconscious and the dream is not dominated solely by the libido, and it is clear also that life is not dominated by destructive forces only.[16] What is in progress is what Jung calls the conjunction, the balance of opposites, the unity created by the opposing forces of Being.

There are still traces of the Freudian school of Surrealists seen in the repetition of orthodox formulas, as in the work of the American Symbolist-Realists like Paul Cadmus, Jules Castellanos, Charles Rain, Alton Pickens, Federico Castellon, Kurt Seligman, Kay Sage, Peter Blume, and Louis Guglielmi; but the leading American Surrealist artists between 1940 and 1960, such as Theodore Roszak, Morris Graves, and Gerald McLaughlin, have developed a free and fantastic vision of their own.[17]

The Surrealist compositions of the English painter Paul Nash derive also from the Freudian school, but this is not the case with the work of Graham Sutherland. The Russian Pavel Tchelichew and the Chilean

Roberto Sebastiano Matta Echaurren explore the biological aspect of man and his conscience in a spirit of clinical dissection, remaining however, as the Freudian theory of Surrealism wills it, within a materialistic sphere and a materialistic conception of the unconscious.

Delvaux, on the other hand, is a poet, the poet of death and youth, of a dream world peopled with young women and skeletons, a realm lying under the silent enchantment of the full moon. Here there is a witchery of beauty both in the human figures and the architecture. A question never to be answered seems to float around these silent figures. Sometimes an intrusion from the world of our reality appears in the shape of a clothed person, or it may be an interior in the style of the Second Empire, or a figure of the twentieth century, jacket closely buttoned, reading his paper and seeming to walk through life without seeing it. With Delvaux, as with de Chirico, the perspective is infinite, melancholic, and of an Ingres-like classicism, expressive of a yearning for the ideal. But in spite of all that is strange and mysterious in the world of Delvaux there is nothing painful in it. One accepts the enigma of life as he presents it in the immobility of the faces and the suspended action of the figures. Whereas the critical spirit, faced with a picture originating in automatism, at once is on the alert and loses itself in the cool subtleties of analysis, the feelings of the beholder meanwhile remaining unaffected, the pictures of Delvaux do not speak to the intellect, but directly to the emotions, and by way of the emotions they penetrate slowly into our consciousness. As a rule the pictures of Delvaux are treated as dream landscapes, yet they owe their original inspiration more to sophisticated literary themes than to visions arising uncontrolled out of the subconscious. These elements of landscape, of classical architecture, of outmoded interiors, of silent machines, of death fixation, of youth and beauty, are all less archetypal than lyrical in their significance. (And here it can be mentioned that, among all the precursors of Surrealism, de Chirico, with his aesthetic-symbolic imagery, has always had a strong influence on new Surrealist conceptions.)

Among the sculptors with Surrealist leanings (including Max Ernst), Germaine Richier, whose weird productions have caught something of the metaphysical Surrealism and the formal language of Giacometti, has to be singled out above all. She covers her sprawling silhouettes of worm-eaten spiders with a texture resembling that of tree bark, reminding us of the biological metamorphosis of man and tree, a well-known theme of classical mythology, but treating it here with all the decadence and morbidity of twentieth-century man.

Debased into the inferior vegetable order of nature, man ceases to be human. On the other hand, Reg Butler hesitates between the animism which he bestows upon his constructions (whose magical, primitive conception is transferred into the domain of a mechanized civilization, thus giving expression to the fascination exercised by the machine) and a certain tendency to identify man with inferior organisms such as the insects. This latter metamorphosis has been explored by earlier artists such as Redon, Ensor, and Kafka.

All this can be conceived (as it was by some religious writers, such as Weidlé, Champigneulle, Berdyaev, and Sedlmayr) as the "degradation of man," but we can find in it also traces of that insistent need of modern man to find a common denominator for the phenomena of life and civilization. It was a well-known preoccupation of the ancient philosophy of India to try to trace the life stream back to its source, there to discover the truth of perception and thought, the elemental, the primordial quality. A similar tendency is to be observed in the work of Dubuffet, although the manner of it is entirely different. Dubuffet has pushed "non-intentionality" as far as to the structure of "matter" itself—to the commonest, the basest, to the surface of mortar or mud, to the patterns formed by rain on dust, to the more or less obscene scrawls one finds on the walls of public lavatories or on the walls and pavements of ill-kept quarters of the town.[18]

As for Wols, Michaux, Bryen: they have pushed the automatic method still further into the domain of dreams and visions (Michaux) or into that of the macaroni-shaped, wiry filigree of organic tissue under the microscope, or again in imaginary maps of towns and landscapes—alcohol here playing the part of a hypnotic drug—raising the degree of sensibility, causing the desert of the modern metropolis to flower and the threshold of consciousness to recede beyond the limits of the recognizable (Wols, Bryen).

In Cuba, Wilfredo Lam has translated his Surrealist ideology into the voodoo magic still existing in his tropical homeland, thus combining the archaic-animist element with the deliberate exploration of the unconscious. A similar case is that of the Mexican Tamayo.

From these few but important examples one may conclude that the roots of Surrealism are still alive, and that, unperceived below the surface, they continue to spread until, here and there, they break through into new growths. But how different is the angle of approach of these new artists as they examine their unconscious life to capture its imagery. It is in full accord with that new inner need, which forbids them to accept any element of thought, analysis, or form that

does not correspond to that need. One might be tempted to say, in psychological terms, that the Freudian phase of Surrealism has had its day, and that we are now in the middle of a process leading to the phase of Jung. This is a phase much less under the governance of science and reason than was that of Breton. It is less automatic, less materialistic, less nihilistic than were the Dadaist progeny; it is less preoccupied with the libido and more with its sublimation, with the archetype, with the mythical, with the primordial element of the spirit.

One may reasonably assume that the Surrealist artists of the future will agree with Jung that "we moderns are called upon to revive the spirit, that is, to make primary experiences. This is the only possibility we have of breaking through the magic circle of biological evolution.[19]

NOTES

1. The modern man of science is becoming familiar with this conception, and tries to arrive at that unity of view which was part and parcel of the older European science. See Erwin Schrödinger, "The Motives for Returning to Ancient Thought," in *Nature and the Greeks* (Cambridge, 1954).
2. A decade after this essay was written a new wave of Dadaist, Surrealist, uninhibited imagery swept through the art world and found an outlet in Pop art.
3. Karl Jaspers, *Die Geistige Situation der Zeit* (Berlin, 1931).
4. How far back this past extends is clear to all those who have studied the predecessors of Surrealism. See A. H. Barr, Jr., *Fantastic Art, Dada, Surrealism* (New York, 1936), and J. P. Hodin, "Surrealism," in *Encyclopedia of World Art* (New York).
5. Schrödinger, *What Is Life?* (Cambridge, 1944); Max Born, "Physics and Metaphysics," in *Science News*, No. 17 (Harmondsworth, 1950); Werner Heisenberg, *Philosophic Problems of Nuclear Science* (London, 1952); A. N. Whitehead, *Science and the Modern World* (Cambridge, 1926).
6. André Breton, *Le Surréalisme et la peinture* (New York, 1945).
7. André Breton, *Manifestes Surréalistes* (Paris, 1924–30). See also bibliography, J. P. Hodin, "Surrealism."
8. See André Breton, *Dictionnaire abrégé du Surréalisme* (Paris, 1938).
9. Max Ernst, *Beyond Painting* (New York, 1948).

10. Salvador Dali, *Conquest of the Irrational* (New York, 1935).
11. George Hugnet, *L'esprit Dada dans la peinture* (Paris, 1932, 1934).
12. Interview with Miró, *Problems of Contemporary Art* (New York, 1947); M. Leiris and G. Limbour, *André Masson et son univers* (Geneva, Paris, London, 1947).
13. *On Modern Art* (London, 1948).
14. *What Is Surrealism?* (London, 1930).
15. *Le Fantastique dans l'art Belge, de Bosch à Magritte*, Special number of *Les Arts Plastiques* (Brussels, 1954).
16. See J. A. Hadfield, *Dreams and Nightmares* (London, 1954).
17. See *Symbolic Realism in American Painting*, Catalogue with Preface by Lincoln Kirsten (London, 1950); and John J. H. Baur in *American Art of the 20th Century* (London, 1962).
18. George Limbour, *Tableau bon levain à vous de cuire la pâte: L'Art brut de Jean Dubuffet* (Paris, 1953).
19. "Der Gegansatz Freud und Jung," in *Seelenprobleme der Gegenwart* (Zurich, 1931).

PART III

ART AND RELIGION

1 • THE PROBLEM OF JEWISH ART AND ITS CONTEMPORARY ASPECT

THE NATIONAL AND THE UNIVERSAL ASPECT OF ART

> The first universal culture of art . . . is not an intrusion but one of the supreme conquests of the West.
>
> ANDRÉ MALRAUX
> *The Voices of Silence*

A REASSESSMENT OF THE AESTHETIC VALUES CREATED BY JEWISH ARTISTS, or by non-Jewish artists for purposes connected with a specifically Jewish life, has taken place during the last decades. Thanks to the researches of archaeologists and the planned collecting of relevant visual material; to new critical attitudes regarding the question of the stylistic influences in art and their significance; and last but not least, to the work produced by Jewish artists themselves, especially in the first half of this century, there is no longer any reason to assume that the Jews are not permitted, and are not capable of, full self-expression through visual art. Although most of the current books on Jewish art still treat the possible truth of this assumption as a problem, it is to a great extent no longer made. Up to the time of the excavation of the synagogue at Dura Europos, with its mural decorations—that is, until 1932—even scholars had denied the Jews creativeness in the visual arts, and it is perhaps revealing to read statements such as that of the German Immanuel Benzinger that "the Israelites lacked from the beginning artistic talent,"[1] and of Hans Lietzmann, after he had visited the excavations in Dura Europos, that the murals were painted by Persian artists: he could not imagine otherwise. Nevertheless he had to acknowledge that the murals were based on an old pictorial

113

tradition; in other words, that a picture Bible must have existed
among the Jewry of the Diaspora who were exposed to Greek cul-
ture. Count du Mesnil du Buisson expresses himself on the same sub-
ject with a Catholic prejudice.[2] Assessing the important fact which
has been established, "the proved existence of a Jewish imagery which
was highly developed even in the third century," du Mesnil du Buisson
suggests that the murals of Dura "do not appear either as the creation
of an artist of genius or of a group of people especially gifted. The
painters of the synagogue have to be considered as mere technicians
who, sometimes very adroitly, made of their art above all a profes-
sion. . . ." The elements of the composition do not "convey in them-
selves any particular Jewish character." In the first statement the
ability of the Jew to be a good artist is in question, in the second the
existence of a specifically Jewish style is queried. We shall later have
an opportunity to deal with both these assumptions at length.

On the other hand, a directly opposite viewpoint has sometimes
been taken. It was the Viennese Josef Strzygowski who in 1901 sug-
gested that in antiquity Jewish art, with Alexandria as a center, may
have had even a decisive influence on the formation of early Chris-
tian art.[3] Similarly, Oskar Wulff has proved that Jewish synagogues
had architectural elements adopted later by the great churches and
cathedrals.[4] The excavations at Dura Europos certainly produced an
important link in the evidence in support of Strzygowski's theory, al-
though they did not prove the existence of a specifically Jewish style
in antiquity. There is no evidence of such even in the Middle Ages,
or indeed up to the end of the nineteenth century. This conclusion,
however, does not necessarily deny the existence of a Jewish art. It
appears to only because the whole problem has been viewed from a
specific angle. A different viewpoint will show that the national, and
in consequence essentially parochial, outlook that it implies is too
narrow to cope with this fundamental question in a satisfactory man-
ner.

Two major works on the subject of Jewish art have been published
recently. They are Carl H. Kraeling's volume on the Dura synagogue,
more or less on the conventional lines of an art-historical or archaeo-
logical report,[5] and the voluminous opus of Erwin R. Goodenough, in
which he has devoted his studies to Jewish art so "that it could be
made into a reliable and accepted historical evidence for the type of
Judaism which produced it."[6] His approach is based on the interpre-
tation of the symbolic significance of Jewish works of art. The present
situation has been described by him as follows:

The discovery of the synagogue at Dura Europos startled the world, because the world had long been ignoring the accumulating evidence, that in the Graeco-Roman period Jews had widely used an art which in itself looked highly syncretistic, one in which the divine figures of the Pagans, and many of their most important religious symbols, were used with the greatest freedom in Jewish tombs and synagogues. This syncretistic art of Judaism had basically the same vocabulary as early Christian symbolism, but this fact had impressed few who dealt with early Christian art, for they, for the most part, had persisted in saying that, since Jewish law forbade it, the Jews had no art. Furthermore, historians of art had utterly failed to see the implications of the ideas of Strzygowski as elaborated by More of Princeton that all early Christian illustrations of the Old Testament are explicable only if the Christians who made them had been adapting a tradition of Old Testament art originally developed by Jews, presumably in Alexandria. As a result of this general rejection of any indications of a Jewish art, the historians of religion and art were completely bewildered when the Dura synagogue was discovered, its walls painted with Old Testament scenes in a way that showed collateral descent from the hypothetical ancestors of the Old Testament illustrations of the Hexateuchs, and of Santa Maria Maggiore in Rome, and when with these were found presentations of Bacchic vines, Orpheus playing to the animals, Bacchic felines and masks, winged victories, and the god Ares, as well as the three nymphs, the divine nurses of the young gods, here as nurses of the infant Moses. They should not have been bewildered at all, for such a discovery was only the next step, the laboratory confirmation of the best thinking and the culmination of the discoveries of long before in synagogues and Jewish graves. The uncovering of the extraordinary Jewish catacombs at Sheihk Ibreik in Galilee two years later was less publicized, but was of equal importance.[7]

Our problem has a historical and a contemporary aspect, and the emphasis is to be laid here on the latter. For several reasons, however, the contemporary aspect of the problem cannot be dealt with in a satisfactory manner without digressing and even revising, at least theoretically, certain historical axioms. ·

Before attempting a sketch of the main aspects of the history of Jewish art we have to reexamine the question which concerned an earlier generation of Jewish art historians: the question whether there was something which could be called Jewish art or whether it would be more appropriate to speak only of Jewish artists, or even more

generally of Judaism and the visual arts. Franz Landsberger main-
tains that both exist, without being able to prove the existence of the
former.[8] He simply says: "There is a Jewish art," whether the works
concerned are created by Jewish-born artists or not. Karl Schwarz,
however, stresses that "the lack of unifying life-conditions is the
reason why up to date no Jewish art could arise."[9] George S. Hellman
in his essay "Jews in Art" is of a similar opinion. His statement runs:
"As for the moot question of 'Jewish art,' that in our opinion does not
offer opportunities for discussion, it remains a doubtful subject at
best. In modern times, there are, of course, Jewish artists . . . who
have devoted their talents to Jewish subjects and Palestinian land-
scapes. Yet even they, artists who are Jews, have been directly affected
by artists who are non-Jews."[10]

Artists themselves have taken up this problem, often with greater
competence than the scholars; it was and still is a main topic of dis-
cussion among them, and we cannot arrive at any definite picture
without including at least some of their opinions here. So Solomon J.
Solomon R. A. (1860–1927) denied the existence of a specifically Jew-
ish art, because he held "that a purely national art can only grow
from the soil."[11]

For the painter Jankel Adler, Jewish art was quite simply the art
of the Yiddish-speaking Jews in the nineteenth and twentieth centuries.
What came before—that is to say, the art which Jewish crafts-
men, painters, sculptors, etc., had previously produced—had a signif-
icance only when it played a role as a stimulus of tradition. Other-
wise he saw no link between the work of the present and the past.
In eastern Europe there was a revival of Jewish cultural conscious-
ness in the late nineteenth century in literature, music, theater, and
the visual arts—so that the number of Jewish artists there was very
large compared with that in the West, despite the appearance of such
masters as Jozef Israëls, Camille Pissarro, Max Liebermann, and Les-
ser Ury. We can speak, indeed, of a renaissance of Jewish culture in
eastern Europe, where the arts became accepted, once again, as an
everyday aspect of Jewish life. Jankel Adler himself was a member of
the "Young Yiddish" group, in which authors, musicians, painters,
sculptors, and actors came together in a single cultural effort.[12]

The painter Endre Nemes denies the existence of the specifically
national Jewish art of Jankel Adler's conception. He acknowledges
Marc Chagall as the only Jewish artist of stature at the present with
a specifically Jewish character, a specific philosophy and mysticism
derived from age-old religious sources, "but even the art of Chagall

has typical aspects of 'assimilation' to his milieu, or more precisely to the milieu of his activity." Nemes therefore finds it diffcult to answer the question whether there is a Jewish art, because it touches upon the entire problem of national art as such, the Jewish problem being even more complicated. "In contemporary art," he says, "I do not believe that there exists a Jewish art in the 'national' sense. What is created in Israel, as far as it is known to me, cannot claim to have such a quality."[13]

If, instead of the general concept of Jewish art, we take that of a specifically Jewish style, the peculiarity of the Jewish destiny has to be taken into consideration. We can say without exaggeration that it is the strange history of the Jewish people which adds strangeness to the history of its art and that this circumstance demands from the art historian the discovery of a special viewpoint. It will not astonish us that even so serious a writer as Ernst Cohn-Wiener will state that "in no instance did there come into the open even a single building or work of art which could take its place beside a Greek or Egyptian one." And, asserting as he does that the art of a people is the expression of its own being and therefore has its own style, he is forced by the historical evidence to the conclusion that

> what distinguishes Jewish art to its disadvantage from the art of other peoples is that in its formal foundations, in its style, it is as dependent as the people itself. It does not possess an absolute independence. Israel has experienced the late Antique, the Islamic, the Byzantine styles, has lived through the Gothic, the Renaissance and the Baroque age, has created in all these styles in the same way as its painters today are Impressionists or Expressionists.

And the reason is, according to this author, that

> the Jew is not so much concerned with his own style as with his own content, the content of his religion. . . . So that a Jewish style has never existed with specific symbols and building forms. For the Jewish religion form is only a hieroglyph of the spiritual. . . . Israel has without any doubt been a thinking, not a shaping people, more gifted in the literary than in the artistic realm.[14]

Here, then, we have accumulated ample statements to offer us a wide perspective for our problem and the solution we wish to suggest. We can in anticipation say that we consider the existence of a

Jewish style in the twentieth century to be a fact, and that its most definite expression has been achieved in the work of Marc Chagall, but we have also to state that his work cannot be detached from the whole European or even global aspect of our present civilization— the national aspect is only a secondary consideration. It did not occur to the authors of histories of Jewish art that the narrow nationalist or racial point of view (even when it was dictated by the onslaught of Nazism, as in the case of Landsberger and Schwarz) must of necessity lead them into a wrong line of argument, and that in seeking to preserve their nationalist stance they were not necessarily saving the "face" of Jewish art. Another statement reads:

> In the Roman period, they [the Jews] were one of the leading peoples in the artistic field. . . . it is not primarily the form but the content which leads to significant Jewish art. Although the architects of numerous synagogues were non-Jews . . . yet nevertheless the influence of the Jewish patrons and donors was so strong that works dedicated to Jewish purposes may rightly be classed as Jewish art.[15]

The author of this passage maintains also that "the history of Jewish art would largely seem the history of painting and architecture."

We shall deal in more detail later with influences on Jewish art and artists, with regard to which there exist many incorrect conceptions. The large Portuguese synagogue in Amsterdam was built in 1675 by the Dutch architect Elias Boumann. Cohn-Wiener argues that "its character is nevertheless Jewish. Is it not the successor of the synagogue of 1639 in which Uriel Acosta and Baruch Spinoza were cursed?" This surely is not art history. Again, Theodor Ehrenstein proclaims that "the Dura frescoes are as little dependent on any contemporary work of art for a stylistic example as was the miniature artist of the Sarajewo Haggadah on some other illuminated manuscript." On the contrary, it is well known that the Dura frescoes are Hellenistic in style, and that the Sarajewo Haggadah is an example of the French Gothic style which penetrated into Spain, where this Haggadah was produced. But the author—like all German-born Jewish authors on this subject—is prepared to go even further: "Masters who could achieve such things as this Haggadah or the Dura frescoes could possibly also have brought forth such outstanding works as, for example, the Vienna Genesis, the Itala illuminated manuscript, that oldest Latin Bible, the Joshua scroll and perhaps even the Ashburn-

ham Pentateuch." Landsberger argues that from the perpetual adoption of foreign stylistic elements one need not necessarily conclude that the Jews have not created their own style. He speaks of antiquity: "Even other peoples have been dependent on foreign styles. The Romans on that of Greece, the Japanese on that of China, the German Gothic style on France, the German Renaissance on Italy, etc. . . . In spite of this nobody would deny most of those nations their own character in art." This argument again is misleading, as the cases are not at all comparable. Even less helpful is the reproduction of mainly insignificant works of art in Karl Schwarz's opus.[16] Nor is much more discrimination displayed in his book *Jewish Artists of the Nineteenth and Twentieth Centuries*.[17] He assumes that it is enough that a work is produced by an artist of Jewish origin.

But let us meanwhile study the criteria which could make a work of art a Jewish work of art. We can enumerate them as follows:

1. That the work of art is produced by an artist of Jewish descent.
2. That its subject matter is Jewish, or that it is conceived in a Jewish spirit—which is difficult to define because there have been many changes of attitude, even though not basically where religious content is concerned, throughout the ages.
3. That the Jewish approach is discernible not only in questions of ideology and feeling but also in formal values, that is to say, in style and its traditional development.
4. That it is produced in a Jewish milieu of a specific, i.e., unique, cultural climate and distinction.

These requirements would be fulfilled, strictly speaking, in any work of art to be regarded as Jewish from a national or racial viewpoint. But we deny that these criteria are workable, either from the historical or from the morphological standpoint. From the morphological standpoint they simply contradict the basic laws according to which cultures are initiated, by which they grow, by which they assimilate foreign impulses, and by which they decay. And the modern nation and modern nationalism are, by definition, products of modern conditions. Nationalism began only at the end of the eighteenth century to grow into a generally recognized sentiment molding public and private life. The American and the French revolutions may be regarded as its first powerful manifestations. The nineteenth century has been called the age of nationalism in Europe, and in the twentieth century we see this idea spreading throughout Asia and Africa. From

the end of the eighteenth century onwards, the nationalization of education went hand in hand with the nationalization of states and political loyalties.[18] From the cultural viewpoint, nationalism was not an altogether desirable development. In the special field with which we are concerned here we can say that mediocre art is always national; great art does not stop at any political borders. The new thinking in national terms is opposed to all the essential conceptions which have predominated through centuries. Man has stressed the general and the universal, and has seen in a spiritual unity the desirable goal. Nationalism stresses the peculiar and the parochial, the national differences and individualities. In the fifteenth century the ideal was the universal world state, not loyalty to any separate political entity. The Roman Empire, the Holy Roman Empire of the Middle Ages, and the "res publica Christiana" were international conceptions, which in a new form are again pressing for acknowledgment in our age. The old unity of Christendom broke down in favor of national states, but a new unity is growing, one based on the scientific spirit and technology in the service of the whole of mankind. We speak nowadays of world government, and there is a definite longing, too, for a unity of spirit in a global sense never achieved by mankind hitherto.

In the realm of modern art the situation is the same. The knowledge of all art forms, from their first beginnings in prehistoric times, produced in all continents and by all races, gives us a global consciousness which has found its most powerful artistic expression in Picasso and its most convincing literary expression in André Malraux's *Essais de psychologie de l'art,* where the idea of a world art is the climax of the exposition. Malraux speaks of "the great resurrection" of our time in the spiritual realm and asserts that "this resurrection has not ceased yet to expand and to enrich itself . . . it is the guarantee of our art, for no age which at the same time is moved by the archaic Greeks, the Egyptians, the Weï sculptors, and Michelangelo can reject Cézanne."[19]

There are certain analogies between our age and other ages in which mature cultures have decayed and the seeds of new spiritual values have begun to germinate. All historians adhering to the cyclic conception of history—the Stoa, Vico and Goethe, and in our time such writers as Oswald Spengler, Pitirim Sorokin, and Arnold Toynbee (and in art history, Heinrich Wölfflin and François Lehel)—agree that we live in an age in which not merely European culture but the culture based on the Greco-Jewish-Christian ideology is decaying and

that a new spiritual world, with a new metaphysics and a new social consciousness, with its own elements of mysticism and irrationalism which lie beyond materialistic and mechanistic science, is beginning to grow. This process corresponds to the growth of the Christian ideology in the decaying Roman Empire. And is there not an obvious parallel between our own times and the Hellenistic period—the very period in which the Jewish art of antiquity developed its most interesting and mature phase? The Hellenistic culture was completely international; its art, intellectual and impressionistic, had spread with trade routes and shipping to unite the whole Mediterranean, with Alexandria, Palmyra, and Antioch its most important harbors. There was a libertine attitude toward religious tradition; different religious traditions, in fact, existed side by side, and skepticism harassed this Hellenistic world of pleasure and wealth just as it harasses our world.

This brings us to an important point. Jewish doctrine is at the root of the national as well as the universal spiritual conception in Europe. The man Moses, who shapes a nation, and the man Paul, who brings into actual being the universal humanitarian doctrine which was a living fact of Jewish thought even before Jesus, belong to the same nation. When in the seventeenth and eighteenth centuries the last phase of universalism in the old sense was reached, the common standards of Western civilization were the regard for the universally human, faith in reason and in common sense, the general love of mankind, and the cosmopolitan convictions of the Christian and Stoic traditions. These standards have their roots in the same soil as the first manifestation of European nationalism in the Puritan England of the seventeenth century, when under the guidance of the Old Testament, England formed its new nationalism by identifying the English people with ancient Israel.

The same duality occurs even today. The new Jewish state, with its political and cultural strivings, is nationalist, while the major part of Jewry living all over the world adheres to a universal creed which is expressed both in its writings and in its art. We must not forget that, long before the conquest of Jerusalem and the destruction of the Temple by Titus in A.D. 70 and the following complete eradication of Jerusalem as a center of national life in A.D. 135 by Hadrian, Jews had lived in cultural centers of the Mediterranean, enjoying their freedom and developing their religion and art. So it was also in the Hellenistic period, when Alexandria was the main cultural center. Before the great migration of peoples there existed no feeling for nationality in Europe. The Jews in antiquity felt themselves to be citizens

of a world state, and they remained so even when historical conditions changed. They still preserved the tradition of the Hellenistic age when in the fourth century Germanic barbarian tribes grew to power and the Roman Empire disappeared in the German state. Even when Israel was united by its kings Saul (c. 1031–10 B.C.) and David (1010–970 B.C.), and when under Solomon (c. 970–30 B.C.) the foundations were laid for a truly royal culture with hitherto unheard-of claims to art and luxury, it still did not exist from the point of view of art history as an isolated, self-contained national body, but participated in a larger stylistic development taking place over the whole Near East. The reason for this was that the nomadic Israelites, and even the peasant inhabitants of Canaan, had no means and no time to develop an advanced culture like that of Egypt or Phoenicia. Phoenician arts and crafts at that time represented an international style which was famous, hailed alike by Homer and the Bible, with an area of influence extending from Assyria to Armenia in the East, and to Hellas, Etruria, and Gallia. Aramaic inscriptions were found even in the holy center of Olympia. In the style which the Phoenicians elaborated, all stylistic elements of the Near East were welded together, and this was the style of the Temple of Solomon.

A similar situation developed in the Hellenistic age, and again in our own time. The Middle Ages, the long period between antiquity and the modern age, which for the Jews did not come to an end until their emancipation, is marked by the fact that dispersion became slavery. This small nation, which has shaped the religious conception of half the world, lacked for almost nineteen hundred years the prerogative of a nation: a homeland. Its new state, only a few decades old, is from a historical point of view the manifestation of an extraordinarily strong national consciousness, and considering the very short period of political freedom and self-determination which it has enjoyed, and also the fact that all the great cultures of Babylon, Assyria, Phoenicia, and Egypt, which surrounded it, have long ago ceased to exist both in their religious and artistic foundations, we have here to do with a quite exceptional historic destiny. This destiny has, in fact, molded the Jewish mind and therefore Jewish art: nevertheless, we come of necessity to the conclusion that the nationalist approach to the problem of Jewish art is not the appropriate one. Jewish works of art must be seen in conjunction with the greater cultural units in whose life the Jewish people took part. An intelligent study of Jewish antiquities and an analysis of the work of Jewish artists throughout the ages will quickly reveal this. Such a study has to find its right place in the uni-

versal history of art. A world of beauty, passed by, forgotten, or ne-glected, has to be brought to the consciousness of mankind.

In a civilization in which distances shrink as they have in the last fifty years (the idea of the Great Chinese Wall is the exact antithesis of the jet-propelled airliner), the peoples know each other better than before. A global consciousness is born. The Jews understand this well, for it flows in their blood together with humanitarian ideals, and with equal force. In times when practically no communication existed, closed stylistic areas and epochs of specific styles could develop. But even in the era of the Phoenician culture, state or national frontiers were nonexistent, and they did not exist in a stylistic sense even later. One has only to study the Romanesque, the Gothic, the Renaissance, the Baroque, or modern developments to confirm this view.

Seduced by national ideologies, many peoples have made earnest attempts to develop special national trends in art. Modern art, how-ever, is and has been since Delacroix and Courbet based on what France has created. The fact that France has attracted great talents of many nations to its artistic center, Paris, is of more importance than all these national efforts. There is not a single great artist of modern times who has not felt the call of Paris and who has not spent at least a short time there for study or observation.

JEWISH STYLE, ITS TRADITION AND SYMBOLISM

If we are to consider a work of art as Jewish only if it is produced by a Jewish artist, we shall have to exclude the majority of Jewish buildings, illuminated manuscripts, and even objects serving ritual purposes throughout the ages. King Solomon, when planning to build his palace, approached the Phoenician king for assistance; according to II Samuel 5:11 the latter furnished him not only with cedar wood but also with carpenters and masons. And it is established that the plans both for the palace and for the Temple of Solomon are of Phoe-nician origin. The Temple, completed in 959 B.C., is described in I Kings and II Chronicles. Its special features, the two brass columns Jachin and Boaz, are items of Phoenician religious symbolism, and the so-called Molten Sea, with twelve brass oxen supporting the bowl, as well as the brass lavers provided with wheels are derived from Sumerian and Babylonian temples.[20] As the Jews were not fa-miliar with brass founding a certain Hiram or Hirambi from Tyrus produced the pillars. For the second temple, completed in 516 B.C.,

the Persian king Cyrus had plans furnished by his own court architects.[21] The magnificent temple of Herod (reigned 37–34 B.C.), his palace, amphitheater, and circus were all built in the Hellenistic style and probably not by Jews. The same is true of most of the synagogues in antiquity and the Middle Ages. In the Middle Ages, however, the reasons that sacred buildings were not built by Jews themselves are different. Whereas in the time of the kings it was due to the lack of building tradition of a nomadic people who had settled down in an area with an already existing ancient culture, in the Middle Ages it was due mainly to the oppression to which the Jews in Europe (with the exception of those living in Islamic countries and at a certain period in eastern Europe) were exposed and to their exclusion from the guilds in central Europe; this prevented them from acquiring artistic tradition and skill. Nevertheless, there are names recorded of Jewish builders of synagogues in all countries, and of painters, masters of handicrafts, and even sculptors.

But we are here concerned with an analysis of the problem stated in the first lines of this chapter. We must agree with statements such as the following:

> With the Greeks it was the aesthetic sense, inherent in them in a higher degree than in any other people, a sense which transformed the coarse Asiatic models into creations of the highest human beauty (from the Asiatic Asthoreth Aphrodite was evoked); with the old Hebrews it was, rather, the moral sense, inherent in them in a higher degree than in any other people of antiquity, the differentiation between good and evil by the help of which the legends originated in Babylon acquired an incomparably nobler meaning in the Bible.[22]

During the Middle Ages the Jews were impelled by adverse circumstances to live an introverted life, and they became known as a meditative people, religious- and literary-minded rather than artistically creative. Considering, however, the outburst of Jewish creative energy in the first half of the twentieth century, it seems to us that such a conception of them has validity only for one limited historical period. Modern art education has shown that Jewish children are no less talented or eager to draw, paint, and sculpt than others. Herbert Read reproaches E. R. Jaensch for attempting, in his *Eidetic Imagery and Typological Methods of Investigation,* to force racial distinctions, a tendency characteristic of modern German scientists. "This is not to

deny," he says, "a general average of racial or national characteristics; but the extreme of the average is the universal. National differences are more likely to be the product of imposed conditions of an ideological kind.[23] Similarly, Alfred Adler denies the importance of heredity in respect to psychological data:

> The reason that there are characteristic traits which are common to a family, a people or a race lies in the fact that one individual copies the other . . . that he develops inclinations which he derives from the others. There are certain notions, spiritual peculiarities and bodily forms of expression, which in our culture constitute temptation to immature people to imitate them.[24]

An artist's Jewish descent therefore does not ensure that his work represents some genuine Jewish quality.

Among the "imposed conditions of an ideological kind" the prohibition against making "a graven image, or the likeness of any form that is in heaven above, or that is in the earth beneath, or that is in the water under the earth" (Exod. 20:4; see also Lev. 26 and Deut. 16:22) has had a detrimental influence on the course of Jewish art. Although it was originally meant as a safeguard against idolatry, it became a serious hindrance to free artistic development. Facts from the life of the two most significant Jewish artists of modern times, Marc Chagall and Chaim Soutine, demonstrate this vividly. Chagall, in *Ma Vie*,[25] mentions that his art never played any role in the life of his parents. When he repeatedly implored his mother to let him be an artist she answered: "It is enough! What? A painter? You are mad, you. . . ." He continues: "My uncle is afraid to shake hands with me. They say that I am a painter. Shall I try to draw him? God forbid! It is a sin." More tragic is the story of Soutine as related to us by his biographer Waldemar George: "In the strictly orthodox home of his parents, learning is all that matters. . . ."

> [Soutine] dreams of nothing but pencils or a few crayons. But it is not allowed. Taking at last some household articles, which he sells, he gets the crayons. His father hears about it and beats the boy until he draws blood and locks him in the cellar for days without food. Noticing his absence in school, they ask about him and are informed of his misdeed. Alas, a thief! And he is expelled from school. The entire village is indignant about the outcast, the evil son of such a pious man. Terrified, the boy wanders aimlessly, for his parents have disowned him. A man

in the village has pity on him, takes him in and even permits him to draw his portrait. These are the boy's first happy days. He draws and realizes now that he wants to be an artist. When his hideout becomes known, the sons of the rabbi lie in wait for him and attack him one day as he leaves the house. Covered with blood, seriously injured, he drags himself to the nearest hospital, where he collapses. At fourteen he flees to Vilna and arrives in Paris at the age of seventeen.[26]

There were periods, however, in which this prohibition was not taken strictly, in the Hellenistic period for instance, or in Spain under the influence of Islam. The Talmud reflects this greater leniency toward the arts.

The law prohibiting art was taken over from the Jews by the founder and prophet of Mohammedanism. This, however, was expressed only in his oral statements. There was an absolute prohibition of "figural representation" in the early period of Islam and under the Berber dynasties of Africa and the Mamelukes of Egypt and Syria, though under the Omayyads and Abbasids and most of the Shi'ite and Turkish dynasties it was excluded only from public buildings.[27] Jewry did not develop such a rich fantasy in abstract ornamentation as did Islam. Its art remained more or less naturalistic, adapting ornaments derived from foliage, flower, and animal shapes, and sometimes even the human figure, for the decoration of objects used in the service of religion, for mosaics and illuminated manuscripts. Generally speaking, Jewish art in antiquity, and in the Middle Ages up to the emancipation, remained bound to the religious cult. In this it did not differ essentially from the art of other peoples. Only with the Renaissance and the accent on individuality, when humanism began to supplant theocracy, did a new element appear, especially in the portrait. The Jews remained, however, essentially theocratic. This has its roots in a specific conviction, a philosophy. The feeling that art has to serve religion, the inclination of so many Jewish artists to illustration, even the main preoccupation of Jewish artists with figuration rather than with abstraction, are so many symptoms of it. The Jewish spirit aims at the sanctification of life itself. Spinoza's *deus sive natura* is not in contradiction to the traditional Jewish spirit. On the contrary, it is as much an essential expression of it, a stage in the development of the anthropomorphic idea of God, as the humanistic teaching of Jesus and the religion of Paul, which are developments of the messianic and apocalyptic thoughts of earlier Jewish prophets. The emphasis in Jewish religious philosophy is on the "reality" of the present life (which

is sanctified by God), not on the life to come, not on the flight into symbolism or spiritualism, and therefore not even on the idea of life's reality or religion being replaced by art (a concept which arose in the ideology of the nineteenth century) or of art's acquiring a magic significance, as in the Paleolithic age or in Egypt. This Jewish philosophy does not exclude art as ornament, decoration, expression, or symbol, but does not accept it as "interpretation," that is, as a philosophy or a religious belief. Martin Buber speaks typically of the "most precious heritage of classical Judaism, the tendency to *Verwirklichung* —realization."[28] Such a tendency proclaims real human life to be life in the countenance of God. God is to Judaism not a Kantian idea but the fundamental substance of the present.

This orientation of the Jewish spirit, the shortness of the political freedom of the historic Jewish state, and the hardships of the *Galuth* and ghetto have prevented the crystallization of a Jewish style, defining style as the specific and permanent features which distinguish human, especially artistic, achievements. The nonexistence of a Jewish style, particularly in architecture, may be the reason why Oswald Spengler does not include the Jewish culture among the other great cultures. (The two oldest cultures, he declares, arose around the Nile and the Euphrates about 3000 B.C.: Egypt, Babylon, the empire of Sumer and Akkad. About 1500 B.C. an Indian culture developed on the upper Punjab, about 1400 B.C. a Chinese culture on the middle Huangho, and about 1100 B.C. the antique culture on the Aegean sea. The Mayan, the Christian, and the Islamic cultures complete the picture.)[29] For the Russian scientist N. J. Danielevsky (1822–85) the artistic line of development does not seem to be of overwhelming importance, and his list of ten great cultures reads as follows: Egyptian, Chinese, Assyro-Babylonian, Hindu, Iranian, Jewish, Greek, Roman, Arabic, European. Toynbee acknowledges Judaism as a higher religion with an alien source of inspiration (Syriac) developed in the Babylonian civilization. When, however, he also defines the source of inspiration of Christianity, growing in the Hellenistic civilization, as "alien" and specifies it as "Syriac," he is neglecting later developments, both Greek and Jewish. Christendom must be considered as one main branch of the Jewish religious development not confined to the Jewish community. (See Albert Schweitzer, *The Mysticism of Paul the Apostle*, and particularly *The Quest of the Historical Jesus, A Critical Study of Its Progress from Reimarus to Wrede*, with its interpretation of Jesus' life under the auspices of the Deuterojesaja's conception of the servant of God.)[30] Toynbee's conception of Judaism as a philoso-

phy and belief which ceased to develop in the century before the Christian era is not only misleading but must of necessity produce wrong conclusions in other fields. Thus Toynbee classifies the Jews as "fossils" and assigns them to the extinct society to which they originally belonged. "The Jews and Parsees are fossils of the Syriac society as it was before the Hellenistic intrusion upon the Syriac world." To couple the Jews with the Parsees is indeed not only to underestimate the impact of Jewish ideology on the world—the more significant because it was produced by a small people, similar to the Greeks—but also to fail to take into account the spiritual force of a community which was able to restore its political independence after nineteen centuries.

The different national milieus in which the Jews lived, and the long period of their existence as a people united only by a strong spiritual bond, made it practically impossible for them to break through the different styles which were used in these milieus, but very definite Jewish variants of styles, subject matters, and motifs were established. An essential part in the development of styles and their interrelations is an unbroken tradition. The work of any artist is based upon the work of generations of artists before him. Such a stylistic tradition exists in Jewish art only sporadically. In the twentieth century, however, Jewish antiquities have come fully into their own as sources of artistic inspiration. This is conditioned by the fervent interest of our modern age in all forms, particularly archaic forms, and is part of the global consciousness of art. The Russian-born El Lissitsky (1890–1941) studied Jewish folk art from synagogues, tombstones, and illuminated manuscripts, especially Haggadahs, in which the creative fantasy of Jewish artists of the Middle Ages found a rich sphere of activity. The same is true of the Polish-born Jankel Adler (1895–1949). Adler loved Jewish folk art and folk poetry, and he not only started his work in a monumental-representational manner, depicting Jewish folk types (A Stone Carver, The Family, The Carter, The Two Rabbis), but when, later, his art had developed, we find that even in his abstract compositions he made use of Jewish ornaments derived from prayer shawls, Torah curtains, tombstones, the vessels and plate decorations of Jewish feast days, and of Jewish symbolism as well: the two hands of the Kohanim, and mystical letters and numbers; the peacock, the symbol of eternal life, seen already in the mosaics of the old synagogues of Palestine; the dove, the symbol of peace; the white kid, the symbol of purity and innocence, of the acceptance of fate and nonresistance to it; the lamb of sacrifice. (Adler was a mystic influenced by Martin Buber. As such he felt himself drawn to the world

of Franz Kafka, who was also rooted more in eastern than in western European tradition, having been born in Prague. Adler made many intriguing studies after Kafka's work.) In Adler's painting *Hommage à Gabo,* one hand of the figure is pointing to an abstract shape which reveals itself on closer inspection as the two tablets of the law, while the other hand points to a three-dimensional abstract construction. He thus expresses homage to the creative Jewish artist.[31] However, Adler experienced the revival of Jewish culture only spiritually, not stylistically. Stylistically his work is mainly derivative from Picasso and Klee.

It was Marc Chagall, also a product of the spiritual revival of eastern European Jewry known as Hassidism, who was the great initiator and inspirer of a Jewish style in art, a style which has now exercised its influence on the third generation of Jewish artists. Chagall not only used traditional Jewish symbols and symbolic forms, still in his day a living reality in eastern Europe, but himself invented new symbols: the wandering Jew, with no roots in the earth, flying through the air; the praying Jew, the man meditating on the Scriptures or fleeing with the Torah scrolls; the Jewish musician; the animal with the soul; the animal with the human head; the crucified Jew; the white bride; the hanging lamp, a synagogical requisite; the lighted candelabrum; the goat; the rooster; the pendulum clock, symbolizing the transitoriness of time. The accumulation of figures and objects in his pictures, often massed together, has therefore not only a purely formal significance. Chagall used them like the letters of a secret alphabet, like words from which his artistic language springs. Chagall is the painter of the yearning for the first unforgettable impressions that life bestows on man. This explains the quite personal quality of his art. These impressions, however, were not only personal; they lingered on in his mind as primeval images because they are the essence of the imagery of his people, of the branch which has lived in eastern Europe and has created there its own milieu with typical features.[32]

This genuine connection of Chagall with his people—and "people" also in the social, not only the national, sense—can be studied in his stylistic dependence on folk art. We see, for instance, traces of the style of the popular sign painter. The fantastic-expressionistic, primitive-realistic style in which he worked can still be studied today in a quarter of Jerusalem where eastern European Jews have settled and shaped their surroundings as they existed in eastern Europe prior to their complete destruction.

Besides visual inspiration there is also in Chagall's art a literary inspiration. This inspiration is often drawn from picturesque Jewish sayings. In one of the early Chagall pictures, for instance, there are

birds depicted on the wing. This may well have some connection with
the saying *"Er ist begabt as er kan mulen faigl in de liften"*—he is so
gifted that he can paint birds on the wing. Aschmuda, the chief of all
devils, appeared often in the shape of a goat, and at night one could
see him jumping over the moon, the clouds, the roofs.[33] Chagall has
painted animals jumping over the moon. There is a Russian saying
that a stupid woman should have a goose's head on her shoulders, and
Chagall's figures have animal heads.

There may be other sources for this type of imagery, too. The
painter Josef Herman said to me:

> We all come from Chagall. It was he who made us feel that
> there was poetry in the poor, dirty, narrow ghetto streets and the
> life which was lived there. And to those who have turned away
> from the old tradition and have tried to assimilate themselves
> and their work to the spiritual climate of the ethnical group
> among which they have lived as a minority, he has given confi-
> dence and self-respect.

In Chagall we can recognize all the elements which might provide
the Jewish quality of a work of art: the Jewish descent, the Jewish
approach, both thematically and stylistically, based on traditional
values, both formative and spiritual, and the evocation of a specific
imagery in a closed and distinct cultural milieu. That he left for Paris
does not affect the situation very much. Just as the Jewish people
in the synagogical period, through the Bible and the fulfillment of the
law, lived a spiritual life which took the place of their lost native land
and its spiritual center, the Temple, so Chagall recalls in practically
all his work the imagery of his youth. In spite of having, as he said
himself, "penetrated into the heart of the French painting of 1910 and
fastened himself there,"[34] in spite of all the formal inspiration he de-
rived from Cubism, from Odilon Redon, from Gauguin and Matisse
and the whole artistic climate of Paris, the West was not able to ex-
tinguish the age-old spiritual values which had come to new life in
a genuine and novel way in Hassidism.[35] In his illustrations for the
Bible—the only adequate pictorial rendering of the Old Testament
created by a Jewish artist and the most masterly since the days of
Rembrandt—Chagall entered not only the realm of a living Jewish
reality but the holy ground of Jewish spirituality itself. So fertile still
and so unexplored is this ground that it could inspire even a non-Jew-
ish author such as Thomas Mann to a monumental epic tetralogy. The

masterly quality of Chagall's work, the ineffable quality which makes a painting a work of art—it is this and not only the Jewish motif which distinguishes Chagall's art. Therein lies the difference between his work and the work of such painters as Mané Katz.

Is the Jewish motif altogether such an important factor, we have to ask ourselves? If it were, Rembrandt would be considered the greatest Jewish artist. And how would we classify the works of Chagall which do not depict a Jewish subject matter? It seems therefore a quite untenable position to declare that "it is not primarily the form but the content which leads to significant Jewish art."[36] The problem was analyzed by Max Liebermann in his book on Jozef Israëls:[37]

> German genre painters (and for the same reasons also all Jewish genre painters) tend rather to illustrate their subject; they search more for the anecdotal, the characteristic contingency. Israëls on the other hand searches for the typical. Instead of the rational analysis he gives the poetical synthesis.
>
> Let us consider for instance the *Solomonic Wisdom* by Knaus —one of the most admired and rightly admired pictures of German genre painting—and put beside it Israëls' *A Son of the Old People*. Knaus shows us an old Jew initiating his grandchild into the secrets of the old-clothes trade. Delightful figures, every single trait, every movement observed from nature and rendered with the smallest details. With Israëls, on the contrary, only one figure, a poor Jew, sitting quite simply and quite motionless in front of his shop. The whole picture lies in the expression of the head, the rest is only intimated by a few spots of colour. But in the face of the old man, who sits there quietly, his hands clasped, we experience the thousand-year-old pain of which Heine sings.
>
> With the whole inwardness of his nation and race Israëls feels himself into nature, wherever the expressiveness of feeling reveals itself most naïvely: in the life of the very poor and miserable. Israëls, like the psalmists, depicts toil and labour as delight. Conciliation speaks to us from Israëls, something of the higher quietness of the philosopher who forgives everything, because he understands everything.
>
> Only a lyrical poet could render full justice to Israëls, for Israëls' painting is colour transformed into a poem; a simple folk song, childlike in the biblical sense, innocent, nothing but heart and feeling. . . . He paints well because he feels rightly. And like Rembrandt, he feels with the figures he paints. He observes the world not with a smile or with mocking condescension, but

with compassion. Hence the melodramatic quality reminiscent of Rembrandt.

Stylistically Israëls represents Realism in its romantic phase, while Chagall represents a style which is a part of the pictorial revolution of modern art in its second and radical phase, and at the same time is Jewish, that is, is typical and expressive of eastern European Jewry up to the revolution in Russia and to the Second World War in the whole area east of the German frontiers. This geographic and historical limitation does not exclude its essential quality as a style. This style was born of a spirit which had prevailed in eastern Europe for centuries, and through the work of art it is lifted out of the chronology imposed by mathematical time. It enters another category of time, that defined in the work of Henri Bergson as *durée*.

We must pause here to note some of the symbols occurring in Jewish art which have become established in its historical course and which play such an important part in the language of modern Jewish art. This symbolism is defined in a most intriguing manner in a small publication by Heinz Edgar Kiewe, *The Forgotten Pictorial Language of Israel*.[38] Kiewe uses a method familiar from similar works such as Harold Bayley's *The Language of Symbolism: An Inquiry into the Origin of Certain Letters, Words, Names, Fairy-Tales, Folklore and Mythologies*,[39] or from specialists' work such as M. H. Farbridge's *Studies in Biblical and Semitic Symbolism*,[40] or Paul Romanoff's *Jewish Symbols on Ancient Jewish Coins*,[41] or in a more compilatory manner in Rahel Wischnitzer-Bernstein's *Symbole und Gestalten der jüdischen Kunst*.[42] The first comprehensive study of the subject has been published by Professor R. Goodenough.[43]

On the oldest gilt glasses from Jewish catacombs (first to third centuries) we find depicted the symbol of the Temple—not Solomon's Temple but the ideal Temple, the eternal Temple of a future life: four Greek columns bearing a pediment. When the change from Temple to Torah service was accomplished, the Torah shrine took the place of the Temple structure together with the scrolls between two seven-branched candelabra, or two lions—symbols of Judah's strength. There was often also the esrog (citron), the lulab, the shofar, the dove with the olive branch, and the fish (a messianic symbol) on a plate, the whole an image of the "pure," the holy repast. In Roman tombs we find peacocks and doves, genii and even pegasi (eternal life). Fishes and peacocks appear in the mosaics of Ham-

mam-Lif and Beth-Alpha, and among other symbols there we find the amphora (Greek two-handled vessel for oil or wine), the branch, the vessel with manna, Aaron's rod with or without buds, the well of life, the ram, the altar (in Beth-Alpha), the goblet with wine, the fig leaf, the grape (symbol of Israel; another symbol of Israel is the olive tree), and the palm tree (symbol of Judah). Among the ornaments of the temple in Capernaum we find the sacred Ark on wheels and the niche for the scrolls. And on tombstones there are symbols of time such as the lamp, the hourglass, and the skull; the open book (for a doctor of medicine or a teacher), the hexagram of the star of David, and the hands of the Kohanim in the gesture of benediction.[44] Among the symbols analyzed in Rahel Wischnitzer-Bernstein's book we find the holy implements of the Temple; the tablets of the law; the table with the showbreads (from a Bible dated 1299 from Perpignan); the pillar of fire (from a Haggadah of the fifteenth century); God's hand in the cloud (which already occurs in Dura Europos); the symbol of the vision of Zacharias; the seven-branched candelabrum between two olive trees; the olive tree on the hill with the fence—the Masora is the fence of the Torah (this from a Torah curtain dated 1783, from a Mainz synagogue); the star of Bar-Kochba; the candelabrum as a development from the Tree of Life or the Tree of the World; the Zodiac (synagogue of Beth-Alpha, probably sixth century); the three- or four-fold fish, the symbol of the trinity (Eliah the precursor of the Messiah, the Messiah ben Joseph, the other precursor of the Messiah, and the Messiah ben David).

We have spoken previously of the Jewish variants of styles, by which we mean the creative assimilation and the transformation of stylistic elements into an artistic language which is the adequate expression of the spiritual values of a community. We are therefore here concerned not merely with the question of influences, nor merely with the question of Jewish art as a part of greater cultural units such as the Phoenician or Hellenistic cultures, but with something more. When restricting one's viewpoint to a somewhat academic classification one is likely to miss the process of creative adaptation. The Roman portrait is a creative adaptation of Greek realism. Dürer's work is a creative adaptation of Renaissance principles in a Gothic environment. The Japanese color-print represents a creative adaptation of Chinese painting. It has been given to only a few peoples to realize under favorable conditions what is in fact the climax of an artistic development, a great style. The Greeks achieved it on the basis

of Egyptian or Minoan stylistic impulses, but the Romans never achieved an individual style; only significant characteristics distinguish Roman works of art. The Germans similarly have never achieved a particular style of their own, only certain characteristics common to non-Latin peoples. They emphasize the expressive at the expense of classical balance. Mathias Grünewald is thus more typical of German art than is Dürer. The Spanish, subject to Moorish influences, did not follow the Greek stylistic inspiration and are expressionist and fantastic both in their Catholic imagery (El Greco, Ribera) and in their anti-Catholic imagery (Goya). Dali combines both. The English never created an individual style; they have only developed certain national characteristics in their art and architecture. The Jewish people, as we see, are not an exception in this respect. And again, there are nations which can be called predominantly artistic or talented in all realms of creative expression (the old Greeks, the old Chinese, the Italians, the French); others are predominantly religious (the Indians, the Jews), others again predominantly philosophical and musical (the Germans). The Russians have great talent for literature, theater, music, and dance; the English, like the old Romans, for theater and literature. Only the gifts for prose writing and science seem more evenly distributed nowadays.

So when we state that the House of the Forest of Lebanon in Solomon's palace represents an architectural idea derived from the large halls of the Persian palaces in Susa and Persepolis (the so-called Apadana); that the type of the synagogues in Palestine, and also in Hellenistic Alexandria and elsewhere, is based on the classic type of the basilica (or *diploston,* that is, double-pillar hall); that the arches of the synagogue in Toledo show the typical horseshoe shape of Spanish-Islamic architecture; that the old synagogues of Italy (Venice, Padua) are conceived in the style of the Renaissance; that the famous Alt-Neuschul in Prague is pure Gothic; and that the wooden synagogue structures of eastern Europe are based on the wood architecture of their respective countries; when we establish that the second Nürnberg Haggadah, 1492, shows a similar conception to that of German illuminated manuscripts, and the Haggadah from Manchester and Paris a northern, French-Burgundian style— we must also add that the building style of King Solomon originated a genuine folk art although it could not, because of political developments, build up a long tradition.

In architecture the large synagogue of Alexandria (this town had forty-two synagogues) established a prototype with its own charac-

teristics, as did that of Delos or that of Worms or that of Prague, all of which were examples for other similar buildings. The same is true of illuminated manuscripts. Jewish art has also influenced the arts of other peoples. We have mentioned Strzygowski's and Wulff's researches into the early Christian era, and may add that the small objects found in early Christian catacombs have a style and character similar to those of Jewish catacombs, but that there was none which could be dated as early as the first gilt glasses of the Jewish Roman catacombs. In the time when the Jewish art of antiquity had reached its zenith, creating new and definite forms for life in the Diaspora, Christendom had only started to establish itself, and it is significant for both that even in about A.D. 100, Christians preached in Jewish synagogues.[45] The Jews brought to Italy the faience technique and inspired its development there, as they introduced the production of decorated glassware. The development of the crafts in Poland during the sixteenth century owes a great deal to the Jews. About ten thousand Jewish craftsmen of all kinds emigrated from Germany to Poland at that period, called in by Casimir the Great to devote their skill to a country which had no highly developed crafts as yet. Even in the eighteenth century the Jews had their own guilds there. Modern researches have discovered new information on this matter.

MODERN JEWISH ART

The fall of the Bastille marked practically the end of the Jewish dark ages, which may be said to have extended from A.D. 311 to 1789. The emancipation, as it is called, was expressed first in the American Declaration of Independence, where the fundamental human rights to liberty of conscience and of worship were established. The French National Assembly of September 27, 1791, formulated these rights for the first time in Europe. Napoleon became the testamentary legatee of the French Revolution. Wherever he went he spread the teachings of French liberalism—*Liberté, Egalité, Fraternité*. Jewish equality was imposed in practically every land which he conquered. This liberation provided one of the preconditions for the rich development of creative artistic work.

However paradoxical it may sound today, in the beginning of modern Jewish art there were single artists of Jewish origin but no Jewish art as such. This is true as much of the Jewish genre painters (Maurice Gottlieb, Leopold Horowitz, Isidor Kaufmann, Samuel

Hirszenburg, and others) as of most of those who can be called the first modern masters of Jewish origin (Jozef Israëls, Camille Pissarro, Max Liebermann, Isaac Levithan). Such single Jewish artists, particularly painters, had existed indeed in former ages, and practically every country has had its share of them. It would lead us too far, however, to deal with them here; their names can be found in any general history of Jewish art. What interests us more is the fact that even in the first modern generation, artists of Jewish origin played a leading part in the development of art in their respective countries. As these countries were at the same time making an effort to establish national schools of art we can realize with what anathemas the efforts of Jewish artists were greeted. Stylistically this new start was more than awkward. The Jews began to paint and to sculpt freely in a modern society in which art had reached its lowest standard for centuries. Historical painting, genre, classicism fossilized in academism—such was the artistic situation. It is only with the revolution of modern art against conventionalism, with Courbet and Delacroix, that the Jewish artist moves, although still without the support of a continuous tradition, in the right direction. It is astonishing, considering the shortness of the time and the relative smallness of their nation, what an impressive number of Jewish artists there were toward the end of the nineteenth century, a number ever growing in the first decades of the twentieth century. And in the third generation of artists, beginning with Moritz Oppenheim of Frankfurt (a sentimental painter of Jewish conversation pieces, who was connected with the German Nazarenes in Rome and was famous for his pictures of Jewish family life), we already encounter artists who stand in the creative forefront of modernism. Only by dividing Jewish artists into groups according to their importance, whether for their home countries only or for the creation of new stylistic trends, and according to their importance for the emergence of a specifically Jewish style, can we produce an historically valid measuring rod.

The first group of Jewish artists we shall deal with here are those who not only attracted the interest of Jewish liberal circles because of their Jewish themes but also made a contribution to the modern revival of art in their respective home countries. In Russia we encounter Mark Antokolski (1843–1902) the sculptor, and Isaac Ilitj Levithan (1861–1900) the painter. Antokolski began his work at art school with Jewish themes, received a scholarship abroad, and was later made a member of the Russian Academy of Arts for his statue

of Ivan the Terrible. In Rome he produced a statue of Peter the Great. The nationalist opposition attacked him as having no right to portray the national hero "because his work is not dictated by a truly Russian spirit." He was applauded by Turgenev and the influential Russian art critic Stassof, who wrote of him: "He is the greatest sculptor of our time, and his personality differs from that of everybody else. . . . Let us not forget that he is a Jew and what this means in Russia. In order to reach his goal, he endured privations and suffering in a measure such as no artist of another race ever had to bear." Antokolski established realism in Russian sculpture. We see a similar line in the life and work of Maurice Gottlieb (1856–79), a Polish-born painter. He painted history pictures in the style of Makart, Piloty, and Matejko. Among them were Jewish subjects, such as Casimir the Great admitting the Jews into Poland. Graetz's history of the Jewish people inspired him to paint Shylock and Jessica, and Uriel Acosta, and he also made sixteen sketches for Nathan the Wise. Matejko hailed him as "the most promising disciple of Polish art" and his worthy successor. For his fellow artists, however, he was only the "Jewish intruder." So he too retired to the Jewish subject. In *The Praying Jews* he produced perhaps the masterpiece of his short artistic life (he died at the age of twenty-three), transcending the theatrical pathos of his masters in a spiritualized lyricism. "Not since Rembrandt had portrayed Jews from the Amsterdam ghetto—he having been the first to present them as real people, not just as genre figures—had any artist gone beyond anecdotal *milieu* descriptions.[46] Although emancipated as we see, the fate of the Jewish artist in countries throttled by a nationalistic mentality was not enviable. Only Paris was to offer the complete creative freedom so essential for any genuine artistic development, and of the eastern Jewish artists it was preeminently Chagall and Soutine whose genius allowed them to make the fullest use of it.

Isaac Levithan (born in Lithuania) established *plein-air* painting in Russia after having studied in Paris with the help of a private scholarship. At thirty-seven he was a member of the Russian Academy of Arts and director of the department for landscape painting. He died at the age of forty. The nationalistic *Novoja Vremya* wrote then: "This full-blooded Jew understood, as did no one else, how to teach us to know and love our land and our country. Isaac Levithan . . . was Russia's greatest landscape painter."

Ernst Josephson (1851–1906), a Swedish-born painter, was the foremost artist of his generation. He became the spiritual leader

of the opposition to the Academy organized by the Swedish colony of artists in Paris. He became mentally ill in 1888—the same year as van Gogh. The tragedy of Josephson's fate lies in the obstacles which were put in his way by Biedermeier Sweden: the inability to appreciate his great ambitions, his failure in the eyes of critics and public, and the treachery of his colleagues, who left him when his personality expressed itself too strongly in opposition. In considering his life we must lay the greatest emphasis on the daemon of his willpower, which once made him exclaim: "I shall either become the Rembrandt of Sweden or die!" Born of a wealthy Jewish family, Josephson had to struggle also against Jewish conservatism. This allowed him to admire Rembrandt's religious realism, but inculcated distrust of everything new and also of the revolutionary element which was his own driving power. A Jewish artist is more likely to approximate the style of Rembrandt than that of Raphael. When he attempts to go against this, as Josephson did, he is doomed. For a Raphael is the fulfiller of an old tradition, and so he is exactly the opposite of a man like Josephson. No individual aspiration can make up for the lack of generations of intensive cultivation.[47] In Sweden, Ernst Josephson has always been spoken of with great respect. During the last fifty years, under the influence of changing taste, this respect has been extended to include the works he produced during his insanity. In an essay published in Stockholm in 1942, I attempted to prove that his importance is not only to be measured by Swedish national standards, but that he is to be regarded as a pioneer of modern Expressionism.[48] This point of view was accepted, and Josephson is counted nowadays among the creative avant-garde of modernism.

In the year 1893, quite independently of van Gogh, Josephson painted the first Expressionistic portrait east of the Rhine. (Van Gogh had painted his portrait of Dr. Gachet in 1890.) It is a picture with an utterly frightening intensity of expression, in its effect stronger than Chagall, and in its conception anticipating the portraits painted fifteen years later by Oskar Kokoschka. Composed in dark colors, glowing like blood and jewels, it represents the artist's uncle, the theatrical producer Ludwig Josephson, directing Shakespeare's *A Midsummer Night's Dream*. The small figures sketched into the background of the picture make us think of James Ensor, the Belgian master who was then, also quite independently, painting Expressionist pictures which afterwards influenced Paul Klee. At the same time Edvard Munch had begun to carry out his Expressionist program, as did later on the German Louis Corinth. Expressionism as a language of the time did not develop in central European art until the first decade of this century.

In the West it was only the work of van Gogh, Rouault, Soutine, and Chagall that could be regarded as Expressionistic. Josephson influenced the German Expressionist movement.

The second phase of modernism in Swedish painting also found in a Jewish artist its most powerful representative and defender. Isaac Grünewald (1889-1946), the first professor of the modernist school at the Academy of Stockholm, was one of the most gifted and successful pupils of Matisse. He not only prepared the ground for Fauvism in Sweden, but also revolutionized theater decors there. Stylistically and artistically, Grünewald went beyond Leon Bakst (1868-1924), another Jewish artist who had performed the same service for the Russian theater. Grünewald took up the challenge of the Diaghilev ballet in Paris in a completely westernized way, demonstrating the dominance for Sweden of French stylistic consciousness and taste. He was the first modern artist to revolutionize the art of pottery, long before Picasso. Chagall embarked on the same undertaking about 1943 under Picasso's influence.[49]

Max Liebermann (1847-1935) was similarly westernized and played a leading part in the foundation of the "Berliner Sezession" which followed the scandal caused by the exhibition of Edvard Munch's work in 1892. He established Impressionism in Germany and was its most prominent representative there. A professor at the Berlin Academy of Arts and a member of the Prussian Academy of Arts and Sciences, he believed in complete assimilation, a dream to be painfully shattered when the Nazi regime stripped him of his honors and prevented him from practicing his art. He died an embittered man. He acknowledged his mistake in a letter to Professor Landsberger: "For youth there is no other salvation than emigration to Palestine, where they can grow up as free people and escape the dangers of remaining refugees." The basic beliefs of his life he defined as follows: "For me there is only art in its plain sense; art which knows neither religious nor political frontiers. There is a difference, however, for the artists who are linked together by both their home country and their religion. Although I considered myself throughout my whole life as a German, my link with Judaism was not less vital for me" (letter of August 12, 1931, to Meir Dizengoff). To be pinned down always offended his feeling of individual freedom. "For after all there are other people besides the Jews. And whether Jew or Christian, man as man is fascinating" (letter of November 17, 1929).[50]

Under the influence of Israëls, whom he admired as both human being and artist, Liebermann was inspired to paint Jewish subjects such as *The Synagogue in Amsterdam* (1877), *The Synagogue in*

Venice (1878), *The Linen Room in the Jewish Hospital in Amsterdam* (1908), and above all the Jewish streets in Amsterdam (the first dates from 1905; he painted many versions).[51] Liebermann also exposed his relationship to Judaism by publishing an autobiographical study in the *Allgemeine Zeitung des Judentums* in 1910.[52] Although his writings and his subjects suggest a traditional line from Rembrandt by way of Israëls, it would be inadequate to describe the style of Liebermann's work as Jewish.

Jozef Israëls, of whom we have already spoken at length, was the acknowledged and venerated master of Dutch modern realism, who revived art on the basis of a genuinely social, human reality. His art decisively influenced the young van Gogh, who mentions his name in his letters several times. In April 1884 van Gogh wrote to the painter Anthon van Rappard,

> My sympathy in literature and in the realm of art is attracted most strongly by those artists in whom I feel the intensity of their work. Israëls is efficient as a technician, but V. also. I love Israëls however much more than V. because I find in Israëls much more and something quite different from the masterly rendering of a subject matter, something quite different from the *clair-obscur*, something quite different from the colour. ... Art is something which is greater and higher than our own skill or learning or science. Art is something which, although produced by human hands, is not produced only by the hands but springs from a deeper source, from our soul; skill and technical knowledge in connection with art remind me of something which is called in religion self-righteousness.[53]

Max Weber, born in Bialystok in 1881, has lived in America from the age of ten. After a decisive visit to Paris at the age of twenty-four he became one of the leaders of American modernism; he went through different phases of development, Cubist, even abstract, but what has always broken through his formalism has been the Expressionist trend with its Fauvist distortion, oscillating between a coarse primitivism and a sophisticated abstractionism, and connected on the whole with Jewish motifs. "One of the deepest sources of strength in Weber's art is his Jewish inheritance. Instead of denying it, he has built his art on it. He is more consciously Jewish than most of his fellow religionists in the arts." (Among these we can name Ben Shahn (1898-1969), Mark Rothko (1903-1970), Jack Levine (b. 1915), Abra-

ham' Rattner (b. 1895), and Larry Rivers (b. 1923). In Max Weber there is "a strong sense of the Hebrew past, of that long history so rich in spiritual genius, so full of tragedy and triumph. After his early years of interest in the contemporary world he was now to return to his racial background and to create his art of imagery expressive of the mind of his race."[54] Other Jewish attributes are his gift for verbal expression, unusual in a painter, and his love of music, second only to his love of his art. In the reminiscences of Adolphe Basler and in monographs on the Douanier Rousseau he appears as the man taking part in musical performances of the French *maître populaire*, rather than as a painter.

However important the Jewish artists just mentioned may be for their individual achievements or for their service in artistic matters to their home countries, the group which we shall now study has had the most decisive bearing on the emergence of a modern Jewish style. The artists named above have followed stylistic trends dominant in their time or characteristic of the avant-garde, but they did not initiate them. There are, however, artists of Jewish origin who took part in the discoveries and the elaboration of modernism and, as in the special case of Chagall, we are even able to connect them with a Jewish imagery (though not necessarily Jewish motifs) and a specifically Jewish approach, thus creating an example of a modern Jewish style. This Jewish creativeness appeared in different guises in conformity with the isms in which the metamorphoses of modern artistic creativeness are arrayed. Jewish artists took part in the invention and creative development of Impressionism (Pissarro), Neo-Classicism (Modigliani), Fantastic art (Chagall), and Expressionism in France (Soutine).[55] Suprematist-Constructivist-Cubist art owes much to El Lissitsky, Antoine Pevsner, Naum Gabo, Jacques Lipschitz, and Ossip Zadkine.

Camille Pissarro, son of a Portuguese Jew of French nationality, was born in 1830 in the Antilles on St. Thomas, an island which was colonized almost exclusively by Jews. (Dutch, French, and English Jews had settled there since the second half of the seventeenth century.) Educated completely freely, he did not experience any confining ghetto walls as these existed in Europe. "A many-sided genius, at the same time inquisitive and humble before nature, Camille Pissarro has not the place in the history of art which he deserves": so says his biographer Charles Kunstler.[56] The critics liked to

classify him "in the rank of the excellent artists of secondary importance" because of the inspiration he drew from Corot, Courbet, Millet, Seurat, and Signac. However, if one investigates thoroughly the dates of the earliest beginnings of Impressionism, one will find that Monet and Renoir were first concerned with Impressionist problems in the summer of 1869 (the so-called Grenouillières period). Pissarro and Sisley, it is said, accepted these principles only with reservations; they found them a little too abstract. In 1870 Pissarro met Monet and Sisley in London. The peculiarity of London light, the impression made on him by Turner and Constable, caused Pissarro during his stay in London to resolve "to give light that primacy which subsequently Impressionism was officially to confer on it."[57] But we must not forget that Pissarro had painted already in 1869 in Louveciennes two pictures of the Seine bank at Bougival with a study of the play of light on water. The question of primacy here has as little meaning as with Braque and Picasso in Cubism, especially as the unity of the Impressionistic style was not a reality until about 1873. It would surely be more important to know how the artists themselves judged Pissarro. Gauguin writes in *Racontars d'un rapin*:

> If we observe the totality of Pissarro's works we find there, despite the fluctuations, not only an extreme artistic will which never lies, but what is more, an essentially intuitive pure-bred art. . . . He looked at everybody, you say! Why not? Everybody looked at him, too, but denied him. He was one of my masters and I do not deny him.

And Cézanne may have the last word on this question. "Perhaps we all come from Pissarro. As early as 1865 he eliminated black, dark brown and ochres, this is a fact. Paint only with the three primary colors and their immediate derivatives, he told me. . . ."[58]

There is no Jewish element in his art at all, except, as Ludwig Meidner pointed out to me, that Renoir and Monet seem optimistic and serene when compared with Pissarro, whose melancholy temperament was expressed in his color moods.

The problem of Jewish art and the Jewish artist did not arise in France before Soutine. Diaz de la Peña (1807-76), of Spanish-Jewish descent, inspired Corot, Millet, and also Monticelli, and was thus an important link in the chain of influence on van Gogh and Expressionism. His significance in the *plein-air* movement has been reassessed in the light of new facts and deserves the attention hitherto given only

to Theodore Rousseau, Jules Dupré, and Charles François Daubigny by French art critics and the art historians who followed them.[59]

Of Amadeo Modigliani (1884-1920), Jean Cassou has said that he

> once more has brought us Italy, glorious Tuscany, his home country, and particularly perhaps the Siennese grace or should one say, the Siennese mannerism: an exquisite elegance as notable in its artistic expression as in the figures represented, an elegance so unusual, so sinuous, that it seemed caused by a constraint. One does not know what severity of exigence—plastic space or moral setting—demanded these gestures of sympathy and arabesque, these looks of concern, this frail melancholy which pleases. . . . Such an art is a precious miracle. It is the art of a good race, of the best race, that of the most princely artists who ever existed. Modigliani appeared among us in France after so many famous Italian appearances, as a gentle foreigner bringing with him the most extraordinary gifts, those of a master.

With these words Enzo Carli's book on Modigliani was introduced.[60] The term "melancholy" occurs here again. There is a strong element of emotion, a softness in Modigliani's concept of a figure or a face, that is not only Gothic or Botticellian, but human, in a modern sense. Waldemar George finds in Modigliani a magnificent synthesis of the Nordic genius of the Gothic, or the art of dramatic and lyrical expression, and of the spirit of the South, of Latin harmony, of the classical handwriting.[61] There is no trace, however, of any Jewish stylistic element in him at all. Some of his models show Jewish traits (Soutine, Max Jacob, Jacques Lipchitz and his wife, *Jeune Fille*, 1916). Adolphe Basler mentions the one sign of nobility which is so characteristic of the Sephardic Jew: "*Subtilité maladive*"—morbid subtlety. "He fled all that seemed to him vulgar. His wide intellectual interests: literature, music, philosophy, could also be described as Jewish."[62] Ludwig Meidner, who met him in Paris in 1907, related that Modigliani spoke with admiration of Munch and Ensor, that is, of the Expressionists, whom the French did not acknowledge at all. One never met him but he had a book peeping out of his pocket: "*Adoro la filosofia e ne subisco profondamente il contagio in famiglia: mia madre discende da Spinoza*" —I admire philosophy and have experienced profoundly my family's involvement with it; my mother is descended from Spinoza.[63] An intimate friend of Soutine, he decisively influenced the neo-classical trend in Italy, in France, and elsewhere. His sculptures had an impact on Jacob Epstein in an early phase of his development.

> Chagall added to the changing pictorial conception of the West something new, something that was to bear its fruit in the future. At a time when mathematics and science were the only guides of Parisian painters, he assessed the rights of poetry. Not literature, but poetry, the expression of his intimate being.

So writes Lionello Venturi, and he calls Chagall's work an unexpected treasure. Chagall has made one of the greatest contributions to the realization of freedom in art.[64] Chagall is acknowledged as a forerunner of Surrealism, and by his exhibitions in Berlin (Der Sturm) before, during, and after the First World War he has decisively influenced modern German painting. "He is the first artist upon whom his heritage does not rest as a burden and a hindrance, but who is able to give positive and joyous expression to his Judaism."[65] This was due to the spirit of Hassidism. About his roots in Jewish tradition Chagall himself said:

> I want to speak so very little of myself. I have never said to myself that I have accomplished anything or reached somewhere. The only thing that I wanted in my life was—not to get near the great masters of the world like Rembrandt, El Greco, Tintoretto and others—but to get close to the spirit of our own fathers and grandfathers, to be of their essence, to mingle myself among their folds as if lying hidden in their garments—with their souls and sorrows, with their worries and rare joys.[66]

In this spirit Chagall took up and developed the Jewish folk style, until then expressed in story and song only; through it he was able to give plastic form to the poetic imagery of the Old Testament.[67] He paints and draws the metaphors which are so vividly employed by the psalmist or by the prophets or in the Song of Songs:

> My beloved is unto me as a bundle of myrrh that lieth betwixt my breasts. My beloved is unto me as a cluster of henna flowers in the vineyards of En-Gedi. . . . thine eyes are as doves behind the veil, thy hair is as a flock of goats that lie along the side of mount Gilead. Thy teeth are like a flock of ewes that are newly shorn . . .

A Chagall painting is like a transposition of lyrical poetry and opens up to modern man a new beauty, a new visual conception.

Throughout the literature we find that one of the characteristics ascribed to the work produced by Jewish artists is its humanistic

quality. Jewish artists use for their purpose either the objective reality or the visually definable elements of a symbolic value. This, however, does not cover the work of artists such as El Lissitsky and the brothers Naum Gabo (b. 1890) and Antoine Pevsner (1884-1962), who belonged to the avant-garde generation of Russian Suprematists and Constructivists during and after the First World War. Russian Suprematism and Constructivism had a decisive influence on the German Bauhaus, and later on American modern art. Sir Naum Gabo is indeed a great artist among the Constructivists, who in applying a completely novel vision achieved new enduring values of beauty. Gabo wrote,

> We are in a chaos temporarily, in a time of transition, simply because we have not yet established a new module for living as well as for thinking. It is for this reason that the picture of our civilization seems to be out of joint. It is the artist's rôle as well as the scientist's, the philosopher's and the poet's to try to give as much as possible towards working out an approach to this new module or order on which to base our orientation, our value assessments and the like in the new world.[68]

Here, then, we see a creative artist who is no longer concerned with the purely physical aspect of the world, who grew out of the Jewish mentality straight into the great problems posed by a scientific civilization. This civilization is global in its aspects, and Gabo as well as Pevsner did not hesitate to make their contribution to it, shedding among the values which belonged to a past world that of nationalistic standards for the judgment of art and that of local tradition. A similar problem occupied the painters Max Weber, Alva (b. 1901), and Jankel Adler (1895-1949). Adler aimed at a personal and vital synthesis between his Hassidic philosophy, the folklore element, symbolism, and the traditional ornament in his art on the one hand and a Klee-Picassoist modernism in his art on the other. Whereas in the case of Gabo we cannot speak of a Jewish style, only perhaps of a Jewish spiritualism and dematerialization in the construction of a new image of the world,[69] in the case of Adler we might speak of a tragic fate which bereft an artist at the height of his creative power and craftsmanship of the possibility of fulfilling a synthesis of great promise. His goal was a Jewish style which should go beyond the Realist-Fantastic-Expressionist phase. In Endre Nemes one can recognize another masterly and personal synthesis of the same kind, with symbols of death and of the transitoriness of things, whether embedded in a Surrealist, in a post-Picassoist, or in an abstract form world.

With Jacques Lipchitz (b. 1891) we have to acknowledge the fact
of a new unified world view based on the scientific revolution and to
agree with his biographer that "the problem of ethnic heredity seems
this time and in his case to have received a hard blow."[70] His inventive
power, his influence on contemporary development (on Henry Moore,
for instance), his leading position are firmly established. "Thanks to
Jacques Lipchitz the twentieth century will see, among other mar-
vellous things, the birth of a completely renewed sculpture."[71] Never-
theless, there is much in his work that is nourished by old Jewish
imagery, as the following titles indicate: *Jacob Wrestling with the
Angel* (bronze, 1932); *The Return of the Prodigal Son* (plaster, 1931);
David and Goliath (plaster, 1933). Even the inspiration he draws
from human themes (*La Joie de vivre; Mother and Child; Benedic-
tion*), as well as his passion for the great initiates and mystics, the
Kabbalah, alchemy, magic, and various mythologies, can be traced
back to his Jewish origin and upbringing. In the question of style we
cannot do more than simply acknowledge a new formative will. Just as
we can establish that Mondrian's puritanism has its roots in the Dutch
character, so we might also find that Lipchitz's emotional quality is
Jewish.

After Lipchitz we may place Ossip Zadkine (1890-1967) as a
sculptor of importance but not of the same inventive power as the
early Lipchitz. There is in many of his works a passionate and ex-
pressive primitivism: *Prophet* (bronze, 1914); *Head of Woman*
(quartz, 1933); *Head of Man* (quartz, 1943). "The soul of the Slavs
and the soul of the Negroes, like all the souls of primitive peoples,
possess sources of sensibility which are absolutely common to them,"
says Raynal of Zadkine.[72] This primitiveness, and a formal vocabulary
based on Cubism, produced that personal quality which is Zadkine's
and which was acknowledged through the first prize at the Venice
Biennale of 1950. To speak of a Jewish style is scarcely possible, even
here. His style is contemporary and universal. The creative freedom
provided by Paris enabled the Jewish artist to develop his gift on a
world stage for the first time since Hellenism.

Among the creative pioneers the Polish-born American sculptor
Elie Nadelman (1885-1946) must be mentioned. In his later years he
worked in an archaic style, but in the first decade of this century he
was preoccupied with abstract studies. Adolphe Basler wrote of him:
"The brothers Nathanson, former directors of *La Revue Blanche*,
drew the attention of Gide and Mirbeau to this new talent. The re-
searches of Nadelman disturbed Picasso also." Other prominent

American sculptors were William Zorach (b. 1887), Theodore Roszak (b. 1907), Chaim Gross (b. 1904), Ibram Lassow (b. 1913), George Segal (b. 1924), and Bernard Reder (1897–1963).

Sir Jacob Epstein (1880-1959) was born in America of Polish parents and lived in England. He was a well-known sculptor but not of the modernist school, although he experimented in his youth. His work shows affiliations with Michelangelo and Rodin, but also with the primitive art of Africa and of the Far East. Epstein had the sensuousness of the Oriental and deep affinities with Jewish life (illustrations to Hutchin Hapgood's book *The Spirit of the Ghetto: Lower East Side of New York*); Jewish subjects (*Jacob Kramer*, 1921; *La Belle Juive*, 1930; *Rebecca*, 1930; *Albert Einstein*, 1933), and Jewish tradition (*Adam*; *Genesis*; *Behold the Man*; *Jacob Wrestling with the Angel*; *Lazarus*).[73] Epstein wrote:

> I saw a great deal of Jewish orthodox life, traditional and narrow. As my thoughts were elsewhere, this did not greatly influence me, but I imagine that the feeling I have for expressing a human point of view, giving human rather than abstract implications to my work, comes from these early formative years. . . . In 1931 I made a series of drawings for the Old Testament. I became so absorbed in the text and in the countless images evoked by my reading, a whole new world passed in vision before me.[74]

Thus, even in sculpture, the field which was the least developed and favored in Jewish art, the Jewish artist, given the freedom, has placed himself among the foremost representatives of this art.[75]

Expressionism has only recently been acknowledged in western Europe, and it was foreign appreciation, especially the appreciation of American scholars, which made the French critics reassess the work of Chaim Soutine (1894–1943). They recognized that the art of Soutine, "through the very fact that it exists in such an aggressive and individual fashion," posed with unusual force two important questions: the question of Jewish art and the question of the beauty of ugliness, that is, the right not to please. These are in fact two primary problems in contemporary art, two questions which are generally avoided but which Soutine does not allow us to ignore. To fail to take them into account when judging him is to misunderstand him; to deny their presence, as some have tried to do, is to refuse to see who he

really was.[76] In reaching a high level of French painterly culture, a feeling for *la belle matière*, Soutine differs from German Expressionism and approaches the late work of van Gogh, who also was representative of a non-Latin heritage. Van Gogh personified the protest of the artist against a highly materialized, a-religious, anti-artistic society; Soutine brought into art also the age-old apocalyptic heritage connected with the Jewish fate, with a highly developed instinct for approaching catastrophe. His paintings are tormented by anxieties in the same way as is the writing of Franz Kafka—the haunted rhythm of destruction and fear, symbols of death (raw meat, dead chickens hanging by elongated necks, disemboweled rabbits, bloody carcasses—altogether a desperate vision).

So the problem of Jewish art had to be taken up in France:

> Certainly in France there were Jewish painters before him, but what can be called more specific in their work which would place them in opposition to or simply distinguish them from other French painters? What special characteristics do we find in the work of Pissarro, of Leopold Levy, of Simon Levy, among others, which would establish a particular aesthetics? Truly, there was no Jewish art in France prior to Soutine. Beginning with him, on the contrary, one can construct a complete conception of art exemplified by many painters: Mané Katz, Ryback, Max Band, Leon Zak, Menkès, Krémegne, and many other painters, to whom one can without artifice also add Chagall.[77]

G. di San Lazzaro also grappled with this question:

> It is commonly said that one of the characteristics of the École de Paris . . . was the revelation of Jewish painting. The East European artists of Jewish origin (Soutine, Chagall, Krémegne, Kikoine, Henri Epstein, Kisling, Zak, Menkès, Max Band, Feder, Mané Katz, Kanelba, etc.—other names are Aberdam, Mintchine, Chapiro, Peretz, Sterling, Seifert, Blond, Pailes, Weingart)—may differ on account of their particular sense of humanity, from East European Catholic and Orthodox painters, such as Larionoff, Gontscharova, Annenkoff, Andreenko, who are more inclined to view art as a purely aesthetic matter, and from painters like Terechkovitch and Jean Pougni, who can now be looked upon as straightforward French Post-Impressionists. But we must not forget that Marcoussis, for example (who was a Polish Jew, like Eugène Zak), and many others who developed under the influence of Picasso and the sculptor Jacques Lip-

chitz, also of Polish Jewish origin, are much closer to Larionoff than they are to Soutine, Pascin or Moïse Kisling.[78]

Jules Pascin (1885–1930) particularly pinpoints a new problem in Jewish art—the conception and rendering of the nude, a subject hitherto suppressed by religious taboos.

The enumeration above allows us to declare that "Jewish" art is entirely the product of painters who have not only Jewish origin but also a Slavonic background, and that their contribution to contemporary art is not only a Hebrew aesthetic but, perhaps even more, an almost Oriental imagery, with primacy of color, and with dream and imagination acting strongly in the choice of subject matter and its interpretation. "It is certain that Soutine is the most violent representative of this particular expression in which we can discern without difficulty three essential characteristics: firstly, the exaltation of color carried to the extreme, then violence in contrasts and refinement in the interrelations of all of them, culminating in an intensity and rhythm which can be called musical."[79] Cogniat adds significantly: "This aesthetic . . . remains all the time dominated by man. This need for the human presence motivates the importance of the portrait in Jewish art." He understands that this arises from the "solitude and emptiness of those transplanted, who, having broken with their past, find themselves without a home country in a world much too intellectual, with which they do not feel themselves to be connected."

Elie Faure, the French-Jewish art historian, is not far wrong in judging that Soutine's master was Rembrandt.[80] But he has still to ask about the man whom Waldemar George calls "a saint of painting":[81] "Where does his genius of painting, so rare in the Near East and practically unknown amongst the Jews, come from? Where this transposition of creative forces which inundates today the genius of the Jewish people, until now restrained to banking and commerce, throwing itself against the walls which were erected for twenty centuries between itself and the world, banished from culture, banished from the luxury of suggestibility, banished from freedom." And again we are confronted with the problem we have tried to solve here: Is the Jew reflected in his painting? It is difficult to answer, because there is no Jewish painting; nevertheless, Faure writes in his book on Soutine,

the Semite, especially when he mixes with other races, has marked them with a burning sign which can be traced back

to their figurative language. The art of the Assyrians, Phoenicians, the Arabs, the Moors of Spain, has something in common, a furious conflict between the genius of the desert, where abstraction reigns, and the genius of the complementary peoples, who are attracted to and hold on to their object. This is the origin of the sensual ardor, the spiritual fire whence the drama arises and which manifests itself so often in a kind of cruelty. Thence comes the sinister consent to the reign of ferocity and horror. There is something of all these elements in the work of this gentle but many-sided man. . . . I believe that this European-Oriental represents a great moment of painting, maybe an atheistic painting such as that of the West has been for the last four centuries, but a painting no longer intellectual and naturalistic in its appearance. It tries to create from within a new organism with the elements of reality.

Faure seems to recognize in it "the mysticism of the future, a mysticism supported by no creed," and he asks, "Can European rationalism be cured otherwise than by the heart?" It is the first time in the history of European art that it has been said of a Jewish artist, "*cet homme qui n'est qu'un peintre*"—this man, who is nothing else but a painter.

It would be impossible within the scope of a study such as this to mention the name of every Jewish artist. There are a great number now, especially among the abstractionists.[82] Nor have the question of the half-Jewish artist, the question of the Jewish art collector, art dealer, and art critic and their roles in the liberation and support of the Jewish artist, been touched upon here. We have merely attempted to arrive at as clear a picture as possible of the problems connected with Judaism and the visual arts. Now we shall examine the ideas of some modern artists of Jewish origin on these problems as expressed in conversations with the author.

Marc Chagall himself is against attempting to identify Jewish art, but he has said: "And yet, it seems to me, had I not been a Jew, I would have never been a painter, or an entirely different one." The problems examined in this essay were discussed with six prominent Jewish artists: Ludwig Meidner, Alfred Aberdam, Friedrich Feigl, Endre Nemes, Jacob Bornfriend, and Josef Herman.

Ludwig Meidner (1884–1966), along with Lesser Ury (1861–1938) and Max Pechstein (1881–1955), was one of the most outstanding Jewish painters in Germany after Liebermann. Meidner was an Ex-

pressionist and, toward the end of his life, painted with a visionary, ecstatic realism. Alfred Aberdam (1896–1963) was representative of a trend to fantasy in the tradition of Monticelli, Goya, and Watteau. Friedrich Feigl (1883–1964) was a post-Impressionist, and in his later years adopted the Rembrandt tradition in a modern trend to Luminism. Endre Nemes (b. 1909) strove for a synthesis on the basis of Rouault and Picasso, Surrealism and abstraction. Jacob Bornfriend (b. 1904) based his earlier painting on a true folk-art tradition and post-Cubist principles, but is now abstract. Josef Herman (b. 1911) is an Expressionist-Realist painter in the tradition of Permeke.

All these men agreed that the Jewish artist has practically no tradition. The consequence of this is that "compared with the Latin masters they always give the impression of heaviness and gaucheness" (Feigl). Meidner named in this connection Israëls, Pissarro, Soutine, and even Liebermann. Chagall, however, said Bornfriend, is very adroit and so is Nemes; they are exceptions. Modigliani is an exception also, because he was born on the very soil of classical tradition. In Bornfriend and in Meidner elements of the primitive or the naïve are discernible. Naïvism, which one would not expect in the work of Jewish artists, has its roots mainly in eastern Europe, that is, in the tradition of crafts and folk art. A robust Jewish folk art has arisen before in previous phases of Jewish history: as a consequence of Solomon's building activity, in German illuminated manuscripts of the thirteenth century—the Machsor in the Raschi synagogue of Worms, 1272—and also in Poland in the eighteenth and nineteenth centuries. Closely allied to this primitivist trend is also the fact that Jewish artists in general are more romantic than classical. "Nobody can begin as a classic. Even Gothic man had to start anew, with the sentimental, and had to return to nature. Besides, the Germanic peoples, like the Jews, lack the Latin harmony, the sense of *mésure*" (Feigl). Bornfriend expressed his view that the Jewish artist, wherever he may live, is closest to the Nordic temperament. In Herman's view neither realism nor classicism ever completely succeeded with the Jewish artist, whereas Romanticism and Expressionism clearly have succeeded. He sees a parallel in the development of Jewish literature. "In general the Jewish artist will always represent or return to an Expressionist trend" (Bornfriend). "There are definite symptoms that the Jewish avant-garde still has—against the so-called formalistic trends—a strong leaning towards the expression of psychological contents. And this either in a direct manner, as in Israëls or Soutine, that is, expressionistically, or again in a roundabout way,

often literary and sentimental, as for instance in Chagall, Kisling, or Pascin. Both methods have their attraction, for they still shelter possibilities of an enrichment of reality" (Aberdam).

Bornfriend finds that the Jewish artist is a humanist rather than a purely decorative artist, and can only with great difficulty part with the figurative motif. This, according to him, has its origin in the fact of a too short tradition. For the Jewish artist the motif is still a great experience and not yet exhausted. He is fascinated by and tied to the expressiveness of natural phenomena. Jewish art is, so to speak, in its infancy. For the homeless artist the motif, the human quality, replaces the homeland. Lonely, isolated artists are rarely abstract, nearly always humanists. They need to lean against something. Abstract art, on the other hand, is always a symptom of satiation. The humanistic quality in Jewish works of art has often a shade of intimacy, a lyrical quality. The disadvantage of this taste for the intimate lies, so Aberdam thought, in the fact that the Jewish artist takes only a small part in the trials and errors of modernism. He remains aloof and outside his own time. Such a conservatism is, however, still capable of bringing good results in a period when so much modern painting is far removed from any human quality. This conservatism, this tendency toward the intimate, is in some way a regression, a symptom which is not new in Jewish art history. The arches in the synagogue of Worms are Romanesque although the building was begun in the earliest Gothic period, in the twelfth century. Romanesque stylistic elements still appear in Baroque times. The Lemberg synagogue of 1582 is still Gothic; only the ornaments are Renaissance, although it was built in the Renaissance period.

As we have mentioned before, a common feature of Jewish works of art is their melancholy and a certain nostalgia. Bornfriend is convinced that nearly all Jewish painters show signs of this melancholy. Aberdam stressed in this connection the restrained quality of their colors. Josef Herman agreed with him. He based his judgment on the impression made on him by the great exhibition at the Festival of Jewish Art in Glasgow in 1951. For Nemes, common features in Jewish art are a lack of and nostalgia for roots, the urge to find a tradition and milieu: "This problem has been the most intense—at least in my generation—and the cause of endless discussions amongst us." The lack of tradition seems to have produced a certain eclectic element in Jewish art. "Nevertheless, even without a 'national' tradition, Jewish painters and sculptors have brought forth, in the short

time since their emancipation, an art which can well stand comparison with the art of the great nations—and which has even been a source of inspiration to them" (Nemes).

The question whether a Jewish stereotype is characteristic of Jewish art is answered in the affirmative by Bornfriend. "Each artist formulates his own type in a metamorphosed form. Hence the importance of the Jewish type for the Jewish artist."

Meidner expressed his belief that a specifically Jewish art exists in modern times. Nemes, however, preferred to regard Jewish art as the art of a number of disparate individuals and tendencies. Bornfriend answered the question as to the existence of a Jewish style with another question: "Is there a Czech style, an English style, a Polish style?" The problem of Jewish art today is closely connected with the whole spiritual problem of our time. There is no unified artistic style in our age because there is no common denominator of spiritual outlook, despite the common material (technological) and scientific base. There are thirteen distinct stylistic isms. Many modern nations have contributed to what is known as "modern art": France first and foremost (the Symbolists, the *plein-air* painters, the Realists, the Impressionists, the Fauvists, the Surrealists); Spain (Picasso, Gris, Miró, Dali); Norway (Edvard Munch); Germany (Klee, Max Ernst, Nolde); Austria (Kokoschka); Belgium (Ensor); Holland (van Gogh, Mondrian); Russia (Kandinsky and the artists already named); the Jews (Chagall). Expressionism and the School of Paris represent a universal art in the same sense as the Phoenician or Hellenistic art was universal. That is why we must say that the art which is produced nowadays in Israel is strongly influenced by Expressionism, the School of Paris, and more recent abstract trends. Not even the persuasive preface of Gabriel Talphir to his portfolio *Israeli Painters*[83] nor the controversial article on "Painting in Israel"[84] can convince us otherwise.

No modern people has been able to preserve a national style in art. But there are characteristics, variants, due to race, climate, and tradition. As long as art in Israel is honest, it will find its place in the general pattern of the art of our time. "Art," said Chagall in *Ma Vie*, "seems to me to be a state of the soul: The soul of all people is holy, of all bipeds in all points of the world. Only the honest heart which has its natural logic and reason is free. The soul which on its own has arrived at this state . . . is the purest."

NOTES

1. *Hebräische Archaeologie* (Frieburg im Breisgau, 1894).
2. *Les Peintures de la synagogue de Doura-Europos* (Rome, 1939).
3. *Orient oder Rom* (Leipzig, 1901).
4. *Altchristliche und Byzantinische Kunst,* Vol. 1 (Berlin, n.d.).
5. Final report, Part I, in *Synagogue: Excavations at Dura Europos* (New Haven, 1956). See also A. E. Chase, *The Yale Excavations at Dura Europos* (New Haven, 1944).
6. *Jewish Symbols in the Greco-Roman Period,* 11 vols. (New York, 1953–64).
7. *Eranos Jahrbuch,* Vol. 20 (Zurich, 1951).
8. *Einführung in die jüdische Kunst* (Berlin, 1935), and *A History of Jewish Art* (Cincinnati, 1946).
9. *Die Juden in der Kunst* (Berlin, 1928).
10. *The Universal Jewish Encyclopedia* (New York, 1939).
11. "Art and Judaism," in *Jewish Quarterly Review* (London), July 1901. See also Olga Somech Phillips' biography of the artist and her preface to the loan exhibition held at the Ben Uri Art Gallery in May 1946.
12. From a conversation with the painter Josef Herman, with whom Jankel Adler had often discussed these questions in London.
13. Letter to the author, August 1953.
14. *Die jüdische Kunst: Ihre Geschichte von den Aufängen bis zur Gegenwart* (Berlin, 1929).
15. Helen Rosenau, *A Short History of Jewish Art* (London, 1948).
16. *Die Juden in der Kunst,* 2d ed. (Vienna and Jerusalem, 1936).
17. (New York, 1949).
18. Carlile Aylmer Macartney, *Chambers' Encyclopedia* (London, 1950).
19. *Les Voix du silence* (Paris, 1951).
20. "Die alte Kunst Palästinas," in Karl Woermann, *Geschichte der Kunst,* Vol. 1.
21. Landsberger, *A History of Jewish Art.*
22. Paul Deussen, *Die Philosophie der Bibel* (Leipzig, 1923).
23. *Education Through Art* (London, 1943).
24. *Menschenkenntnis* (Leipzig, 1928). See also: Lewis Way, *Alfred Adler: An Introduction to His Psychology* (Harmondsworth, 1956).
25. (Paris, 1931).
26. *Soutine* (Paris, 1928).
27. A. F. v. Schack, *Poesie und Kunst der Araber in Spanien und Sizilien,* 2 vols. (Stuttgart, 1877); Al Gayet, *L'Art Arabe* (Paris, 1893); J. v. Karabacek, *Das angebliche Bildverbot des Islam* (Vienna, 1876).

28. *Der heilige Weg* (Frankfurt, 1920).
29. *Der Untergang des Abendlandes,* Vol. 2 (Munich, 1922); *The Decline of the West* (London, 1926–29).
30. *Die Mystik des Apostels Paulus* (Tübingen, 1930; English edition, London, 1931), and *Von Reimarus zu Wrede: Eine Geschichte der Leben-Jesu-Forschung* (Tübingen, 1906; English edition, London, 1910). Also Gregory Dix, *Jew and Greek: A Study in the Primitive Church* (London, 1953).
31. See the catalogue *Jankel Adler (1895–1949),* Gimpel Fils Gallery, London.
32. J. P. Hodin, "Marc Chagall: In Search of the Primary Sources of Inspiration," in *The Dilemma of Being Modern* (London and New York, 1956).
33. Kurt Seligmann, *The History of Music* (New York, 1948).
34. *Ma Vie.*
35. See Martin Buber, *Die Chassidischen Bücher* (Hellerau, 1928).
36. Helen Rosenau, letter to the author, August 1953.
37. (Berlin, 1901).
38. (London, 1951).
39. (London and New York, 1952).
40. (London, 1923).
41. (Philadelphia, 1944).
42. (Berlin-Schöneberg, 1935).
43. *Jewish Symbols in the Greco-Roman Period.*
44. See Marvin Loewenthal, *A World Passed By* (New York, 1933).
45. See Dix, *Jew and Greek.*
46. Schwartz, *Jewish Artists of the Nineteenth and Twentieth Centuries.*
47. J. P. Hodin, "Ernst Josephson and C. F. Hill: A Study in Schizophrenic Art," in *The Dilemma of Being Modern.*
48. *Fundamentals of a New Approach Towards Ernst Josephson's Art, Personality and Insanity,* privately printed. Quoted by Ernst Kris in his *Psychoanalytic Explorations in Art* (London, 1953).
49. J. P. Hodin, *Isaac Grünewald: A Biography* (Stockholm, 1949).
50. Max Liebermann, *Siebzig Briefe,* ed. Franz Landsberger (Berlin, 1937).
51. *Max Liebermann: Ausstellung zum 70. Geburtstag des Künstlers.* Königl. Academie der Künste, Berlin (Leipzig, 1917).
52. Reprinted in Max Liebermann, *Gesammelte Schriften* (Berlin, 1922).
53. *Briefe an den Maler van Rappard, 1881–1885* (Vienna, 1937).
54. Lloyd L. Goodrich, *Max Weber,* Catalogue of the Retrospective Exhibition, Whitney Museum of Art (New York, 1949). See also Emery Grossman, *Art and Tradition: The Jewish Artist in America* (New York, 1967).

55. Ludwig Meidner in Germany belonged to the second Expressionist generation, following the lead given by "Die Brücke" and Oskar Kokoschka.

56. *Camille Pissarro* (Paris, 1930).

57. Maurice Raynal, *From Baudelaire to Bonnard: History of Modern Painting* (Geneva, 1949).

58. "Preface," *Camille Pissarro: Letters to His Son Lucien* (London, 1943).

59. See D. C. Thomson, *The Barbizon School of Painters* (London, 1891), and Karl Woermann, *Geschichte der Kunst* (Leipzig, 1922), Vol. 6.

60. (Rome, 1952).

61. *Note e Riccordi su Amadeo Modigliani, 1884–1920* (Rome, 1945).

62. *Modigliani* (Paris, 1931).

63. Nietta Apra, *Tormente di Modigliani* (Milan, 1945).

64. *Marc Chagall* (New York, 1945).

65. J. P. Hodin, "Une Rencontre avec Marc Chagall," in *Les Arts Plastiques* (Brussels), No. 2 (1950). See also J. P. Hodin, "Marc Chagall," *The Month* (London), No. 4 (1950).

66. Isaac Kloomok, *Marc Chagall: His Life and Work* (New York, 1951). This book is the only one on Chagall which has thoroughly explored the Jewish source of Chagall's world of ideas. See also Franz Meyer, *Marc Chagall* (London, 1964).

67. See "Le Message Biblique de Marc Chagall," Catalogue, Musée du Louvre (Paris, 1967).

68. *Three Lectures on Modern Art* (New York, 1949).

69. James Johnson Sweeney, "Modern Art and Tradition," in *Three Lectures on Modern Art.* See also Gabo, *Constructions, Sculptures, Paintings, Drawings, Engravings,* with introductory essays by Herbert Read and Leslie Martin (London and Cambridge, Mass., 1957).

70. Maurice Raynal, *Jacques Lipchitz* (Paris, 1947).

71. Maurice Raynal, "Lipchitz," in *L'Art d'aujourd'hui.* Quoted by Roger Vitrac in *Jacques Lipchitz* (Paris, 1927).

72. *Zadkine* (Paris, 1924).

73. Robert Black, *The Art of Jacob Epstein* (New York, 1942).

74. Jacob Epstein, *Let There Be Sculpture: An Autobiography* (London, 1940).

75. Flavius Josephus testifies, in his *Jewish Antiquities,* that no free sculpture or figural works were tolerated in holy places, although we know, of course, of the "molten sea" supported by the twelve brass oxen, and of the stone lions standing in pairs in front of the Torah shrines and reminiscent of the Cherubim placed in the Temple of Solomon in front of the Ark of the Covenant. We know

also of Hellenistic sarcophagus sculptures and temple reliefs and consoles.

76. See Raymond Cogniat, *Soutine* (Paris, 1945).
77. Ibid.
78. *Painting in France, 1895–1949* (London, 1949).
79. Cogniat, *Soutine*.
80. *Soutine* (Paris, 1929).
81. *Soutine*.
82. See Rudi Blesh, *Modern Art, USA: Men, Rebellion, Conquest, 1900–1956* (New York, 1956), and Michel Seuphor, *A Dictionary of Abstract Painting* (London, 1958).
83. (Tel Aviv and New York, 1953).
84. Signed J. W. (ed.) in *Gazith: Art and Literary Journal* (Tel Aviv), No. 139–40. See also Archibald Ziegler, "Art in Israel," *The Studio* (London), February 1952.

2 • THE PERMANENCE OF THE SACRED IN ART

The Artist Speaks

Bear witness, all of you, that I have done my duty
As a perfect chemist and as a saintly soul.

<div align="right">

BAUDELAIRE
Les Fleurs du mal

</div>

Religious feeling always remains the same in man, but it always expresses itself in new forms. The old Greeks were in their way as religious as the Indians or Mohammedans and Christians, and the new European of the twentieth century will not feel less religious, but will feel religious in his own way.

<div align="right">

FRANZ MARC

</div>

WHEN RODIN WROTE HIS OBSERVATIONS ON THE CATHEDRALS OF FRANCE he found himself confronted not only with the true genius of France but also with the problem of religion and art,[1] and, as an artist of the nineteenth century, with the disturbing problem of art and the scientific age. He went so far as to say that good art has always been religious art, and in this Renoir agreed with him. Speaking once about the general progress that takes place in art and its unity wherever there exists a high appreciation of religious concepts—in Egypt, Greece, and western Europe—Rodin concluded that this held true to such a degree that one might be tempted to say that outside religion there can be no art.

On this account his own time worried him, because "people do not want gods any more but our fantasy cannot do without them."[2] (One has to admit that modern rationalism, even if it satisfies the savants, can never be reconciled with the concept of art.) And Dela-

158

croix maintained that we pray as little to the saints as to beauty. And if the gods are banished, to whom should the artist address his enthusiasms? A painting of Giotto's threw the whole population of Florence into raptures. Delacroix, asked whether he believed in God, answered,

> Yes, when I work. When I subdue myself and become humble, then I feel that someone is helping me who allows me to create works which go beyond me. Nevertheless, I do not feel any gratitude towards him, for to me he is like a conjuror whose tricks I cannot unravel, and thus I am deprived of the advantage of an experience which in fact should be the reward of my toils. I am ungrateful, without repentance.[3]

Baudelaire, using in his essay on the Exposition Universelle of 1885 the phrase "shifting of vital energy," proclaims that "the artist is a law unto himself. He promises future ages no work but his own. He takes full responsibility for what he does. He is his own king, his own priest, his own god." At the Salon of 1859 he had gone even further: "Art is the only spiritual realm in which man can say: 'I shall believe if I want to believe, and if I do not want to believe I shall not believe.' "[4]

These statements reveal stages in a process which, a century later, may seem to us to have gone still further, yet without our having come to grips with the essential underlying questions. Rationalism is not enough, for, as Marini once said to me, "there are things under the sun which cannot be expressed in words." There was no problem, of course, for a believer such as Rouault, for whom art was a "glowing confession." But between these two statements of Alexis Jawlenski, "Art is nostalgia for God"[5] and "Art is the visible God,"[6] is the whole abyss of longing, uncertainty, unrest, and change which in Rodin's mature thought found its battlefield and its solution.

In the nineteenth century an attempt was made to replace religion with art, and new "cathedrals" were built in the shape of museums. At the same time there was a tendency to replace religion with humanism and faith with knowledge.[7] This had happened before in Greek culture and again in the Renaissance; it is not a new problem: it is only new to us who are confronted with it in a world changed by technology.[8] Rodin knew, though, that "it is necessary to bind the present and the past together." For past generations "art was one of the wings of love; religion was the other. Art and religion give hu-

manity all the certainties it needs in order to live, except at times
when humanity is sunk in indifference—that moral fog." And so he
could say: "An art with life in it does not reproduce the glories of
the past; it continues them." He wished to replace the religion of
dogma with a religion of the miracle of creation, claiming: "Art con-
sists of the praise of nature by men filled with love and admiration
for her. Art is the harmonious ritual of that great religion—the re-
ligion of nature. . . . To produce those masterpieces of the Gothic
period, those cathedrals of the human spirit, a gentle and pious mind
was needed." And, castigating the scientific spirit of the nineteenth
century, he asked:

> Is it man who has diminished, or is it the Godhead? . . . Europe,
> like a weary old Titan, changes its attitude and in so doing
> loses its balance. Will Europe be able to adapt itself to new
> conditions, or will it, instead of changing, completely lose its
> equilibrium? . . . In time, man raised himself to the height of
> God. Then man replaced God, and now all has to be begun
> anew.[9]

Is this not exactly where we still find Picasso today? After the end of
the Second World War I ventured upon my pilgrimage to the great
artists of our time, not to ask them the secret of their techniques and
styles but to receive from them, whose works will reveal to future
times the countenance of our age, an answer to the ultimate ques-
tions of life and death, art and civilization. In 1952, in Picasso's
studio in No. 7 Rue des Grands Augustins, there stood the original
L'Homme au mouton (The Man with the Sheep), which he created in
1944 and which is now in front of the church in the potter's town
of Vallauris, where Picasso himself was involved for a long time in
adventures as a potter. The figure has an appearance of timelessness,
as though it had been standing there for centuries, much longer than
the church itself. Was it a religious symbol, a memento, the Good
Shepherd?

> It isn't religious at all. . . . The man could carry a pig instead of a
> sheep!
> There is no symbolism in it. It's simply—beautiful. The symbol-
> ism is read into it by the public. The people create it. In
> *L'Homme au mouton* I expressed a purely human sentiment, a
> feeling which exists today as it has always existed. *The Man Car-
> rying a Calf* from the Acropolis Museum, *The Man with the*

Sheep and, if you like, *The Man with the Pig*—why not? They are all human.

I had just come from Chartres and felt strongly that something essential was missing in our time. I voiced my doubts whether one can speak of a contemporary style in the same sense as one speaks of a Gothic style. "One cannot," he said:

> There are centuries between the two and we are facing, in fact, a different formalism. It is dangerous to use the terms Gothic or modern in an abstract manner. Abstract terms lend themselves to everything. In art the question is not one of pure formalism. There is always a unity with life. What one has to start with is the sense of reality. And anyhow: what can we say about the human soul? The reason why our age has not produced a masterpiece like Chartres, with its complete integration of the arts and crafts, may be sought in the conditions of our epoch. What peace of spirit there was in the Gothic age, while we have to face on all sides the threats of war!

Picasso was not willing to enter into a discussion of whether our time is lacking in religious spirit. He seemed to be satisfied that a peaceful mind produces a different kind of reasoning from one disturbed by war and revolution.

(This view is not shared by Julius Bissier: "As to the 'reality' into which our generation was born: we should not forget that the art of the Middle Ages had also to contend with a reality surpassing 'the worst nightmares of the human race.'")[10]

Is not Picasso's humanist position that of Amphitryon in Euripides' play *Heracles*? For Euripides' description of the world conveys a message entirely different from that of Sophocles. To the questions of a sufferer Sophocles offers one answer: reverence for the unfathomable wisdom and power of Zeus. Euripides wrote for men who had lost that faith, and exhorted them to rely on themselves and, if they were fortunate, on the loyalty of friends. In *Heracles* Amphitryon in particular illustrates what must have been the progress of many religiously minded Athenians from belief in divine goodness, and a rather smug confidence in divine favor, to a conviction that the whole concept of moral goodness begins, operates, and ends in man alone.[11]

On my first journey abroad after the war I met the aged James Ensor in his home town, Ostend. It was in 1949. I complained about

the restlessness of our time, the disheartenment and nihilism, despite the peace. And I expressed a feeling of doubt about the progress which many people believed in without recognizing how the mechanization of life has robbed us of our innermost strength. He said: "I see no evolution. All that I see is great uncertainty. And above all —uneasiness . . ."

"Where will it all end?"

"That is beyond our present power of comprehension."

Answering my question about God, he said: "God? God is power— something that is powerful." And after a pause: "God is what we believe in. This varies from one person to the next [*Ça change de maître et de maîtresse*]. It is a garment in which we clothe our nakedness."

When I asked why he had painted *Christ's Entry into Brussels,* he answered simply: "Christ is a very great figure, one that has occupied the attention of generations of men. Christ has a compelling significance."

Henry Moore finds himself today in a comparable position. There exists not only the question of permanence, the persistence of the sacred in art, even in modern art—the sacred being the essence of art, inherent in it and independent of any organized church—but also the problem of the renewal of church art, even though it may be in an abstract manner. When, after the end of the Second World War, conditions again allowed Henry Moore to work on sculpture and he was faced with a commission for a Madonna and Child, the problem for him was one of faith above all. He found it difficult simply to model, as the Renaissance artists had done, a mother and child for a church—it had to be something worthy of a church and of the belief in which he had been educated. He produced a Madonna and Child after many trials. However, he did not accept other commissions of a similar type later on, although they were offered to him; instead he created a symbolic image in his *Glenkiln Cross* of 1955–56. It is, in fact, a new symbol of the Cross, formed of shapes reminiscent of bones, phallic, organic forms, not architectural ones but monolithic and totemic. "I believe," he said to me,

> that art in itself is akin to religion; art is, in fact, another expression of the belief that life is worth living—and that is what religion is basically about. I go further and say that artists do not need religion, for art is religion in itself. If one believes that life is significant, and everyone who does not commit suicide must have this feeling, then one is religious in one's art. It

is much more important to have good art in the churches and good artists working for churches than to ask a practicing Christian who is a bad artist to produce a work for the church. What he will do is not religious art. All good art is religious but not all good art is suitable for placing in a church. I would not put a Boucher in a church but I could put a Watteau there. And certain works by Klee or Picasso and Braque, and also abstractions by Soulages and others. Matisse in his chapel in Vence has that kind of innocence which is like the pure innocence of an adolescent girl of fourteen. He imparted a purity to his work which is the kind of thing that Christ meant when he spoke of the children as something holy.

But in what way, we may ask, can an abstract work of art give expression to a sacred quality apart from the fact that it may have been created out of a "religious" emotion? "In the Middle Ages," said Hans Hartung, sitting in his studio and looking at a quatruptych which was about to be sent to an exhibition of sacred art at Lourdes,

the Church was the chief employer of art, its purpose and meaning. It devised the spiritual content. But already in the Renaissance church art was barely spiritual. Religious art had become a subject matter. Abstract art as a means of expression, with the help of its own language, has become anew capable of being a vehicle of spiritual communication. Impressionism was absolutely incapable of it. Surrealism, because it was tied up with a specific mental attitude, contradicted it—in fact it proved to be anti-religious. Abstract art has no specific concept, but its means are capable of all expression. There are different ways of conveying a spiritual message; there is also a religious one. If a beholder looks at these four paintings of mine, he may experience the universe, stars, the mystery of light. I think merely in terms of movement. It may be that the movements of electrons or a trail of a jet plane in the cold sky have certain similarities with the linear elements which I used here. In my four paintings there is a nightly quality, a seriousness in the color, something which makes one think little about the existing world. Certain chance possibilities of a force are here written down; they flicker and disappear again in the darkness. They live only a short while and fade away. As if symbolically. . . . Down below they disappear entirely and then they appear again. . . . All this happens in the subconscious rather than being thought out when one is involved in the act of painting. These things either appear in a secondary manner or they re-

main subconscious altogether. What I had was an absolute awareness that I wanted to produce something dark, black, threatening, and at the same time something vital. There was a general basic mood which wanted to be expressed. The composition is built like a symphony. On the left—the movement is very fast; the second panel becomes more dreamy, poetical; in the third panel there is stillness. In the fourth everything dissolves. The entire composition offers a relatively simple and clear solution from the top to the bottom.

When I paint I am more concerned with the inner laws which lead to a reality than with the result itself. What one can see in a microscope leads only to a new naturalism. I prevent such chance relationships from becoming dominant. Two dots always look like a face—this is not a deliberate "chance" effect. What is deliberate? The necessity, the need to produce the work. Then the consideration that a sensitive beholder can experience the same pleasure from this, my flickering restlessness. The artist helps the beholder to experience things which he otherwise would not experience. There is a primary need in man to express himself. There is a difference between an abstract work of art and doodling. What makes a work of art out of doodling is the intensification, the composition, the order. To make order out of chaos. To make something formed out of unformed elements. Psychologically and emotionally, what is thus produced corresponds to different states of feeling.

Here, then, is a relationship between states of mind or emotion and the existing world, and the means of correlating them. But not an absolute relationship, although the language is abstract. But artists like Julius Bissier aim at the absolute because their souls are nourished by the absolute. Freedom and love, Bissier thinks, are operative as fundamental impulses in art. But they have their place in that region which the Greeks called "*Logos*," the Taoists "Being," and the Christians "Providence" or "Divine Law." That the artist turns away from the outward face of nature is merely an accompanying phenomenon, never the essential.[12]

It is to me as if I listened to the voice of that other enchanter, this time in France, the unfailing lover of life, "of the same race as Christ," as Raissa Maritain so beautifully described him—Chagall. Chagall said to me, when I visited him in Orgeval in 1949:

I grasp everything simply by instinct. Art is for me a condition of the soul. And as for religion—what do you need beyond the

human heart? Life is like a great picture book. There is no need to know a lot. It is enough if we look, love, understand. Life—death—eternity—resurrection. Understand? One is mistaken, time after time. Life is like that. I would rather err through optimism and love.

When we left the studio Chagall stopped:

> I shall explain to you why intellectuals never grasp the full meaning of my art. All post-Cubist artists substitute brain activity for what should be in the heart. Anything constructed can easily be analyzed by any brain. When they talk about my work it is always about the poetic element, about the inventiveness in it. But I don't search for the poetic. I have searched for neither poetry nor literature nor for symbols. I only try to be myself.

Although since then he has painted and drawn many religious themes, *King David, Moses, The Resurrection,* the stories of the Bible, the Jerusalem windows, he does not speak much about it. He showed me some sketches and said—this time it was in Vence in 1952: "Something which happens in an instant can open out into eternity. And eternity itself can change in an instant of time." And suddenly, "Well, that's me. And you? Do you understand yourself? I don't understand Chagall."[13]

In the case of Alfred Manessier, after Georges Rouault the only great painter of the Christian faith in our time, it is not so much the question of the permanence of the sacred in art that matters as that of the representation of the tenets of an age-old faith by contemporary means of expression. "More and more I wish to express man's inner prayer," he once said of himself. "My subject matter is the religious and cosmic impressions of man when confronted with the world. In every way my paintings seek to be the testimony of a thing lived from the heart and not the imitation of a thing seen through the eyes."[14]

In November 1966 Manessier answered my questions about what necessity determined his manner of expression (that is, abstraction).

> There is a spiritual climate which determines the style of the centuries. There is, as it were, a leading thought, like an arrow, in every epoch which influences all the activities of man. It is in this way that both the artist and the scientist are hit by

the same arrow. You see, the further I penetrated into non-figuration the more I approached the inwardness of things. . . . I am not an intellectual; my non-figurative trend was not chosen or decided upon at random, but it corresponded to an inner necessity.

And, as if he wanted to explain his religious feeling more explicitly, he concluded: "It is good to have firm foundations."[15]
The religious grasp of life, the secret of old Judaism, of Tao and Zen, this feeling of the limitless in the limited, was it not also the core of Klee's meditations?

Every artist would like to live in the central organ of creation. . . . Not all are destined to get there . . . but our beating hearts drive us deep down, right into the pit of creation. . . .
 The heart must do its work undisturbed by reflective consciousness.
 One learns to look behind the façade, to grasp the root of things. One learns to recognize the undercurrents, the antecedents of the visible. One learns to dig down, to uncover, to find the cause, to analyze.[16]

Valéry defined this direction of mind in his own inimitable manner: "What we call 'a work of art' is the result of an action whose final aim is to provoke an infinite series of developments in someone."[17]
Let us listen to another great painter east of the Rhine, the Expressionist Oskar Kokoschka. Speaking about religion and the unitary view of the world which it provided, he once said to me:

A world of ideas with a universal aspect is perishing. We are the witnesses of it. What is there left but to cling to one's own roots? A long period of desert will come, a long period of sterility. In life there is no progress. There is a substance of life, a vital power. It appears to me like a great earthworm—behind several parts die off, in front new ones grow. It remains the same organism. . . . Because I am a mystic I need no saints. I am against the legend of great men. There are greater times, lesser times. There are artists. People have wanted to convert me to a belief in progress. I believe in the Goddess, in the return of the Matriarchy. The maternal side of life is a reality, not an idea. I believe in this as strongly as the Chinese did. In the period of spiritual drought which is coming the

essential values will survive in spite of everything, and then will come the future. It will follow the same pattern as the myths. . . . I am no defeatist, no optimist, no pessimist. That which I know is something which I see, like a stone falling, like stars gleaming. If I think a little further and ask myself: Why then do I commit follies, why do I squander my lifetime painting? Then I can say to you: When I am painting I am in the midst of something living. So true, so concrete can the spirit be. It finds its form in aesthetic realization. In the Upanishads there is a passage which runs: the painted form is a spirit in the hierarchy of the world phenomena, the Maya. It has shape and body and life.[18]

The determining feature of life, its essence, is the consciousness of the image. The essence, whether of bodiless or corporeal character. Consciousness is the cause of all things, even of ideas. It is a sea whose horizons are images. The consciousness of images is not a condition in which we recognize or comprehend things, but a state in which consciousness experiences itself.[19]

Do not some artists of our time bear out Rodin in saying that true artists are the most religious among mortals?

"All true works of art are an act of praise," says Barbara Hepworth:

Out of inert substance a new inevitable idea is born which is of itself an apprehension of the force of life. It is an acknowledgment of the external power which enables man to create in an infinitude of ways visions which all share. A perception of the holiness of life and the universe.

Reverence for procreation and the whole vital generating power of life in our universe has endowed the human spirit with the gift of an affirmative creation in art. This will persist as long as human life continues. The image is the mystery and the mystery lies within the image.

The sculpture within the hands can be as moving as the head of an infant. To look within a painting can be an experience equal to the unfathomable beauty in human eyes. The force is unseen and unknown; but it is the universal principle which speaks to men at all times.[20]

And Louise Nevelson:

All creative work is sacred. Religion is another form of creation. The formal religions that are inherited by mankind are

like any other lovely thing—they are heirlooms. One does not destroy beautiful concepts—on the contrary they become more important, more valuable with or in time.

Creative minds living in their own present time create their own crescendos (lifted beings), as they understand them. For reference they use any symbol be it of the past or present or future. In the end it is all necessary for our own well-being.[21]

"My religion?" says Marino Marini:

It is love of life. Does one need to make a Christ or a Madonna to be religious? All things made with love become religious.

What is art? It is vitality. To be an artist means to understand things which are not understood by many others, a music which is missed by most. It is so simple, but it is difficult to be simple. Nowadays man has become too complex. They search for the difficult things which say nothing, for there is nothing in them. But if you demand much you are in love.

Artists are always out for new impressions but they do not always ask themselves: Is there something in it all? What one has to find out for oneself is whether there is poetry in it or not. One must not take things at their face value.

We now live through a period of mechanization. Nevertheless, I love to maintain the continuity of poetry. The poetry of today is our poetry.

Honesty? But an artist cannot be honest if he has imagination. One does not stop at the head, one goes down to the toes. It is imagination that counts. That artist is most honest who has a fantasy which rises higher and higher, incessantly. . . .[22]

What poetry is to Marini beauty was to Braque. I still remember the mild look in his eyes as he sat in La Colombe d'Or in St. Paul de Vence—it was the early summer of 1952—drawing a few lines on a paper: the contour of a face, the outline of a bird. This bird acquired later on in his life the quality of the human soul vanishing into the unknown. In his personality and work Braque strove for the simplicity and beauty realized in the Greek works of the fifth century B.C. "I have no love at all for classic art or for that of the Renaissance." The ideal of beauty is to Braque as sacred as the ideal of humanism. Of beauty he said,

It is not a problem. There is no one solution for your life, only a perpetual adaptation. For the idea of eternity I substitute per-

petuity. The question of beauty is one of arriving at a state of harmony and that harmony is a sort of intellectual void wherein words have no value. At this moment we just understand.

Replace harmony with serenity and you have the creed of Miró: "What I wanted to do was go beyond painting," he said to me in Paris in 1952. "Painting as a means of poetic expression is not enough. Art is something more. One sees the hidden thing, the soul of things. . . . The spirit of Catalonia, the tradition of Romanesque frescoes and popular art, stood godfathers to my formal conception."

Miró worked on the development of a disciplined language, an individual plastic method capable of expressing the future—not our own time:

> In my opinion it is the art of the antique world, the art of the great civilizations of the past, that is supremely fitted to reach into the future. Today we are living in a period of transition. There is gaiety in my work—a moment of reaction against tragedy. If Picasso may be said to be a typical Andalusian or a Castilian, then I am a man from the Mediterranean, the Balearic Islands, or Catalonia—a living link with the Greek tradition and its sacred concepts of Apollo and Dionysos.

When I say that Brancusi was a saint and a hermit I am conscious of the religious connotation of those terms, but never before had I met a man who so intensely personified these characteristics. His monastery was the three rooms in his two studios, 15 Rue de Vaugirard and 11 Impasse Ronsin, where I visited him in 1950. His prayers were his sculptures, his wilderness was the forest of figures, columns, heads, and abstracted shapes among which the bearded artist moved as between trees or in thick undergrowth. He was the creator of *The Kiss* (*Le Baiser*)—a symbol of peace to be placed on the frontier between two peoples (he himself was born where two countries meet), of *The King of Kings* (*Le Roi des rois*), of *Wisdom* (*La Sagesse*), of *The Egg* (*L'Oeuf*), and of *The Newly Born* (*Le Nouveau Né*). And, too, he created *The Endless Column* (*La Colonne sans fin*), expressing his belief in infinity, in the eternal continuation of life. As he imagined it, "every generation builds a story for itself. Obelisks and pyramids have been made, but they all have an end. . . . If an obelisk is merely big it is grotesque because at a certain point it ends. But this is an endless column." All these, to him, are religious symbols.

The Ionian Greeks were supreme in their sense of measure. Here, in France, their successors were the Gallo-Roman artists of the tenth century. They had a just sense of measure, of proportion, and that because their age was an age of religious belief and everything that has ever been made in an age of faith is right. Our age is an age of cataclysm.

As an artist he knew more about the sacred quality of life: "I suffered, and through suffering I was made to act." And: "The things that we do are in direct relationship to our faith and love."

With Giacometti we enter the vast region of Existentialist thinking. Everything was somewhat twisted, complicated. There were no definitions; the experience was elemental, agnostic, and anti-intellectual, and remained so. Giacometti spoke like an oracle: "Instead of copying nature I try to do something that has touched me emotionally." But if I made an attempt to analyze his work he said:

> I haven't the slightest idea what people see in my work. But then I am not at all sure what I see in it myself. I am disturbed by what I see from the other side. I am on the opposite side, I am of the earth—all this is very complicated. If you say, "That thing is beautiful because I should like to have it on the table," it is wrong. I want to have it on the table because it is beautiful.

And a moment later: "Things belonging to far-off times are nearly always beautiful. There is no symbolism at all in my work—not a trace."
How then did he see? What did he see?

> There is no such thing as sight that is purely and simply physical. A person who is not conscious of what he sees, sees nothing. I see in my own way. I am concerned with what I see. In general one makes use of visible reality for the purposes of painting or sculpture. Everyone imagines that in his way he is treating things objectively. My ultimate aim is not the picture that I paint but the complete comprehension of what I see. I have no thought outside the action involved. Painting is a fact, not a theory. Technique of itself has no existence; it is just what one happens to do and is the thing itself. Technique and expression cannot be regarded as separate facts. The technique is the vision. What happens within man is a complete mystery.

The obscurity of Giacometti leads to mysticism; Dubuffet's provocative taste, his dexterity and attitude lead to mystification. The values are perverted, we play with false cards. Dubuffet lived at 114*bis*, Rue de Vaugirard, when I visited him. There was a light, well-furnished reception hall with a loft, and a store room near the entrance. The half-open door allowed a glimpse of stacks of new canvases and boxes of paint and other material, well ordered as if in a paint shop. The master of *l'art brut* served wine from a crystal carafe into crystal glasses. Well-dressed, well-behaved, polite: yet I sensed Mephisto beneath his smooth gestures and the devil's foot in his elegant shoe. His face was pale, as if he lived all the time in caves or cellars. He played the role of refined depravity out of boredom, the rebellion of matter against any form, of chaos against cosmos, of post-Surrealist Dadaism against any attempt at sensing one's way out of the darkness, the bewilderment. He maintained that "those artists who have brought something new into the world of art have always provided some scandalous element." He who saw in the graffiti of lavatory walls the highest expression of art pretended to believe that even naturalistic Greek art was scandalous. He declared that he saw irritable, depressed, suffering, and nihilistic modern man as poisoned by Existentialism, then said, suddenly,

> Art is of the same family as crime. Art means changing the human spirit, confronting it with something new. Art, the human mind. There are no professional artists! Are there professional lovers? You see, art is one of the elements of anarchy. Keep your children out of the cages of the zoo where the public mind is formed. Make people drunk, as at a spiritual bacchanalia. Set up a Ministry of Delirium, a Biennale of madness. Art is a great feast of the spirit, partaking of the nature of intoxication.

Dionysiac? The cult of brute nature, of base matter, for him—for us the anguish of the sacred.

The thought of Matisse when I saw him last—it was just after his chapel at Vence was consecrated—still gives me an intense feeling of happiness. Everything conspired to produce it on that lovely day in June 1952. The colors of the flowerbeds in the public garden near the Boulevard des Anglais seemed inspired by the aged master, and the white walls of the villas standing among palm trees, on the way uphill to Cimiez, where he lived, were brilliant in the sunshine.

He rose only for a few hours a day, three or four; the rest he
spent in bed. This bed, high and with a table across it on which
he could draw, stood diagonally in the room, which was one of many
in a monstrously large, typically Victorian building, which had, in
fact, a monument to Queen Victoria in front of it. Here in the south,
where light and shade became pure color, lived the man who ex-
pressed the joy of life in his canvases and drawings, the high priest
of *luxe, calme, et volupté*. The long bamboo stick with a crayon on its
end with which the decorations in the Chapelle du Rosaire were
drawn stood in a corner of the room. Large leaf and flower shapes
cut out of colored paper formed a frieze. Matisse did not wish to
answer any questions before I had seen the chapel. He was stubborn
about this, like a child. As I had not yet seen it he sent me there.

In the chapel everything was gay and good, so clear, and as it was
a sunny day, the yellows and greens and blues of the large stained-
glass windows created a tangible color in the air, a vibrating mauve
which added to the serenity of the place and the harmony of the
tones, lines, objects, and materials. Everything was beautiful and
meaningful, thought out and designed by Matisse himself, even the
architecture: the stone of the altar, porous, full of shells, as he said
himself, like bread, the bread of the Eucharist; the black outlines
of the mural of the Stations of the Cross; the metal of the crucifix and
the candelabra; the tiles. When I returned to the master, I expressed
surprise at my strong feeling of happiness. He nodded in a friendly
way and gave me a booklet on the chapel, saying, "The work cost
me four years of constant labor, and it may be looked upon as the
end result of a lifetime devoted to the art of painting. I consider it
my masterpiece."

Later I read the booklet: "This is not a work of my own choosing,
but rather one for which I was chosen by destiny towards the end
of my journey, which I pursue, occupied with my studies. The chapel
is giving me an opportunity of confirming them by bringing them
under one roof."[23] Matisse mentioned the drawing, color, values, and
composition, and explained how these elements of construction may
be brought together in a synthesis allowing each element its full scope
undiminished by the presence of the others. He well knew how simple
colors can act upon the emotional content of a picture all the more
forcibly for their being simple. A blue, for example, in association with
rays from its complementaries, has an emotional impact like that
of the sound of a loudly struck gong. The same holds true for a yel-
low or a red.

He spoke of the chapel as "that expression of human feeling whose shortcomings, if such there be, will fall away of themselves. But a vital part will remain which may serve to reunite the past and the future of the plastic art. And I hope that this part, which I call my revelation, is expressed with sufficient force to become a fertilizing element and to return to the source whence it came."

To make people happy—is that not a mission?

If modern France had given nothing to the world but Braque and Matisse it would have given enough to prove the permanence of the Sacred, of the harmonious and the beautiful.

NOTES

1. Auguste Rodin, *Les Cathédrales de France* (Paris, 1921). See also Georges Rouault on this problem: "A new world is dawning. Tragic is the light I see on the horizon. Egged on by hypocritical politicians and their shrewd hangers-on, material appetites have gone beyond all bounds. The entire universe is out of joint, spiritual values are being destroyed ever more rapidly. There is scarely any time left for leisure or higher things. New speed records . . . Man is wolf to man—*homo homini lupus*—under the guise of civilization." Quoted from Pierre Courthion, *Georges Rouault* (London, 1962).
2. *L'Art: Entretiens réunis par Paul Gsell* (Paris, 1911).
3. Eugène Delacroix, *Journal*, ed. A. Joubin, 3 vols. (Paris, 1950).
4. *Curiosités esthétiques* (Paris, 1946).
5. Courthion, *Georges Rouault*.
6. Quoted from *Künstler über Kunst: Ein ewiger Dialog über die Probleme der Kunst*, ed. Eduard Thorn (Baden-Baden, 1951).
7. See Gottfried Semper, "Plan eines Idealen Museums," in *Wissenschaft, Industrie und Kunst*, ed. H. M. Wingler (Mainz and Berlin, 1966). See also in the same volume Wilhelm Mrazek, "Gottfried Semper und die Museal-Wissenschaftliche Reformbewegung des 19. Jahrhunderts."
8. See Gilbert Murray, *Four Stages of Greek Religion* (New York, 1912); 3rd ed., *Five Stages of Greek Religion* (New York, 1955); Jacob Burckhardt, *Griechische Kulturgeschichte*, Vol. 1: *Der Staat und die Religion* (Leipzig, n.d.).
9. *Les Cathédrales de France.*
10. See p. 44 of this volume.
11. Gilbert Murray, *Euripides and His Age* (London, 1913); Preface to *Harakles*, in Ulrich von Wilamowitz-Moellendorff, *Griechische Tragödien*, Vol. 1 (Berlin, 1911).

12. "Time and the Artist," Part I, Chapter 4, of this volume.
13. See J. P. Hodin, "Marc Chagall: In Search of the Primary Sources of Inspiration," in *The Dilemma of Being Modern: Essays on Art and Literature* (London, 1956).
14. René Huyghe, *La Peinture actuelle* (Paris, 1941).
15. J. P. Hodin, *The Painter Alfred Manessier* (London, 1971).
16. Quoted from Herbert Read, *Klee (1879–1940)* (London, 1948).
17. *Collected Works*, Vol. 13: *Aesthetics* (New York, 1964).
18. J. P. Hodin, *Oskar Kokoschka: The Artist and His Time* (London and New York, 1966).
19. Kokoschka, *On the Nature of Visions,* quoted in Hodin, *Oskar Kokoschka.*
20. From a letter to the author, 1964.
21. From a letter to the author, 1964.
22. Quoted from J. P. Hodin, "Marino Marini, *Man and Horse, Man and Woman,*" *The Studio* (London), Vol. 167, No. 851 (March 1964).
23. Henri Matisse, *Chapelle du Rosaire des Dominicaines de Vence* (Vence, 1951).

PART IV

SCIENCE AND MODERN ART

1 • ART AND MODERN SCIENCE

OUR PRESENT STATE OF MIND IS A PROBLEMATIC ONE. THIS, IT MAY BE said, is true of all ages in the history of man; but it is particularly pertinent in times of violent changes of thought and forms of life. The human condition is problematic, as Montaigne once expressed it, in that since the beginning of time everything in the world has been and always will be in question. Our modern dilemma is due to special conditions, as contemporary philosophers and scientists have stated categorically. The direct cause of it is modern science and technology. The problem is not only a social, a moral, an aesthetic, or an ontological one; it is a spiritual problem, *kat exochén*. This is the first contention of our thesis.

Erwin Schrödinger, more than any other scientist, has pointed to the deficiency which an exclusively scientific viewpoint produces in the innermost realm of human spiritual faculties. We can find a warning already in his book *Science and the Human Temperament*,[1] especially in the chapter entitled "Science, Art and Play," and again in his *Science and Humanism*,[2] but it broke out for the first time as a cry of spiritual suffering in his study *What Is Life?*,[3] where we read:

> We have inherited from our forefathers the keen longing for unified, all-embracing knowledge. The very name given to the highest institutions of learning reminds us, that from antiquity and throughout many centuries the *universal* aspect has been the only one to be given full credit. But the spread, both in width and depth, of the multifarious branches of knowledge during the last hundred years has confronted us with a queer dilemma. We feel clearly that we are only now beginning to

177

acquire reliable material for welding together the sum-total of
all that is known into a whole; but, on the other hand, it has
become next to impossible for a single mind fully to command
more than a small specialized portion of it.

Let us now come to our second contention, that the human dilemma
of today is a spiritual one. An analysis of the special meaning for our
time of the term "spiritual" will enable us to approach a valid con-
clusion. For this purpose we turn to those contemporary philosophers
who have contributed to the comprehension of this question, as well
as to some artists and aestheticians, and all this in the somewhat nar-
rower context of aesthetics, which is our main concern here, rather
than that of philosophy as a whole. This will finally lead us to the
third contention of our thesis, which is threefold in nature:

(1) that philosophy cannot be called philosophy if it restricts itself
to being a handmaiden of science;

(2) that aesthetics, which is a part of philosophy and psychology,
cannot proclaim itself to be a science in the modern sense when it
omits from its sphere of research and concern the very essence of
the symbolical, the significant, the vital to be found in art, its ineff-
able quality which it shares with life itself;

(3) that art ceases to be art if its aim is not a spiritual one: insofar
as art accepts the domination of scientific thought and method, and
the tendency toward intellectualization and specialization, it is led
to become an a-human and anti-anthropomorphic, quasi-objective ac-
tivity which eventually ends in the destruction of art.

Further to (1): In accepting the viewpoint of science the philoso-
pher attempts to give philosophy a strictly scientific foundation.
Philosophy is thus looked upon as just one science among others
dominated by specialists. The philosopher has taken up the problems
common to all the sciences and reserved for philosophy only the
questions of logic, epistemology, phenomenology. Today some schol-
ars even consider the science of logic (meaning) to be the whole of
philosophy.[4]

Further to (2): In accepting the viewpoint of science and pro-
ceeding from a naturalistic-relativistic or behavioristic point of view,
the aesthetician—even when assuming that all the individual arts,
and art generally, are evolving as parts of the larger process of cul-
tural evolution—will reach a systematization of concepts, to be sure,
but he will miss what ought to constitute the very essence of his re-
search. Logic, statistics, the quantitative rather than the qualitative

approach will change aesthetics into an abstract scientific speculation instead of aiding philosophy and the arts to regain the awareness that "we can never dispense with the deep language of the metaphysicians, which speaks to us down the millennia," and that it is essential "to make it our own, to understand its origin by means of the historical study of the past, but also to give it new life in the present." This, however, has meaning only if based on the certainty that the true modern philosopher "stands against those who scorn the sciences, against the would-be prophets who cast suspicion on scientific research, who mistake the aberrations of science for science itself, and who even attempt to make science, 'modern science,' responsible for the disasters and inhumanity of our age; . . . [the true philosopher has] his gaze fixed unmistakenly on the true philosophy which is the *philosophia perennis*."[5] Those who believe that mythological thinking is a thing of the past, who in Aristotle's manner set up an opposition between myth and science (Comte developed this into a system) and proclaim that myth is overcome by scientific thought, have disregarded the modern flowering of poetry, art, and meditation. "Mythological thinking is not a thing of the past; it is ours at any time."[6] Aesthetics in its true sense will always have to face the human as the only source, the essence, and the aim of its investigations. How could it live on the meager fare with which the application of the modern scientific approach, especially that of physics and biology (the interpretation of imaginative phenomena, for instance, in terms of neural mechanisms), would provide the aesthetician? It must be a "science" in a much wider sense. For, in investigating, "as a systematic science, the general rules of creativeness, the impact of works of art, their functions, their techniques, their changing aspects,"[7] what is needed is a concept of science related more to that of the old Greeks[8] and permeated with the Eastern concept of wisdom.[9]

"Artistic activity begins when man finds himself face to face with the visible world as with something immensely enigmatical." This was Conrad Fiedler's credo.[10] Max Dvořak still demanded ˙of aesthetics that it provide us with a *Stillehre*.[11] Accepting the claim that it ought to be a science, he demanded something which a science cannot give. What it can give is that which it has already provided. A *Stillehre*, yes, but not in the absolute meaning of the term, for style is one of the most mysterious phenomena of art; its roots reach down to the essence of the spirit of a whole race or culture.[12]

Today I am convinced that had he lived, Dvořak, like Dilthey in the later volumes of his large *oeuvre*, would not have emphasized the

scientific aspect of aesthetics without pointing out the limits of science, the incompatibility of the spiritual need with a purely scientific approach. So much for aesthetics: a more comprehensive discussion is beyond the limits of this study.

Further to (3): In accepting the domination of scientific thought and method in art, the artist will ultimately deceive himself and those around him. He will betray what Rodin proclaimed to be the inner life of art. "Art is spiritualization. It represents the highest delight of the intellect which penetrates nature and senses in it the same spirit with which art itself is imbued."[13] And Klee once asked,

> What artist would not like to dwell where the central organ of all temporal and spatial change—call it what you will, the brain or the heart of creation—orders all the functions? There, in the womb of nature, in the primeval realm of creation, where the secret key to the universe is safely kept. But not all are meant to go there. Each must follow the yearnings of his own heart. . . . But our pounding heart longs to thrust far down, to burrow deep into the primeval.[14]

The enigmatic character of art is also emphasized by the sarcastic statement of Picasso: "You expect me to tell you, to define for you: what is art? If I knew it, I would keep it to myself."[15]

We should compare such an essentially metaphysical orientation with others of modern times: that, for instance, of the Russian Marxists, who insisted that art should liquidate itself. They demanded from the artists that they should use their talents for the construction of useful objects. Being materialistic in philosophy, they could not see in art anything but a pleasurable occupation cherished in a decadent capitalist society and totally useless, even harmful, in the new society of communism.[16] This was dictated partly by revolutionary necessity in the constructive phase of Soviet society, but was also a consequence of a purely materialistic-mechanistic scientific outlook.

Dadaism also needs examination. "Art is stupidity," declared Jacques Vaché in his *Lettres de guerre.* Naturally, all art would appear quite senseless to a generation "which decided to adopt a name [Dada] for their activities by which they intended to show that they had given up all hope for human intelligence and were expecting still more insanity from the future."[17] What Dadaism accomplished was a demonstration against the pragmatic mentality that had led mankind into a world war. Duchamp's "ready-mades" signify, as Hugnet wrote, the artist's disgust with art.[18] We find also therein:

(1) the negation of art, its place to be taken by everyday objects;

(2) the recognition of material culture as the only real and valid one;

(3) the attitude that this material culture is to be represented only by the ordinary, the brutal, the sexual, the banal;

(4) that the machine-like, the mechanical, quality has overcome the spiritual quality; that is to say, has vanquished the power that alone can master chaos.

If in Dadaism we can recognize the protest against a world governed by technology, science, and a materialistic ethos, and devoid of all idealism, Freud's psychoanalysis represents another impact, registered in Surrealism, pushing art aside. "Breton announced proudly that the Surrealists are simple registering machines which are not hypnotized by the motives which they trace; that they serve, maybe, an even nobler cause; thus they give back quite honestly the talent which was lent to them."[19] "We have no talent."[20]

Futurism emphasized a similar trend:

> We have already behind us the grotesque burial of passéist Beauty (romantic, symbolic, decadent) . . . the mists of legend produced by the vastness of time . . . the solitude of the wilderness . . . etc. We declare that the world's splendor has been enriched by a new beauty, the beauty of speed. A racing motor car . . . a roaring motor car . . . is more beautiful than the Victory of Samothrace. . . .[21]

The machine has suppressed man.

Science confesses that its aim is not and cannot be to provide us with a wholist conception of creation; and science has dominated analytical, abstract art, which has proclaimed as the final aim of all art its own exclusive viewpoint. Sir Arthur Eddington once wrote: "The relativity of physics reduces everything to relations; that is to say, it is structure, not material, which counts. The structure cannot be built up without material, but the nature of the material is of no importance."[22] No wonder that in theoretical writings on abstract art we can find statements such as this:

> At the same time that scientists were proclaiming that matter is not material, but is an X-factor in the universe, non-objective painters were representing something not material, yet, like matter, something primary, cosmic and indestructible. The ex-

periments, equations, and equipment of the scientist had led to the same kind of conclusion as reached by the intuition of the artists: that is, objects as we see them, and atoms as material are far from being ultimate and accordingly far from being the only truth.[23]

To this we can only say that there always is something unsatisfactory in "abstract" art. A specialist's work, it neglects what Goethe was adamant in claiming as the alpha and omega of any creative process: "Nobody will understand that the formative process is the supreme process, indeed the only one, alike in nature and art"— that life is manifest in *Gestalten,* not in abstractions.[24]

With the equation: Aesthetics equals science, with the status of scientific aesthetics, we have reached the stage of a cumulative definition of art, one which not only includes all the basic notions of the existing known definitions of art in their historic perspective but also foresees all possible future developments, and thus a comprehensive and seemingly final definition. Alas, this definition, just because it aims ultimately at embracing every aspect connected with the notion of art in an objective, that is, scientific sense, remains a quantitative and statistical definition rather than an essential one. We may find that behind the urge to define art in a comprehensive way are hidden the will and desire to preserve and take stock of everything that was and still is the genius of Europe, or even the *genius artis* of the globe. Nevertheless such a definition reminds one of a box designed to contain art, into which the soul of art has not entered because it eludes analysis in exactly the same way as the essence of life eludes definition. For the one is the emanation of the other, having the same roots and nourishing itself from the same source. In aiming at a scientific definition of art we have entered a world of schemes and shadows, where the living pulse, the heartbeat of inner experience, is missing. We have, in fact, dehumanized and dehydrated the innermost origin, content, and meaning of art. How could such a result come about when we believe that we have striven for and achieved the clearest and most incontestable conclusion, exhausting all our exact knowledge? Because the rational, the mathematical, offers only one aspect, and where art is concerned a very pale aspect, of the whole phenomenon. We may therefore rightly ask ourselves whether we have achieved more than just an enumeration of present and past vital happenings in the field of art. For just as science has refrained from visualizing as its aim a world view, a contemporary

valid image of the wholeness of the macrocosmos and the microcosmos, and is therefore unable to satisfy those powerful inner needs which since the dawn of mind have prompted man to comprehend the miraculous and the poetical, so scientific aesthetics has viewed the world of art in a naturalistic-relativistic, that is, a self-limiting, sense. Only the artist, the poet, the original thinker will, when creating, gain a notion of art which is at the same time spiritual and historically valid. "Historically valid," because it actively propounds past developments from the point of view of what has already been "done"—that is, has already been achieved by persons involved in the act of doing and achieving, and "spiritual" because it reflects a philosophy of life, the spirit of a personality, an age, or a whole culture. It mirrors necessity, not chance, and because there is no choice there is and can be no completeness either in aim or in achievement, merely the one-sidedness of timebound life as the only manifestation of an eternal and primary force.

When contemplating a definition of art which expresses either an individual or an era or a whole civilization, we will find it imbued with this precious essence which is at the center of thought, establishing its uniqueness, its limits, and its eternity.

NOTES

1. (London, 1938).
2. *Science and Humanism: Physics in Our Time* (Cambridge, 1951).
3. (Cambridge, 1944).
4. Consult on this question Karl Jaspers' writings, especially his *Philosophie* (Berlin, 1948), *Von der Wahrheit* (Munich, 1947), and "Philosophy and Science," *World Review* (London), 1950. Also, *The Revolution in Philosophy*, by A. J. Ayer et al., with an introduction by Gilbert Ryle (London, 1956); C. A. Mace, ed., *British Philosophy in Mid-Century: A Cambridge Symposium* (London, 1956); Gilbert Ryle, *Dilemmas* (Cambridge, 1954); Rudolf Carnap, *Meaning and Necessity: A Study in Semantics and Modal Logic* (Chicago, 1947); Ludwig Wittgenstein, *Tractatus Logico-Philosophicus* (London, 1922), and other writings; Edmund Husserl, *Die Idée der Phönomenologie: Fünf Vorlesungen*, ed. Walter Biemel (The Hague, 1950), and other writings.
5. Karl Jaspers, *Philosophy and Science* (London, 1950). Compare also Aldous Huxley, *The Perennial Philosophy* (London, 1947).

6. Karl Jaspers and Rudolf Bultmann, *Die Frage der Entmythologisierung* (Munich, 1954). See also Friedrich Gogarten, *Demythologizing and History* (London, 1953).

7. Max Dvořak, "Die Kunstgeschichte des Mittelalters," Lectures, Winter 1913–14, Vienna. Unpublished.

8. For the notion of ancient Greek science, see: Werner Heisenberg, *Philosophical Problems of Nuclear Science* (*Wandlungen in den Grundlagen der Naturwissenschaft*) (London, 1952); Erwin Schrödinger, *Nature and the Greeks* (Cambridge, 1954); Friedrich Nietzsche, *Die Philosophie im tragischen Zeitalter der Griechen*, in *Werke*, Vol. 1 (Leipzig, 1930). See also "Charakter der ältesten griechischen Wissenschaft," in Wilhelm Dilthey, *Einleitung in die Geisteswissenschaften* (Leipzig and Berlin, 1922); Heinrich Gomperz, *Die Lebensauffassung der Griechischen Philosophie und das Ideal der Inneren Freiheit* (Jena, 1915); Wilhelm Nestle, *Griechische Studien: Untersuchungen zur Religion, Dichtung und Philosophie der Griechen* (Stuttgart, 1948); *Künste und Forschung*, in Jacob Burckhardt, *Griechische Kulturgeschichte* (Leipzig, 1929).

9. Count Hermann Keyserling, *Schöpferische Erkenntnis* (Darmstadt, 1922). Also, S. Radhakrishnan, *Eastern Religions and Western Thought* (Oxford, 1940); F. S. C. Northrop, *The Meeting of East and West* (New York, 1946). Further: *Eranos Jahrbuch*, Vols. 1–5 (Zurich, 1933–37); Karlfried Graf von Dürckheim-Montmartin, *Im Zeichen der Grossen Erfahrung* (Munich, 1951); Charles A. Moore, ed., *Essays in East and West Philosophy* (Honolulu, 1951); William S. Haas, *The Destiny of the Mind: East and West* (London, 1956).

10. *On Judging Works of Visual Arts* (Berkeley, 1949).

11. See n. 7.

12. See Oswald Spengler, *Der Untergang des Abendlandes* (Munich, 1917). Compare Alois Riegl, *Stilfragen* (Berlin, 1923), and Alois Riegl, *Die Entstehung der Barockkunst in Rom* (Vienna, 1908). Also, Heinrich Zimmer, *Kunstform und Yoga im Indischen Kultbild* (Berlin, 1926), and again Dilthey, *Einleitung in die Geisteswissenschaften*.

13. Auguste Rodin, *Die Kunst: Gespräche des Meisters* (Berlin, 1933).

14. "Über die Moderne Kunst." Lecture, Berne, 1946.

15. Wilhelm Boeck and Jaime Sabartes, *Picasso* (London, 1955).

16. Naum Gabo, "A Retrospective View of Constructive Art," in *Three Lectures on Modern Art* (New York, 1949).

17. *Dictionnaire abrégé du Surréalisme* (Paris, 1938).

18. George Hugnet, *L'Esprit Dada dans la peinture* (Paris, 1932 and 1934); English translation in the *Bulletin of the Museum of Modern Art* (New York), Vol. 4 (1949), pp. 2–3.

19. J. P. Hodin, "L'Avenir du Surréalisme," Brussels, October, 1954.
20. André Breton, *Manifeste du Surréalisme: Poissons soluble* (Paris, 1924).
21. Marinetti, "Futurist Manifesto," in *Le Figaro* (Paris), 1909.
22. *Space, Time and Gravitation: An Outline of the General Relativity Theory* (Cambridge, 1920).
23. Jerome Ashmore, "The Old and the New in Non-Objective Painting," *Journal of Aesthetics and Art Criticism* (Cleveland), June 1951.
24. See J. P. Hodin, "Goethe's Succession," in *The Dilemma of Being Modern* (London, 1956).

2 • THE TIMELESS AND THE TIMEBOUND IN ART

Thoughts on the Problem of Abstraction

> You tremble before nature: tremble but do not
> doubt.
>
> <div align="right">INGRES
Écrits sur l'art</div>

> It has been said that poetry is a picture without
> form, and painting a poem with form.
>
> <div align="right">KUO HSI
An Essay on Landscape Painting</div>

ALLOW ME, IN DEALING WITH THE QUESTION OF THE RELATIONSHIP OF daily life to forms in art, to adjust the wording of the problem so as to clarify its meaning for my purposes. To me, the question is not so much one of the forms in which the art of any single culture manifests itself in its urge to find its own expression, its peculiar character; it is rather the question of the influence on art of the forms of life: those enigmatic, unchanging, accomplished, unique forms of life, the infinite variety of which is an inexhaustible source of experience and knowledge. To me, a question more burning than that of the elaboration of a modern style in architecture, its influence on the arts and crafts and the cooperation of painting and sculpture of this effort, more burning than that of the stigma imprinted upon our consciousness by science and technology in the exploration of new analytical forms in art which find their way back again into industrial design, is the question: What has happened to the visual appearances of life in our generation, in which the artist refuses to use these eternal forms of Being, these primary manifestations of vision and touch, as a direct source of inspiration?[1] It seems as

186

if he were afraid of them, and by disguising them—as did de Chirico, Ernst, Giacometti, Dali—is making them acceptable, in a meta-morphosed form, to his own incurable anxiety.

In my youth, during the difficult and troubled years after the First World War, everyday life—*der Alltag*—appeared to us young writers and artists in central Europe as a degradation of life itself. *Der Alltag*—that was the life of the adults, tied up in economic con-siderations, the life of politicians, generals, and professors, of engi-neers and bus drivers, the realm of petit-bourgeois illusions and the craving for security and safety—all adding up to a narrow outlook of boredom and banality, the philistine himself grumbling under its yoke, until finally he and his privilege to grumble were swallowed up by the sound and undiscriminating appetite of the working class. I am inclined to think that every young creative person, in whatever country and whatever period, even a peaceful and ac-complished one, must have encountered the same experience.

There was Existence, however, true Existence, the eternal mani-festation of the mysterious and hidden will which had brought forth the miracle of life, its manifold forms and hieroglyphics. Life was the great enigma, it was love and hate and meditation, it was creation, and only in art were those immortal traces to be found by which man's spirit might seek to unravel its riddle through forms and capture its beauty. Art was the dialogue between man and creation; man was a part of it and yet something more: the witness, before man and God, of this great living reality.

The artist was a witness, the witness of the glory of Being. The concept of a Godhead who had created it was then still alive. The artist had remained the witness even after the anthropomorphic notion of God had yielded pride of place to another notion: that of life engendering life in an equally miraculous movement of evolution and unfolding—Pasteur's concept of *generatio spontanea* or *aequivoca* (*Urzeugung*). To us, the Darwinian formula did not appeal, nor did that of Einstein. We did not wish to replace the divine with a biological or mathematical formula. This was left to the generation following us, a generation which treated all idealistic notions as mere illusions instead of powerful vehicles of the mind and the will; which rejected life's own appearances and replaced the wholeness of subject and object by an introverted vision alone, replaced elemental shapes by abstract forms, dynamic multi-enlarged aspects of microscopic data, diminished cosmic vistas, aerial per-spectives of a rather vague although sometimes poetic suggestivity;

which had eyes only for crude "matter" instead of for the picture itself and the proclamation of its beauty, and declared the relief from inner tension in the artist through the assault on the pictorial material to be the primary and main content of art—all this, in rebellion against the meaning and the finality of every single spatial form in creation, be it vegetable, mineral, animal, or cosmic.

It was Goethe who once said to Boisserée that direct vision of things was everything to him: "The highest of all things would be to understand that all that is concrete is already theory. . . . It is essential not to try to go behind phenomena; they are themselves the doctrine."[2] When I first came to Paris as a youth, it embodied for me the great spirit of directness and *clarté* of the French. There the natural forms themselves were apprehended; they were not just pretexts for the beyond. In other words, one *saw*; one did not only think speculatively, as was the case east of the Rhine. Now, after so many years, we find ourselves confronted, even in Paris, with a world in which the prime motive power is not seeing, but knowing and feeling, the behind and the beyond, the vagueness or presumed precision of scientific or philosophical-aesthetic, or psychological, or Germanic, or Far Eastern notions. Innocence of vision no longer exists. We are as far away as can be from a classic and mature notion of art. The clearly defined visual concepts have been replaced by concepts reminiscent of Otto Weininger's *henides*[3] —shapeless notions, not yet crystallized, which the young Weininger ascribed mainly to the thought process of women in which a blending of emotion and cognition takes place without the will and the power for formative definition.[4]

In practically all countries, more than half the production of the visual arts today is abstraction in one form or another. This has never before been so in the history of mankind. It is certain that a comparison between our abstract expression and the abstract trend of Neolithic art, with its deep symbolic significance, will not stand up before historically well-founded criticism. Our abstract art has a more analytical, as well as a distinctively symptomatic, character; only to a very limited degree does it possess the symbol-craving quality of the primitive mentality, which was dictated by an inner necessity. Frequently, however, and much more characteristically, it reveals a similarity to the decorative arts of Islam or a dependence upon archaic, mainly primitive, sources of art, upon the pictographic and ideographic stages of writing throughout the world. An abstract artist whose judgment I believe to be honest[5] has repeatedly

declared in all seriousness that ninety-nine per cent of abstract art today is not art at all but an acquired attitude and a fashion demanding very little true effort, an exploitation of a trend which offers quick recognition.

On the other hand, we must not forget that the so-called Neo-Realist approach in art, with all its variations, has produced only more or less talented Realist mannerisms; it has not brought forth a renewed vision of reality. Working with the old formulas of composition and idea content, it has often remained academic in its nature. It is founded on a misconception, because the artist's reality is a vital poetic reality, a reality distilled from perceptions passing through the human mind. It is not the basest, or the saddest, or the most prosaic and naked of experiences.

My statement on the Realist movement is meant as a criticism; that on the abstract movement in general and on Tachism, Spazialismo, and Action painting in particular represents criticism only up to a point. The phenomenon is too striking, too serious not to involve more than criticism. I am writing here as a critic, but I have on other occasions pointed out that criticism has need of a philosophy if it is to be creative and constructive.[6] Let me approach the problem of abstraction by way of a geometrical analogy. There is a "horizontal" line of relationship in the unfolding and evolution of art[7]—tradition—which in our investigation assumes that any new idea, itself constituting the starting point for a next step, a further exploration, a further specialization of its "revolutionary" content, has its own roots in previous developments. Thus, analytical Cubism grew out of Cézanne's experiments, and geometric abstract art out of analytical Cubism; organic abstract art arose as a protest against the one-sided geometric concept; the dynamic *Art autre* sprang from opposition to a merely static conception, and the Expressionists opposed the purely cerebral notion of geometric abstraction; the combination of color elements and shapes arose from Impressionist brushwork and Pointillism. The emphasis on the action rather than on the result, on the artist rather than the work, is a direct deduction from a former position, with its acceptance of the non-art quality of art as stated by Surrealism.

Malraux has contended that

> the most naive sculptor of the Middle Ages, like the contemporary painter obsessed with history, when inventing a system of forms, derived it neither from his submission to nature nor

from his own feeling, but owed it to the conflict with another art form. . . . That one may become a painter not before the most beautiful woman but before the most beautiful picture.[8]

However powerful, however lasting may be the impressions emanating from the work of art, they always are refractions, reflections of another spirit, never the direct experience from which alone the formative can grow.

I do not suggest that Malraux is unaware of a line of relationship other than the horizontal. He emphasizes, however—and necessarily for his research—the historical, the horizontal line; we must emphasize in our present investigation the lost world of visual experience.

Is there then another line of relationship besides the horizontal? Yes, most certainly there is, and it is indeed the most important one, without which there can be no profound experience at all. To the extent that it is primary it is also subjective—for it is not given to us to recognize the eternal.[9] It is our contention that there is not and cannot be any true art without the experience of this primary and subjective relationship. We speak of the vertical line of relationship, the relationship between man and creation experienced anew in every single individual as the irreplaceable happening without which there is no inner life. As a tree grows vertically and cannot exist without its roots, so man's mind cannot work creatively unless his roots reach into the consciousness of Being, unless they are nourished by the springs of the primary, of subjectivism.

When in the modern development of art subject matter was dismissed as being literary, what was dismissed, or rather what should have been dismissed, was only the traditionalist concept of reality, not the whole world of natural forms. This would seem to us a grave error in logic on the part of a movement which is distinguished by a very logical development. Although subject matter came back into modern art—after analytical Cubism there was Purism, then synthetic Cubism, then Surrealism with the dream and the subconscious, and finally all branches of the new Realism, Social and Existentialist—it did not achieve that elemental power which is the essence of each individual primary vision.

What a unique experience—this experience of "seeing," for the first time, a flower, a bird, fire, the moon! The sensation, for the first time, of the smell of reseda, of freshly baked bread, or the sound of the sea at night! To feel the gentle softness of a woman's breast,

to dip one's hand into the water, for the first time! What is this unknown element water, cool and evasive, which yields to my hand? The wind plays on its surface, the light penetrates it and changes its color in the depths. The formula H_2O is a definition. But can it define water's appeal to the senses? What is a pear? Its ripe form like the tender shape of a hip, its surface like a look veiled by sorrow, the sweet scent of its flesh, the taste of its juice! Without having experienced it, what can we say? Do you see how far we get with logic alone? Not very far, either in art or in philosophy. Modern thought, building on logical positivism, cannot go a step further than the ironic knowledge of the old Greek Cynics: that a pear is a pear.[10] Tautology, not cognition. The senses are the doors of perception to human and artistic experience. A definition can name a thing, but without life's experience there is no content. The form identifies it. The final shapes of nature, so supremely present in the first vision of a child or the primitive artist, must have a meaning, a significance, or the life process would not have stopped where it did. To regain this faculty of seeing the appearances of life as though for the first time—this and only this will bring the efforts of modern art to fruition. Again, has not our generation, in its continued thrust toward the elemental, the primitive, committed a similar error in logic when it confused the manner in which children or primitive men reproduce their vision with the vision itself? In most cases this has led, *not* to the rediscovery of the virgin vision in all its overpowering intensity, but merely to a recapitulation of the child's and the primitive's way of giving it form. From that end we cannot reach it. We cannot become children or primitives again and, honestly, we do not want to. We do not want to neglect or diminish that mental process which lies between the primary impression and its mature, formal expression.

There are some paintings by Matisse in which every single form is experienced for its own sake, not only as part of a compositional whole but as a manifestation of form *per se*.[11] By the directness of his intuition the painter has here achieved a visual finality which we could call philosophic. It is as convincing as the visions in old Chinese master paintings, as compact as any sentence of the *Tao-Tê Ching*, as deep and beautiful as a page from the Gilgamesh Epic, as holy as the Song of the Bhagavad-Gita. Here forms of life are experienced as though seen for the first time. Here the sensual organ, the eye, has wrested the supremacy from the brain. Here painting is painting and not science, not logic. Our senses possess a unique

faculty, and unless we use them primarily, whatever we may achieve in art will be non-art. Only the senses, by restating the forms of life, can humanize them, that is, unveil their significance through the poetic process of creation and force it out of the anonymity which is the fate of life without witness.

In Matisse, to give but one example, modern man reached for the new, which is the eternal. For there is eternity in life; but styles and formulas in art are timebound. In the sequence of time, the time-bound, changing quality of art can acquire the inner faculty of a rebirth to life only if in the secret process of crystallization it has reached into the timelessness of being.

Why are styles and formulas in art timebound? Because it is the fate of human thought that it is fettered to its own predestined nature. Whatever problems man encounters in his individual life or in the life of his generation, they compel him to embark on their solution, to enable him to survive. That is why Nietzsche conceived of the thinker as searching not for the truth but for the metamorphosis of the world in man.[12] That is why we have dark ages and enlightened ages, times when mythical and philosophical imagination rules and others when rationalism dominates. Rarely are there times when a balance is achieved between the two. Whenever man tries to break through his own nature in thought, he arrives either at the bleak bones of logical analysis and semantics or at Platonic ideas, both estranged from life. Art alone can restate the visual essence of life itself. It can—but does not yet do so in our time, because it is enslaved in the same chains of logic which shackle the rationalistic schools of philosophy.

When Cézanne painted apples he perceived them with a struggling and troubled mind so as to regain the faculty of seeing; but he rendered them with the help of conventional laws of composition. The next step was taken by Matisse—to the roots, to the source of primary experience. It was not only a logical step in the horizontal direction; it was an essential step in the vertical direction. Every single artist will have to take this step or time will undo his art.

Abstraction has become the *Alltag*—the everyday life of our presence in art. Unless we glorify life's forms in their ultimate significance, unless we reconcile emotionalism and analytical cerebralism in line, color, and handwriting with the finality of life's formative processes, we shall not be able to create an art which is congenial to the wholeness of life.

NOTES

1. A few titles of studies relevant to this problem: Karl Blossfeldt, *Urformen der Kunst*, introduction by Karl Nierendorf (Berlin, 1935); D'Arcy W. Thompson, *On Growth and Form* (Cambridge, 1942); Henri Focillon, *La Vie des formes* (Paris, 1947); L. L. Whyte, ed., *Aspects of Form* (London, 1959); L. L. Whyte, *Accent on Form: An Anticipation of the Science of Tomorrow* (New York, 1954); René Huyghe, "L'Evolution du régime des formes," in *Atti del III Congresso Internazionale di Estetica, 1956* (Turin, 1957); Oskar Kokoschka, "Das Wesentliche Bildender Kunst," in *Oskar Kokoschka: Das Werk des Malers*, ed. Hans Maria Wingler (Salzburg, 1957).

2. Quoted in J. P. Hodin, "Goethe's Succession," in *The Dilemma of Being Modern* (London, 1956).

3. *Henides* from ἕν, because they do not yet indicate any duality between feeling and cognition, representing two different elements which can be isolated for the purpose of abstraction.

4. Otto Weininger, *Geschlecht und Charakter* (Vienna and Leipzig, 1903).

5. Victor Pasmore.

6. J. P. Hodin, "Problems of Living Art Criticism," in *The Dilemma of Being Modern;* "Art Criticism Now," in *The Studio* (London), September 1950; "Art and Criticism," in *College Art Journal*, XV (1955), 1; "The Interpretation of Modern Art," in *The Museum and Modern Art, Art News and Review* (London), VIII (September 17, 1956).

7. The term "evolution" is used here without the implication of a continuous development in one direction for the better or the more accomplished.

8. "La Création artistique," in *Les Voix du silence* (Paris, 1951).

9. "Eternalize" an idea and it becomes sterile. Force the concepts of a certain type of man upon another and you arrive at dogma.

10. A. J. Ayer, *Language, Truth, and Logic* (London, 1936); G. E. Moore, *Some Main Problems of Philosophy* (Cambridge, 1953); R. G. Mayor, *Reason and Common Sense: An Inquiry into Some Problems of Philosophy* (London, 1951).

11. *Pink Onions (Les Oignons roses)*, 1906, in the Statens Museum for Kunst in Copenhagen; *La Desserte*, 1908–9, in the Moscow Museum of Modern Western Art; *The Blue Window (La Fenêtre bleue)*, 1911, and *Les Colaquintes*, 1916, in the Museum of Modern Art in New York. All these are reproduced by Alfred H. Barr, Jr., in his *Matisse, His Art and His Public* (New York, 1951).

12. *Der Philosoph sucht nicht die Wahrheit, sondern die Metamorphose der Welt in den Menschen: Die Unschuld des Werdens. Der Nachlass* (Leipzig, 1931).

3 • AESTHETIC JUDGMENT AND MODERN ART CRITICISM

A Contemporary Problem

THE MAZE OF AESTHETIC THEORIES THAT AROSE IN EUROPE AFTER HEGEL erected in his *Ästhetik* the most comprehensive system up to that time, and a temple to this subject, is an exact image of the ever-changing, confusing, and radically revolutionized situation we find in the development of the arts during the last hundred years, a development which has reached its phase of chaos and the annihilation of form since the middle of this century. There is no serious study of aesthetics which does not possess obvious or hidden links with Hegel's superhuman effort, either accepting or repudiating it, developing its ideas as a whole or parts of it, and inevitably so because in itself it is to be seen as an encyclopedic and critical condensation of all the theories on art in existence up to his own time.[1] There is nothing new or particularly surprising in this statement, even if we include, besides obvious examples such as the aesthetics of Benedetto Croce or Eduard von Hartmann or George Santayana, those of Oswald Spengler, Ludwig Klages, or André Malraux, which are all closely connected.[2] It is even true of Martin Heidegger. It was this oracular thinker who, pointing to the weighty remark contained in Hegel's *Vorlesungen über die Ästhetik*: "But we have no longer the absolute need to give expression to content in the form of art. As far as its highest realization is concerned, art is for us a thing of the past," added significantly: "It has not yet been decided whether Hegel's sentence is right."[3]

Today, after the most violent and intense development in the entire history of art, we see that what has been attacked and destroyed in aesthetic appreciation during the last five decades is not only the tradition of five centuries, including the Greek stylistic

195

tenets from after the fifth century B.C. which are at its roots, but also the whole system of thought, philosophical, religious, and ethical, feeding it as an *alma mater*. We are in the midst of this vehement process and, in fact, in its most confused stage. Our concern here is how such a process can possibly be dealt with in aesthetics with a notion which belongs to a spiritual concept long since destroyed, and which is the expression of an ideal which has consistently been repudiated and defeated: beauty. That for Hegel the subject and study of aesthetics was "the wide realm of beauty . . . art, i.e., beautiful art" and that in defining his science he called it "philosophy of art, or more precisely philosophy of beautiful art" is not astonishing. But that even Heidegger cannot free himself from this notion and has to struggle with it until he arrives at last at the conclusion that the history and substance of European art "can be comprehended neither through beauty by itself nor through the capacity of experience, provided the metaphysical concept does reach into its essence at all"[4] forces us to scrutinize this term anew. It seems easier for an art historian than for a philosopher to adopt this position of detachment from a fixed concept. Bernard Berenson, who was beyond all suspicion of having been too interested in the modern effort in art, being well known for his conviction that European art attained in the Renaissance the highest level ever reached by a human culture, wrote about the scarcity of the terms "beauty" and "beautiful" in his opus on aesthetics and history: "I have not avoided them deliberately, but art history is the history of art as an experience and is indifferent to questions of beauty."[5] Since Zola coined the phrase *"Le beau c'est le laide,"*[6] which was accepted by the Realists in art and literature, the notion of beauty has been discredited. From Baudelaire's concept of satanic beauty—*le beau satanique* (and it was he who said, "Beauty is an enormous monster, terrifying, artless")[7]—to the Hegelian Surrealist André Breton's command: "Beauty will be convulsive [i.e., it will be erotic] or it will not be"[8] is only a step. It is a shade, a degree, in the same anti-aesthetic attitude which led to the dictum: "Ugliness—the theme of our century." It is also the step from the aesthetic contrast of beautiful-ugly to the psychological deepening of the meaning of ugliness, ugliness as the hidden life of man with his passions, his instincts, and his vices caught unawares in the latent stage, devoid of any mask or disguise, released by the artist in their true hideousness without a care of sublimation.[9] This reasoning on the literary concept of beauty may be finalized here with the clear-cut pro-

nouncement of Valéry: "In our time a definition of beauty can only be considered as an historic or philosophical document. Taken in the ancient fullness of its meaning, this illustrious word will join many other verbal coins no longer in circulation, in the drawers of the numismatists of language."[10]

Let us now consider the reasons for the modern artist's enmity toward the notion of beauty. In a statement to Christian Zervos in 1935, Picasso said:

> Academic training in beauty is a sham. We have been deceived, but so well deceived that we can scarcely get back even a shadow of the truth. The beauties of the Parthenon, Venuses, Nymphs, Narcissuses, are so many lies. Art is not the application of a canon of beauty but what the instinct and the brain can conceive beyond any canon. When we love a woman we don't start measuring her limbs. We love with our desires— although everything has been done to try and apply a canon even to love. The Parthenon is really only a farmyard over which someone put a roof; colonnades and sculptures were added because there were people in Athens who happened to be working, and wanted to express themselves. It is not what the artist sees that counts, but what he is. Cézanne would never have interested me a bit if he had lived and thought like Jacques Emile Blanche, even if the apples he painted had been ten times as beautiful. What forces our interest is Cézanne's anxiety—that's Cézanne's lesson; the torments of van Gogh— that is the actual drama of the man. The rest is a sham.[11]

Henry Moore, in a conversation with me in 1956, stressed the disturbing element, the distortion giving evidence of a struggle of some sort as the basic quality of all art which he considers great. In opposition to it stands classical art with its pleasing quality and a happy finality. Beauty as an ideal, with its perfectionist tendency, does not enter the realm which Moore embraces as great.[12] When Klee, speaking of the artist who has been used to represent things visible on earth which he enjoyed seeing or would have liked to see, said: "Now we reveal the relativity of visible things, and thereby express the belief that visible reality is merely an isolated phenomenon latently outnumbered by other realities," he showed that he is not at all concerned with the notion of beauty but with the notion of Being. Intuitively, and as a mystic, he considered Being, and analogously art too, to be a conjunction of contrasting elements,

where each force requires an opposing force to achieve a stable, self-contained state—as did Jung, Heraclitus, Nicolas Cusanus (*coincidentia oppositorum*). Beauty is nowhere mentioned in his theoretical writings.[13]

"Destroy the cult of the past, the obsession of the antique . . . rebel against the tyranny of the terms 'harmony' and 'good taste.' . . . Take and glorify the life of today" proclaimed Marinetti in 1909.[14] "Museums! cemeteries . . . Museums; public dormitories . . ."[15] From here to Jean Dubuffet's thesis of *l'art brut préféré aux arts culturels* (that is, the art of the untrained, the ignorant, the idiot, the madman, the sexual graffiti on pavements, walls, and the doors of public lavatories, and only rarely the art of unperverted children) is only a step and a very logical one, in the way that everything happens logically in the unfolding of modern art. Dubuffet's pretended struggle against the museum notion of art—a problem considered seriously by Spengler, Malraux, Sedlmayr, and others[16]— constitutes a debasement of art in which delving in matter, the dirtiest of matter, is confounded with the great achievements in the image-making faculty of man. Proclaiming himself to be concerned with the most humble element—as matter contains the primeval mud —and with non-art,[17] Dubuffet is guilty of the crudest cynicism, for his paintings and *assemblages* are sold and acquired by museums all over the world. Michel Tapié, fighting for this utter vulgarization like a St. George eager to kill the already dead Academism, confuses it with the spirit of the *grandes civilisations*. He defends the perverted subtleties of this sensationalist who represents a low denominator of human dignity and aspiration, his emulations of the primitive, his acted brutalism, as the sure sign of the coming Messiah: "Until now only the historically or geographically *Barbarian* arts have escaped the childish canons pickled under Pericles and brought out again with a thousand more or less grotesque affectations by those epochs of historic aberrations which incredibly have been catalogued under the name of *grands siècles!*"[18] Here, then, we have the other extreme: the antagonist of culture, the sworn enemy of any "ideal" conception, including that of beauty—and in saying this I am painfully aware of the fact that we have none.

At this point in our reasoning we may understand fully Hegel's doubt whether art still corresponds to an absolute necessity of expression in our age; we see now that *art in its highest realization* may be for us a thing of the past. And what else again can this art in its highest realization be but art as conceived by Heidegger, the

very essence of which is defined by its metaphysical content. "Metaphysics is concerned with the recollection of the essence of Being and with the decision on the essence of truth."[19] In the same vein, Karl Jaspers states that the urge of man's metaphysical thinking is toward art.[20] Making an essential differentiation between sensual and spiritual art he claims that only the latter is the language of the transcendental.[21]

In the wake of Heidegger, Ernesto Grassi proclaimed that modern art, "like the art of all epochs, is art only if the material of its representation serves the 'idea' of what it is possible for man to achieve"—"possible" meaning to him the highest, not the lowest, degree of man's spiritual aspiration. Only then can it evade the arbitrary interpretations which are so disastrous for its existence.[22]

We realize that the term "aesthetics," by virtue of its too close identification with ideal beauty, the beautiful, is not only discredited but misleading. Hegel already seems to have felt this. The original meaning of the term $αἰσθητικός$, as used by the Greeks and by Kant, was "of sensual perception,"[23] and is not of great help to us, for the very reasons for which we hesitate to accept the term "aesthetics."[24]

We ourselves prefer the phrase "philosophy of art," within the scope of which fall the theories of art; the relationship of technique and expression; the definition of art in its historical perspective; the classifications and the interrelations of the arts; the psychology of artistic creation and the response of the public; the interpretation of art in connection with the *Zeitgeist*; the life and meaning of changing forms and styles; and, last but not least, the metaphysics of art. We prefer this phrase for two reasons: first, because we are convinced that aesthetics is not a science which can apply the methods and aims of the natural sciences to the sphere of art, and secondly, because we do not believe that there can be a rigorous division between aesthetics and philosophy in general. In the deeper strata where the essence of art is referred to there is no separation. Again, when speaking of philosophy we do not mean the academic discipline of philosophy, the knowledge of past and present systems *per se*, but knowledge to be used in the service of thought, the search after meaning and truth, the right and original function of philosophy, which is the pursuit of wisdom. Such philosophy, which has been proclaimed in our time as dead by both philosophers and scientists, is entering a phase of unforeseen renewal. A majestic effort to widen the scope of philosophical investigations has

been ventured upon recently, characterized by a study of the lead-
ing philosophers and their schools, Eastern and Western—in Jaspers'
terms, *Die fortzeugenden Gründer der Philosophie:* Plato, St. Au-
gustine, Kant; *Aus dem Ursprung denkende Metaphysiker:* Anaximan-
der, Heraclitus, Parmenides, Plotinus, Anselmus (Cusanus), Spinoza,
Lao-tse, Nagarjuna—joined by the figures of Socrates, Buddha, Con-
fucius, and Jesus (*Die massgebenden Menschen*); by the philoso-
phers in poetry (the Greek tragic poets, Dante, Shakespeare, Goethe,
Hölderlin, Dostoevski); in research (Kepler, Galileo, Darwin, van
Baer, Einstein, Ranke, Burckhardt, Max Weber); in politics (Machi-
avelli, Morris, Locke, Montesquieu, Burke, Tocqueville); in the
humanities (Cicero, Erasmus, Voltaire, Shaftesbury, Vico, Hamann,
Herder, Schiller, Humboldt, Bacon, Bayle, Schopenhauer, Heine);
in life's wisdom (Epictetus, Boethius, Seneca, Epicurus, Lucretius,
Montaigne); in the practice of life (Ichnaton, Asoka, Marcus Au-
relius, Frederick the Great, Francis of Assisi, Hippocrates, Para-
celsus); in theology (Mo-ti, Mencius, Paulus, Tertullian, Male-
branche, Berkeley); in the teaching of philosophy (Proclus, Scotus
Erigena, Wolff, Erdmann). We may add the philosophy of the men
of art (Leonardo, Michelangelo, Dürer, Rembrandt, Goya, Dela-
croix, Kokoschka, Klee) and of architecture (Palladio, Villard de
Honnecourt, Bernini, Loos, Le Corbusier). Our age is the first to
reveal, in its concept of philosophy, art, and history, a universality
never before dreamed of.[25] In view of this fact, can aesthetics still
be allowed to isolate itself in the attempt to copy the specialization
of the exact sciences, which is necessitated by diametrically opposite
aims and methods—depriving both philosophy in its general con-
cept, and aesthetics in its specialized one, of their very life blood?[26]
The two phases in the history of modern aesthetics, those in which
it was seen first as a special branch of philosophy, then as a science,
must now be followed by a third phase, in which the thorough
methodology, the concern for form and style in art, for the applica-
tion of the sciences of sociology, psychology, statistics, archaeology,
anthropology, ethnology, and history for the purpose of aesthetics,
that is, the analytical aspect of aesthetics,[27] is completed by the hu-
manist aspect, the metaphysical approach, which reinstates man as
a totality far richer, far deeper, far more powerful than his rationality.

In this connection it might be said of the relationship between
aesthetics and art criticism that however we define these provinces
of knowledge, we must realize that no critical discrimination, no
judgment, no description or interpretation of works of art is possible

without the use of doctrines of aesthetics and of art history to-
gether with all the specialized sciences which nowadays reinforce
them. The history of aesthetics is in fact to a great extent the his-
tory of art criticism[28]—the term aesthetics only appearing relatively
late (A. G. Baumgarten, 1750).[29] Lionello Venturi's *History of Art
Criticism* is equally a history of aesthetics. He approaches his sub-
ject as a philosopher rather than as a critic, placing his emphasis
on the philosophy of art. He pleads for unity to avoid anarchy, the
unity of art history, art criticism, and aesthetics:

> Recently an authoritative voice in France has insisted upon
> the differentiation of the three disciplines. The history of art
> should present works of art—all the works of art—without judg-
> ing them, without commenting upon them, with the richest
> possible documentation of the facts. Art criticism should judge
> works of art in conformity with the aesthetic feeling of the
> critic. Aesthetics should formulate the definition of art in its
> universal meaning.[30]

When speaking about the method and terminology of art criticism
in 1957, Venturi expressed his conviction that "a properly prepared
vocabulary would contribute to the method of art history and criti-
cism." He stressed the fact that an art term can only be understood
historically; after its original meaning has been determined, the
evolution of that meaning as a result of changing ideas must be
traced right up to the present.[31] Unity of art history and art criticism!
In a similar spirit a study was published some time ago in which
the unity of aesthetics and art criticism was proclaimed.[32] But alas!
Aesthetics is therein understood as "that branch of philosophy whose
function is to investigate what is meant to be asserted when we
write or talk correctly about beauty. It is concerned logically to elu-
cidate the notion of beauty as the distinguishing feature of works
of art and to propound the valid principles which underlie all aes-
thetic judgments." Here is the devil beauty again, that is, beauty
in art conceived as the ideal, as though during the past fifty years
there had been no complete reversal of taste or style. It is a truism
to say that a critic has to deal with contemporary art. But how can
a critic today believe that he will be able to assess the earthquake
in our artistic traditions with the help of this specific and antiquated
notion of beauty?

In a time in which the non-art quality of art has been solemnly
proclaimed (Dadaism, Surrealism), when all notions of traditional

technique, of composition, of the concept of the work of art and its function have been shaken, when the figurative has been supplanted by the abstract, the constructive element by chance and accident, the brushwork by the drip and the splash, the paint by Polyfilla, the cellulose adhesive filler and bond, by plaster, sand, sackcloth, wood, bits and pieces of rubbish, wire, etc.; the volume in sculpture by linear writing in space or by the inclusion of architectural elements, the modeling or carving by drilling and welding; when technique stands in the foreground and the "thing itself" is forgotten or neglected—in the stage of development in which our art finds itself now, of what use can the ideal notion of beauty, as it was established in classic art, be to us?

In former times the critic was critical, but he has now long refrained from evaluation. He cannot keep pace with the rapid and violent changes and plays safe by accepting everything. Far removed is the time when critics barred the way to development and progress in art. There are no longer martyrs and saints of modern art such as van Gogh, Gauguin, or Cézanne. The public no longer storms the art galleries in protest; it does not attack the works; it has become apathetic and accepts change as if defeated by destiny. The artist stands today like a film star in the spotlight of public admiration, or he is a teacher of art, safe like a pensioner. What is left is the passive acceptance by public and critic of every whim that comes along. What is left are the speculations of the art trade. But there are artists who are bewildered by this most recent development and look for something more constant to hold on to. Who can give it to them? The creative critic, the art historian? Once I mentioned to a young and already successful painter the Chinese saying: "When painting has reached divinity there is an end of the matter," and noticing his interest, I spoke to him about the traditional canon of Chinese art, the treatise *Chieh Tzu Yüan Hua Chuan*, in which not only are all things visible depicted as examples but man's attitude toward nature is fixed and his love of creation, his philosophy of life, the Tao, defined.[33] The painter grew thoughtful and said:

> Why do you not write such a canon for us? Isn't it your duty? The Gothic time had one, the Baroque time had one, we have none. There are thousands of artists nowadays who can do a lot but they have no hook to hang their craft on. If we could only get a mental image of ourselves, we could pull ourselves up by our shoestrings. But no: the painter rushes into this

corner and comes back bleeding and then he rushes into another corner—and that is that. Then he says: See how I have wounded myself, it looks very decorative! What we need is an imaginative structure which the theoretician can share with the artist now, in a closer manner than ever before. Once upon a time the painter did something and then the theoretician came and proclaimed: This means this and this means that. Now the relationship is more instantaneous. . . .

You see what I am aiming at. It is perhaps the failure of our profession not to recognize where the true task lies.

There is a Cubist aesthetics, there is a Futurist aesthetics, an Expressionist, a Purist, a Dadaist, a Surrealist, a Realist, a Fauvist, a Symbolist, a Pop, an Op, a Kinetic, an Abstract, many Abstract, aesthetics.[34] Is it, taken all together, something a critic can use in the creative way suggested above? No. Something more is needed for that, something wider and deeper. The whole present development can be seen as an atomism of aesthetics, in the same sense as we speak of an atomism in philosophy or, of course, in science. For the atomic method forms the basis of nearly all exact analysis.[35] As cognition of reality atomism is a short-sighted method. Despite the multiplicity of objects one can no longer see reality; despite all isms and their theories, no longer recognize what art is. But there is a viewpoint beyond these specialized and fragmentary ways of approach, a viewpoint in which they are all united, in which they all receive and conserve their true meaning, the meaning which we call the philosophy of art. And here again beauty can play its part—not as a historically established dogma but as a necessary corrective to all the unbalanced and nihilistic attitudes of today, whether the concept of life's absurdity or that of *Angst*, the destructive urge, the regression to primitivism or the gospel of ugliness[36]—the search for beauty as nostalgia, as the enigma of perfection, as Kant spoke of transcendental beauty or as the prophetic woman spoke of man in search of beauty to Socrates in the *Symposium*: he will begin

with the love of beautiful things and continuously ascending, as though by steps, for the sake of Beauty itself, from one beautiful body to two and from two to all and from beautiful bodies to beautiful Morals and from beautiful Morals to beautiful Sciences and from the Sciences finally to that Science which is nothing less than the Science of pure Beauty, wherein the true essence of Beauty is learnt. Therein, my dear Socrates, if any-

where, should life be lived, in the contemplation of Beauty's self.[37]

Perhaps the search for beauty calls for a force great enough to recognize a higher and deeper meaning in and behind our time's tragic conflicts and hateful abysses. What is at stake, we repeat, is not an ideal but a force which refines and elevates. For only he who loves can see beauty. And only he who loves can truly create. Braque, when I asked him about the problem of beauty during a conversation in the summer of 1952, said:

> There is first the question whether beauty is a problem. It is not, because there are no such fixed data. Fixed data are misleading. There is no solution for life—but there is a perpetual process of adaptation. I have replaced the notion of the eternal by the idea of the perpetual. The question of beauty is a question of achieving harmony. And harmony is nothingness for the intellect where words have no value. It is a state of grace or of mystic illumination. In such a state one comprehends beauty.

Our present difficulties make me believe more than ever that the personal contact with the artist is of the utmost importance for the critic, in order both to learn and to give. Did not great critics such as Diderot and Baudelaire owe their knowledge of the artist's craft to the artists themselves?[38] Julius Meier-Graefe sought the company of Max Liebermann when visiting art exhibitions. And again, did not the artist owe much to his contact with the writer? Delacroix to Baudelaire, Hildebrand to Fiedler, Cézanne to Zola? The relationship between Picasso and Max Jacob or Apollinaire, between Kokoschka and Altenberg or Hasenclever, the interest of Klee for Kant, of van Gogh in the written word, are well known.[39] What the writer has to give is the knowledge of philosophy, of literature, of music, of religious concepts, of aesthetics, of art history, in short, of the history of human culture. He will use the history of art not as an academic discipline, but as the source and background to contemporary creativeness—see it, as it were, in reverse: not from the earliest date forwards but from today backwards, constructive in appreciation, and vital. He will take aesthetics as the continuing effort of man to grasp the significance and the inner meaning of art as a way to the comprehension of life; he will, by confronting the past with the present, spin the thread which connects the past with the fu-

ture. He will thus promote that impetus which dominates any artist worthy of the name and any person of integrity: the desire to ennoble and embellish human existence and to hand it with dignity to the coming generation as the most precious gift bestowed upon us.

To sum up: the concept of beauty is not appropriate when approaching the modern movement in art. Since the term aesthetics is too closely associated with the notion of beauty, it should be replaced by the term philosophy of art. This also involves the repudiation of aesthetics as science and the acknowledgment of the metaphysical roots of art.

The modern art historian who works on a global scale is more ready to accept this position than the academic philosopher who bases his world of ideas on Plato, Kant, and Hegel; but new philosophical thought is providing us with a definition of the transcendental without which art remains only play or decoration or pleasure, the expression of sensualism or mental nihilism (Jaspers, Heidegger).

The personal relationship and cooperation of the artist with the art critic and historian is a necessary one. The first has the knowledge of his aims and his craft, the second has the wide awareness of the history of culture. Only together, in their mutual influence and inspiration, can they relieve the modern movement of its present dilemma. The time of ideological revolutions, of destruction, decomposition, and profanation, must be ended. What has to arise now is a new cultural consciousness, the style of a new culture.

NOTES

1. Georg Wilhelm Friedrich Hegel, *Ästhetik* (first complete edition, with an introductory essay by Georg Lukacz, Berlin, 1955).
2. Benedetto Croce, *Estitica come scienza dell'espressione e linguistica generale*, 9th ed. (Bari, 1948); E. von Hartmann, *Philosophie des Schönen* (Berlin, 1924); Willard E. Arnell, *Santayana and the Sense of Beauty*, Foreword by Irwin Edman (Bloomington, Ind., 1957); Oswald Spengler, *Der Untergang des Abendlandes*, 2 vols., 65th ed. (Munich, 1923); André Malraux, *Les Voix du silence* (Paris, 1951); Ludwig Klages, *Der Geist als Widersacher der Seele* (Munich, 1954).
3. Martin Heidegger, "Der Ursprung des Kunstwerkes," in *Holzwege* (Frankfurt, 1930).

4. Ibid.
5. *Aesthetics and History* (New York, 1948).
6. Quoted from "Das Schöne," in Eduard Thorn, *Künstler über Kunst* (Baden-Baden, 1951).
7. *Curiosités esthétiques* (Paris, 1946).
8. *Nadja* (Paris, 1928).
9. See Lydie Krestovsky, *La Laideur dans l'art à travers les ages* (Paris, 1947).
10. *Variété*, Vol. 3 (Paris, 1936).
11. Quoted from Alfred H. Barr, Jr.: *Picasso: Fifty Years of His Art* (New York, 1946); French version in Florent Fels, *Propos d'artistes* (Paris, 1925).
12. J. P. Hodin, "Conversation with Henry Moore," *Quadrum I* (Brussels), May 1956. See the essay "The Philosophical Meaning of the Work of Art," pp. 32–40 in this volume.
13. *Das bildnerische Denken* (Basel-Stuttgart, 1956); C. G. Jung, *Psychologische Typen* (Zurich, 1921), see: "Enantiodromie"; W. Nestle, *Die Vorsokratiker* (Jena, 1922); J. Hommea, *Die Philosophische Gotteslehre des Nikolaus Kusanus in ihren Grundlehren* (Munich, 1926).
14. *Fondazione e Manifesto di Futurismo*, Pubblicato del "Figaro" di Parigi, il 20 Febbraio 1909 (Venice, 1950).
15. "First Manifesto of Futurist Painting" (1910), in *Le Futurisme* (Paris, 1911).
16. Spengler, op. cit.; Malraux, op. cit.; Malraux, "Le Problème fondamental du musée," in *La Revue des Arts* (Paris), No. 1, 1954; Hans Sedlmayr, *Verlust der Mitte: Die bildende Kunst des 19. und 20. Jahrhunderts als Symptom und Symbol der Zeit* (Salzburg, 1948).
17. Georges Limbour, *Tableau bon levain à vous de cuire la pâte: L'Art brut de Jean Dubuffet* (Paris, 1953). See also: Georges Limbour, Introduction to the Catalogue, in *Jean Dubuffet, Paintings 1943–57* (London, 1958).
18. *Hautes Pâtes de J. Dubuffet* (Paris, 1946).
19. "Die Zeit des Weltbildes," in *Holzwege*.
20. *Philosophie*, 3 vols. (Berlin-Göttingen-Heidelberg, 1956).
21. *Lionardo als Philosoph* (Berne, 1953).
22. "Das Problem der Modernen Kunst," in *Kunst und Mythos* (Hamburg, 1957).
23. Rudolph Eisler, *Wörterbuch der Philosophischen Begriffe* (Berlin, 1927–30).
24. The definition of modern art is given in the chapter "What Is Modern Art?" in this volume.
25. Karl Jaspers, *Die Grossen Philosophen*, Vol. 1 (Munich, 1957); André Malraux, *Les Voix du silence*; Malraux, *La Métamorphose*

des dieux (Paris, 1957); René Huyghe, *Dialogue avec le visible* (Paris, 1955); Huyghe, *L'Art et l'homme* (Paris, 1957); Arnold Toynbee, *A Study of History*, Vols. 1-10 (London, New York, Toronto, 1934-54).

26. See J. Bronowski and Bruck Mazlish, *The Western Intellectual Tradition* (London, 1960). See also Friedrich Heer, *Europäische Geistesgeschichte* (Stuttgart, 1953).

27. For sociology: Arnold Hauser, *The Social History of Art*, 2 vols. (New York, 1951); Walter Abell, *The Collective Dream in Art* (Cambridge, Mass., 1957). For psychology: Charles Baudouin, *L'Art et psychoanalyse* (Paris, 1929); Hanna Segal, "A Psycho-Analytical Approach to Aesthetics," in *New Directions in Psycho-Analysis* (London, 1955); Sigmund Freud, "Psychologie der Kunst," in *Vorlesungen zur Einführung in die Psychoanalyse* (Leipzig, Vienna, Zurich, 1920), pp. 435–37; Freud, *Gesammelte Werke*, Vol. 7: *Der Dichter und das Phantasieren;* Vol. 8: *Eine Kindheitserinnerung des Leonardo da Vinci* (London, 1943); C. G. Jung, *Über die Beziehungen der analytischen Psychologie zum dichterischen Kunstwerk*, in *Seelenprobleme der Gegenwart* (Zurich, 1931); Jung, "Ulysses," and "Picasso," in *Wirklichkeit der Seele* (Zurich, 1947); Anton Ehrenzweig, *The Psycho-analysis of Artistic Vision and Hearing* (London, 1953); Rudolph Arnheim, *Art and Visual Perception* (London, 1956); Ernst Kris, *Psychoanalytic Explorations in Art* (London, 1953); G. W. Digby, *Meaning and Symbol in Three Modern Artists* (London, 1955); Anton Ehrenzweig, *The Hidden Order of Art* (London, 1967); Rudolf Arnheim, *Towards a Psychology of Art* (London, 1967).

For statistics: P. A. Sorokin, *The Crisis of Our Age* (London, 1942); Lewis Mumford, *The Transformation of Man* (London, 1957); Mumford, *The Myth of the Machine: Technics and Human Development* (London, 1967); Arnold J. Toynbee, *Change and Habit: The Challenge of Our Time* (London, 1966).

For archaeology: Julius E. Lips, *The Origin of Things: A Cultural History of Man* (London, 1949); Glyn E. Daniel, *A Hundred Years of Archaeology* (London, 1950).

For anthropology and ethnology: Kroeber, *Anthropology* (rev. ed., New York, 1948); E. D. Chapple and C. S. Coon, *Principles of Anthropology* (London, 1947); Gene Weltfisch, *The Origins of Art* (Indianapolis, New York, 1953).

For history: Richard Hamann, *Geschichte der Kunst von der Altchristlichen Zeit bis zur Gegenwart* (New York, 1945); Wilhelm Suida, *Kunst und Geschichte* (Cologne, 1960).

28. K. Gilbert and H. Kuhn, *A History of Aesthetics* (London, 1956); A. Dresdner, *Die Kunstkritik. Ihre Geschichte und Theorie*, Vol.

1: *Die Entstehung der Kunstkritik* (Munich, 1915); Guido Morpurgo Tagliabue, *L'Esthétique contemporaine: Une enquête* (Milan, 1960).

29. Baumgarten, *Aesthetica* (Frankfurt, 1750).
30. *History of Art Criticism* (New York, 1936).
31. J. P. Hodin, "The VIth International Congress of Art Critics," in *The Bulletin of the International Institute of Arts and Letters* (Lindau), No. 51 (1957).
32. H. Osborne, *Aesthetics and Criticism* (London, 1955).
33. Mai-mai Sze, *The Tao of Painting*, Bollingen Series XLIX, 2 vols. (New York, 1956). See also Amanda K. Coomaraswamy, "The Theory of Art in Asia," in *The Transformation of Nature in Art* (Cambridge, Mass., 1934).
34. Christopher Gray, *Cubist Aesthetic Theories* (Baltimore, 1953); Marinetti, *Le Futurisme;* U. Boccioni, *Pittura, Scultura Futuriste* (Milan, 1914); U. Boccioni, *Estetica e Arte Futuriste* (Milan, 1946); *Archivi de Futurismo* (Rome, 1957); Hermann Bahr, *Expressionismus* (Munich, 1916); Wilhelm Worringer, *Über Expressionismus in der Malerei* (Berlin, 1919); Eckart von Sydow, *Die deutsche expressionistische Kultur und Malerei* (Berlin, 1920); Ozenfant and Jeanneret, *Après le Cubisme* (Paris, 1918); G. Hugnet, *L'Esprit Dada dans la peinture*, Cahiers d'Art (Paris, 1932, 1934); W. Verkauf, *Dada* (London, 1957); André Breton, *Les Manifestes du Surréalisme* (Paris, 1955); G. Lemaitre, *From Cubism to Surrealism in French Literature* (Cambridge, Mass., 1941); Charles E. Gauss, *The Aesthetic Theories of French Artists* (Baltimore, 1949)—covers Realism, Symbolism and Fauvism, Cubism, Surrealism; Alfred H. Barr, Jr., *Cubism and Abstract Art* (New York, 1936); M. Seuphor, *L'Art abstrait: Ses origines, ses premiers maîtres* (Paris, 1950); M. Seuphor, *A Dictionary of Abstract Painting* (London, 1957).
35. L. L. Whyte, *The Two Philosophies: Atomism and Pattern* (London, 1949); Bertrand Russell, "The Philosophy of Logical Analysis," in *History of Western Philosophy* (London, 1946); J. D. Bernal, "Science in Our Time," in *Science and History* (London, 1954).
36. Albert Camus, *L'Homme révolté* (Paris, 1951); Sören Kierkegaard, *Fear and Trembling* (1843), *The Concept of Dread* (1844), *Sickness unto Death* (1849); Sigmund Freud, *Zeitgemässes über Krieg und Tod,* in *Gesammelte Werke,* Vol. 10 (London, 1949); C. G. Jung, *Aufsätze zur Zeitgeschichte* (Zurich, 1946); Robert Goldwater, *Primitivism in Modern Painting* (New York, 1938); Lydie Krestovsky, *La Laideur dans l'art;* Jurgis Baltrušaitis, *Le Moyen Âge fantastique* (Paris, 1955); Jurgis Baltrušaitis, *Aberrations: Légendes des formes* (Paris, 1957).

37. *Plato's Symposium or Supper*, trans. and with an introduction by Shane Leslie (London, n. d.).
38. Gita May, *Diderot et Baudelaire* (Paris, 1957).
39. *Journal d'Eugène Delacroix* (1882–63), 3 vols. (Paris, 1932); Adolf von Hildebrandt, *Briefwechsel mit Conrad Fiedler* (Dresden, 1927); Paul Cézanne, *Letters*, ed. John Rewald (Oxford, 1941); Boeck and Sabartès, *Picasso*; Will Grohmann, *Paul Klee* (London, 1954); Vincent van Gogh, *Briefe an seinen Bruder*, 3 vols. (Berlin, 1914); Hodin, *Oskar Kokoschka*.

4 • THE EMPIRICAL APPROACH TO AESTHETIC PROBLEMS IN MODERN ART

THE PROBLEM I PROPOSE TO RAISE IN THIS ESSAY IS THAT OF THE METHOD and the character of the aesthetic approach to contemporary works of art. It is my contention that this is and can only be a question of a direct and living experience. No traditional or purely speculative viewpoint will yield any substantial results, for neither of them can have access to the world of abstract forms, relationships, and dynamics which we are now witnessing in the unfolding of the modern movement. The sequence of short-lived revolutionary periods in modern art makes it quite impossible to use notions which have been valid for centuries or only, as in our time, for a few decades. The concept of geometrical abstraction, for example, having been accepted as one defining the constructive and the architectural, lawfulness and spiritual harmony, order and the balance of values, is of no use to us when dealing with that composite abstract movement which started some twenty years ago in direct opposition to it, and which is called *Art informel,* Abstract Expressionism or Impressionism, Action painting, Tachism, or *Art autre.* It presents itself as the evocation of amorphous shapes or planes, indefinable signs and blurred images which, perhaps, have a quality of the primordial and can only with difficulty be expressed verbally. In similar opposition today stand Pop art and kinetic art.

We encounter another aspect of this cumulative anti-geometrical trend in a violent eruption which produces convulsive effects and accentuates biological vitality as opposed to all conscious processes (Cobra, Vitalism); a creative process based on instincts alone and proposing that the indirect, the indefinite, way of rendering sensa-

tions, thus activating a suggestive power, is the only manner of representing reality. It is chance that counts, not law; the emotional, not the rational; brutality, not refinement; the disturbing element, not perfection; chaos and matter more than order and form (*Art brut*). Something is aimed at in art today in which the dualism of art (that is, spirit) and nature is being abolished, in which the act of producing seems of greater significance than the product itself.

Protagoras' dictum that man is the measure of all things has become obsolete. Modern man sees himself as a negligible quantity in a vast universe; powerful forces disrupt his inner peace, the security of life, the Greek notions of beauty and of the ideal. But it was another Greek, Heraclitus, who spoke of *Panta rei* ($\pi\alpha\nu\tau\alpha$ $\rho\epsilon\hat{\iota}$), of everything being in movement, and apart from the concept of Apollonian art, the Greeks produced also the concept of Dionysian art. But they never lost control, the balance of freedom and necessity, as we seem to have done in our age under the onslaught of superhuman forces and dangers.

Confronted in art with abstract images of lava-like eruptions, of lust and fear, unrest and violence, with visions of cosmic energies, of a microscopic universe, of organic and technological processes, with the efforts of rendering limitless space, the expanding universe or nothingness, or again, with unceasing attempts to come to grips with an essence, with an ultimate meaning in an absolute manner—what other approach is left to the aesthetician than the exclusively empirical one which sets out on its quest from the scientific imperative to investigate what is, not what should be (Goethe). In our context this can only mean to see modern art as a natural phenomenon. This very fact may query the position of aesthetics as a specialized sphere of philosophic research. A purely aesthetic viewpoint can hardly embrace the complicated mental attitudes contained in present-day art, nor can it define the scientific, cognitive elements which are detectable in the work and the strivings of the modern artist.

To investigate what is, not what should be! Let us here also remember Karl Jaspers' words: "Only the creative faculty can give birth, reason cannot." We cannot reject artistic facts and developments even if they are not agreeable to our taste or sympathetic to our minds.

In a time which has produced the formula of non-art, all aesthetic valuations seem to be excluded *a priori* simply because there are no common standards. What the aesthetician has to contend with in relation to modern creativeness is a day-to-day existence; the only

consolation for his urge to clarify, to order, to define is that art is a mirror of life and that in an earthquake area one cannot apply the rules of the Golden Section.

What are the consequences of this development for the aesthetician?

1. He must take part in the living process of the changes in art not only by contemplating the works but through contact with the artist, either through personal meetings or by way of his writings, to ascertain the artist's aims and methods as far as these are conscious and can be expressed.

2. He must assess critically the artist's ideas or urges, which will not lead to a theory but only to a more objective and historically founded statement. A theory, being in itself definitive, cannot be applied to a process which is in progress and ever-changing.

3. He must investigate the works only by describing the formal aspects themselves, their aesthetic character, the figurative and suggestive elements employed, structure and composition: whether dynamic or static, spontaneous or calculated, concentric or asymmetrical, etc.; by describing the technical means: the materials used, and, to ensure the continuity of art's historic development, the connection with tradition. Any philosophical interpretation in an attempt to assess the meaning of such works of art, of the ineffable element contained therein, will necessarily border on the poetic or speculative. A depth-psychological analysis may elucidate inner motives, leading to new formative concepts, or may declare them to reflect the spiritual ambiguity of our age, but it will not assess the artistic quality of the work.

We see in the aesthetic approach to the modern movement in art a situation analogous to that dominant in science, where the major emphasis is on finding concrete answers to concrete problems, not on investigating those questions that seem to elude scientific analysis.

5 • THE SPIRIT OF MODERN ART

THE QUESTION "WHAT IS THE SPIRIT OF MODERN ART?" IS COMPLEX AND will yield an answer only if the reasons which led to its formation are thoroughly examined. By analyzing the basic elements on which it is built we shall advance toward an understanding of the whole movement known as "modern," and comprehend its raison d'être. In the process of analyzing the foundations we must not be perturbed by the confusing multitude of isms, of schools, of stylistic trends, but search for the ideas behind the great variety of new forms of expression, study their causes and the driving power which moves them. Their meaning, of which their strange shapes, their manner of composition and construction, and their combinations are the visual embodiment, will become obvious to us.

There are other than aesthetic questions involved in our inquiry, and I would like to touch in this chapter on some of the general problems of an art-historic and humanistic character. Any more detailed examination would go beyond its framework. It has been dealt with in another connection.[1]

First let me illustrate the scope of our quest. There is an enigmatic character about modern art, a mystery, something which requires to be understood before it can be enjoyed and appreciated. There is, too, an inner need to be satisfied for the people who fill the modern exhibition halls. What is it that they are searching for? And can this need be satisfied? In juxtaposing works of a modern with those of a traditional conception the scope of our quest can be grasped in its far-reaching consequences and in its profundity.

Let us, for instance, confront the *Fresco of a Cup Bearer* from Candia, Crete, 1500 B.C. (Greek), with a rectangular architectural

composition by Mondrian from 1921; the Pompeian wall painting *Maiden Gathering Flowers*, from Stabiae, first century A.D. (Roman), with Pierre Jeanneret's Purist still life of 1924; Giotto's *Meeting of Joachim and Anna at the Golden Gate* from the Chapel of the Scrovegni at the Arena in Padua (first decade of the fourteenth century; early Renaissance) with Dali's Surrealist paranoiac *Soft Construction with Boiled Beans* from 1936; Uccello's *The Rout of San Romano* (about 1450; Renaissance) with Juan Gris' Cubist *Ace of Clubs* from 1916; Mathias Grünewald's Expressionist *Crucifixion* from the Isenheim Altar in Colmar (1509–11) with Paul Klee's Primitive-Fantastic *Flora on the Rocks* from 1940; Rembrandt's humanist-realistic *Scholar Seated in an Interior with a Winding Stair* from 1663, with Miró's naïve-elemental *Mercury* of 1930.

What strikes us at once is that traditional art does not put any difficulties in the way of our understanding. It can be appreciated directly, enjoyed and even interpreted without an immediate need for and reliance on some theoretical or art-historical knowledge. It speaks directly to our senses and through them to our mind. In the modern work of art we are often left alone and wondering. Because it is not a world of our senses or universally known symbols that is confronting us, but an imaginary, a subconscious, a visionary, a constructed, a personal, world, a world of concepts, forms, and signs which we cannot comprehend unless we are informed about their meaning, the motivating power behind their existence, their link with a chain of traditions novel to our experience and different from those we have hitherto accepted.

The tradition of European culture in general and its art in particular has primarily a Greek root with a Roman dependency on the one hand, and a Judeo-Christian root on the other. It will be advisable for the sake of clarity to approach our preliminary inquiry from two different angles, the one mainly art-historic, the other ideological.

We know, or at least we believe that we know, what *Greek man* was. This knowledge we have acquired from studying his social and political history, his religious beliefs, his philosophical systems, his art and poetry, that is, his thinking and feeling, his relationship to the universe, his reaction to life. We can imagine this man and reconstruct him in our mind with the help of the works of art which he produced, the architecture and the literature which he bequeathed to us. Greek myth-creating man. Apollonian and Dionysian man,

the initiator of the notion of ideal beauty, of cosmic harmony, of the dignity and greatness of man: man fighting with the beast, the symbol of the supernatural powers that he cannot understand and cannot master; tortured, dread-ridden man fumbling in darkness, until the hero appears, Hercules, Theseus, to liberate him and start a new phase in human consciousness. Greek man, the first scientific thinker, to whom even the modern scientist returns in his meditations.[2]

Roman man—man the great lawgiver and organizer, the conqueror and empire builder, the man of order, of civilization, who retained as the most precious part of all his conquests the style, the ideas, and the mythological universe of Greek culture.[3]

Byzantine man—man subdued by an overpowering concept of the Godhead, man of a rigid hieratic social order, of absolute values and ideas.[4]

Romanesque man—man in need of salvation, struggling with the beast. (Compare with the statement on Greek man; in Romanesque churches the beast crept in right up to the altar, where it was often given a grotesque representation.) Man of fear and trembling groping in the *labilitas rerum,* the uncertainty of all things.[5]

Gothic man—man finding his way out of darkness into light, to love, to cosmic harmony, to the beauty of nature; the man of a new Christianity, the third Gospel,[6] of a new philosophy, that of Joachim of Floris (Gioachino da Fiore), of a new style, in which the striving upward to the heights and the longing for light and color and beauty are expressed in one of the few examples of a pure style in the history of art. The beast is expelled from the Gothic church and cathedral; it remains only on its outside, where it hovers, a gargoyle, a power full of temptation and danger, but conquered, for the moment, by the faith and goodwill of man.[7]

Renaissance man—the rediscoverer of classical antiquity, the founder of the modern concept of humanism, of a new erudition, proud man searching after the truth without the tutelage of the Church, the first experimental scientist, art-loving, art-sponsoring man, the man personifying the very struggle of the European spirit, the struggle between the Greek and the Christian view of life, and their fusion into a whole, a cultural unity; the man with an aristocratic social ideal as elaborated by Castiglione, elegant, skeptical, bold.[8]

Baroque man—man who faced the greatest crisis in the history of the united Christian Church since Christianity was divided into an Eastern and a Western branch with Rome and Byzantium as its

respective centers; Baroque man who fought the ideas of the Reformation and who in the service of the *ecclesia militans,* the fighting church, and the *ecclesia triumphans,* the triumphant church, brought forth what is considered to be the last great style in European architecture and art, the Rococo style which followed being only an effeminate, worldly, and "aesthetic" variation of the former.[9]

But who is modern man? And how is he represented? Look at Giorgio de Chirico's faceless dummy sitting in a geometrically defined dead and melancholy space (*The Seer,* 1915); or at the tortured expression of André Masson's *Self-Portrait* (1946). What is left of the human face in Picasso's Neolithic shapes presented as *Head* (1929), and what happened to the human likeness in his *Portrait* of 1938? We will devote ourselves to this question directly.

The revival of the classical style in Neo-Classicism, the sentimentality of the Pre-Raphaelites or of the German Biedermeyer, the emotional concept of Romanticism and the decorative quality of *Art nouveau* or *Jugendstil,* all the art devoted to these trends produced works often of great technical skill but without the vitality which is the mark of every genuinely great style. These manners ceaselessly copied and imitated became sterile at last, and the art taught in the academies of Europe about the middle of the nineteenth century and later was completely impotent, accepting as its only canon a slavish repetition of the Renaissance doctrines of naturalism and scientific perspective, and with it the subject matters of antiquity, more or less adapted to the bourgeois mentality, more or less romanticized. Art was at a dead end, and it is here that we have to search for the new beginnings: from academism arises the need for a reorientation of art altogether.

When the artist turned to nature again, in Pleinairism (the *paysages intimes* of the School of Fontainebleau, the landscapes of Bonnington, the small sketches of Constable—not his large paintings, which were produced for the exhibitions of the Royal Academy) and later on in Realism, we have to recognize a new orientation toward life and its representation in works of art. A new element of truth entered—the truthfulness of life. The Pleinairists painted in the quiet light of a forest, the Impressionists painted in the full sunshine. They developed a new theory of color based on scientific research. Here we are already in the midst of what we call the early phase of modern art. For us today there is still no enigmatic character in this art, the breach with tradition has not yet taken place. We

today are inclined to define as modern only the more extreme tenden-
cies, although in their time both Realism and Impressionism were
repudiated and violently criticized.

The real break came with Cubism. In a nutshell Cubism is the
determination to abandon the Renaissance tradition entirely and to
try to conceive a new idea of representation, composition, and con-
struction of space, a completely novel way of organizing the plane
surface inside a picture frame or, in sculpture, the revolutionizing
of the traditional way of conceiving the sculptural.

We know there is even in this new conception a link with tradition,
but with a tradition which lies outside and beyond the unfolding
of the great European styles—the primitive styles of all peoples and
ages and the styles of prehistoric times. Primitive art already knew
the "Cubist" representation of objects viewed from different angles
simultaneously, knew the superimposition of forms, that is, the use
of transparency, knew of a perspective which was not the perspective
of the Renaissance, had by instinct a freedom of representation that
was not bound by any rules. The Cubist notion, developing to its
extreme the concept of art for art's sake, led to what is considered
to be the absolute freedom of the artist in creating and shaping his
vision. Between this notion and all the extreme isms, especially in
the field of abstraction (Tachism, *abstraction lyrique*, Action paint-
ing, informal art, kinetic art), there is a direct and distinct connec-
tion, a logical line of development. Primitivism had been discovered
for European art already by Gauguin and his contemporaries, the
Symbolists, and it is Gauguin's great influence which is felt in Fauv-
ism, the style initiated by Matisse, which freed the artist in the use
of primary strong colors so typical of all primitive art and in the use
of simplified and typified forms with a decidedly decorative quality
but without the symbolic implication which dominates primitive art.
"Instinct is recaptured," Apollinaire exclaimed when presenting this
new trend of the Fauves, "The Wild Beasts," to the public.[10] The
discovery and interpretation of new primitive cultures through an-
thropology and archaeology during the first decades of the twentieth
century had strong repercussions in the aesthetic field. The taste for
the primitive as an aesthetic, not a purely ethnological, quality was
transmitted by the artist to his surroundings, a fact which changed
the stylistic feeling of the whole age.

It is a long step from ethnology to the concept of a new, a primi-
tive, beauty as source of inspiration, to a direct, instinctive relation-
ship and attitude to life and living.[11] So we have a clearly rational

element in modern art. On the one hand, there is a primitive, spontaneous quality; on the other, there is the constructive quality of Cubism, both analytical and synthetic, and derived from it the constructive character of Futurism, Purism, geometric abstract art, and kinetic art. Both contribute to the complex state of art as we know it today.

Here, however, we have to stop for a moment and turn our attention from art-historic considerations to ideological ones. Let us start with the assertion—or shall we call it an axiom?—that art is expression. It is the expression of human values, of emotions, and of thoughts, it is one form of the cognition of the universe as reflected in us, it is the visual form given to our view of life and the world. We have spoken already in this sense of Greek, of Roman, of Byzantine, of Romanesque, of Gothic, and of Baroque man. What is modern man? And what is the main difference between him and his ancestors? We will find in our answer the answer also to our question about the meaning and significance of his art.

There is no doubt that the significant factor in the development of man during the last three hundred years is modern science and, stemming from it, modern technology. This force has not only changed the way and rhythm of life and its surroundings, it has changed man in his entire outlook on Being.

This change has both a negative and a positive aspect. The negative or destructive aspect consists of the breaking up of what has been credited and accepted as a body of certainties in the realm of religion, of philosophy, and of art. What once was considered to be of permanent and fundamental value is now being questioned, dissected, and pushed aside as unsatisfactory and obsolete.[12] The positive aspect we can recognize in the fact that the revolutionizing consequences of scientific thought and method have entrusted to the hands of man unforeseen powers and a new certainty: the certainty that nondogmatic science will lead man toward the basic understanding of the phenomena of life.[13] In dominating and changing nature by technological means and in a hitherto undreamed-of manner, man is entering a new phase in his ambiguous history: he now has the means to create a universal culture.[14] But there is also the danger of man destroying not only his culture but life on earth itself by pollution and overpopulation or by the misuse of atomic power. Serious thinkers have expressed the doubt whether man will still be in existence in a hundred years' time.[15]

Scientific man no longer has the comfort of a privileged position in the universe as it was known to the Greeks—I refer to Protagoras' dictum that man is the measure of all things; or to the Christian era: that man is the beneficiary of God's grace, that he is assured of his salvation and of eternal life through the sacrifice of God's own Son. Modern scientific man seems to be more modest and patient in his aspirations. In fact, he has become more determined to penetrate, through reason and scientific experimentation, the realm of the microcosmos and the macrocosmos. Here, perhaps, we can find a point where a synthesis of the old and the new is possible. On the one hand we have Existentialist man with his skepticism, the notion of the absurdity of human life, his *Angst* and isolation, finding himself to be a mere living speck in a vast expanding universe, a minute phenomenon among innumerable phenomena of equal importance, experiencing again in our age the upsurge of the apocalyptic beast. He dreads the mysterious powers of creation, with no spiritual force to harness them, to harmonize them, to reveal the world and himself as one and the same emanation of an entity. He has lost himself and the Godhead in splitting up the world into the duality of a cerebral subject and an analyzed object. But he is beginning to realize more and more in the second half of the twentieth century that his position is a lost one. A victim of psychoanalysis, he has to fight to gain ground under his feet again or accept being swallowed up by nothingness. He has to reconcile fear with the new certainties provided by science. Scientific man, on the other hand, self-confident, inspired, and courageous, the conqueror of outer space and of the atom, searching, restless, Faustian; scientific man, after his victories in physics, now has embarked on the quest of securing from life its own secret. But in this new sphere of research, in biology, he encounters mystery after mystery which, as Adolf Portmann has observed, he will never be able to penetrate by rational means.[16] In turning back to learn from the ancients what they perceived of the miracle of creation by intuition, he is opening up new vistas in science with a *leitmotif* of reconciliation. Existentialist and scientific man are slowly moving toward each other.

This whole process is mirrored in the art of our day. We have said that age-old values are fading away or are being scrutinized from the platform of a new scientific knowledge, values of faith, of morals, of art—human values. At one time in the nineteenth century a purely mechanistic and materialistic view of the world predomi-

nated. It was based on the idealistic philosophy of the seventeenth century and developed in the eighteenth century by the genius of physicists. A. N. Whitehead has described the process in a most penetrating and at the same time poetic manner.[17] This view of the world was a phase only, an extreme phase; we find it reflected in modern art in the stroboscopic representation of movement by Duchamp and the Futurists, in the Dadaistic ready-mades, in the matter painting of Dubuffet.[18] Soon, however, counterforces developed, especially in the realm of philosophy, the science of mythology, the comparative history of religions, and psychology. We have only to look at the works of Klee, Miró, Kokoschka, Tobey, Julius Bissier, and Giacometti to see that this wave of anti-rationalism is reflected, and very decidedly so, in the realm of art. Contrary to the opinion that it is the artist who is a discoverer of ideas reflecting life,[19] it is, in our opinion, always someone else, the philosopher, the scientist, the psychologist, who discovers new aspects of thought which are reflected in art.

Modern art is greatly dependent on the spiritual climate produced by science, or equally by the forces opposing it. It has accepted more or less consequently three decisive factors in the approach of the scientist to his own particular problems. First, specialization. Every single ism in modern art is an example of a specialized approach. For Surrealism it is the investigation of the unconscious in its Freudian aspect, for analytical Cubism it is an attempt at a new pictorial organization which is an analogy to the atomic, or molecular, concept of matter in particular and the concept of the new for its own sake as represented by science in general. For Futurism it is movement, for abstraction it is the dissolution of matter in energy. Secondly, we can identify as a consequence of specialization the modern artist's determination to push any problem to its extreme. Hence the extreme movements in modern art, Expressionism and Fantastic art, Dadaism and abstraction. Third, there is dehumanization. In art as in science, man has given up his privilege of occupying a central place in the care of divine providence; he is leveled down, distorted, atomized, and finally disappears altogether. Art is no longer humanistic, it is cosmic, it is microscopic, it is dynamic, it is chaotic, it is vitalistic, it may be lyrical, it is abstract: it mirrors the inward aspects of disintegrated modern man, it mirrors dehumanized scientific man and his constructive technological willpower, it gives fractions of inner and outer experiences but not a whole. Not yet. At the point, however, where Existentialist and sci-

entific man will meet in their urge for reconciliation, at this crucial point of synthesis, art will achieve a new unity, a wholeness, a new subject matter.

NOTES

1. Erwin Schrödinger, *Nature and the Greeks* (Cambridge, 1954); Werner Heisenberg, *Philosophical Problems of Nuclear Science;* Jacob Burckhardt, *Griechische Kulturgeschichte, Künste und Forschung*, Vol. 59 (Leipzig, n.d.); André Bonnard, *Greek Civilization*, 3 vols. (London, 1957–61); J. P. Hodin, *The Enigma of Modern Art*, in preparation.

2. Here the following works may be named to illustrate our points: the Vatican copy of Myron's Discobolus, from about 450 B.C., the Venus (fifth century B.C.) from the Museo Terme in Rome, and the Parthenon in Athens, a Doric temple designed by Iktinus and built about 450 B.C.

3. Head of Tiberius Claudius Drusus, who conquered Britain (first century A.D.), found in the British Isles (bronze); a Roman orator (second century B.C.) from the Archaeological Museum in Florence; the Colosseum, a Roman amphitheater built about A.D. 80.

4. Mosaic of Justinian from S. Vitale in Ravenna (sixth century); *Descent from the Cross*, Byzantium (fourteenth century); the exterior (S.E.) from S. Vitale in Ravenna (sixth century).

5. A figure in stone from the South Arcade, West Front of the Church in Civrai (France; twelfth century); capital in narthex from the Church of St. Pierre in Moissac (France, twelfth century); the Church of Moissac in the department Tarn-et-Garonne.

6. The Gospel of the Holy Spirit, the first being the Gospel of the Old Testament, the second the Gospel of the New Testament.

7. Head of Adam from the dome of Bamberg (thirteenth century), high Gothic, Germany, influenced from France; Annunciation and Visitation from the West Front of Rheims Cathedral (thirteenth/fourteenth century), French high Gothic; exterior of Laon Cathedral, French early Gothic.

8. Perugino, teacher of Raphael (1450–1523), portrait of Francesco dell'Opere (Florence, Uffici); Donatello (1386–1466), the monument of Gattamelata in Padua; façade of the Palazzo Farnese in Rome (sixteenth century).

9. Bernini (1598–1680), Urban VIII (Rome); portrait etching of Francesco Borromini (1599–1667); the church Santa Maria della Salute (Venice) built by Baldassare Longhena in 1631–56.

10. Quoted from Jean-Paul Crespelle, *Fauves et Expressionists* (Neuchatel, 1962).

11. Ludwig Goldscheider, *Towards Modern Art, or: King Solomon's Picture Book: Art of the New Age and Art of Former Ages Shown Side by Side* (London, 1951); *Chefs d'oeuvre du Musée de l'Homme* (Paris, 1965); S. Giedion, *The Beginnings of Art: The Eternal Present* (London, 1962).

12. See René Huyghe, *L'Art et l'âme* (Paris, 1960).

13. Bertrand Russell, *The Scientific Outlook* (London, 1931); A. N. Whitehead, *Essays in Science and Philosophy* (London, 1948).

14. See André Malraux, *Le Musée imaginaire de la sculpture mondiale* (Paris, 1952).

15. Karl Jaspers, *Die Atombombe und Die Zukunft des Menschen* (Munich, 1958); Bertrand Russell, *Common Sense and Nuclear Warfare* (London, 1958); J. D. Bernal, *World Without War* (London, 1958); see also Gordon R. Taylor, *The Doomsday Book* (London, 1970).

16. *Biologie und Geist* (Zurich, 1956).

17. *Science and the Modern World* (Cambridge, 1926).

18. Alfred H. Barr, Jr., *Cubism and Abstract Art* (New York, 1936); *Fantastic Art, Dada, Surrealism*, ed. Alfred H. Barr, Jr. (New York, 1936); J. P. Hodin, "Surrealism," in *Encyclopedia of World Art* (New York).

19. Herbert Read, *Icon and Idea: The Function of Art in the Development of Human Consciousness* (London, 1955).

6 • WHAT IS MODERN ART?

DEFINITION OF MODERN ART

To answer the question "what is modern art?" we cannot avoid answering the wider question "What is art?" The general problem whether the art of our present epoch can claim to have produced a style comparable to the styles of previous ages (Archaic, Classical, Early Christian, Byzantine, Romanesque, Gothic, Baroque),[1] and the more particular problem whether a division ought to be acknowledged between pure art (previously called the liberal arts, the fine arts, or the *beaux arts*) and applied art (also called crafts, handicrafts, arts and crafts, industrial arts),[2] whether there is an essential difference between them—as we believe—and where the boundary between art and craft lies, seem themselves difficult to answer. For there is no unity of concept in the philosophical sense, no accepted world view, no universally valid code nowadays from the system of which the humanist categories could be deduced. On the contrary, there is a continuous, even violent, change of spiritual climate due to the impact of scientific thought on old established aesthetic, religious, philosophical, and humanist notions.[3] In the theory and history of art as well as in art itself the opposites clash, and no definite answer can be given. We accept the position that it would be wrong to follow in the footsteps of the Hegelian and post-Hegelian philosophy (Spengler, Sorokin, Toynbee)[4] in an attempt to find an answer in the middle of such a development; until this development is concluded, any answer, whether right or wrong, would be only prophecy at best.[5]

We shall have this difficulty with almost any question in the field of art that we approach for closer inspection. What is accepted and comprehended by feeling demands to be defined. In the process of definition, logic and comparative experience play their part—insofar as the phenomenon lends itself to rational treatment at all. For there are phenomena in the realm of art which elude all rationalization.[6] Comparative experience, on the other hand, is only possible on a historical basis. The formation and re-formation of the concept of "art," its metamorphoses, are of importance to us not only because they bring home to us the truth that every great period has had to forge this concept for itself anew, but also because every culture sees its social and spiritual structure reflected in it.[7]

We cannot be surprised, therefore, that it seems particularly difficult for our age to produce its own definition of art. We lack a spiritual common denominator, except perhaps an agnostic one, and modern science is not yet capable of accepting or of creating a new metaphysics.[8] It is not in the reach of science to proffer a world view, nor is this its aim. The findings of science, based as they are upon premises which exclude the comprehension of the wholeness of life, of the miracle of Being, are too specialized and narrow for this purpose. Sir James Jeans expressed it as follows:

> Physics tries to discover the pattern of events which controls the phenomena we observe. But we can never *know* what this pattern means or how it originates; and even if some superior intelligence were to tell us, we should find the explanation unintelligible. Our studies can never put us into contact with reality, and its true meaning and nature must be forever hidden from us.[9]

Scientific knowledge has not yet given birth to that wisdom which compels recognition as the ripe fruit of a balanced development, as the highest expression of a culture. The lack of such wisdom has even been described as the mark of modern art: "*L'art moderne a manqué de sagesse, il a été radical.*"[10] This statement suggests that we cannot hope to find this wisdom in art. The whole fabric of our culture is in convulsion.[11]

The concept of art has in different periods changed its meaning. Antiquity distinguished between the liberal and the servile, or mechanical, arts. Solon as well as Plato and Aristotle used this distinction. In Greek, Roman, and medieval history, we find that literature

and mathematics are often regarded only as preparatory studies for philosophical knowledge, oratory, and the interpretation of religious texts. The conception of the "Seven Liberal Arts" of the Middle Ages was largely an intellectual one, devoted to the "scientific" disciplines of grammar, dialectic, rhetoric, arithmetic, geometry, music, and astronomy. They were instruments for higher studies, especially philosophy. They involved little manual skill or pursuit of sensuous beauty. The study of theoretical music put its emphasis on the proportions of numbers. Literature, in the modern sense, was not an integral part of the Seven Liberal Arts. The "arts of design" (*arti di disegno*) and the visual arts as a whole were looked upon as crafts only. Their chief aim was usefulness. The useful aspect of architecture is obvious. Figurative art had to illustrate and support religious doctrines; painting and sculpture were admired to the extent that they mirrored reality.[12] Ornament for its own sake was not known until later times.[13]

As late as the fourteenth century, the artist was still regarded as an artisan, the architect as a master mason, and the musician as a minstrel. There was no social distinction between the ordinary craftsman and the artist. Dante's mention in the *Commedia Divina* of two well-known miniaturists was denounced by his contemporaries as immortalizing "men of unknown name and low occupation."[14] During Greek and Roman times the visual arts, on the whole, had a low social status. It is related that Isocrates (436–338 B.C.) recommended that Phidias, Zeuxis, and Parrhasius should not be classed with vasepainters and doll-makers. Even in the time of Augustus, Vitruvius had to defend the dignity of architecture.[15] Pliny the Elder (first century A.D.) refers to a teacher of Apelles as the first painter who was thoroughly trained in different branches of learning, especially in arithmetic and geometry, without which he considered that art could not be perfect. It was from his example, according to Pliny, that painting on panels was taught to freeborn boys, and that this art was accepted as a preliminary step toward liberal education.[16]

The Greeks spoke of *mousike techne*, the useful arts under the protection of the nine Muses: astronomy, history, choral song and dance, comedy, tragedy, and epic, erotic, lyric, and sacred poetry. The arts of the Muses showed two different characteristics. They were fine in the sense that their products were not considered to be the result of only manual or useful skills, and they were useful from a moral and educational point of view. Neither Plato nor Aristotle regarded the arts as being devoted mainly to pleasure or sensuous beauty. Epi-

curus, however, did so and he is quoted as saying: "I know not how to conceive the good, apart from the pleasures of taste, sexual pleasures, the pleasures of sound, and the pleasures of beautiful form." For Plato, arts, like painting or music, were not the necessities but the luxuries of life. He disapproved of a great many luxuries on moral grounds. In his metaphysical system the imitative arts, whether poetry, painting, or sculpture, occupy a place far removed from truth, which lies with the eternal ideas. Aristotle, in his *Politics*, continues to ponder which arts can be used in the education of free-born children and to what extent. There could be no social attitude more diametrically opposed to ours than his, when he states that the arts are vulgar when exercised as paid employments and that it is not good if a freeman attends to the arts too closely in order to attain perfection in them. Baldassare Castiglione still holds the same opinion in the first half of the sixteenth century.[17] It was only Plotinus who conceived the idea of fine arts as the expression of an absolute value, Beauty, purged of all moral content.[18] How deeply the Renaissance was influenced by concepts of antiquity can be seen in the struggle of the Renaissance artists and architects to raise their status by emphasizing the scientific and noble character of the arts.[19]

The seventeenth century in France introduced the term *beaux arts*. Louis XIV founded the Académie Royale des Beaux Arts in 1648. Unified later with the Académie d'Architecture, which was founded in 1671, it included musical composers as well as painters, sculptors, architects, and engravers. From among the members of the society who were painters was chosen the director of the French Académie des Beaux Arts in Rome, also instituted by Louis XIV in 1677. When the Paris Opera was founded it was given the official name of Académie Nationale de Musique, thus providing a separate academy for music in its operatic form.

In 1661, Louis XIV created the Académie de Danse, and the sciences received their academy in 1666. The organization of these academies had as its model the Académie Française, established in 1635 for the discussion of literature and language. The French Revolution abolished the academies and organized one single Institut National with three classes: physical and mathematical science, moral and political science, literature and the fine arts. Later, the third class was divided into French language and literature, ancient history and literature, and fine arts. So the arts achieved at last the social status which was the privilege of the philosopher and the writer.[20] Today, as increasing emphasis is placed on science, we are witnessing a

gradual decline in the importance attached to the message contained in works of art. In direct proportion to this decline stands the popularity of the contemporary artist and the economic value of the work handled by the art trade. Whereas the artist of antiquity strove to be recognized as genteel, the Renaissance artist achieved this status to such an extent that even kings, popes, and emperors showed him reverence.[21] And whereas the artist in the seventeenth and eighteenth centuries became a member of a royal academy, in the late nineteenth and the early twentieth century there are signs that he is returning to the old concept of craftsmanship and often likes to be looked upon as a "worker." In the West, he is a self-employed man, in business connection with his art dealer and often a teacher at a public art school; in the East, he is a member of a state-controlled trade union of artists.[22]

The term *art* has acquired its aesthetic sense only recently. *Ars* in ancient Latin meant any craft or skill, *ars* in medieval Latin meant any form of book learning. That was still so in the time of Shakespeare. The Renaissance reestablished the classical meaning, and the Renaissance artists, though striving to be recognized as educated men, as members of a humanist society, thought of themselves as craftsmen. In the seventeenth century began the slow process of separating the aesthetic point of view from that of technique. This led in the late eighteenth century to a distinction between the "fine arts" (a translation of the French *beaux arts*)[23] and the "useful arts." In the nineteenth century, the fine arts became simply "art." In the twentieth century we can discern a tendency to call art not only what previously was known as fine arts but all handicrafts and various other aesthetic activities as well.

To arrive at a contemporary definition of art, the definitions of the past have to be submitted to a critical examination with a view to our own position, and what is still of use in them combined with the new elements which enter.[24] The most comprehensive attempt of this kind was undertaken in the middle of this century.[25] The philosophical standpoint from which the problem was considered, and also the scientific method which was applied to its solution, reflect a philosophical naturalism based on natural science. For dialectic reasons, we accept this new definition as a starting point. We shall, however, confront it with other definitions to arrive at a more critical definition, one that takes into account the necessity of valuation. Whether the art of our transitory time can live up to such a definition is another question. In pointing out the special significance we

attach to the idea of art as primary cognition (Schelling),[26] to the quality of transcendental realism in the work of art, to the significance of the creative personality in comprehending the miracle of Being, it is clear that we are concerned not so much with the quantitative aspect of the definition as with what it suggests of the spiritual quality of art, that is, with the humanistic and hierarchical character inherent in the concept of art both in its historical aspect and in its living reality.

The naturalistic comprehensive definition of art consists, in fact, of three definitions. In the first, art refers to certain related types of skill; in the second, to a type of product; in the third, to a social area, to culture. An elucidation of the naturalistic definition of art is given by Thomas Munro in *The Arts and Their Interrelations*:

> 1. a. Art is skill in making or doing that which is used or intended as a stimulus to satisfactory aesthetic experience, often along with other ends or functions; especially in such a way that the perceived stimulus, the meaning it suggests, or both, are felt as beautiful, pleasant, interesting, emotionally moving, or otherwise valuable as objects of direct experience, in addition to any instrumental values they may have.
>
> b. Art is skill in expressing and communicating past emotional and other experience, individual and social.
>
> c. Especially that phase in such skill or activity which is concerned with designing, composing, or performing with personal interpretation, as distinguished from routine execution or mechanical reproduction.
>
> 2. Also a product of such skill, or products collectively; works of art. Broadly, this includes every product of the arts commonly recognized as having an aesthetic function, such as architecture and music, whether or not that particular product is considered to be beautiful or otherwise meritorious [an important point showing that the establishment of value in works of art is of concern neither to the scientist-aesthetician who defines art, nor, with very few exceptions, to the art historian].
>
> 3. Art, as a main division of human cultures and a group of social phenomena, includes all skills, activities, and products covered by the above definition; but these divisions overlap in part.

This definition embraces everything which in the widest sense can be connected with any artistic activity and the concept of the aes-

thetic; and historically not only what may be today regarded as art, but also what past ages have considered as such. This is of interest to us because all concepts particular to a certain cultural epoch have been put aside. But what a purely quantitative definition also puts aside is the specific character of each cultural epoch, including our own. This is a severe limitation. Is it not itself evidence of the "subjectivity" of every aesthetic concept and judgment that we look at a Romanesque sculpture or a Gothic painting not, so to speak, with Romanesque or Gothic eyes, but with our own, applying to it our own aesthetic criteria?[27]

What is the art of our time? Is it everything that has been considered art up to now, or is it something quite special which has yet to be defined? Is the attempt to conceive an all-embracing quantitative definition a sign in itself that we have only a historical view of art and not a particular one which is ours, "modern," connected with modern man? Is it a sign that we are uncreative and only repetitive, that art has ceased to have, as Hegel believed it to have, a primary importance for us?[28]

In its refusal to consider the hierarchy of values the comprehensive quantitative definition of art is also an instrument for the leveling-down of taste and creative aspiration. In the context of such a definition, art is "democratized"; even hair styling and window dressing must be considered as art.

In addition, many artistic skills which formerly were widespread, like painting on the reverse side of glass (*peinture églomisé, Hinterglasmalerei*), miniature painting, tapestry weaving, ivory carving, intarsia work, mosaic, stained glass, etc., are today to be found only sporadically or have been quite forgotten. Against this, however, new art forms have arisen, like abstract constructions, mobiles, the film, photomontage, the photogram, lumia or color music, which all claim to be art. Much of what we are inclined today to regard as art would not have been admitted into the field by earlier epochs.

Thus the quantitative definition of art is only a statistical tool; it does not touch the vital center of artistic creation and its products. Since it is scientific and relativistic, the statistical viewpoint proves to be insufficient. Let us consider other definitions.

Art can be seen in its origin, that is, in connection with Existence itself, which brings forth both philosophy and art. "It is the illumination of Existence by an assurance which visually presents Being as a tangible reality, while in philosophy Being is comprehended as

something capable of representation" (Jaspers). Only in metaphysical speculation, in the attempt at a rational reading of the *chiffre*-writing of Being, can an analogy to art be found.

> [Man's] mind opens up to that primary state when art was meant in earnest and was not mere decoration, play, sensuousness, but *chiffre*-reading. Through all the formal analyses of its works, through all the telling of its world in the history of the mind, through the biography of its creators, he seeks contact with that something which perhaps he himself is not but which in its quality as Existence questioned, saw, and shaped in the depth of Being that which he too is seeking.[29]

This has been the essence of art for millennia.

> All the glitter of the art of the none but evident loses its significance before the visibleness of the invisible, the drive for life's fulfillment, before the drawing power of Being in eternity, the vitalization of the spiritual, before the spiritualization of the living. . . . [In this struggle for the spiritualization of art] the sensual is the inevitable which must not escape; for only empty abstraction would remain. The spiritual is the essential; it must not be given up to the vital quality, to passion, to the sensual forms in which it appears; all that would be left would be a reality without transparency on the one hand and intoxication on the other. Nothing is real without entering the sensual. But the sensual as such, as none but sensual, is void.[30]

Similarly Conrad Fiedler in the nineteenth century: "Art in the highest sense can be lost out of sight for whole generations. . . . In the creation of a work of art, man engages in a struggle with nature not for his physical but for his mental existence."[31]

Speaking of the Gothic cathedrals, Rodin proclaimed: "I have always looked upon 'religious art' and 'art as such' as one; if religion disappears, art too is lost; all Greek, Roman as well as all French masterpieces are religious works of art."[32]

Of the artists of more recent times, let us consider the words of Max Beckmann: "In my opinion, since Ur in Chaldea, since Tel Halaf and Crete, all the essential things in art have always sprung from the deepest feeling for the mystery of our existence."[33]

Spiritualization, the urge of man's metaphysical thinking, the enigmatic, religious, or mystical quality at the roots of artistic creation,

these are the distinguishing marks of any truly great art. Our time has lived up to it in the work of a few artists. But the greater part of the contemporary art production is on quite a different level from that of previous epochs. Purely experimental work using the methods and gadgetry of science, never before embarked upon in art, has a special status altogether. We therefore cannot miss this distinction of greatness, particularly because under the impact of cerebralism, science, and technology the basic tenets of art are in danger of being diluted and falsified, as the development around the middle of the twentieth century clearly shows. A definition of modern art must of necessity remain in flux. It cannot be final. It is a living definition, not a retrospective one only. Since the modern movement is still in the process of unfolding, its definition has to be seen not exclusively as the registration of historically established facts but also as a critical force, a dynamic element which enters the movement in an effort to influence its direction, to interpret the meaning of its tentative efforts, to uphold its purity, and also to help clarify its problematic character, which has been denounced in art literature as the perpetual crisis of modern art.

Modern art is primary cognition, the findings of which, often highly specialized and elaborated on an analytical basis, are organized into a new visual order. Linking up with a tradition of its own choice, of universal significance and without limitations in time, and thus breaking with the chronological tradition generally acknowledged in art history, it strives for a synthesis in the work of the individual artist as well as through the influence of its different trends upon one another; a many-faceted process moving toward a new unitary concept, a new aesthetic totality, in other words, a style.

THE BEGINNINGS OF MODERN ART

What does the concept "modern" mean within the framework that we have drawn up so far? In colloquial speech *modern* is often replaced by *contemporary*, which basically has the same meaning but is more limited in time. Strictly speaking, *contemporary* can be applied only to a particular generation. There is a further distinction to be made. Nobody could call the work of an "academic" artist modern, though it might be called contemporary. The *New English Dictionary* defines *modern* as "being at this time; now existing—of or pertaining to the present and recent times, as distinguished from the

remote past, pertaining to or originating in, the current age or period."
And *modernism* is defined as "a usage," "a mode of expression," or
"a peculiarity of style or workmanship, characteristic of modern
times."

The term *modern* in painting was employed by Baudelaire in his
"Salon de 1859" in connection with painters whom we would not
consider moderns. Huysmans in his "Salon of 1879" labeled the re-
action of Manet, Degas, and the Impressionists to contemporary life
as modern.[34] Today the term has acquired another and necessarily
wider meaning than it had even in 1900, a so much wider meaning,
in fact, that we may well doubt whether in continuation it can legiti-
mately be used at all. Modern, then, close to us in time, not remote
from us in idea and taste. In this sense it contains no characteristic,
far less the indication of a style. From the point of view of art his-
tory, the concept "modern" even contains a negative element, in that
it draws a boundary between one epoch of art, the most recent, and
all other preceding ones.

The closer study of the affiliations of the modern movement with
the form speech of previous ages will show that such a boundary is
nonexistent. On the contrary, whereas the art of the last four cen-
turies made itself dependent on one stylistic source only, namely
that emanating from the Renaissance and its study of antique
classical art, the new movement is united by close ties with all
the existing styles and formal trends in defiance of that of the
High Renaissance. It has become universally minded in its sources
of inspiration, that is, not limited to one concept, or to Europe, or
to high civilizations only but worldwide in knowledge and timeless
in extent, in that it has discovered and duly admired prehistoric art
and the art of the primitives of whatever racial background.[35]

Some authors, such as Max Deri, introduce a significant caesura
already around the year 1800 by speaking of one great line of devel-
opment since the Renaissance, leading from the Baroque to the
Rococo and ending with the empire; what comes later—Classicism
up to 1825, Romanticism up to 1850, Objective Naturalism up to
1875, and Subjective Naturalism—Pleinairism and Impressionism—up
to 1900—belongs in his view to a new line of development.[36] What
Elie Faure calls modern art in his volume of the same title would
go as far back as to Rubens in Flanders, to Franz Hals in Holland,
to El Greco in Spain. Although in his chapter on Romanticism and
Materialism the main ideological forces are well defined—the one
looking backward, the other trying to face life anew—it is the name

of Cézanne which introduces his final chapter, "The Contemporary Genius."[37] On the whole Faure, as also Richard Muther, André Michel,[38] and Fritz Knapp, is not particularly interested in answering our question. Knapp speaks of *Die Malerische Problematik der Moderne: Vom Klassizismus zum Expressionismus,* indicating that to him there exists no essential happening either ideological or formal which could claim the introduction of a term distinguishing Classicism and what is called Expressionism.[39] Nevertheless, he sees one thing clearly. "The nineteenth century," he writes, "at about the half-way mark, moved toward a new character of its very own, in a sharp break with all that is called Romanticism and Poetry." Inventions, discoveries, triumphs of the natural sciences, the purely rationalistic disciplines, and even the pseudo-wisdom of the archivist and the chronicler in the sciences of history, these are the new instances which he enumerates. In another publication at the same time, however, the historical emphasis is placed on Naturalism as the ideological beginning of the modern movement.[40]

Jacob Burckhardt said of the nineteenth century that "it had once more to recite the lesson of the past." Fritz Burger, mitigating this harsh judgment, sees in the nineteenth century "a sort of stopping for breath of mankind, after the great achievements of its genius," a stopping for breath "before the most triumphal achievements of its spirit." This is a resolute siding with modernism. "After the example of Greece and the Renaissance, mankind begins anew to reflect upon itself and to create, from the objectivized forms of its thinking, the living unity of a new world." The tangible symbol of this new spirit is to Burger the Eiffel Tower, erected in 1879.[41]

As a dialectical antithesis to the position stressing science and technology, let us quote Lionello Venturi, who under the heading of modern painters includes Goya, Constable, David, Ingres, Delacroix, Corot, Daumier, Courbet, Manet, Monet, Pissarro, Sisley, Renoir, Degas, Cézanne, Seurat, Gauguin, van Gogh, and Toulouse-Lautrec. His argument is as follows:

> The choice of these painters is justified for two reasons. All have created works of absolute artistic excellence. Their common characteristic consists in their perfection as painters. . . . The painters who have been selected are not only perfect artists but modern artists. In qualifying them as "modern," we do not mean to give only a chronological indication. It is absurd to detach the work of art from the spirit of its time, to transport it

into a rarefied atmosphere which would stifle it, to suspend it in the sky fixed for eternity, like a platonic idea. Of course, the perfect work of art is eternal, that is to say it outlasts its time; but its perfection is inconceivable outside a framework in which the artist's freedom and the spirit of the times, creative imagination and taste coincide. The author of this book is convinced that determinism of the *milieu* as understood by Taine is an error which fails to recognize precisely that creative freedom of the artist. However, the creative freedom does not exist in a vacuum; it acts within given historic conditions which are conditions of life.

The twentieth century woke up to art with an ideal called romantic from which it has never completely detached itself. In this ideal, the artists have sometimes found a spur for their creations, sometimes also an obstacle which has itself called forth reactions. But they could never disregard the ideal of their time; they could have done so only at the risk of stifling their production, of creating an archaelogical work and not a work of art. In spite of the anti-romantic inclinations of our century, in spite of certain pretensions of abstraction and a return to antiquity, our age has only one tradition, one support, one point of departure: the art of the nineteenth century.[42]

This is a point of view which can be well understood from the angle of art history but which must be comprehended also in a deeper sense. The later development of modern art, the art of some of the masters following those treated in Venturi's book (such as Chagall, Bonnard, Klee, Picasso in certain periods, Kokoschka, Delvaux, Miró, and some nongeometrical abstractionists, among others), makes the emphasis on Romanticism quite acceptable. But not exclusively. Rather than to call the art of these painters dialectically an antithesis to the spirit of science and technology, we ought indeed to think of it as the other side of the coin, both together signifying the struggle between rationalism and intuition, the tangible and the symbolic, and their necessary and ultimate unity in this process. We encounter here the concept of the *coincidentia oppositorum* (conjunction of opposites) in the realm of modern art established in philosophy since Nicolas Cusanus and critically propounded in modern psychology.[43] Elie Faure has expressed it poetically in the words:

> The more I progress, the more I observe, the more I watch myself live, the less I conceive it to be possible to consider the history of peoples and the history of the spirit otherwise than

as a series of alternations, now slow and now hurried, of dis-integration through knowledge and of integration through love.[44]

The content of Florent Fels' *L'Art vivant*, of Werner Haftmann's *Malerei im 20. Jahrhundert*, and, by the way, also of *Les Clés de l'art moderne*, in the Table Ronde series *Les Guides du monde moderne*, is nothing but the description of this dramatic and violent struggle of opposing formal tendencies and ideas in modern art to the neglect of its roots or primary causes.[45] Only from an examination of the roots and primary causes will we be able to grasp the meaning of this extraordinary development, not from description only or from divi-sion and arrangement into isms, trends, or schools with their main representatives in historical sequence alone. Florent Fels starts with the *fin de siécle* in Paris, and his first fixed date is 1900; the Table Ronde volume starts with the Impressionists. Haftmann, with his self-imposed limitation to the twentieth century, places his emphasis on the more advanced trends of avant-gardism and shows, on the one hand, their clash with *"Die Kunstwende"*; on the other hand, he seems to conceive the whole formal revolution in the first decades of the twentieth century, with the exception of the *maîtres populaires de la réalité*, of Dadaism, Surrealism, and geometric abstract art, only as *"Wege zur Ausdruckswelt,"* "roads to the world of expression," as if leading mysteriously to an unknown fulfillment.

The absolutely new element which determines the rhythm and es-sence of modern life is technology based on modern science.[46] It is only from this awareness that we can understand the tremendous changes which have taken place in life and art and understand also the tendency of art to emulate the concepts of modern science as well as repudiate them. For this reason it seems more acceptable to see the beginning of modern art in the emergence of Realism. This is what Paul Ferdinand Schmidt does in his *Geschichte der modernen Malerei*,[47] what René Huyghe does in his *Dialogue avec le visible*. Huyghe speaks of the *"accomplissement et mort du Réalisme,"* going on to discuss not only the radically new which modern art has brought into the history of art but also the basically traditionalist character inherent in Naturalism, with its interest in the optical truth of the visual form, and Impressionism, with its interest in the disso-lution of this form by the impact of light.[48]

The boundary where old and modern meet being fluid, it will in-deed be necessary to find some property which distinguishes equally all products of the art of the last hundred years. This distinguishing

feature is to be found exclusively in the influence of empirical-ana-
lytical science on art and life. Perhaps this conclusion will lead one
day to a new and more significant name for that art epoch which
today we still call so inarticulately "modern" or "contemporary." Even
a designation like "the art of the age of technology" reveals some-
thing more essential about its character than "modern" or "contempo-
rary."[49]

Another important question is to determine at what date the for-
mal, technical, or ideological character which is for us the mark
of "modern" art comes to the fore. Writers are by no means in agree-
ment on this point. Some critics and art historians begin with the
year 1858, when Eugène Boudin first guided Claude Monet's early
efforts in Le Havre,[50] some with the year 1863, the date of the found-
ing of the Salon des Refusées by the Emperor Napoleon III, who
thereby gave artists like Monet and Pissarro the opportunity to ex-
hibit their pictures that had been refused by the Salon des Beaux
Arts;[51] another author takes the year 1895 as his starting point, when
in December the young art dealer Ambroise Vollard hung Paul Cé-
zanne's first personal exhibition in his little gallery in the Rue Lafitte
in Paris. It is from this exhibition that Cézanne's reputation dates.
According to Lionello Venturi, the year 1895 also stands as a symbol
of the new tendency in art which had begun to appear and grow
during the previous years.[52] From an ideological point of view, how-
ever, the year 1889 seems a more decisive one: Bergson published
his work "Essai sur les données immédiates de la conscience"; the
Mercure de France, the mouthpiece of the Symbolists, was founded;
and the generation of artists born between the years 1850 and 1870
produced their first representative pictures. At the time when Realism
was predominant, Puvis de Chavannes, Odilon Redon, and Cézanne
were preparing their new painting. In the same year, too, this new
painting appeared on the scene for the first time as a collective mani-
festation against the Realism that was so formidably represented in
the world exhibition of 1889. It stood for the metaphysical revolt, the
restoration of mysticism and of religious consciousness, even of magic,
of the occult sciences, of Satanism (Huysmans, Claudel, Villier de
l'Isle Adam, Maeterlinck, Mallarmé, Baudelaire) against Compte's
Positivism and the predominance of science and so-called Realism.
It was Bernard Dorival who pointed out the significance of this date
as the starting point of the opposition of an irrational, transcendental-
idealistic form of art and trend of thought to Naturalism.[53] Compared
with this, the emphasis on the chronological fact that the Realist

movement which began at the end of the forties was a development of the Romantic movement of the thirties and forties seems quite unsatisfactory (Wilenski). In the middle of the twentieth century we have to go a step further to the assertion that we today possess a deeper notion of reality and that the opposition of realism and non-realism is to us only one facet of a wider concept, that of the conjunction of opposites in which the one trend appears as the function of the other, the complete picture of art being then and at present the interaction, an interlacing, conflicting, and fusion, of these two notions. In the realm of science as well as of art, reality has been redefined: a new viewpoint has been gained on the creative faculty of man.[54] Taking into consideration the impact on art of empirical-analytical science, we come to the surprising conclusion that both realism (naturalism) and geometric abstract art come to stand on the same side of an equation—surprising because all trends of abstract art see themselves only as antipodes of realism.

Since realism, in the old classical sense and in the new scientific sense, and non-realism play an equally important part in contemporary art, and their different traditional bases must be taken into account, it is difficult to name one particular artist with whom the present art era opens. We can take Courbet as a starting point, as did Henri Focillon, and construct a bridge to the Romantic movement of the Second Empire (Gustave Moreau, Monticelli)[55] or say like Raynal with a certain reservation:

> While readily admitting the influence of Ingres, Delacroix, Constable and Corot on the course of modern painting, we have thought it best to place the name of Gustave Courbet in the forefront of this history, the reason being that of all the masters of form and color Courbet is one as to whose supremacy all painters are in agreement. None, indeed, but sees in him a past master in that excellence of craftsmanship which is the lodestar of every professional artist. The daring and the power, the delicacy of execution and the sheer splendor of his art opened up so many new vistas that even artists with radically different temperaments, such as Matisse and Picasso, join in regarding his work with that slightly envious deference which is accorded only to what is permanent in the *métier*.[56]

By the same reasoning, however, we might put the emphasis on Delacroix: "A great star hovers over Manet and his friends: Delacroix. . . . not one of the many masters of color of Manet's genera-

tion can make us forget the colorist Delacroix; everything or almost everything that they are given credit for adds to his fame.[57] Cézanne declared: "We painters all spring from him." Delacroix is a Romantic but, from the point of view of form, a Realist. His realism is modern with hitherto unknown contractions and a summary conception of form.[58] We realize that without underlining the primary importance of science and technology to the ideology of modern art we cannot arrive at any definite conclusion.

Sheldon Cheney, in referring first to the Classicism of David, Ingres, Gros, and Gerard, and then to the Romanticism of Delacroix and Gericault, tries to root contemporary art in the broadest possible way.[59] This is also the case with Hans Hildebrandt, who, before embarking on a discussion of the ventures of modern creativeness, feels obliged to sketch first the background against which it stands out: the Classicism of about 1800 and the reaction against it in early Romanticism; early Realism; and the climax of these two trends, leading to something unexpectedly new.[60] Germain Bazin, under whose auspices a *History of Modern Painting* was compiled, proceeded similarly.[61] We feel that Cheney would like to declare Goya to be the first modern master—as previously suggested by Meier-Graefe in connection with Manet[62]—were he not deterred by the fact that between Goya's death and Daumier's and Manet's mature work twenty and thirty years lapsed respectively, so that there is no question of a direct succession. Nevertheless, there is a spirit discernible, a creative unrest, in the late work of Goya which is definitely modern and which found its ultimate expression in modern Expressionist masters such as Munch and Kokoschka, in certain aspects of Picasso's work, of the Surrealists, of Fantastic art.[63] With seemingly as much justification we could call El Greco (dramatic foreshortenings, modern color concept) or Hieronymus Bosch (in connection with Surrealism and modern *Angst*) or Franz Hals (Impressionist technique) "modern" masters. Such a line of reasoning would have the most bewildering consequences. It could mislead us to include in the connotation of "modern" all sources of inspiration, even the most distant in time, which are connected by tradition with the modern movement.[64]

Before we leave Classicism and Romanticism, the styles of the nineteenth century, it is appropriate to throw some light on a problem which Oswald Spengler formulated thus:

> Great art is altogether extinguished with the arrival of civilization. The transition is expressed in every culture by some form

of "Classicism and Romanticism." The one means a fanaticism for an ornament—its rules, laws, types—which has long become antiquated and soulless, the other an enthusiastic imitation, not of life, but of an earlier imitation. An architectural fancy takes the place of an architectural style. Painting and literary styles, old and modern, native and foreign forms, change with fashion. All internal compulsion is lacking. There are no more "schools" because everyone chooses what he likes, where he likes. The whole compass of art, including architecture and music, verse and drama, becomes craft. A sculptural as well as literary standard is formed which is merely handled with taste, and is without any deeper significance.

Spengler's condemnation of modern art as a mere degeneration of great art and as the expression of a culture in decline—Spengler accepted the cyclic theory of culture as proposed by Giambattista Vico[65] —has been shared by many authors (Champigneulle, Weidlé, C. G. Jung, Melichar, Berdyaev, Soloviev, Unamuno, Sorokin, Toynbee, Huizinga, de Chirico, Sedlmayr, P. Meyer, Berenson, Bodkin, L. Lindsay, W. Lewis).[66] But the mere fact that technology based on modern science is an absolutely new factor in the history of mankind and that its influence on modern art has been established may prove that his judgment is superseded. Naturally, as in all intellectual matters where the reasoning is dependent on the angle from which a problem is viewed, one can also turn the whole question upside down and say with Leopold Ziegler

> that every historic culture requires a civilization in order to grow and to exist, that culture can never make civilization superfluous, that it only begins with civilization, because culture does not become a possibility until there is a genuine need of culture, that is, when the whole of human activity is not absorbed in the process of liberation from nature.[67]

The term *culture* is here synonymous with spiritual life, as was the case in the usage of Jacob Burckhardt.

Both old culture and new civilization overlap, and parallel to the process of the disintegration of a culture in the structure of a new civilization goes the process of the building of a new culture. "If we want to preserve culture, we have to lead the way by creating culture," said Huizinga when speaking of the cultural crisis of our day. The etymological position that the term *culture* has primarily an agri-

cultural implication and that the term *civilization* is derived from the word for citizen may also throw light on the problem. Culture is the deeper term, suggesting the hidden sources of life itself; civilization refers to human, social commitments.[68]

Let us now return to the nineteenth century. In defying both Classicism and Romanticism, the Realist artist sought the freedom to find his bearings again in life and in art. What a fatal mistake it was, however, to regard the repudiation of an obsolete tradition as freedom. A Realist artist like Courbet did not represent only his own theory of art; he reflected also the spirit of his time, which was imbued with the hypotheses of the mechanistic-materialistic phase of science. The scientific spirit had already gained such power over this period that it even entered into purely aesthetic evaluations, as is evident from the writings of Saint-Simon, August Comte, and P. J. Proudhon.[69]

Our position after a critical examination of all these factors, therefore, is as follows: Realism is the first example of the permeation of science into all forms of expression. Considering that the central problem of present-day art is the negation, through abstraction, of nineteenth-century Realism but not always the negation of science, it seems after all most advisable to us to start our observations with Courbet and Realism, or rather with Naturalism. (Realism on the level of appearance is Naturalism. In the more recent usage we can speak of Realism on the level of artistic concept, as in Cubism and abstract art.)[70] Naturalism, as Dorival described it, "swept in in three great waves" between 1848 and 1889. First came Millet and Courbet, then Manet, and finally Impressionism.[71] René Huyghe speaks of the two pillars of the nineteenth-century world view as *"la notion du réel"* and *"la notion de la raison"*; in their collapse—*"faillite du réel"*— he sees the essence of the art of the first half of the twentieth century, the new and truly modern.[72]

Classicism, Romanticism, and Realism are the main pillars of academic art, whose disintegration is to Herbert Read the signal for a new conception of art.[73] Lionello Venturi starts his short survey of the development of modern art with the year 1905 and Fauvism,[74] a point of view which seems to be shared by Huyghe: *"Le mouvement moderne commence 'vraiment' avec les Fauves et leurs amis."*[75] But now we find the second generation of abstract artists claiming to be traditionally bound to Impressionism and especially to the late Monet

(this is still true of the Tachists),[76] and Chagall speaking of the return to reality in terms of the primary phenomena of reality selected by Monet.[77]

Here, then, we seem to encounter not only a disagreement as to the starting point of modern art but also an altogether different concept of the term modern. Whereas in the early literature on modern art the fact is mirrored that the sudden and violent development of modern art appeared as a confusing happening,* we can recognize in René Huyghe's *"vraiment"* and Venturi's somewhat arbitrary division into the two groups 1905–20 and 1920–45[79] the germ of another more timely distinction. We therefore speak of a first and a second phase in the development of modern art. In the mid-century we can make a more comprehensive division. We shall speak of an early phase, of a phase of radicalism, and of a middle phase. We are hardly in a position to classify the present phase, as it is not completed; and to speak now of a late phase would be prophecy, not art history. Christian Zervos, with his own peculiar intuition, seems in spite of his aversion to documentation and systematic thought to support this classification, in talking of Cézanne, Renoir, Gauguin, Toulouse-Lautrec, Seurat, van Gogh, and Rousseau as forerunners, and in making Fauvism and the influence of Negro art his starting point.[80] It is certain, however, that in such a classification the first group would have to start before Cézanne and the second with Cubism. The following picture of the development of contemporary art is thus formed:

*So Carl Einstein together with H. Kröller-Müller and other similar early writers on the modern movement represent a type of literature that has been superseded both in method and knowledge by a much higher standard. Kröller-Müller presupposes a far too generalizing juxtaposition of the terms Realism and Idealism, and Einstein starts with an arbitrary juxtaposition of names like Matisse-Derain-Modigliani-Kisling-Rousseau-Rouault-Utrillo. There is no documentation, no systematic thought, not even a chronological order, with which Wilenski's book on the other hand is too overburdened, and there is also no attempt to investigate the primary causes of modern art. We have to acknowledge, however, the fact that attempts such as J. Meier-Graefe's are great achievements of interpretation and of systematic penetration considering that they were undertaken at the beginning of the century.[78]

THE CLASSIFICATION OF MODERN ART SCHOOLS

The Early Phase
Realism
Impressionism
Neo-Impressionism, also called Pointillism or Divisionism
 Seurat
Symbolism
The Great Independents: Manet, Gauguin, van Gogh, Renoir,
 Bonnard, Cézanne

The Phase of Radicalism
Parallel Developments:

Fauvism	Expressionism
Matisse	Munch
	Kokoschka
	Nolde
Cubism	Fantastic Art
Picasso	Chagall
Braque	Klee
Futurism	Neo-Primitivism or Naïvism
Boccioni	Rousseau

Purism
 Ozenfant
The Intermezzo of Dadaism
 Duchamp
Surrealism
 Breton, Ernst
Abstract Art
 Mondrian, Kandinsky, Kupka, Delaunay, Arp, Wols,
 Manessier, Pollock, Rothko, Still
Neo-Realism and Neo-Humanism

The Middle Phase

 Paris played a rôle in the modern movement similar to that of Florence in the Renaissance. All countries followed, more or less closely, the French development after Delacroix and Courbet. With the emergence of the extreme trends, French and non-French artists shared initiative and fame. Paris lost its exclusive central position. Particular and significant developments were occurring in Russia before the revolution and in Germany, Italy, Holland, Belgium, the

United States, Mexico, and elsewhere before, during, and after the two world wars.

The characteristic of the middle phase in the evolution of modern art is the gradual assimilation of the radical discoveries of the previous generation. Their principles were explored in a consequent and logical way to their extremes. The mutual influences across the boundaries of the highly specialized doctrines and form speeches resulted in a most complex picture. No phase in the history of art has shown such a variety of styles and their reciprocal enrichment. The most powerful development took place in the realm of abstract art: an evolution of all its possibilities with the geometric trend receding before the exploration of more organic shapes, of the dynamics of line (influence of Eastern calligraphy), of planes, of color as such (building further on the color concept of Symbolism and Fauvism and conveying to the color blotches, their integration into the picture and their mutual relationships, the exclusive faculty of poetic expression), and their combination led finally to the ever-increasing emphasis on the chance element, on emotionalism, that is, to Abstract Expressionism or Impressionism (Expressionism or Impressionism without subject matter) in the new form of *abstraction lyrique,* Tachism, *Art autre,* and Action painting. Impressionistic tectonic elements derived from the late work of Monet, Bonnard, and others, the stylistic approach of Kandinsky in his Abstract Expressionist period (1910–14), and a further development of Surrealist automatism and of the Dada attitude were thus put into the service of a new Expressionist dynamism.

On the whole, the tendencies in the middle phase are as follows:

Continuation of the Work of the Masters
New Developments in Realism
The Followers of Symbolism and Fantastic Art
The Followers of Matisse and Fauvism, and
The Followers of Picasso and Cubism (both closely connected, which is already indicated by the influence of Matisse on Picasso and the inclusion of color in the Cubist program—Léger, Delaunay, and others)
The Followers of Futurism
The Followers of Purism
The Followers of Surrealism
The Followers of Expressionism
The Followers of Neo-Primitivism

L'Art Brut (combining Archaic, Primitivist, and Dada-Surrealist ele-
ments with the primary significance of the pictorial matter itself)
Unfolding of Abstract Art

Both the number of artists and the literature on contemporary art
increased enormously during this period. Among the many names in
the fermenting process of the most recent developments, only a few
can be looked upon as historically established by this time. (For a
more comprehensive survey of the various movements and their ex-
ponents, see Appendix B.)

In our classification of the movements in modern art, it will be
noted that among the generally accepted schools and isms there occur
also the names of a few individual artists. They were the leaders, the
initiators of trends. Among them Cézanne and Picasso deserve special
mention. Cézanne played such a role in the development of post-Im-
pressionist art that his work can be regarded as the point at which
something decidedly new began. And another decidedly new ele-
ment found its prototype in Picasso. The problem is posed, to what
extent do the different trends of modern art exist independently of the
personalities of their original creators? They exist independently only
insofar as they express, through the application of new techniques
and concepts, what is called the *Zeitgeist,* the spirit of our age, the
changed relationship of man to the universe and modern man's image
of himself. It is through the isms that we define the special fields of
artistic research and of the creative urge behind them in the pro-
cess in which we recognize the emergence of a modern world view
of which modern art is only one aspect.

Certain modern artists have made expansive theoretical pronounce-
ments (Maurice Denis, Emile Bernard, Gleizes, Ozenfant, Kandinsky,
Lhote). Others—by far the majority—have been satisfied with sug-
gestions (Renoir, van Gogh, Matisse, Picasso, Kokoschka). The indi-
vidual artist cannot be nailed down to one school or direction based
on a theoretical pronouncement made at a certain period in the liv-
ing development which he goes through. Picasso—an extreme case—
was for a time a Romantic Realist, then an Expressionist, a Cubist,
a Classicist, and a Surrealist. He has built his art on both primitive
and highly civilized forms of expression, but his vehement, restless,
and encyclopedic nature can be comprehended only when it is con-
sidered in its natural unity, that is, through his personality and its
relationship to his time. Other artists, Juan Gris and Chagall, for ex-

ample, are less many-sided, and then it may happen that their life
work coincides with a general term defining a school: Juan Gris and
Cubism, or Chagall and Fantastic art. In the comprehensive histori-
cal approach to contemporary art the critical study of both style and
personality is necessary, the one helping us to grasp the revolutionary
ideas, and the other to understand these as living realities. While the
latter point of view prevails in a monographic treatment, the former
is more profitable for a general survey.

Let us return once more to the various historians of modern art,
in order to consider those points on which their classifications vary.
It frequently happens that contemporary authors and artists have the
ambition to originate new terms which often cannot be made to
conform with any fundamental idea or order, and which add consider-
ably to the irritating confusion of the various isms. When Raymond
Escholier speaks of Neo-Traditionalism[81] (this is the title of a treatise
by Maurice Denis from 1880), he names Vuillard and Bonnard with
the Nabis and the circle of Synthetists around Gauguin (The School
of Pont-Aven). The term traditionalism is too vague; the concept of
Renaissance and academic art, whose weight has always threatened
to overwhelm the modern impetus, creeps in again. Apart from this
it is important to define exactly which tradition is meant. In the case
of Maurice Denis, for instance, the concept coincides with religious
painting. The term is today by no means unambiguous, considering
the various new traditional chains to which particular modern trends
are linked. In the future, considering the universal aspect of our
knowledge of the history of art and its influence on our modern con-
sciousness,[82] the term will become even more complicated and un-
manageable. While Gauguin and the Nabis, to a certain extent at
least, developed from a common ground, Bonnard is more related to
the post-Impressionist development, to Fauvism and its sphere of in-
fluence.

Next to the fact of an underlying spiritual relationship, the direc-
tion in which the artist's style is developing must be the deciding fac-
tor. Here we ought to be guided by the principle that the style which
is the determinant is not that in which the artist may have begun to
work, and through which he has passed, but that which is essentially
connected with his personal achievement. So it is not the Impression-
ism of Gauguin's earliest works, or the fact that Vuillard and Bon-
nard once belonged to the group of Nabis, that counts. The special
difficulty that arises with artists like Picasso and Klee will be over-
come by recognizing what is their essential characteristic, namely,

the perpetual urge to adapt new stylistic stimuli in an effort to es-
tablish a modern style.

The compression of Escholier's treatment—he covers the whole de-
velopment of twentieth-century painting in four chapters—led him
also to group under one heading the Primitivists, the Surrealists, and
the École Juive. The École Juive in any case does not exist; the term
merely expresses the author's surprise at the number of Jewish artists
emerging in the modern movement. Bernard Dorival's classification
is more far-reaching than this, in that he distinguishes three main
stages in historical chronology: "De l'Impressionisme au Fauvisme,
1883–1905," "Fauvisme et Cubisme, 1905–11," and "Depuis le Cubisme,
1911–44."[83] In the last stage he establishes subsidiary groups which
have developed in opposition to the rational and constructivist as-
pects of the modern movement. They are *la protestation de l'instinct
et du coeur*," that is, the Primitivists; "*la protestation du bon sens*,"
in fact the return to Realism and Neo-Humanism; "*la protestation de
la subjectivité*," the Expressionists, the Surrealists, and Marc Chagall;
and finally the tendencies in the youngest French painting. Herbert
Read, too, with the same justification, has made a distinction between
subjective Idealism, where he treats Picasso, the Surrealists, and Klee,
and subjective Realism, by which he means Expressionism.[84]

Lionelli Venturi, like Escholier, works with the term "Traditional-
ists," under which he places Bonnard and Vuillard as well as Signac,
Marie Laurencin, and others.[85] This term is opposed in Venturi's book
to the nonrealistic or nonfigurative style tendency. Such a distinction
would be justified were this figurative style tendency expressed in
one and not, as in fact, in numerous highly different manifestations.
Venturi underlined through this classification his one-time opposition
to the nonfigurative. He also hesitates to distinguish between Cubists
and abstractionists, for to him both were abstract: "Today when we
speak of Abstract Art, we mean Cubism and its variations."[86] It must
be stated against such a definition that Cubism was never abstract,
even though there was a tendency toward abstraction to be noticed
in it. Among the first abstract works we find those completed by Kan-
dinsky about 1910. They grew out of an Expressionist mood and not
out of Cubism; their character is entirely intuitive, not cerebral. Kan-
dinsky and Mondrian are treated by Venturi together with the Fu-
turists, who are privileged to have a separate title apart from the
abstractionists, although their style defines them as being akin to
the Cubists. This expresses an outspoken Italian point of view which

coincides with the generally accepted classification. Modigliani and Utrillo are classed together with Chagall, de Chirico, and Klee in the chapter on Fantastic art. Another school of thought would associate Modigliani with Cézanne, Gauguin with the Negro tradition (Picasso), and Utrillo with the Neo-Primitives. Odilon Redon, who in the realm of Fantastic art was of undoubted influence, is left out, and so is Miró, who is nevertheless found in the first group of Surrealists. Miró can be counted as a Surrealist only in one short period of his work and might quite as wrongly be described as abstract. The determining element in his style is that fantastic-primitive, poetic-serene trait which makes the essence of his personality.

R. H. Wilenski's grouping is also unsatisfactory. "The Modern Classical Renaissance," for instance, comprises Cézanne, Seurat, Renoir, Rousseau, Gauguin, van Gogh, Toulouse-Lautrec, Maurice Denis, Matisse, Modigliani, and Severini.[87] Wilenski borrowed the term "Classical Renaissance" from Robert Rey's "La Renaissance du sentiment classique"; but contrary to Rey he uses it as classification. A title like "Rhythmic Decoration," too, in which Matisse and Dufy but also Rouault, Modigliani, and Picasso occur, is more a flight of fancy than a classification, while the introduction of the term "Unschooled Painters" for Neo-Primitivism is misleading because it can be applied to many artists with different styles. It is a fact that the great majority of modern artists are self-taught. Wilenski's division of Surrealists—Chagall, de Chirico, Picasso—and Neo-Surrealists, who are generally known as Surrealists, is historically incorrect. Chagall never belonged to the Surrealist movement,[88] and de Chirico was "discovered" by Breton in 1917 when there was yet no Surrealism. Picasso, on the other hand, was during only one short phase of his work influenced by Surrealism (about 1925/27), by its disquieting quality and not by its peculiar form speech, and should therefore be treated on his own.

Christian Zervos also gives little satisfaction from the point of view of classification. But unlike Wilenski he has never aimed at classification and systematization. He calls the chapter on Chagall "Le Surnaturel," playing on a word which Apollinaire applied to Chagall in 1910. "Le Lyricism des signes" denotes Klee, and "La Poésie de l'enigme," de Chirico. In "Au delà du concret" and "Au delà de la peinture" he deals with artists who show abstract tendencies, while "La Poésie rebelle" simply stands for Surrealism. These titles are used by Zervos in a distinctly poetic sense, rather like Paul Eluard's

titles, and in judging them one must keep in mind the nature of his book as the first to treat the extreme tendencies of art after Cézanne in a comprehensive manner.[89]

In a general history of modern art, it is not only the artists who have worked in France that must be considered. Today it is recognized that artists east of the Rhine and elsewhere have made important contributions to modern art. The greatest weakness of Zervos' book is that it does not mention Expressionism at all, and so leaves out Edvard Munch, the German Expressionists, and Oskar Kokoschka, in spite of the fact that the title of the book is *L'Histoire de l'art contemporain,* while on the other hand he devotes a special chapter to Russian abstract artists. René Huyghe, Sheldon Cheney, Herbert Read, and Lionello Venturi are, however, aware of this omission, and there is in their work a noticeable tendency to take into account the development of modern art in different countries. In this of course the Italians come off particularly well with Lionello Venturi, while Sheldon Cheney deals with the Americans more closely. A world history of modern art does not yet exist, although there is already a great deal of material available.

The need for clarity and lucidity in the nomenclature of modern art is particularly apparent where a question of practical and not merely academic import arises. Today there are museums for modern art in many capitals and a classification at once historically correct and instructive has proved necessary to their organization.

In the Paris Musée Nationale d'Art Moderne it was found necessary to devote particular rooms to important artists as well as to schools. The French Suzanne Valadon, Felix Vallotton, Georges Desvalières, Albert Marquet, Maria Blanchard, Roger de la Fresnaye, Louise Hervieu, and Charles Dufresne have special rooms. These artists are emphasized from a French but not from an international point of view.[90]

The same applies to New York's Museum of Modern Art, which of course lays great stress on the representation of the Americans, as in the sections "American Painting, Classic and Expressionist," "The Romantic Tradition in the U.S.A.," and "American Scene," where next to Primitives appear Surrealists and Realists. South America too is well represented. The division of the Museum of Modern Art is made partly according to style (Modern Primitives, Abstract Painting: Geometric, Return to the Object, etc.) and partly according to geographical and chronological considerations. This leads to some con-

fusion. For instance there is one section "Realist and Romantic Painting in Latin America," but if we are looking for other South American styles, we find them in the section "The State of the World: Art with a Political Bias," where next to the Mexicans Orozco, Siqueiros, and Rivera the Germans George Grosz and Otto Dix are represented. But Dix and Grosz could also appear in the section "Realist and Romantic Painting in Europe" and the Mexicans in the Latin-American section.

The idea of setting up a section on art with a political bias cannot well be maintained by the side of a stylistic and geographical classification. A geographical classification has its justification, but works inconsistently when it is mixed with a chronological order, as in the section "Late 19th Century, Europe." Instead of this an adequate style designation would be welcome, as in the sections "Painting in Paris, Classic and Expressionist" and "Expressionism in Central Europe." Purely practical reasons must have called for this classification. Even so, it hardly makes for greater clarity. For instance, Utrillo is included in the group "Painting in Paris, Classic and Expressionist," when the museum has a separate section, "Modern Primitives"; and a section called "Magic Realism" allows the concept of Surrealism to be bypassed to include Surrealist works by Ernst, Tanguy, Magritte, Dali, and Roy, as well as the Fantastic art of de Chirico. Klee, Miró, and Chagall, however, appear next to the abstract Kandinsky and to Arp in the section "Free Form, Free Symbol," which causes a confusion of the terms Abstract, Fantastic, and Surrealist. Fantastic art cannot be called magic, because it is only rarely so, and the essence of abstract art consists less of fantastic than of constructive and only lately also of emotional elements.[91]

The thirteen modern schools adopted in our classification are easily defined. (Abstract art itself can today be subdivided into at least as many trends as these.) Many of the schools have today only a historical interest as radical trends that were initiated to solve special problems. But on the whole they are indispensable links in a logical chain of development, in a process which characterizes our age as an age of transition in which old established traditions are discarded, dissolved, and metamorphosed through revolutionary ideas and the discovery of new primary sources of inspiration, creating a new tradition which binds mankind, for the first time, into one indissoluble whole on its march toward a common future with its guiding ideals of science and technology.

THE INFLUENCE OF SCIENCE ON MODERN ART

The impact of science and technology on modern art is so far-reaching in importance that it has determined not only our choice of Courbet's Realism as the appropriate beginning of the movement, but also our viewpoint for the interpretation of modern art. Such a claim needs substantiation, from the philosopher and the historian of culture and, above all, from the scientist. The next question to be studied, therefore, is that of the influence, direct or indirect, of scientific thought and method as well as of technology on the ideology, form, and subject matter of modern art itself and consequently on aesthetics.

These selected quotations may suffice to support the first contention of our thesis:

It is only by considering the scale of world history that the deep incision becomes visible which has occurred in our time, an incision which had been in preparation for two centuries and for which, in the multitude of its consequences, we find no comparison in our knowledge of the past 5,000 years. What alone is essentially new, fundamentally different, without comparison to Asia, distinctly specific to our time and foreign even to Greek civilization, is modern European science and technology. Retrospectively, the total picture of world history so far shows a continuity, a coherence even which found its loftiest expression in Hegel's view of history. With the advent of modern technology all this changes. This is the reason why, until 1500 A.D., there is still considerable similarity between Asia and Europe; it is only during the past centuries that the difference becomes so pronounced.[92]

Science has changed the condition of man's life. It has changed its material conditions; by changing them, it has altered our labour and our rest, our power and the limits of that power, as man and as communities of men, the means and instruments as well as the substance of our learning, the terms and the form in which decisions of right and wrong come before us. It has altered the communities in which we live and cherish, learn and act. It has brought an acute and pervasive sense of change itself into our own life's span. The ideas of science have changed the way men think of themselves and of the world.[93]

Civilisation as we know it today would, in its material aspects, be impossible without science. In its intellectual and moral aspects science has been as deeply concerned. The spread

of scientific ideas has been a decisive factor in remoulding the whole pattern of human thought.[94]

Science, as a dominant factor in determining the beliefs of educated men, has existed for about 300 years; as a source of economic technique for about 150 years. In this brief period it has proved itself an incredibly powerful revolutionary force. When we consider how recently it has risen to power, we find ourselves forced to believe that we are at the very beginning of its work in transforming human life.[95]

Scientific achievements have changed "our whole way of life beyond recognition in the course of less than two centuries, with further and even more rapid changes to be expected in the time to come."[96]

"The changes in the foundations of modern natural science are an indication of profound changes in the foundations of our existence which, in their turn, will surely produce a reaction in all other spheres of life."[97]

The influence of science and technology on art can be studied historically. Through an analysis of the theories and concepts, the techniques, the laws of composition, and the subject matter of the modern trends, we can gain a complete picture of the whole process. In our procedure we shall, for reasons of clarity, deal first with those trends and personalities in which the influence of science and technology is undeniable, and afterwards with those that stand in opposition. The dialectic process of action and counter-action, or the significance of the parallelism of the phenomena, cannot here be investigated. It is the proper content of the history of modern art, not of the problem which we want to elucidate. Only a few related instances may follow here.

Realism. Courbet proclaimed in 1861:

> The art of painting should consist solely of the representation of objects visible and tangible to the artist. Any epoch should be reproduced only by its own artists, I mean to say, by the artists who have lived in it. I hold the artists of any century radically incompetent to reproduce the things of a preceding or future century, or otherwise to paint the past or the future. . . . I also hold that painting is essentially a *concrete* art and does not consist of anything but the representation of real and existing things. It is a completely *physical language* using for words all visible objects. An abstract object, one which is in-

visible, non-existent, is not of the domain of painting. *Imagination* in art consists in knowing how to find the most complete expression of an existing thing, but never to suppose or create that thing. *Beauty* is in nature and is found in reality under the most diverse forms. After it is found there it belongs to art, or above all to the artist who knows how to see it.

Courbet's mental world is that of the positivist philosophy of Auguste Comte. For positivism, the world is the sum of those objects that the scientific observer finds in his experience, so that knowledge for the positivist is built solely on rational experience. A metaphysical power of substance need not be brought into the argument. The scientist disregards what he cannot verify empirically. The mind is passive while it registers and organizes experience, and to that experience it adds nothing intuitive or constructive.[98]

Impressionism. Renoir painted from 1869 onwards mainly with the colors of the spectrum, the rainbow palette. He was the first of the Impressionists to carry to its logical conclusion the use of the so-called *mélange optique,* the system of broken color. The Impressionists took over and used the observations of the optical science of their time. In the works of Augustin Fresnel on diffraction and polarized light (1866), we find it stated that monochromatic light is a succession of simple vibrations and that color is a matter of frequency. Helmholtz laid the foundations for a physiological theory of perception. M. E. Chevreul propounded the theory of color (*De la loi du contraste simultané des couleurs,* 1839); O. N. Rood studied the quantitative analysis of color contrasts.[99] That the Impressionist masters were great artists they owe to their talent, their quality of mind, not to the influence of scientific theory.

Divisionism. Felix Fenéon wrote in 1886: "It is in 1886 that there appeared works painted . . . by a reasoned method." And Pissarro on Seurat's theories:

> Seek the modern synthesis through scientific means, which will be based on the theory of colours discovered by Chevreul, and according to the experiments of Maxwell and the measurements of O. N. Rood. Substitute the optic mixture for the pigmentary mixture, in other words, the breaking up of a colour tone into its component elements, for the optic mixture creates much more intense luminosities than the pigmentary mixture.[100]

Cézanne is a true analogy in advanced modern art to the Renaissance artist. The Renaissance artist was a scientist, his studies of per-

spective, of anatomy, were scientifically based. Because he was predominantly an artist, however, the artistic truth prevailed. This is also valid for Cézanne, but not always for the extreme artists who based their art on some of his theoretical statements. Cézanne said:

> Pure drawing is an abstraction . . . drawing and colour are not separate and distinct. . . . Treat nature by the cylinder, the sphere and the cone; the whole placed in perspective, let each side of an object or a plane be directed towards a central point. Lines parallel to the horizon give extent. . . . Lines perpendicular to this horizon give depth. . . . In art above all everything is theory developed and applied in contact with nature.[101]

The unity of visual experience and formative process is preserved.

Cubism. In the first decade of this century, as we have seen, two diametrically opposed trains of ideas had a decisive effect on the course of modern art. One of these was Primitivism and the other was analytical science; in a most singular way these came together in a symbiosis in Cubism. The analytical method, which dominates, even if not exclusively, the scientist's manner of working, has set in motion a spiritual rhythm that has taken possession of all provinces of life and, in the literal sense of the word *analytical,* has shattered the compact forms that life brings forth. It is not at all necessary to be acquainted with the experimental methods of science in order to fall under their influence. The will of the Cubist artist to bring about the break with the traditional Naturalist representation founded on the Renaissance has its roots in the urge to produce something as revolutionary and new as the world envisaged in the changed conditions caused by science and technology. Without the radical spirit of Cubism, the subsequent evolution of modern art is unthinkable. This is true even where Cubism is denounced as a formal inspiration. A new plastic language has been founded in accordance with the evolution of science and contemporary thought.[102] The connection between Cubism and the Einsteinian space-time continuum has been stressed by critics.[103] "There is no objective rational division of the four-dimensional Continuum into the three-dimensional space and a one-dimensional time continuum. This indicates that the laws of nature will assume a form which is logically most satisfactory when expressed as laws of the four-dimensional Space-Time-Continuum."[104] As early as 1911 Apollinaire said, "The fourth dimension—this utopian expression should be analysed and explained. . . ."[105] In *Du Cubisme* Gleizes and Metzinger proclaimed:

The pretence of representing the weight of bodies and the time spent in enumerating their various aspects is as legitimate as that of imitating daylight by the collision of an orange and a blue. [This refers to the Impressionist and Divisionist color theory.] Then the fact of moving around an object to seize several successive appearances which fused in a single image, reconstitute it in time, will no longer make thoughtful people indignant.[106]

To Moholy-Nagy, Cubism is nothing more than "vision in motion, a new essay of two-dimensional rendering of rotated objects."[107] Gleizes' and Metzinger's theory of Cubism made painting a rationalized enterprise. The business of the artist is no longer to reproduce the surface appearance of natural objects, or the world as he emotionally experiences it. The object he paints is a logical formalization of the natural model.[108] The "Primitive" source of Cubism and the genius in painters such as Picasso and Braque has saved them from becoming scientists or geometricians of the canvas. The doctrinaire application of extremist art theories leads to a negation of art.

Futurism. In the same way in which Cubism devoted itself to the question of a new representation of space, Futurism took up the problem of representing movement in a new way. In connection with the isms of modern art, one might speak of specialization in the way that it occurs in science as a division of labor in the solution of rational problems. The Futurist aim was the representation of movement as such. They were against tradition in art and for the glorification of the machine. "We declare that the world's splendour has been enriched by a new beauty, the beauty of speed."[109] One of the devices of the Futurists was "the lines of force," the *linee-forze* treated in the foreword to the catalogue of the first Futurist exhibition in Paris in October 1911. "The dynamism of an automobile is diagrammed by a series of increasingly acute resisting chevrons through which drives the half-dissolved silhouette of the car."[110] The main interest of the artist is concentrated not on the object, on matter, but on energy. Therein he follows directly the theory of modern physics, according to which mass and energy are identical.[111]

Dadaism. Born of the despair following the First World War, Dadaism proclaimed art to be a "stupidity" (Jacques Vaché in his *Lettres de guerre*). Dada was cultural nihilism (Duchamp).[112] "Let us all shout: there is a great work of destruction and negation to be done." Dada was born of a need for independence, of a mistrust

of the community. The nihilism of Dadaism is frustrated idealism. Reality, everyday reality, is "material, is mean, banal, mechanical, low." It is the only content of art.[113] Even Dadaism is a child of the misconceptions and consequences of science: "In regard to the aesthetic needs of civilized society the reactions of science have so far been unfortunate," said A. N. Whitehead. "Its materialistic basis has directed to things as opposed to values. . . . It may be that civilization will never recover from the bad climate which enveloped the introduction of machinery."[114] Similarly Alexis Carrel, himself also a scientist, writes:

> We must free ourselves from blind technology. . . . We are still plunged in the world constructed by the sciences of inert matter without regard for the laws of our nature. All the countries which have blindly adopted the spirit and the methods of the industrial civilization . . . are exposed to the same dangers. . . .[115]

Robot-like machine shapes began to replace the human frame in the art of the Futurists, the Purists, of Léger, Duchamp, the English Vorticists, etc.

Surrealism is another example of an organized art movement specializing in a limited field: the discovery and application of the Freudian notion of the unconscious in the realm of art. André Breton, a trained psychoanalyst, accepted the conclusions of Freudian scientific theories and also its clinical methods (automatism) as suitable for art:

> I believe in the future resolution of these two states which in appearance are so contradictory, that of the dream and that of reality, into a kind of absolute reality, a surreality. . . . Surrealism rests on the belief in the superior reality of associations neglected before its time; in the omnipotence of dreams, in the disinterested play of thought. . . . [Pure psychic automatism expresses] either verbally, in writing, or by any other means, the real functioning of thought. A dictation of thinking in the absence of all control exercised by reason and outside of all aesthetic or moral preoccupations.[116]

Abstract Art:

> To be contemporary in a true sense demands a most advanced knowledge of the facts governing the life of today [that is,

science, technology]. . . . The language of vision, optical communication, is one of the strongest potential means both to reunite man and his knowledge and to reform man into an integrated being. . . . To perceive a visual image implies the beholder's participation in the process of organization. The experience of an image is thus a creative act of integration.

So wrote Gyorgy Kepes.[117] The new abstract language of vision has a parallel in physical theory: "The relativity of physics reduces everything to relations; that is to say, it is structure, not material, which counts. The structure cannot be built up without material, but the nature of the material is of no importance."[118] If the art of painting undertakes

> to paint the solid or the volume, a weight, a direction, a tempo; cohesion, adhesion, attraction, antipathy, elasticity, gravity, rhythm, harmony, etc., the question is one of forces . . . and if art consists of forces and if forces cannot be seen in things, then things, as seen by the mechanical action of the eyes, cannot enter art. . . . Art can only be made with symbols analogous to those of science. Abstraction is the structural constant of art. It remains constant from the primitive savage to Spengler's civilized megalopolitan, that hard-city man who, detached from the soil, no longer feels the pulse-beat of nature. . . . By the very truth of organic growth modern art is irrevocably committed to a further exploration of abstract structure.[119]

In modern nonobjective painting there is also something emphatically new:

> It is the indication in this kind of painting, of the theory of an atomic universe. . . . At the same time that scientists were proclaiming that matter is not material, but is an X-factor in the universe, non-objective painters were representing something not material, yet, like matter, something primary, cosmic and indestructible. The experiments, equations and equipment of the scientists had led to the same kind of conclusion as reached by the intuition of the artists; that is, objects as we see them and atoms as material are far from being ultimate and accordingly far from being "real."[120]

(This view is philosophically untenable, as Jaspers has pointed out: see "Symbol and *Chiffre* in Art" in this volume.) A parallel development

to this phenomenon of abstraction in art is that trend of philosophy called logical atomism, or the philosophy of logical analysis: the Vienna circle (Moritz Schlick, Rudolf Carnap, Otto Neurath, Herbert Feigl, Victor Kraft, and Ludwig Wittgenstein) and the new English School (Bertrand Russell, G. Ryle, G. E. Moore, Francis H. Bradley, A. J. Ayer, G. Frege, and J. Wisdom).[121]

Ozenfant: "Our senses are accustomed to scenes where geometry reigns; our very spirit, satisfied to find geometry everywhere, has become rebellious against aspects of painting that are inconsistently geometrical." Mondrian: "To dehumanize is to abstract. . . . the new man has achieved a deeper vision of sentient reality."[122] Of Kandinsky, one of the initiators and first theoreticians of abstract art, it has been said: "The art of Kandinsky shows the limitations of a culture acquired through research and theory. For despite an enormous output and a deep knowledge of the scientific aspects of painting, it seems as though abstract painting, like other branches of art, must stand on its quality in the end."[123] Speaking in 1940 at a symposium arranged by the United American Artists, I. Rice Pereira analyzed abstraction as being of three different kinds. The first was "representational," meaning that it broke down objects in nature to obtain their essence. The second was "intuitional," or shapes drawn from the subconscious. The third, obviously her own kind, was "the pure scientific or geometric system of aesthetics" which seeks "to find plastic equivalents for the revolutionary discoveries in mathematics, physics, biochemistry and radioactivity."[124] This is still true of Tachism and Action painting. How an artist himself reads technology and science into Action painting is exemplified by the statement made by Mark Tobey in the preface to the catalogue for an exhibition of the work of Georges Mathieu in 1954:

> I am reminded of relentless traffic—the intense shimmering of lights in wet patent leather nights—the red glow of danger and the white neons of Paris which twist the eye-ball. . . . His work is independent to an extreme, is sought only within his personality and comes forth direct, uninhibited by the past, suggesting in its Now the possibilities of modern science reaching Mars, the Moon, or what may be approaching us in time's unending line.

Tachism and Action painting is abstraction, as such analytical in the pre-action stage, in spite of pushing toward the metaphysical,

combining elements of Expressionism (emotionalism) with those of Surrealism (chance) and nongeometric (amorphous) abstract art. Thus the gap is slowly closing between the two extremes of modern art: the one analogous to scientific research, the other in direct opposition to it, relying on means of cognition that are deeper and more direct than rational analysis, and independent from it. Tachism is a new step forward in the development of abstract art, strictly logical as all scientific research is logical, often using basic scientific data such as microscopic views of tissues, suggestions from the shape of animals without backbones, telescopic views. The proof is in books such as *The Thirteen Steps to the Atom,* a photographic exploration by Charles-Noel Martin (London, 1959) in which scientific views of matter appear to the untrained eye to be works of abstract art.

In a preface written for a new translation of Cennino Cennini's *Livre de l'art,* Renoir wrote:

> Faith was the regulator of their phantasy which could nourish itself without fear from profane sources. Today, Gods are no longer wanted, and Gods are necessary to our imagination. It must be confessed, modern rationalism, if it is able to satisfy the learned, is a manner of thinking incompatible with any conception of art.[125]

The thinker who had the greatest influence on Renoir's generation and who furnishes the philosophic parallel to his conception of art was Henri Bergson. To him reason is the intellectual power which enables us to comprehend the world of space, of pure extension; but intuition gives us the key to the understanding of life. While reason can give only relative knowledge, that which we know through intuition is absolute.[126]

In *Symbolism* the struggle between the spirit of science and the mystical and religious attitude toward life enters a new phase. "Europe is played out," wrote Gauguin in a letter to Emile Bernard; "it has been given over to the rage of money and the analytical spirit." He defined the method of Primitivism as "proceeding from the spirit and making use of nature" (against Realism). "I have gone far back, farther back than the horses of the Parthenon, as far back as the Dada horse of my boyhood, the good rocking horse" (against the tradition of great art, in favor of the directness of vision, purity, and naïvism). The Impressionists "pursued their searches in accordance

with the eye and not toward the mysterious centre of thought, and consequently fell into scientific rationalization. . . . Colour, being an enigmatic thing in the sensations it gives us, can logically be used only enigmatically . . ." (against Impressionist and Pointillist color theories).[127] Van Gogh in the later phase of his creative life had a similar experience: "I tried to express with red and green man's terrible passions" (symbolic value of color). "I have moments when I feel possessed with enthusiasm, or madness, or prophetic ecstasy like a Greek oracle on its tripod."[128]

Matisse's *Fauvism* was greeted in 1907 by Apollinaire with the words: "Instinct is regained." "What I strive for above all is expression," wrote Matisse. "I become aware of the expressive aspect of colour in a purely instinctive manner. My choice of colours is based on no scientific theory; it is based on observation, on feeling, on the experience of my sensibility."[129] The art of Matisse is anti-rational in the Bergsonian sense.

There are no scientific theories in the naïve, direct approach to art of the Neo-Primitivists, the *"maîtres populaires de la réalité"*; it would be a *contradictio in adiecto*. Nor are there any in the conception of the masters of Fantastic art. "Art has no other source than the soul of the world in which it lives. Its essence, like that of life, remains unknown." So said Odilon Redon. "All my originality," he said, "consists in putting the logic of the visible to the service of the invisible."[130] "In the fundamental notion of symbolization . . . we have the keynote of all humanistic problems. In it lies a new conception of 'mentality,' that may illuminate questions of life and consciousness instead of obscuring them as 'scientific methods' have done"; that is the contention of Susanne K. Langer in elaboration of the ideas of her master Ernst Cassirer.[131] Chagall declared: "I don't believe that the scientific tendency is a good thing for art. . . . Art seems to me to be above all a state of mind. The soul of everything is holy. . . . Only the sincere heart with its logic and its own reason is free. The soul that has arrived of itself at that stage when men call it illiterate and illogical is the purest of all."[132] And James Ensor: "Let us above all condemn the infamous doctrines of Descartes, this servile lackey of the odious Christina of Sweden, and the stupid Malebranche. The doctrines of these unwholesome people sterilize the heart in the name of reason." Ensor reckoned himself among those who are "slaves of the vision" and who "are obstinately opposed to positive rays as well as to positive reason." He turns toward those "beauties hidden from the positive spirits saturated with reason and

with vain, cruel, brutal and contemptible science"; he is "put under spells at the time of the red moons," and he offers sacrifices "to the goddess of marvels and of dreams."[133]

When de Chirico wrote the words: "Perhaps the most amazing sensation passed on to us by prehistoric man is that of presentiment. It will always continue. We might consider it as an *eternal proof of the irrationality of the universe*. Prehistoric man must have wandered through a world full of uncanny signs, he must have trembled at each step," he wrote them from a position of utter despair and melancholy, the elegiac loneliness of the artist in modern technical civilization. The son of an engineer, he became the mouthpiece of irrationalism, of metaphysical art. "What is most of all necessary," he said, "is to rid art of everything of the known which it has held until now; every subject, idea, thought and symbol must be put aside. . . . Thought must so far detach itself from everything which is called logic and sense . . . that things may appear to it under a new aspect. . . . "[134] Nietzsche, who had a decisive influence on the formation of de Chirico's mind, has forcefully defined this metaphysical root of the artistic vision: "And we may imagine how, through Apollonian dream-inspiration, his own state, i.e., his oneness with the primal nature of the universe, is revealed to him in a symbolic dream-picture. . . . The beautiful appearance of the dream-world, in creating which every man is a perfect artist, is the pre-requisite of all plastic art. . . . "[135]

"I know," says Masson, "that I am surrounded by the irrational. I let my reason go as far as I can. It traverses the court of objects and reaches finally a waste land of infinite desolation; it is a truly human place, which creates its own time." To the concept of this artist, to whom Heraclitus the obscure remains the essential philosopher, corresponds the thought world of Existentialism.[136]

Miró states that

> art is not exhausted in a synthesis of the physical and formal with the psychic. The grand symphony gives expression to the possibilities of *phantasy* as well as to the actuality of imitative realism. Art is at once the truest and most complete science of the actual and the fullest expression of the possibles. . . . Our philosophy prepares the modern mind for the full appreciation of art. For it corrects the traditional supposition that the deliverances of imagination are less real than the findings of inductive science. . . . What would be the meaning of the interplay

of lines and colours if it did not lay bare the drama of the cre-
ator?[137]

He protests against the "signs" which he uses being seen as abstrac-
tions. "As if the signs that I transcribe on a canvas, at the moment
when they correspond to a concrete representation of my mind, were
not profoundly real, and did not belong to the world of reality!"[138]

Masson connected the little world of Paul Klee with the idea of
chamber music, and the notion of sacred art which, drawn from a
mysterious center of life, circles around life like a planet.[139] And to
quote Klee himself: "Where the central organ of all temporal-spatial
movement—be it the head or the heart of creation—rules all func-
tions: who would not live there as an artist? There in the womb of
nature where the secret key to all being is hidden? . . . Our quaking
hearts drive us downwards, deep down to the origin of things."[140]

What could exact science mean to a man who wrote in his diary
(1902) that

> the progression towards a philosophy of life is essentially pro-
> ductive; it grows automatically with the passage of time, and
> frequent usage makes its lines ever clearer. It is more fate than
> will. . . . It is both a great trouble and a great necessity to have
> to begin with the smallest. I want to be as though new-born,
> knowing nothing about Europe, nothing. No knowledge of the
> poets, not to be pulled in any direction, to start at the begin-
> ning so to speak. . . .[141]

And so also the *Expressionists*. Max Beckmann: "I seek the bridge
that leads from the visible to the invisible. . . ."[142] Franz Marc spoke
of his art as a "mystically intimate construction." "Modern artists,"
he said, "have to create through their work symbols for their time
to be laid upon the altar of the coming spiritual religion."[143] Georges
Rouault, in a poem of his *Paysages légendaires*, sings: "Interior light,
deign to illumine me / Let me be drunk with secret harmony."[144] And
Emil Nolde: "The artist does not believe in science. It is but half."[145]
Alexej Jawlenski: "Art is longing for God."[146] And, finally, Oskar Ko-
koschka:

> The present crisis caused by science and technology is destroy-
> ing the old culture. A world of ideas with a universal aspect is
> perishing. We are witnesses of it. These ideas are the opposite

of any analytical process. A long period of desert will come, a long period of sterility. . . . In this period of spiritual drought which is coming, the essential values will survive in spite of all, and then the future will dawn. It will follow the same pattern as the myths.[147]

NOTES

1. Berthold Haendcke, *Entwicklungsgeschichte der Stilarten* (Leipzig, 1913); Ursula Hatje, ed., *The Styles of European Art* (London, 1965); Rolf Parow, *Kunststile: Lexikon der Stilbegriffe;* and Hans E. Pappenheim, *Kunstsprache, Lexikon der Fachsprache von Kunst und Kunsthandel* (Munich, 1957).
2. Thomas Munro, *The Arts and Their Interrelations* (New York, 1949; rev. and enl. ed., Cleveland, 1967).
3. Alexis Carrel, *L'Homme, cet inconnu* (Buenos Aires, 1949); Johan Huizinga, *Im Schatten von Morgen* (Bern-Leipzig, 1936); Henri de Lubac, *Die Tragödie des Humanismus ohne Gott* (Salzburg, 1950); Karl Scheffler, *Der Neue Mensch* (Leipzig, 1932); C. G. Jung, *Gegenwart und Zukunft* (Munich, 1957); Julian Huxley, ed., *The Humanist Frame* (London, 1961).
4. G. W. F. Hegel, *Ästhetik* (Berlin, 1955); Oswald Spengler, "Musik und Plastik," in *Der Untergang des Abendlandes,* 2 vols. (Munich, 1929); P. A. Sorokin, "Contemporary Crisis in the Modern Western Fine Arts," in *The Crisis of Our Age: The Social and Cultural Outlook* (London, 1942), and *Man and Society in Calamity* (New York, 1943); A. J. Toynbee, *A Study of History,* 10 vols. (Oxford, 1935–54), and *A Historian's Approach to Religion* (London, 1956).
5. Karl Jaspers, *Philosophie,* 3 vols. (Berlin-Göttingen-Heidelberg, 1956).
6. Henri Bergson, *L'Evolution créatrice* (Paris, 1908); George Boas, "The Ineffable," in *Wingless Pegasus* (Baltimore, 1950); Martin Heidegger, "Der Ursprung des Kunstwerkes," in *Holzwege* (Frankfurt am Main, 1950); Ernesto Grassi, *Kunst und Mythos* (Hamburg, 1957).
7. Leo Frobenius, *Paideuma: Umrisse einer Kultur- und Seelenlehre* (Munich, 1921); Karl Joël, *Wandlungen der Weltanschauung* (Tübingen, 1928); Leopold Ziegler, *Das Wesen der Kultur* (Leipzig, 1903); Wilhelm Dilthey, *Gesammelte Schriften,* Vol. 2: *Weltanschauung und Analyse des Menschen seit Renaissance und Reformation* (Stuttgart-Göttingen, 1957); Fritz

Knapp, *Die künstlerische Kultur des Abendlandes*, 3 vols. (Bonn-Leipzig, 1923); André Malraux, *Les Voix du silence* (Paris, 1951).

8. E. A. Burtt, *The Metaphysical Foundations of Modern Physical Science* (New York, 1955); John Rowland, *Mysteries of Science: A Study of the Limitations of the Scientific Method* (London, 1955); Jacques Maritain, *The Degrees of Knowledge* (London, 1959); Max Born, "Physics and Metaphysics," in *Science News*, Vol. 17 (1950), pp. 9–27; Jaspers, "Philosophie und Wissenschaft, 1948," in *Rechenschaft und Aufsätze* (Munich, 1951).

9. *Physics and Philosophy* (Cambridge, 1942). See also A. N. Whitehead, *Science and the Modern World* (Cambridge, 1945); A. S. Eddington, *Science and the Unseen World* (London, 1949); Ewald Wasmuth, *Kritik des Mechanisierten Weltbildes* (Hellerau, 1929); L. S. Stebbing, *Philosophy and the Physicist* (Harmondsworth, 1944); Erwin Schrödinger, *Science and Humanism* (Cambridge, 1951); Werner Heisenberg, *Das Naturbild der heutigen Physik* (Hamburg, 1955).

10. René Huyghe, *La Peinture française: Les Contemporains* (Paris, 1949).

11. Jaspers, *Die geistige Situation der Zeit* (Berlin-Leipzig, 1931), and *Vom Ursprung und Ziel der Geschichte* (Munich, 1950); Hugo Dingler, *Der Zusammenbruch der Wissenschaft und der Primat der Philosophie*, Part 2: *Gegenwart und Zukunft* (Munich, 1931); Jung, "Das Seelenproblem des modernen Menschen," in *Seelenprobleme der Gegenwart* (Zurich, 1931); Jacques Maritain, *Science and Wisdom* (London, 1944); Jung, *Aufsätze zur Zeitgeschichte* (Zurich, 1946); Jung, "Die Bedeutung der Psychologie für die Gegenwart," "*Ulysses*," and "Picasso," in *Wirklichkeit der Seele* (Zurich, 1947).

12. Lionello Venturi, *History of Art Criticism* (New York, 1936); Munro, *The Arts and Their Interrelations*; O. Bird, *The Seven Liberal Arts* (New York, 1943); G. G. Coulton, *Medieval Panorama: The English Scene from Conquest to Reformation* (Cambridge, 1938); Katharine Gilbert and Helmut Kühn, *A History of Aesthetics* (London, 1957).

13. Alois Riegl, *Stilfragen: Grundlegungen zu einer Geschichte der Ornamentik* (Berlin, 1923); Wilhelm Waetzold, *Deutsche Kunsthistoriker*, 2 vols. (Leipzig, 1921–24); François Lehel, *Fortschreitende Entwicklung. Versuch einer reinen Kunstmorphologie* (Munich, 1929).

14. The miniaturists Oderisi and Franco; quoted in Coulton, *Medieval Panorama*.

15. Albert Dresdner, "Das Altertum und die Kunstkritik," in *Die Kunstkritik: Ihre Geschichte und Theorie*, Vol. 1 (Munich, 1915); Julius Walter, *Die Geschichte der Ästhetik im Altertum* (Leipzig, 1893).

16. *Caius Plinius Secundus, Histoire de la peinture ancienne, extraite de l'histoire naturelle de Pline*, Book 35, ed. D. Durand (London, 1725); *The Elder Pliny's Chapters on the History of Art*, trans. K. J. Blake (London, 1896).

17. *Il Libro del Cortegiano* (Venice, 1528).

18. Friedrich Ueberweg, *Grundriss der Geschichte der Philosophie des Alterums*, 3 vols. (Berlin, 1867), 1: *Grundriss der Geschichte der Philosophie von Thales bis auf die Gegenwart;* Rudolph Eisler, *Wörterbuch der Philosophischen Begriffe*, 3 vols. (Berlin, 1927–29); Dresdner, *Die Kunstkritik;* Venturi, *History of Art Criticism*.

19. Anthony Blunt, *Artistic Theory in Italy, 1450–1600* (Oxford, 1956); E. Gilmore Holt, *Literary Sources of Art History* (Princeton, 1947).

20. F. A. Yates, *The French Academies of the Sixteenth Century* (London, 1947), Chap. 12; Nicholaus Pevsner, *Academies of Art, Past and Present* (Cambridge, 1940); Munro, *The Arts and Their Interrelations;* Dresdner, *Die Kunstkritik*.

21. Giorgio Vasari, *Le vite de piu eccellenti . . .* (Florence, 1911–16).

22. J. P. Hodin, "The Soviet Attitude to Art," *Contemporary Review* (London), No. 1050 (1953), pp. 346–50.

23. *A New English Dictionary on Historical Principles*, ed. James A. N. Murray (Oxford, 1908).

24. Gaston Diehl, ed., *Les Problèmes de la peinture* (Paris, 1945); Amedée Ozenfant, *Foundations of Modern Art*, Part 1: *The Balance Sheet* (New York, 1952); Madeleine Rousseau, *Introduction à la connaissance de l'art présent*, Le Musée Vivant, Vol. 39 (Paris, 1953); Bernard Berenson, *Aesthetics and History* (New York, 1955); Lucien Schwob, *Realité de l'art* (Lausanne, 1954); Jean Jacquot, ed., *Visages et perspectives de l'art moderne: Peinture, poésie, musique* (Paris, 1956); Jean Cassou, *Panorama des arts plastiques contemporains* (Paris, 1960).

25. Munro, *The Arts and Their Interrelations*.

26. *Philosophie der Kunst*, Gesamtausgabe der Werke Schellings, Vol. 5 (Stuttgart-Augsburg, 1856–61).

27. Hans Tietze, "Auffassung," in *Die Methode der Kunstgeschichte* (Leipzig, 1913); Boas, "The Mona Lisa in the History of Taste," in *Wingless Pegasus*.

28. Hegel, *Ästhetik*.

29. Jaspers, "Philosophie und Kunst," and "Kunst als Sprache aus dem Lesen der Chiffreschrift," in *Philosophie*.
30. Jaspers, *Lionardo als Philosoph* (Bern, 1953).
31. *Konrad Fiedlers Schriften über Kunst*, Vol. 2: *Über die Beurteilung von Werken der bildenden Kunst* (Munich, 1912–14).
32. *Les Cathédrales de France* (Paris, 1914).
33. Lecture given by Beckmann in London, 1938, quoted in Walter Hess, *Dokumente zum Verständnis der modernen Malerei* (Hamburg, 1956). See also B. Reifenberg and W. Hausenstein, *Max Beckmann* (Munich, 1949).
34. Charles Baudelaire, "Salon de 1859," in *Curiosités esthétiques* (Lausanne, 1956); J. K. Huysmans, *L'Art moderne* (Paris, 1883).
35. Ozenfant, *Foundations of Modern Art*; Malraux, *Les Voix du silence*; Charles Biederman, *Art as the Evolution of Visual Knowledge* (Red Wing, Minn., 1948); Rousseau, *Introduction à la connaissance de l'art présent*.
36. "Historische Tatsachen," in *Die Malerei im XIX. Jahrhundert*, Vol. 1 (Berlin, 1920).
37. *Histoire de l'art*, 5 vols. (Paris, 1922–27), Vol. 4: *L'Art moderne*.
38. Richard Muther, *Geschichte der Malerei*, 3 vols. (Berlin, 1926), Vol. 3: *18. und 19. Jahrhundert*; André Michel, *Sur la peinture française au XIXe siècle* (Paris, 1928).
39. *Die künstlerische Kultur des Abendlandes*, Vol. 3: *Die Malerische Problematik der Moderne: Vom Klassizismus zum Expressionismus* (Bonn and Leipzig, 1923).
40. Max Deri, ed., *Naturalismus, Idealismus, Expressionismus* (Leipzig, 1922).
41. *Einführung in die moderne Kunst* (Berlin, 1917).
42. *Modern Painters* (New York, 1947).
43. Jung, *Psychologische Typen* (Zurich, 1946); also *Psychologische Abhandlungen*, Vol. 6: *Symbolik des Geistes* (Zurich, 1953); Vols. 10–12: *Mysterium Coniunctionis* (Zurich, 1955–57).
44. *Histoire de l'art: L'Esprit des formes* (Paris, 1949).
45. Florent Fels, *L'art vivant*, Vol. 1: *De 1900 à nos jours* (Geneva, 1950); Vol. 2: *De 1900 à nos jours, 1914–1950* (Geneva, 1956); Werner Haftmann, *Malerei im 20. Jahrhundert* (Munich, 1954–55); Georges Pernoud, director, *Les Clés de l'art moderne*, in *Les Guides du monde moderne*, La Table Ronde (Paris, 1955).
46. Jaspers, *Vom Ursprung und Ziel der Geschichte*, Part 2; Ozenfant and Jeanneret, "Formation de l'optique moderne," in *La Peinture moderne* (Paris, 1925); Pierre Francastel, *Art et tech-*

nique au XIXe siècle (Paris, 1956); Herbert Read, *Art and Industry* (New York, 1954).

47. (Stuttgart, 1956).
48. (Paris, 1955).
49. *Die Künste im Technischen Zeitalter: Gestalt und Gedanke*, No. 3 (Munich, 1954); P. Mayer, "Die Kunst im Zeitalter der Technik," in *Europäische Kunstgeschichte*, Vol. 2 (Zurich, 1947–48).
50. Maurice Raynal, "The Legacy of Courbet," in *History of Modern Painting*, Vol. 1 (Geneva, 1949–50).
51. R. H. Wilenski, *Modern French Painters* (London, 1954).
52. G. Di Lazzaro, *Painting in France, 1895–1949* (London, 1949); Venturi, *Paul Cézanne*, 2 vols. (Paris, 1936).
53. *Les Étapes de la peinture française contemporaine*, 3 vols. (Paris, 1943–46).
54. Jeans, *The New Background of Science* (Cambridge, 1934); S. F. Mason, *A History of the Sciences* (London, 1953), Part 6: *Twentieth-Century Science*; W. Heisenberg, "Recent Changes in the Foundations of Exact Science," in *Problems of Nuclear Science* (London, 1952); W. Heisenberg, *Das Naturbild der heutigen Physik* (Hamburg, 1955); Brewster Ghiselin, ed., *The Creative Process: A Symposium* (Berkeley and Los Angeles, 1952).
55. *La Peinture aux XIXe et XXe siècles: Du réalisme à nos jours* (Paris, 1928).
56. "The Legacy of Courbet," op. cit.
57. Julius Meier-Graefe, "Manet und sein Kreis," in *Entwicklungsgeschichte der Modernen Kunst*, Vol. 1 (Stuttgart, 1913).
58. J. P. Hodin, "The Painter's Handwriting in Modern French Art," in *The Journal of Aesthetics and Art Criticism* (Cleveland), Vol. 7, No. 3, pp. 181–99; V. Volavka, *Painting and the Painter's Brush-Work* (Prague, 1954). See also H. Ruhemann and E. M. Kemp, *The Artist at Work* (London, 1951).
59. *The Story of Modern Art* (New York, 1941).
60. *Die Kunst des 19. und 20. Jahrhunderts* (Potsdam, 1924).
61. (Paris, 1951).
62. *Entwicklungsgeschichte*.
63. Malraux, *Saturne* (Paris, 1950).
64. Ludwig Goldscheider, *Towards Modern Art, or: King Solomon's Picture Book* (London, 1951).
65. Oswald Spengler, *Der Untergang des Abendlandes*; Giambattista Vico, *Opere*, 6 vols. (Milan, 1853).
66. J. P. Hodin, "The Museum and Modern Art," Section 3: "Art and Education," *Art News and Review* (London), Vol. 8, No. 17 (1956), p. 10. See also "The Museum and Modern Art" in Appendix A in this volume.

67. *Das Wesen der Kultur.*

68. Johan Huizinga, "Die heutige Kulturkrise verglichen mit früheren," in *Im Schatten von Morgen: Eine Diagnose des kulturellen Leidens unserer Zeit,* and "Der Mensch und die Kultur," in *Parerga* (Basel, 1945).

69. Christian E. Gauss, "The Realism of Courbet," in *The Aesthetic Theories of French Artists* (Baltimore, 1949).

70. A definition of Realism is given by Jean Leymarie in *Dictionnaire de la peinture moderne* (Paris, 1954).

71. *Les Étapes de la peinture française contemporaire,* Vol 1.

72. Huyghe, *La Peinture française.*

73. *Art Now: An Introduction to the Theory of Modern Painting and Sculpture* (London, 1933; new ed., 1960).

74. *Pittura Contemporanea* (Milan, 1946).

75. Huyghe, *La Peinture française.*

76. Alfred H. Barr, Jr., *Cubism and Abstract Art* (New York, 1936); Marcel Brion, *Art abstrait* (Paris, 1956); Michel Seuphor, *A Dictionary of Abstract Painting* (London, 1958).

77. J. P. Hodin, "Marc Chagall in Search of the Primary Sources of Inspiration," in *The Dilemma of Being Modern* (London, 1956).

78. Carl Einstein, *Die Kunst des 20. Jahrhunderts,* Propyläen-Kunstgeschichte, Vol. 16 (Berlin, 1926); Kröller-Müller, *Die Entwicklung der Modernen Malerei* (Leipzig, 1925); Wilenski, *Modern French Painters;* Meier-Graefe, *Entwicklungsgeschichte.*

79. *Modern Painters.*

80. *Histoire de l'art contemporain* (Paris, 1938).

81. *La Peinture française du XXiéme siècle* (Paris, 1937).

82. Malraux, *Les Voix du silence.*

83. *Les Étapes de la peinture française contemporaine.*

84. *Art Now: An Introduction to the Theory of Modern Painting and Sculpture* (London, 1961).

85. *Pittura Contemporanea.*

86. *Painting and Painters: How to Look at a Picture* (New York and London, 1946).

87. *Modern French Painters.*

88. Hodin, "Une Rencontre avec Marc Chagall," *Les Arts Plastiques* (Brussels), No. 2 (1950), pp. 123–30.

89. *L'Histoire de l'art contemporaine* (Paris, 1938).

90. J. Cassou, B. Dorival, and G. Homolle, Catalogue-Guide, Musée National d'Art Moderne, Paris, 1947.

91. Barr, *Painting and Sculpture in the Museum of Modern Art.*

92. Jaspers, *Vom Ursprung und Ziel der Geschichte* (Munich, 1950).

93. J. R. Oppenheimer, *Science and the Common Understanding* (Oxford, 1954).

94. J. D. Bernal, *Science in History* (London, 1954).
95. Bertrand Russell, *The Impact of Science on Society* (London, 1952).
96. Erwin Schrödinger, *Science and Humanism: Physics in Our Time* (Cambridge, 1951).
97. W. Heisenberg, "Das Naturbild der heutigen Physik," in *Die Künste im technischen Zeitalter* (Munich, 1954).
98. Charles Gauss, *The Aesthetic Theories of French Artists* (Baltimore, 1949); Charles Leger, *Courbet et son temps* (Paris, 1949).
99. Venturi, *Les Archives de l'Impressionisme*, 2 vols. (Paris, 1939); Rewald, *The History of Impressionism* (New York, 1946).
100. Paul Signac, *D'Eugène Delacroix au Neo-Impressionisme* (Paris, 1921).
101. Paul Cézanne, *Correspondence*, ed. J. Rewald, 2 vols. (Paris, 1937); Venturi, *Cézanne* (Paris, 1936); Joachim Gasquet, *Cézanne* (Paris, 1921).
102. Pierre Francastel, *Peinture et société* (Lyons, 1951).
103. Siegfried Giedion, *Space, Time and Architecture* (Cambridge, Mass., 1946); Barr, *Picasso*; P. M. Laporte, "Cubism and Science," in *The Journal of Aesthetics and Art Criticism* (Cleveland), 7 (1949): 243–56.
104. Albert Einstein, *The Meaning of Relativity* (Princeton, 1923).
105. *Les Peintres Cubistes* (Paris, 1950).
106. Albert Gleizes and Jean Metzinger, *Du Cubisme* (Paris, 1912).
107. *Vision in Motion* (Chicago, 1947).
108. Gauss, "Early Cubism," in *Aesthetic Theories of French Artists*.
109. Marinetti, *Le Futurisme* (Paris, 1911), and *Fondazione e Manifesto de Futurismo* (Venice, 1950).
110. Barr, *Cubism and Abstract Art*; Umberto Boccioni, *Pittura, Scultura Futuriste: Dinamismo Plastico* (Milan, 1914), and *Estetica e Arte Futuriste* (Milan, 1946).
111. H. T. Pledge, "Relativity and Cosmology," in *Science Since 1500* (London, 1939).
112. J. J. Sweeney, "Modern Art and Tradition," in *Three Lectures on Modern Art* (New York, 1949).
113. Hugnet, "L'Esprit Dada dans la peinture," in *Cahiers d'Art* (Paris), Nos. 1–2, 6–7, 8–10 (1932); Nos. 1–4 (1934).
114. "Requisites for Social Progress," in *Science and the Modern World* (Cambridge, 1945).
115. "Preface" and "La Reconstruction de l'homme," in *L'Homme, cet inconnu* (Buenos Aires, 1944).
116. *Les Manifestes du Surréalisme*.
117. *Language of Vision* (Chicago, 1944).

118. A. S. Eddington, *Space, Time and Gravitation* (Cambridge, 1920).
119. Louis Danz, *The Psychologist Looks at Art* (London, 1937).
120. J. Ashmore, "The Old and the New in Non-Objective Painting," *Journal of Aesthetics and Art Criticism* (Cleveland), 9 (1951): 294–300; Hodin, "Modern Art and the Philosopher," *Quadrum III* (Brussels), 1957, pp. 5–14.
121. Bertrand Russell, "The Philosophy of Logical Analysis," in *History of Western Philosophy* (London, 1946); G. Ryle et al., *The Revolution in Philosophy* (London, 1956).
122. Ozenfant and Jeanneret, *La Peinture moderne*; Mondrian, *Le Neo-Plasticisme* (Paris, 1920).
123. G. K. L. Morris, Preface to Catalogue, The Museum of Living Art, New York, 1940.
124. John I. H. Baur, *Loren MacIver and I. Rice Pereira* (New York, 1953).
125. Trans. Victor Mottez (Paris, n. d.).
126. *L'Évolution créatrice* (Paris, 1908).
127. Jean de Rotonchamp, *Paul Gauguin, 1848–1903* (Paris, 1925).
128. *The Letters of Vincent van Gogh to His Brother, 1872–1886* (London, 1927).
129. Quoted in Barr, *Matisse, His Art and His Public*.
130. André Mellerio, *Odilon Redon* (Paris, 1923); Odilon Redon, *À soi-même: Notes sur la vie, l'art et les artistes* (Paris, 1922).
131. *Philosophy in a New Key: A Study in the Symbolism of Reason, Rite and Art* (New York, 1951); Ernst Cassirer, *Philosophie der Symbolischen Formen*, 2 vols. (Oxford, 1954).
132. *Ma Vie* (Paris, 1931).
133. Huyghe, "James Ensor," *Les Arts Plastiques* (Brussels), No. 1 (1950), pp. 9–21.
134. Soby, *The Early Chirico* (New York, 1941).
135. *Die Geburt der Tragödie aus dem Geist der Musik* (1872; Leipzig, 1930).
136. Michel Leiris and Georges Limbour, *André Masson and His Universe* (Geneva-Paris-London, 1947).
137. Raymond Queneau, *Joan Miró ou le poète préhistorique* (Geneva-New York, 1941); J. J. Sweeney, *Joan Miró* (New York, 1941).
138. Interview with Miró in *Possibilities: Problems of Contemporary Art* (New York, 1947).
139. André Masson, "Eulogy of Paul Klee," Catalogue Preface, Kurt Valentin (New York, 1950), pp. 1–6.
140. *On Modern Art* [Über die Moderne Kunst] (London, 1948).

141. Klee, *Tagebücher, 1898–1918* (Cologne, 1957).
142. Benno Reifenberg and Wilhelm Hausenstein, *Max Beckmann* (Munich, 1949).
143. Eckart von Sydow, *Die deutsche Expressionistische Kultur und Malerei* (Berlin, 1920).
144. (Paris, 1929).
145. *Briefe aus den Jahren 1894–1926* (Berlin, 1927).
146. "Über die Kunst," in *Das Kunstwerk* (Baden-Baden, 1948), No. 1/2, pp. 51–54.
147. Hodin, "The Expressionists," in *The Dilemma of Being Modern.*

APPENDIXES

APPENDIX A

ART AND SOCIETY

1 • THE SOVIET ATTITUDE TO ART

PROFESSOR VLADIMIR KEMENOV, DIRECTOR OF THE TRETJAKOV GALLERY
in Moscow, corresponding member of the Academy of Arts in the
Soviet Union, and expert on Russian Realist painting, visited Lon-
don in 1952 as a member of a group of Soviet intellectuals on a
goodwill and propaganda tour to the West. It was organized as a
feature of the peace campaign. He gave a firsthand account of the
intrinsic meaning of Social Realism in the Soviet Union of today.
This statement reflects the official Soviet view on art problems, par-
ticularly on the relation of art to society, and of form to content.

In the following study, which is in two parts, the first part will deal
with the statement itself made by Professor Kemenov in the Institute
of Contemporary Arts in London, written down during the session.
All the terms, definitions, and notions to which a critical attitude will
be taken up in the second part of the study are printed in italics.
The second part will analyze the statement and outline the discus-
sion which followed it. It will also make clear how the West interprets
the freedom of creation and the problem of contemporary creative-
ness.

PROFESSOR VLADIMIR KEMENOV'S STATEMENT
ON ART AND SOVIET SOCIETY

The meeting was arranged at the request of the Society for Cul-
tural Relations with the Soviet Union and took place in a hall in which
at that time a retrospective exhibition of drawings by Picasso was
being held. The fact that Picasso, who after the war joined the Com-

munist party, produces an art so diametrically opposed to the principles of the official Soviet art added spice and interest to the meeting. Professor Kemenov's statement began with a description of the conditions under which artists live and work in the Soviet Union today. Professor Kemenov made it clear that this question had two sides. The one was aesthetic, namely, the relationship of form and content in the work of art; the other was social—the material well-being of the artist, his position in Soviet society, the conditions under which he works, and the possibilities of work. The question of the conditions and the organization of the artist's work in Soviet Russia has, however, a close connection with *questions of principle,* remarked Professor Kemenov.

"A brief account of Soviet aesthetics at the present time reads as follows: The basic principle is the principle of *Realism.* This principle of Realism is not worked out by a few artists or critics, it is worked out by *us* of the Soviet Union on the basis of our knowledge of *world art history,* of the history of Russian painting, and on *our understanding of it.*

"Art's first duty, we believe, is truthfully to depict life. In the famous scene in which Hamlet encounters the actors, Shakespeare says of playing that its end 'both at the first and now, was and is, to hold as 'twere, the mirror up to nature, to show virtue her own feature, scorn her own image, and the very age and body of the time his form and pressure.'

"In holding up this mirror to nature, the actor reflects accurately all the qualities of his age. This statement seems to me to have a direct connection with other forms of art. You will certainly find many quotations of all ages, proclaiming that the aim of art is truthfully to depict *reality in its entirety.* We in the Soviet Union feel that those artists and critics who do not take notice of this development, who are hostile to it are *hostile to a truthful depiction of reality.* The question naturally arises: What is a truthful picture of reality? *Every person might perhaps find something different to be truthful. We however regard such a view as incorrect.* It is solipsism. We reject it. In trying to reveal the inner reality in such a way, the artist would never take into account how other people see it. According to our conviction it is quite impossible for an artist not to take into account the feelings, the knowledge, the ideas of the *people* around him. An endless number of examples can be given of how artists have not only expressed their own inner feelings but the people's. Some English examples: Shakespeare, Robert Burns. Some Russian: Pushkin, Leo Tolstoi. They

have all truthfully depicted society. In the work of the artist the task is not only to reflect what is around him. The work must be *creative*. The people itself is creative. It creates images and metaphors. It sings, it shapes ornaments, it has a tremendous contribution to make. And here we approach an important principle. *The great artist takes his inspiration from the people and works it out in finer, higher forms.* We regard those painters who take no notice of the people as being incorrect in their approach. They are not *doing their work, which is to raise the creative opportunities of the people.*

"All this leads us to two conclusions in the conception of our art: its *Realism* and its *popularity*, that is, the quality derived from the people. Realism is the foundation of all true art throughout the ages, and not just the basis of one style like Naturalism, Romanticism, or Expressionism. The problem for the art historian is to understand Realism and the place it holds in the history of art. It is possible to find the realist kernel in a Romantic or Expressionistic work of art. Now let us approach a third aspect. We call it *Humanism*. [Professor Kemenov avoided any reference here to Communism or Socialism.] It is primitive and incorrect to regard the people as being a grey, shapeless mass. The collectivity is made up of *individuals*. It makes the growth of the individual possible within the framework of the whole. In different periods of history the development of the individual took on a different shape. Sometimes it was rich, in other periods it occurred in much more narrow limits. *The artists were also limited.* Our Soviet artists realize that the most important field of development is the development of the individual, of his many-sided possibilities. *Man is the highest living being in nature.*

"The next aspect we wish to approach is the *national* form of the work of art. The people who look at paintings experience them in a visual way. What the artist represents are not abstract forms. They are concrete. They have developed in their concrete form through circumstances. In other countries they attain a different form. We speak of the national characteristics of any people and say that each people has its own national characteristics. *The artist has to accept them whether he likes it or not.* [There has never been a doubt whether an artist likes to accept his own people or not. What is here implied is the identification of the Russian people with Bolshevism and the acceptance of the latter.] The question of national form arises from the realistic approach and from that of the people. The people form the nation. The Soviet artists and writers regard it therefore as a weakening of their creative possibilities if they *take no account of*

*the national characteristics of the nation's individuals. We reject the
cosmopolitan attitude.* [The Russian foreign propaganda still works
on an international scale in the cosmopolitan sense of Karl Marx's
idea of internationalism, whereas the ideology inside the Soviet Union
has changed into nationalism supporting imperialist aims.]"

THE IDEA CONTENT OF ART

"After having cleared this ground we are able to approach the
problem of the *content of art. If it does not exist, there is not much
left for us to ponder about.* [This is of course a fundamental mistake.
As if abstract art did not represent an idea content.] We in the Soviet
Union regard the form given by the artist to his work as reflecting
his attitude to the world about him. The particular form, the techni-
calities are not technicalities only. They are reflections of the society
in which the artist lives. The artist may like it, he may mock at it
and criticize it, or he has a third viewpoint left: *The reality about
me does not interest me in the least.* [How painful for the doctri-
naires, if the Russian artist would dare not to be interested in what
they are prescribing for him. There are in Russia, we know, many
artists creating out of the primary urge to create, shunning only the
Communist daylight and waiting for a better future.] No matter
what attitude the artist takes up it will certainly be an attitude in-
fluenced by the world around him, whatever this world means to
him personally.

"Everyday life, ordinary reality, offers many sides, many complexi-
ties, many contradictions. New forces begin to grow, old forces begin
to decay. [An exclusive, stereotyped conception of a living process!]
If you take into account the *great classical masters* you realize where
they feel joy and satisfaction and where they are bitter and critical.
Therefore: Art cannot be without idea content. We are either realis-
tic or we behave like an ostrich who hides his head in the sand, deny-
ing, so to speak, the truthfulness of life. [Here realistic means Com-
munist. Soviet criticism has taken up the position of Western Europe
in the second half of the nineteenth century, with Courbet and Zola
as their ideals. How sterile the official Soviet attitude toward art is
can be appreciated in Professor G. C. Argan's study "The Russian
Avant-Garde."][1]

"The idea content can help to advance realist art, it can help the
striving of the people, or it can do the opposite: it can be anti-popu-
lar, against the people's movement. The idea content is a problem
for the humanist artist: whether to raise to a *higher* level the human-

ist feeling of the people, or to further the zoological, the animal, the low instincts, the mechanical instincts of man and debase him. [Again the stereotyped, scholastic Hegelian way of thinking, as if of all the possibilities only two extreme opposites existed!]

"Art plays an active, creative role in society. It can help to develop the people or it can lower its cultural standard. Our artists further the cultural development of the people. The relationship between the artist and our people is extremely close. Art is part of everyday life. Our artists act as teachers, as authorities; they are chosen for the highest administrative posts. Our artists, being closely linked with the people, have a tremendous sense of responsibility—to the people.

"You will ask: what about the freedom of creative work? In our art freedom does not exist in an abstract sense. In fact there is no country in which the artist is not dependent on anyone. No artist can live entirely on his own, for his own sake. [Just to give a few examples showing how narrow this concept is: Did not Rembrandt create the masterpieces of his later period entirely on his own, against the expressed public opinion of those around him? And was van Gogh's position a different one? Think of the tremendous difficulties modern art, beginning with Impressionism, met with at first. Now an Impressionist picture is considered to be "classic."] Even Robinson Crusoe got tired of living on his own. When Friday turned up, he learned how to grow potatoes and wheat. No exhibitions would be possible if nobody came to see them. We therefore reject this abstract conception of an artist being able to live like a Robinson Crusoe on an uninhabited island of art. [*L'art pour l'art.*]

"*The role of the artist in society is to help man to develop, to raise his standard and to seek the truth.* From our standpoint freedom means working creatively within that conception."

The Freedom of the Artist

"Are there any artists in the world who are in a position to create in complete freedom at the sole bidding of their own inspiration? [This whole discussion seems to defend rather the chains of freedom than the freedom of the artist.] Or isn't it precisely their claim that they are seeking the truth, and interpreting the people? [Which party, which state power will ever be able to prevent man from seeking the truth?]

"What were the conditions of the artists in *Tsarist Russia?* They had to take into account the caprices of the Tsar and of those who

were going to buy and to resell—the patrons and the art dealers. *It would be incorrect to say that then the artist had the freedom to work creatively.* [He had the freedom to starve for his creative ideas, if necessary, but he did not need to give up his ideas. In the Russia of today it is a question of life and death not to take into account the power of the party bosses.] *Such conditions, however, do exist for our artists.*

"To give you one example. There is the new university building in Moscow, where a tremendous work is demanded from the artists. It is thirty-two stories high, with many sections and about three hundred laboratories. The garden alone is a vast enterprise. Sculptures, portraits of famous men of science, all kinds and forms of art are required. The artists are embarking on it in the usual way, that is, through competitions. They are completely free to decide what work, what motif within the framework of the whole they want to choose. It may be a sculptural group or a bust, a theme from the distant past or from the present day, anything that goes to show the total history involved. The artist can say: I demand the right of freedom of creation. And he will have it. [Here the fact is suppressed that the artist's work has to be naturalistic and popular, or following the trend of idealizing in the sense of hero worship.]

"Another example: There are seven huge hydroelectric stations being erected now. New inland seas have been created for this purpose, some seven hundred kilometers long and forty kilometers across. It is not only an engineering work. Vera Muchina, our great sculptor who has accomplished the famous Gorkij monument, defined the sculptor's work and its challenge as the problem of how to form monumental sculpture appropriate for the adornment and expression of these vast enterprises, and how to use new materials. You would appreciate only the vastness of these projects. [Materialism means always quantity instead of quality. Taste is outnumbered, style is banalized.] You will find other artists who simply do not like the monumental, the mighty. I like, they say, the intimate, the personal, the familiar—a portrait of my wife, my son, a good book cover. They are not forced to do anything they do not like. Is this not freedom of creation?

"In addition to this, all museums organize art exhibitions which are very popular and crowded, especially on the national holidays. There are all kinds of works of art to be seen—those depicting the past of our country or contemporary aspects. [Realist genre, or historical-literary painting. But the Moscow Museum of Occidental Art,

the former famous Stjukin Collection, is not accessible to the public.] The artist may still say: *I want full freedom of creation.* Such an artist might be asked: Are you quite sure whether you want freedom to create or freedom from creation?"

THE ECONOMIC BASIS OF SOVIET ART

"Is it possible, you may ask, for the artist in the Soviet Union to have his work hung and sold? In Moscow, for example, there are several art salons where artists can exhibit and where everybody can choose and buy according to his pocket. The most mature and valuable paintings are bought by state buying commissions for the museums, art galleries, and for mobile exhibition purposes. But this is not the only possibility for an artist to make his living. Besides the state buying commission and the private individual, works of art can be commissioned, and there is also the artists' cooperative which can buy a painting by a member and show it until another buyer acquires it. In addition to that there is the Union of Creative Soviet Painters, whose members are people with professional standing. A large sum of money is available as an art fund for its purpose.

"There is a rule, for instance, in Soviet law that when a painter has sold a particular work or made a decoration for a theater, the greater part of the sum goes to the artist and a small percentage to the art fund. All unions of creative writers, painters, musicians who form these funds enable the artists to go with their families to homes of creative rest and to sanatoriums, without payment.

"The question will certainly arise how the public money for acquisitions of works of art is allocated. Are there any particular rules which interfere with freedom? Is there a possibility that the level and quality are lowered in some respects? The answer is: the artists are chosen by artists. Such state commissions are *composed of artists of different viewpoints and tastes,* and it is they who decide the standard. During the war the artists went to the front. This effort resulted in memorable works of art. In the postwar period the main theme of art is the reconstruction of the country after the ravages of war. [Both in war and in peace the themes are dictated.] Our "army" of artists moves together with the people. Nobody forces the painter, the sculptor, the musician to go to these places against his own free will. But the artist himself does not want to find a gap between himself and the people about him. And since it is impossible to produce a truthful and realistic work of art without working side by side with

engineers, workers, soldiers, you will find the artist everywhere in public Soviet life. The tasks, problems, subject matters arising from that activity are left to the individual desire of the artist. Every material assistance is given to him, to enable him to fulfill it. And you will appreciate that they have something in common—the artist and the people.

"Recently a good deal of the artist's work has been devoted to the struggle for *peace*. There is, for instance, Vera Muchina's monumental sculptural work: *We Demand Peace*. Marching in the front are a young woman with a dove, a mother with a dead child, a veteran, blind and without a hand. Behind them are the many peoples of the world. Among all the works of Soviet artists you will never find a single attempt to try to develop the idea of war or warlike ideas. [But when the Institute of Contemporary Arts in London made public their international sculpture competition on the theme of "The Unknown Political Prisoner" and Professor Kemenov was asked to represent Soviet Russia on the international jury, neither his acceptance nor his nonacceptance was received.] It is not accidental. This fact reflects truthfully the desire of the Soviet people. In accepting the Stockholm Peace Appeal, the five-powers appeal of China, France, Britain, North America, and Soviet Russia as their own, the part played by the Soviet artist is progressive and advanced."

With this topical political reference Professor Kemenov closed his statement on Soviet art.

HOW WE SEE IT

Let me make a nation's ballads and
I care not who makes its laws.

 —Andrew Fletcher of Saltoun

Nothing in this official statement is more striking than its dryness and academism, typical of the present standard of contemporary Russian criticism. There is a rigid, inelastic doctrine which does not evolve but only marks time, and which has not changed or developed since the Realist theories of St. Simon and Proudhon were enunciated. Russian Realism, represented by Bielinsky and his followers Dobroljubov and Tschernishevsky with an infusion of Plechanow-Marxism, is an endless repetition of the same pattern. Because of this rigidity and the completely unimaginative use made of it (for

art has developed in the hands of the dictatorial state power of the Soviets into a propaganda instrument and a weapon of class warfare) the Russian artist has to fulfill his duty according to the party line or it will be the worse for him. No wonder that the official standard of the plastic arts in contemporary Russia is so low. The Soviets have not been able, however, to kill poetry. We know that there are good poets in Russia. But the pages of the official literary journals are filled with mediocre stuff, and a poet of character and strong personality like Boris Pasternak lived as a persona non grata. He found his own refuge in translating Shakespeare, the publication of his novel *Doctor Zhivago* having been rigorously refused, and died a victim of moral persecution. The arts in which the Russians already excelled in Tsarist times and in which they are still achieving most admirable results are music, the dance, and the theater (the classical Russian ballet, Tchaikovsky, Moussorgsky, Rimski-Korsakov, Shostakovich). In those Tsarist days they also produced novelists of extreme power, a Gogol, a Dostoevski, a Tolstoi, a Goncharov, and playwrights like Chekhov. Nothing in contemporary Russian literature can be compared to their work. Gorki wrote his finest books in Tsarist days; when we compare his prerevolutionary political writings with those that appeared after the revolution we must admit that his later essays are pure propaganda. How different from the letters which he exchanged with Lenin on the subject of the freedom of literature! These show that he knew how to defend the freedom of creation, how he fought against the idea of debasing art to a pure propaganda instrument to be used by the state or the party for its transient needs. He defended the talent, the genius of the individual against being swallowed up by the mammoth of the revolution. He defended the gift of the spirit against the leveling-down tendency in literature, against that mediocrity which always thrives in the brackish water of state organization. He loved the people and freedom; he hated the waste of lives produced by the revolution; and he never advocated the ruthless domination of a nation by the secret and cruel methods of a state police. This brings us to a question which we consider to be fundamental, namely, that of the man of genius and his value as such, his independence of both social freedom and material well-being. We will return to this later.

Now it must be said that all the Russian theories, literary, economic, and political, were imported from the West. None of the ideas which changed this "sixth of the world" into the antithesis of any free humanist ideal grew in Russia itself. All were imported and

grafted on age-old Byzantine conceptions. Out of the idea of the domination by the state of the individual, of religion, and of art there emerged one sinister purpose, which was to ossify or to stifle all living impulses. The modern Soviet police state is a continuation of the old Tsarist police state but is more dangerous, because it is more subtle in its inhuman methods and because it is aided by modern mass organization. Intolerant rules and sterile rigidity are the paradoxical outcome of Hegelian dialectic, of Marxist romantic materialism, and of Byzantine cruelty and conservatism. What Professor Kemenov brought to us with the aim of instructing and converting us is Chernyshevski at his worst, that is, a pedantic repetition of the German materialistic philosophy of Feuerbach applied to art: *Art is a reproduction of reality.* In all its deadliness it was attacked already about 1858 by Turgenev, who said of Chernyshevski: "There is a smell of a corpse arising from him." He wrote in connection with Chernyshevski's "The Aesthetic Attitude of Art Towards Reality": "I had the misfortune to take Chernyshevski's part several times. From now on, however, I shall persecute, attack and destroy him with every permissible and especially impermissible means. I have just read his disgusting essay, this rotten corpse."

Let us now consider these notions which occur so frequently in Bolshevik aesthetics: Realism, Naturalism, the people and the individual, the social integration of the artist and his freedom and well-being.

The philosophic and scientific basis of the Communist world view corresponds with a mechanistic-materialistic interpretation of life which culminated in the Victorian Age. The Russian viewpoint is atheistic and pragmatic, it is a-metaphysical and it is socialist. The one thing that matters is not the relationship of the individual to creation, to the world, but his relationship to society *only.* Toward nature his attitude is one of ruthless exploitation. In this attitude Russia is a latecomer and the heir of a world view which brought about in the West a spiritual crisis of formidable proportions, but one which is now already on the way to being solved by the efforts of three generations of philosophers, artists, writers, and scientists.[2] Modern physical science has adopted a working hypothesis in which material is nonexistent, in which the uncertainty principle (Werner Heisenberg), relativity (Albert Einstein), the idea of complementarity (Max Born) are prominent features. It furthers a reconciliation of the wisdom of the East with that of the West[3] and renders impossible the return of metaphysical notions to science.[4] Thus the whole atomistic world view is dissolved into a series of equations

with unknown entities. The development of mankind is approached from the morphological aspect, and there are signs of a transition to a new ideational culture, after an epoch of sensate culture which lasted for six centuries.[5] All this is indicative of strong spiritual tendencies in the West leading anew to the reintegration of the individual to the whole, to the development of philosophy toward a new metaphysics going beyond the classical conception of metaphysics and dealing with the basic problems of Being (Martin Heidegger), and to the development of contemporary Western art toward a new cosmic myth. The essence of Albert Schweitzer's teaching, for instance, is the reverence for life; the value of the individual in the Greek and Christian conceptions is the root of European culture and is acknowledged as the main goal of free society.[6] All this not only stands in opposition to the Russian conception but shows how far behind its time Russian spiritual life has fallen with its dialectic materialism, its Social Realism, and its falsification of humanism based, as it were, on Professor Pavlov's experiments in the conditioned reflex. Such "social" experiments are applied in Russia unscrupulously to society, thus debasing human nature and its spiritual aspirations to the level of animal behavior. I do not say that similar dangerous tendencies were not apparent also in the West, but they were not represented by the best minds and, what is most important, they were not proclaimed as an official doctrine which could be enforced by a state machine.[7]

It is in the West that the most vital and valuable development has taken place, and where a new culture is being developed which might solve the spiritual crisis of mankind—a crisis due not to Bolshevik revolution but to the violent development of science and technology during the last hundred and fifty years. Only a generation that can bring to an end the tragic conflict between the world of science based on the laws of logic and mathematics and that world of metaphysics whose fundamental postulates are in accord with our deepest feelings will be able to resolve our present dilemma.

Is it not a significant fact that the most outstanding Russian artists and thinkers of our time have fled from Russia and its peculiar conception of freedom and art? Berdyaev, Stravinsky, Chagall, Gabo, Nijinsky, Kandinsky are the best-known instances in this case. Igor Stravinsky changed the face of contemporary music; his impact on his art is comparable to that of Picasso on painting. He was able to produce his art unmolested by antiquated and historically untenable theories of popular art and was not penalized for having presented

freely his views on the subject in his lectures at Harvard on the
"Poetics of Music." There, in the lecture on "The Avatars of Rus-
sian Music," is contained probably the most authentic criticism of
all this state-sponsored nonsense about popular art and the freedom
of creation in Soviet Russia, which in its sum total amounts to the
dominance of the untalented and mediocre party member and the
most severe governmental censorship of thought and work.

Rationalism and its pseudocritical spirit, said Stravinsky, "have
poisoned and continue to poison the whole field of art in Russia,
with the famous arguments over the meaning of art, and of what is
art and what is its mission." He reminds us of the Russian discussion
that was taken so seriously around the 1860's: "Which is the more
important, Shakespeare or a pair of boots?" Even Tolstoi in his aes-
thetic speculations wandered off into the impasse of morality and its
categorical imperative. Finally, the Marxist theory that maintains
that art is only a superstructure based on the conditions of produc-
tion has had as a consequence that art in Russia is nothing more
than an instrument of political propaganda at the service of the Com-
munist party and the government. "This corruption of the Russian
critical spirit is the cause of the fact that the 'reasoning' intelligent-
sia seeks to assign a role to music and to attribute to it a meaning
totally foreign to its true mission, a meaning from which music, as
all the other arts, is in truth very far removed." It is this failure to
comprehend the genesis of any kind of creation which has led to de-
plorable consequences and made Stravinsky say that the Commu-
nists are lacking in any authentic form of expression.

About the freedom of expression in Russia he has no illusions. One
can only remain inside the general concept accepted or step outside
it. For those who are held inside the circle, every question, every
answer is determined in advance. The order of the day for all the
arts is Social Realism, with all its fallacies of popularity and its forced
obeisance to the party line, called freedom. Here a Russian art critic
may be quoted to illustrate the idea of creativeness: "It is high time
that we abandoned the distinction—entirely feudal, bourgeois, and
pretentious—between folk music and artistic music. As if the quality
of being aesthetic were only the privilege of the individual inven-
tion and personal creation of the composer." Musical ethnography
and interest in popular folklore are emphasized, at the expense of
the creative musician. (What is popular music, the great Norwegian
writer Knut Hamsun once asked. And he answered: the mouth or-
gan.) Here, as a further example, may follow how the Russian au-

thor Aleksei Tolstoi superimposes on the music of Shostakovich's Fifth Symphony the whole Soviet propaganda terminology:

> Music must present the consummate formulation of the psychological tribulations of mankind. It should accumulate man's energy. Here we have the *Symphony of Socialism*. It begins with the *Largo* of the masses working underground, and an *accelerando* corresponds to the subway system; the *Allegro* in its turn symbolizes gigantic factory machinery and its victory over nature. The *Adagio* represents the synthesis of Soviet culture, science, and art. The *Scherzo* reflects the athletic life of the happy inhabitants of the Union. As for the *Finale*, it is the image of the gratitude and the enthusiasms of the masses.

Stravinsky calls this description "in its line a consummate masterpiece of bad taste, mental infirmity, and complete disorientation in the recognition of the fundamental values of life. Nor is it any the less the result, if not the consequence, of a stupid concept. To see clearly, one would have to free one's self from it."[8]

The tragic fate of the poet Vladimir Mayakovski, the Russian Futurist, has some bearing on our problem. His suicide in 1930 profoundly disturbed the most orthodox Communists. This suicide provoked protest, indignation, and in fact an insurrection in his name. The persecution of Mayakovski by party bosses began several years before his death and finally was directly responsible for it. The accusations against him were founded on the disapproval of all leftist tendencies in art and literature. It is known that the more cultivated Bolsheviks such as Trotsky and Lunacharski understood and supported the artists of the avant-garde, but Lenin with his comprehension of the practical needs of the revolutionized country found no pleasure in them. He was against the arts with the same rigidity as the Plato of the *Republic* and the *Laws* was against the arts. He defined the revolutionary art and literature of the 1920's as "the infantile disorder of Leftism," and thought that the cinema was more useful to the young Soviet state. In 1921 came the new economic policy, the era of reconstruction and practical materialism. The attitude of toleration toward leftism turned to impatience.[9] When Stalin's personal intervention was demanded, and he proclaimed: "Mayakovski is the greatest and best poet of the Soviet epoch," it was too late.

Although the political climate of Russia encouraged the efforts of outstanding film-makers, especially in the Pudovkin and Eisenstein era,

even there the interference of the state in matters of style and subject frustrated their creative intentions after the decision was taken that the "hero" had to be reinstated to his lost position. It was Pudovkin's merit to have discovered the unknown representative of the people, the non-actor exponent of the nameless mass. This, however, found favor only with the intellectuals abroad, not with the Russian people themselves, who wanted their heroes back, preferring them to the common representative of themselves.

Everyone interested in matters of art will also remember the scandal provoked in Soviet Russia by Shostakovich's opera *Lady Macbeth of Mzsensk* and his ballet *The Limpid Brook*. The performance of his music was temporarily forbidden, and several times Shostakovich had to repent and to promise to adhere to the party line. How an artist can create at all under such conditions is a mystery.

These examples may be sufficient to make us realize what the dictatorship of the proletariat means for the unusually gifted man. There is no art possible without the unusually gifted man. We prefer freedom of conscience and creative purpose in a society which, although in a transition stage, cherishes the idea of freedom. The artist's well-being in Soviet Russia has to be purchased with the loss of his freedom. The mediocre artist needs no creative decisions or visions; to him the bureaucratic prefabricated prescriptions are sufficient. We believe that human genius has to grow as a plant grows; if it is cultivated in a way alien to its nature it can only be frustrated and spoiled. The young Marx, who was a romantic idealist, and who caused the death of millions of people inasmuch as his later theories and ideas were put into practice in the extremist policy of the Bolsheviks, said about the poets: "We must let them go their own way, we cannot apply to them the same rules as to ordinary people."[10] But the rulers of the Soviet Union are no romantic idealists.

In the Thomas Rutherford Trowbridge lecture on "A Retrospective View of Constructive Art," given by Naum Gabo, the Russian Constructivist artist, at the Yale University Art Gallery in 1948, Gabo said:

> My art is commonly known as the art of Constructivism. Actually, the word Constructivism is a misnomer. It has been appropriated by one group of Russian constructivist artists in the 1920's who demanded that art should liquidate itself. They denied any value to easel painting, to sculpture, in fact to any work of art in which the artist's purpose was to convey ideas

or emotions for their own sake. They demanded from the artist, and particularly from those who were commonly called constructivists, that they should use their talents for construction of material values, namely, in building useful objects, houses, chairs, tables, stoves, etc. Being materialist in their philosophy, and Marxist in their politics, they could not see in a work of art anything else but a pleasurable occupation cherished in a decadent capitalistic society and totally useless, even harmful in the new society of Communism. My friends and myself were strongly opposed to that particular trend of thought. I did not and do not share the opinion that art is just another game or another pleasure to the artist's heart. I believe that art has a specific function to perform in the mental and social structure of human life.

Gabo's notion of reality is diametrically opposed to that of the photographic and ideological Naturalism sponsored officially by the Soviet Union. Art is not propaganda for Gabo, nor a means of educating the people. Art is

the most immediate and most effective means of communication between members of human society. I believe art has a supreme vitality equal only to the supremacy of life itself and that it, therefore, reigns over all man's creations. . . . The scientists have made great strides in their search; certain artists, however, stopped at the gates of our sensual world and by calling it Naturalism they retain the belief that they are reproducing the true reality. Little, it seems to me, do these artists know how shallow their image of reality must appear to the scientific mind of today; to the mind which conveys to us nowadays an image of a reality where there is no difference, no boundary between a grain of sand and a drop of water, a flash of electricity and the fragrance of a tree.

And he adds: "The external world, this higher and absolute reality, supposedly detached from us, may exist or may not—so long as our mind has not constructed a *specific image* about it, it may just as well be considered nonexistent."[11]

Rightly, Professor G. C. Argan argues that

it remains to be explained why the Russia of the astronauts— or was it perhaps that of the bureaucrats loathed by Mayakowski?—should deny that it was ever helped, at the beginning, by

an "aesthetic" impulse, whilst in fact at that very time and in the very same field of aesthetics, she took up and made use of the weapons discarded by her opponents, that is to say, the art of the Western *petite-bourgeoisie* of the early twentieth and late nineteenth centuries.

He speaks of the lack of imagination of the Russian leaders and the whole Russian people, who condemned their avant-garde artists twice: at the height of the revolution and later on when the revolution had become a massive apparatus of party and government bureaucracy (see note 1).

When I visited Marc Chagall in France, he told me among other things:

> Youth is always in need of orientation. It is said that talent is necessary too. But who gave me orientation? There was a picture of the Tsar Ivan the Terrible. One saw the frightened people. The swollen veins, every little hair, every pore were meticulously painted. The Tsar had a tear in his eye. "You will never be a painter," I said to myself. Purely artistic reasons drove me out of Russia before and after the revolution.

He said also:

> Avant-gardism is necessary. Art must keep on renewing itself. I don't think the present-day generation of artists has less talent than we had. But tell me, how does it come about that art degenerates in quality from decade to decade? Almost all children have genius, if only they have a chance to develop. All this seems to be caused by restlessness, by the world situation, by politics. It is a sociological problem more than an artistic one.[12]

The picture of Ivan the Terrible described by Chagall was painted by Ilya Repin, on whose work Professor Kemenov is a great expert. In the discussion following his statement Professor Kemenov told his listeners how millions of the primitive Russian people have passed by the experimental art of Malevich, but before Surikov or Repin they have wept. Their reaction was deep and honest. If the greatness of a work of art had been left in former times to the judgment of the people, the work of Dante or Petrarch, Cervantes or Goethe, Leonardo or Mathias Grünewald, Beethoven or Bruckner would never have been accomplished.

The people! To hear from the mouth of a so-called Realist and dialectic materialist this old romantic story of the people being the source of all culture! People's art, folk art! The idealistic romantic notion of Herder and the young Goethe was rationalized and planted in the soil of the romantic social idealism of the young Marx.[13] But what a difference between the people of the old agricultural society and the industrialized "masses" of today! The social history of art illustrates perfectly that folk art has a meaning only

> in contrast to the art of a ruling class; the art of a mass of people which has not yet divided into ruling and serving classes, high and fastidious and low and modest classes, cannot be described as folk art, for one reason because there is no other kind of art at all. . . . Neolithic art bears the marks of a peasant art . . . but it is by no means at the same time a folk art, like the peasant art of today. . . . The folk epic of romantic literary history originally had no connection at all with the common people. . . .[14]

Folk art has always been the unsophisticated, often vulgarized, replica of fine art and is today in Russia a poor repetition of the great Realist painting and sculpture of the West.

In our attitude to the notion of people, we adhere to the idea of the natural inequality of man. This is in fact acknowledged even by the Russians themselves. In spite of their revolution, which was fought for a classless society, they are shaping a society based on new classes and privileges. We adhere to the most realistic notion of Ortega y Gasset, who in his memorable work *The Revolt of the Masses* says:

> Mass-man has risen up everywhere, a type of mankind built up in a hurry, founded on a handful of poverty-stricken abstractions and thus identical from one end of Europe to another. To him is due the colourless aspect, the suffocating monotony which life has assumed throughout the continent. This mass-man is man emptied of his own history in advance . . . and so, docile to all so-called international disciplines. He has only appetites; he allows himself only rights; he believes himself to be under no obligations.

And, speaking of the creative life, Ortega y Gasset pronounces the fine judgment: "Creative life needs to be governed by a healthy society, it needs *nobility*, and a constant stimulus of one kind or an-

other to excite its sense of dignity."[15] It was in the time of the Renaissance that Giovanni Pico della Mirandola, who made a gigantic effort to unify the classical Greek and Christian views of man, asserted once more the dignity of man, the uniqueness of the individual, the miracle of the soul of man which the Christian faith proclaimed to be immortal.[16] The idea of man in the conception of the Russian state organization is that of a cog in a machine.

The Soviets were not the last ones to advance a state art. Joseph Goebbels in his function as propaganda minister of the Third Reich ordered a certain percentage of the costs of all public buildings to be devoted to their artistic decoration. In the Haus der Deutschen Kunst in Munich Adolf Hitler proclaimed the ideas of that heroic realism which represented for him the only, hence the official, art of the Reich, the rest being *Kulturbolschewismus*. How ironic this nomenclature sounds today! Here we have all the elements of official Russian art as well—state patronage and state dictatorship of form. Small democratic countries like Sweden have solved this problem in a more human way. The Swedish welfare state asked the artists to organize themselves in a trade union, and then the Statens Konstråd (State Arts Council) was set up with the aim of decorating public buildings, public places, etc., leaving the problems of style to the artists themselves. Even more surprising is the public patronage of art exercised through the administration of Norway's small capital, Oslo.

The most astonishing fact, however, is that even these arrangements have not produced any genius; they simply support a great number of more or less talented artists. It is always mediocrity which is fostered by such economic means. The patronage of the outstanding work of art must be left to the connoisseurship of individuals with a deep and genuine understanding. So it was in the Renaissance. It was not ideal for the artist, but from the point of view of the artist's work it was certainly effective. The truth is that Soviet Russia consciously fosters mediocrity against the great artist. But why? Why have anonymous periods in culture produced such outstanding works of art—Gothic, Romanesque, Paleolithic—and why can an organized effort in our time not produce them? This goes to the root of the idea of culture itself, and of genius. Culture and genius, as has already been mentioned, are natural forces growing and maturing like plants or trees, developing and aging and decaying like living organisms. Our time in its spiritual crisis cannot produce a ready-made culture overnight. It can only work for it, so that it may flour-

ish when the time is ripe. A state machine built on an interpretation of social life which ignores its main factor, namely, man's spiritual nature, is the deadliest enemy of culture. A conception of history based upon the belief that in the change of rule from one class to another a major step is taken toward the utopian state is fundamentally mistaken as to the nature of man and of society. The Church and the nobility were generous patrons of art compared with the third estate, the bourgeoisie, which became dominant first in France after the revolution and thereafter in the whole world. The proletarian revolution is a continuation of the French revolution, and this not only in theory and in practice but also in its historic transformations. It has produced the same Bonapartism, the same imperialism, the same reinstitution of classes, the same nationalistic passion. What we are here concerned with in the first place is the lack of taste, grace, and grandeur in the realm of Soviet art. Megalomania is the sign of a misunderstood monumentality. It is not the wealth of an epoch which creates cultural values. It was not the wealth of the Renaissance epoch which created the culture of the Renaissance, although it facilitated it; it was the spiritual movement which was strong enough to convert the economic into cultural values. The spirit of a materialistic and atheistic world view is not and never will be able to achieve that.

As Professor Kemenov insisted so strongly on expounding the question of freedom, thinking no doubt that this might be the main argument directed against him, we must here proclaim that genius has nothing to do with political freedom, at any rate not primarily. Sometimes difficult times create a tension which even furthers genius. Gogol saw the problem in those terms, and he himself lived in a time of great intellectual trials and dangers. Times like his produced also a Dostoevski and a Rabelais. And did not Shakespeare live in an age which is known to have been one of the most autocratic? As has been proved recently, one of the most fascinating works by Hieronymus Bosch depicts the secret code of the Adamites, that is, of the *homines intelligentiae*, that brotherhood which was persecuted and finally exterminated.[17] Hidden behind a strange symbolism we can today admire its message of the overcoming of the Old and the New Testament by a third testament, the testament of the Holy Ghost (*concordia novi ac veteris Testamenti*), with its harmonization of spiritual and sensual values. This message, so near to the glorious Gothic vision of Joachim of Fiore,[18] was the only attempt to harmonize human nature since the times of classical Greece,

and it was killed by the rationalistic and puritan spirit of Protestant-
ism. All this only indicates that genius has little to do either with
well-being or with freedom as such and drives home the point that
it is certainly not with the genius of mankind that the proletarian
revolution is concerned.

Among those who came to listen to Professor Kemenov's statement
were people who seriously wanted to discuss the problems involved.
They were disappointed by the doctrines offered to them, and espe-
cially by the skillful cynicism with which their questions were
answered. We will mention here only a few of the questions, to illus-
trate the methods of Russian aesthetic reasoning, the main aim of
which is to force the most precious life energy of artistic creative-
ness into the Procrustean bed of political utilitarianism at home and
to confuse opinion abroad. The question asked by a well-known
artist was whether Professor Kemenov considered the work hanging
behind him (it was one of Picasso's well-known minotaur motifs, the
study used for the curtain of the Alhambra for Romain Rolland's
play *The Fourteenth of July*) to be a good work of art. Professor
Kemenov tried to escape in a way which might have succeeded with
unschooled minds but not with the trained intellects that were pres-
ent. "I am an ordinary human being," he said, "and I cannot see
what is behind me." But as the dead silence which followed these
words convinced him that he could not get away with this trick he
became somewhat irritated and said that he had not come to discuss
Picasso but to tell us about the Russian concept of art; and, further,
becoming more aware of what the question was aiming at, he found
a way out in saying that it would be unjust to the artist if he gave a
quick judgment on a work of art which he had no time to study.
Every one of the people present realized the proper meaning of the
question: If Russian art is as Professor Kemenov has defined it, then,
knowing that Picasso has publicly proclaimed his adherence to the
Communist party, would you officially acknowledge him in Soviet
Russia as a great artist, or do you just use him as a political tool
abroad while decrying his art at home?

The second speaker brought some illustrative material with him.
His question was: Do you consider this picture of Efanov depicting
Stalin distributing prizes to workers a more important work of art
than Picasso's *Guernica*? This was a question obviously sharpening
the edges of the first inquiry. It implied in fact the following: Picas-
so's *Guernica* is the work of an artist protesting against Fascist ag-
gression and against war in general; as the artist is now a member

of the French Communist party this work ought to be considered great even in Russia. But it cannot be so because it does not fulfill the requirements of the official strait-jacket mentality. The photographic and amateurish painting by Efanov, however, does fulfill them. In his answer Professor Kemenov avoided the main point as in the first case. He started by describing the picture part by part and went on to say that it did not represent what the speaker thought it represented. What really was depicted, Kemenov said, was a number of workers' representatives on a visit to Moscow offering Stalin a gift in the presence of prominent members of the government. By then the audience realized that they were confronted with a jesuitical and sophistical mentality; for the Jesuits proclaimed in their day that the end justified the means, and the Sophists rejected straightforward thought and action in favor of a kind of adroitness and routine, misusing the art of reasoning to present the false and the bad as the good and the true, or, according to Protagoras, to make the weaker thing appear the stronger.[19]

Professor Kemenov, when faced with the reproduction of Efanov's picture, remarked that this question was obviously intended to crush him. The next speaker therefore prefaced his attempt to find out what was the official Russian attitude toward Picasso with the reminder that all these questions were asked in good faith with the sole object of arriving at the truth. The answer was another evasion in the form of an allusion to Picasso's versatility, and it ended with an appreciation of one of Picasso's political gestures: when the struggle against war and for peace started, Picasso linked himself closely with the peace movement. He produced an entirely peaceful little dove (*golubienka*), and in doing so he was convinced that he was acting according to the dictates of his conscience. What was the result? The poster with the dove was forbidden in France, and Picasso was refused a visa to the United States and to England. Professor Kemenov repeated once more the Russian view that the artist has to create works which the ordinary people can understand. "If you do not do that, you cannot have in Russia 'this' freedom of creation." This means also that in Russia Picasso would not be allowed to work as he does. Professor Kemenov's answer sounded like requiring a nuclear physicist to restrict his mathematics to the multiplication table.

The problem of Picasso discussed on this occasion culminated in a question put to Professor Kemenov in Russian by a Russian emigrant. Professor Kemenov's face did not show the slightest change,

a remarkable spectacle! The question was, what was Professor Kemenov's *personal* opinion of the picture by Efanov? The answer was his last evasion—this time into history. He could, he said, remember the part which this picture played when it was painted in 1936. That was sixteen years ago. "Now," he said, "the Soviet people have grown considerably. A most important development has taken place in taste and demands and requirements. What was satisfactory sixteen years ago is now considered not sufficiently good, and therefore we are making much higher demands. . . ." This, however, is not true objectively, as the official exhibitions of art held in the framework of the Venice Biennale prove.

The public was deprived of the pleasure of hearing the direct statement that Efanov's painting is a bad work of art, and that Picasso's minotaur motif is an important work of art and the contribution of a great artist toward the creation of a new myth. Let us turn away now from Professor Kemenov to one of the most remarkable personalities in our time, in both morality and integrity: to Albert Schweitzer, who has contributed to the solution of these burning problems the following modest statement: "Where the collectivity acts more strongly upon the individual than the individual reacts upon it, there decline begins, and that because all the greatness upon which everything depends, and which consists in the spiritual and moral value of the individual, is thereby necessarily undermined."[20] Culture depends upon individual personalities, not upon mass humanity. The contrary conception is one of the fallacies of Socialism, and one of the principal dangers for our culture.

NOTES

1. In *J. P. Hodin, European Critic* (London, 1965).
2. See A. N. Whitehead's *Science and the Modern World*, a book which was described by Herbert Read when it came out in 1926 as "the most important book published in the conjoint realms of science and philosophy since Descartes' *Discourse on Method.*" It defines the revolution which took place in our whole concept of life, and seeks to reinterpret not only the categories of science and philosophy but even those of religion and art.
3. F. S. C. Northrop, *The Meeting of East and West: An Inquiry Concerning World Understanding* (New York, 1946); William S. Haas, *The Destiny of the Mind, East and West* (London, 1956).

See also the reports of the second East-West Philosophers' Conferences, University of Hawaii, 1939 and 1949.
4. E. A. Burtt, *The Metaphysical Foundations of Modern Physical Science* (New York, 1955); Erwin Schrödinger, *Nature and the Greeks* (Cambridge, 1954); Adolph Portmann, *Biologie und Geist* (Zurich, 1956).
5. P. A. Sorokin, *The Crisis of Our Age: The Social and Cultural Outlook* (New York, 1941).
6. Albert Schweitzer, *Verfall und Wiederaufbau der Kultur* (Munich, 1923).
7. Ivan P. Pawlov, *Die höchste Nerventätigkeit der Tiere* (Munich, 1926). See F. J. J. Buytendijk, *Mensch und Tier: Ein Beitrag zur vergleichenden Psychologie* (Hamburg, 1958); M. Abercrombie, C. J. Hickman, and M. L. Johnson, *A Dictionary of Biology* (Penguin Reference Books, 1951).
8. Igor Stravinsky, *Poetics of Music* (Cambridge, Mass., 1947).
9. See Alfred H. Barr, Jr., *Cubism and Abstract Art* (New York, 1936).
10. Karl Marx, *Der Historische Materialismus: Die Frühschriften*, ed. S. Landshut and J. P. Mayer (Leipzig, 1932).
11. *Three Lectures on Modern Art* (New York, 1949).
12. "Marc Chagall in Search of the Primary Sources of Inspiration," in Hodin, *The Dilemma of Being Modern* (London, 1956).
13. J. G. Herder, *Briefe zur Beförderung der Humanität* (Leipzig, n. d.).
14. Arnold Hauser, *The Social History of Art*, 2 vols. (New York, 1951).
15. Ortega y Gasset, *The Revolt of the Masses* (London, 1951).
16. Giovanni Pico della Mirandola (1463–94), *Über die Würde des Menschen* (Leipzig, 1940).
17. Wilhelm Fränger, *The Millennium of Hieronymus Bosch: Outlines of a New Interpretation* (London, 1952).
18. Joachim of Fiore (Floris) (ca. 1150–1202), *Das Reich des Heiligen Geistes* (Munich, 1955).
19. See Wilhelm Nestle, *Die Vorsokratiker* (Jena, 1922).
20. Albert Schweitzer, *Decay and Restoration of Culture* (see n. 6).

2 • ART AND SOCIOLOGY

Marginal Notes on Arnold Hausers's
The Social History of Art[1]

To survey the immense material on the social aspects of all the arts throughout the ages is an ambitious task. To systematize the idea that the history of art makes sense only in relation to the evolution of society introduces a rigid viewpoint into the investigation, which, although it provides it with a unifying principle, also constitutes its main weakness. In *The Social History of Art* Arnold Hauser thinks of necessity in Marxian-Hegelian categories for his particular purpose, and in so doing he has built on the work of German sociologists such as Werner Sombart and Alfred Weber, applying their viewpoints to the realm of the arts.[2]

To state our case briefly let us ask: Why not write a history of art as seen from the viewpoint of analytical psychology? This too would examine the subject from a specialized angle and would certainly produce most surprising results. We only wonder whether it would be considered the most appropriate approach.[3] To emphasize the spiritual quality of art by visualizing its history as the history of an important manifestation of the human mind, as part of the history of culture, as the history of its changing forms and themes, of styles and personalities—would that not be the most direct way? This is what Wilhelm Dilthey did.[4] Perhaps the social and economic aspects of art must be seen as the soil from which art grows. No more. That is how Frederick Antal conceived it.[5] But it will prove as difficult to account for the beauty and the shape of an amaryllis or a honeysuckle by analyzing the earth in which they were planted or studying the climatic conditions in which they thrived as it is to account for the specific merits and qualities of a work of art solely by taking into account the sociological point of view. In art history

298

the first consideration seems to be to understand the works of art, to classify them, sometimes to admire the artists and their aims. But if one is mostly concerned with the existence of the common man and with the political and economic conditions which he creates— and every sociologist is impelled to be so—one inevitably develops an inclination to see in the artist an aberration from the rule. It is one thing to write the history of the common man and another to write the history of those who have particular gifts, a heightened alertness, a sharper conscience, and the rare abilities which make the world sound like music and not like the penetrating noises of a political meeting. The sociological point of view can describe and elucidate many facts from the life of the artist in its connection with the evolution of society, it can explain the production and the distribution of a work of art as a commodity, its uses and functions as far as social elements are contained in it—all secondary matter—but it cannot touch upon the intrinsic qualities of a work of art which often has been created against the will and intention of its surroundings, that is, without their economic help and, above all, without their spiritual support. The fact that there are always people who, seemingly against their own personal interests of well-being, security, and success, produce eminent works of art, often under great suffering and privation, and the undeniable existence of a compact body of indifferent and ignorant people who live, intellectually speaking, the life of insects,[6] people interested only in *panem et circenses* and not in higher values—all this provides the critic with powerful arguments against any "sociology" of art. It is also the critic's function to consider why the interests of the majority of the people—the democratic principle of quantity!—should, as seen from the sociological angle, constitute a greater value than the values created by artists and poets, whose works have proved to have a length of life and fascination far exceeding those of political and economic structures or philosophic systems and comparable only to certain metaphysical and religious notions to which mankind clings in spite of all attacks of reason and practicability.

In an age which has stressed the social and economic at the expense of all other aspects of life, it is not astonishing that *Kunstwissenschaft* should turn into *Kunstsoziologie*. There is no need to elaborate in detail how dependent this kind of sociological research is on dialectic materialistic thinking. The sociologist of art tries to reinterpret artistic phenomena throughout the ages by a method which precludes any possibility of seeing the problems of art in society

from the artists' point of view. He interprets culture only as a super-structure of political and economic facts.

The changes in the intellectual outlook of modern man occur quickly. If it may be said that the social outlook was the only weighty one before the First World War, then it can equally well be affirmed that the intellectual climate changed in the years between the two world wars, owing to the change in the philosophy of science and the outlook of science itself on life. The mechanistic and materialistic world view of the eighteenth century which the nineteenth century evolved through the development of technology turned toward one which is much nearer to the ideas of the old Indian speculative philosophy than to the philosophy of the nineteenth century.[7] To approach the problem of art from a Hegelian point of view is necessarily dated.

Can it possibly be the work of one man to cover the ground of the whole history of art and literature? There is a well-founded distrust in the present-day student for works of an encyclopedic character. This is natural, because in a time of intense specialization both the scope of a work and the personality of the author are of the utmost importance. One finds in the journals of André Gide thoughts on the literary production of practically all times and nations.[8] No one will expect them to be complete, and Gide himself would have found such a task absurd. The special interest which we attach to his ideas lies in the subjective view of a writer whom we consider great. The same is true of the highly dramatic attitude of André Malraux in his *Essais de psychologie de l'art*.[9] This work is neither a psychology nor a history of art, but it is a highly personal expression of views on creativeness written by a fascinating, strong, and integrated personality. It could be claimed that the writing of a sociology of art is also a task for a specialist. This is valid only to a limited extent. One single author can write the social history of a definite style in art which has a great attraction for him; or the sociological point of view can be added, when a certain phase or personality in art is analyzed, to produce a complete picture. This has often been done, especially since the establishment of the theories of the French Realists, according to which the "milieu" had a greater importance for the development of the individual than his hereditary substance or his inherent personality. The concept of the social history of art is in fact nothing else than the adoption of this milieu theory of the Realist novelists in the realm of art history.

Didactic literature can be written in a partisan or in a detached manner, it can be subjective or objective, emotional or scientific. A detached, objective, and scientific scholar will generalize only carefully, and any generalization will be the direct result of detailed research. He will define his method and scope of investigation. The work which we are considering here is of a different character. It is partisan above all. It ends with a sort of politico-ethical program for the future from which we can deduce that the only aim of art for Hauser is the education of the broad masses and the elimination of what he calls the cultural "monopoly" of art. As far as we can learn from the history of art throughout the ages, however, it has never been the masses who have produced, appreciated, or supported great works of art. To be concerned to such an extent, as is Hauser, with the concept of the cultural "monopoly," its economic and social basis, and with the preconditions for the elimination of such a monopoly is a questionable attitude. To continue to insist on it, in spite of having proved, in connection with the world of film, that success with the masses is completely divorced from qualitative criteria, must ultimately lead to wrong ethical and aesthetic conclusions. Although Hauser's trend of thought is obvious and is formulated on different occasions, there is no chapter or statement in his book on the basic conceptions of the social history of art. We did, however, obtain a glimpse of these in a lecture which the author gave in London in 1951. There we found him taking a decisive stand against any "romantic" aesthetics and evincing a genuine hostility toward any approach to the history of the arts which is not tied up with its material basis, a hostility which we may well feel includes *eo ipso* a mistrust of all major aspects of the history of the arts. Can it be right to proclaim that "whether a work of art dies away from sight or maintains itself as living art in subsequent ages is a question of luck and chance rather than of ambition and merit"? What constitutes the quality of a work of art, what makes one work survive and another die? No "sociological" approach can ever define it.

Again, can it be right to emphasize that our response to a work of art and our mental equipment are above all the expression of our social existence and the results of our social behavior? The fact that we are born social beings is of lesser importance for the study of the arts than the manner in which we use our mental equipment. Without the social framework, Hauser proclaims, we are still liable to

relapse into the state of the wild beasts. This sounds unreasonable after all the excesses of the dictatorial state machines, the use of slave labor and the inhuman policy against prisoners of war as it was practiced by the heirs of the basically "romantic" Marxist and National Socialist ideologies.

"There is, in fact, nothing human in us which is not social in its origin and development." For a sociologist like Hauser the mainspring of human interest, the mainspring of art and of scientific research, that is to say, the relationship of man to the universe, to creation, seems not to exist at all. Seeing human endeavor in such a narrow framework cannot be right, and it is not true either to proclaim that there is always a conscious or unconscious practical purpose, a manifest or latent propagandist tendency in every work of art. Marx, it is stated, was the first to expound the doctrine that whatever men have produced intellectually, whatever they have thought, believed, preached, striven after, and fought for, was, above all, a means in their struggle for life, a weapon in the war they were waging against antagonistic groups and hostile classes. How far are we today from this concept of "class struggle, the war that fills the history of mankind," from the shortsightedness of the whole class conception of human nature. The danger today lies not in a class but in the materialistic mob that has received political and economic power through its mass organizations, without aiming at establishing a code of religious, aesthetic, and ethical values. Hauser seems at times to doubt the universal validity of the Marxian doctrine. But what remains unshakable to him is the belief that the material and economic facts are the *ultimate* causes, the *independent* data, the ever-changing factors of historical development. They influence the course of history, the history of art, science, philosophy, and religion. He has to confess that there are no material facts which would directly influence the stylistic development of art. This statement in itself considerably limits the importance of the sociological approach to art history. Nevertheless the conviction remains that "the proper task of the sociology of art consists in the inquiry into the social foundation of form rather than of subject-matter." An impossible task, as we have already indicated, because sociology limits the function of art to the "horizontal" relationship of man to man, without taking into consideration the "vertical" component, the relationship of man to creation and to the creative process itself. An impossible task in that it attempts to identify the validity of art solely through the aid of material and historically limited facts, in

this way reducing the work of art to the level of activities of a merely practical aim and value. In the same breath the author of the book asserts that there is no such thing as the "soul" of a nation or the "genius" of a folk. This seems, indirectly, to be an acknowledgment of the human value of the personality as proclaimed by Albert Schweitzer or Jacques Maritain, by C. G. Jung, Martin Heidegger, Nicholas Berdyaev, or by Alfred North Whitehead, that great scientific champion of the English Romantic poets of the nineteenth century. Not one of them is mentioned in this work, which deals in its last chapters with the spiritual difficulties of our age. We, on the other hand, are concerned with those values which rightly claim to stand above our daily pettiness, we are concerned with the greatness and the courage of the human mind, its fantasy, its dreams against that leveling-down tendency which Marxist thought will always bring with it. We are in need of the age-old tradition of spiritual values, its examples, particularly in this time of the breathless development of scientific thought and technological method. Marxism was effective in the elimination of certain social hardships, but it is no tool for the solution of our spiritual crisis. Its premises are psychologically wrong. When, therefore, a method is adopted in which the significance of the work of art disappears like an egg in the hands of a conjurer and what remains are social conditions, social influences, the social skeleton, then we feel the necessity to speak freely against such a method.

There have always been comprehensive histories of art, or general histories of mankind: they are informative and useful and basically dull. Only rarely do they rise above the generally accepted level, as in H. A. L. Fisher's *A History of Europe*,[10] where from time to time one feels the heartbeat of a human being. Once such works grow pretentious then we must ask ourselves: what doctrine do they advocate and where does it lead us? But even wrong conceptions can inspire when they are poetically conceived. Spengler's *Decline of the West*[11] is an example of a vast accumulation of cultural and social facts which is, in spite of its pessimistic view or independent of it, whether this view is right or wrong, a work of great fascination. It can even inspire artists. But I doubt whether in spite of its optimistic philosophy of evolution Hauser's work will be able to do so.

We feel the edifying effect when we study human culture as seen *sub specie aeternitatis*, with the understanding of the tragic sense of life as Miguel de Unamuno conceived it,[12] or when we behold the ever-changing aspects of the human mind and its assessment and

reassessment of values as revealed to us in *Aion,* Jung's investigations of the history of symbols.[13]

Whenever other than social elements are dealt with in this social history of art, whenever intrinsic problems of art are discussed—and they are discussed—we encounter an irritating vagueness. Stylistic facts are placed side by side with social, historical, or economic facts without the slightest chance of proving any connection between them. It is said of the Renaissance age, for example, that the court gradually changed over from the sensual to the more classical Baroque, just as the aristocracy adopted the economic rationalism of the middle classes, in spite of its dislike of anything to do with figures. There is no indication of any relationship between the two sets of facts. For the emergence of artistic values no sociological recipe can be given; the most sociology can do is to trace some elements in the work of art back to their social origin, and these elements may well be the same in works of very different quality. In other words, a purely social history of art is impossible and even undesirable: bringing the social facts into relation with the creation of works of art cannot by any means bring us nearer to the appreciation or understanding of them.

THE ARTIST AND SOCIETY THROUGHOUT THE AGES: AN ASPECT OF THE SOCIAL HISTORY OF ART

The Social History of Art is at its most reliable when analyzing the relationship of the artist to society and the function of art in its historical setting. When speaking of a legend such as that of the Golden Age, however, Hauser leaves the safe ground of history to enter the realm of speculation. His own ground remains materialistic. He cannot exactly define the sociological reason for the reverence for the past; it may be rooted, as he says, in tribal and family solidarity or in the endeavor of the privileged classes to base their privileges on heredity. A psychologist, whose science is concerned with the knowledge of man as an individual in relation to society, not of society alone, who is aware of the importance of first impressions from childhood and youth on the personality, its desire for power, would give a different interpretation of this legend. And so would any student of comparative religion. In order to expose the poverty and shallowness of Marxist reasoning, let us investigate the notion of "the ages" throughout the history of various cultures:

For the purposes of the morphology of symbols, an age is exactly the same as a phase. The lunar "model" of the four phases (of waxing, fullness, waning and disappearance) has sometimes been reduced to two or three phases, and sometimes increased to five. The phases in the span of human life have undergone similar fluctuations, but in general they are four, with death either omitted or combined with the final phase of old age. The division into four parts—quite apart from the importance of its relationship with the four phases of the moon—coincides with the solar process and the annual cycle of the seasons as well as with the spatial arrangement of the four points of the compass on the conceptual plane. The cosmic ages have been applied to the era of human existence, and also to the life of a race or an empire. In Hindu tradition, the *Manvantara,* also called *Mahâ-Yuga* (or the Great Cycle), comprises four *yuga* or secondary periods, which were said to be the same as the four ages in Greco-Roman antiquity. In India, these same ages are called after four throws in the game of dice: *krita, tretâ, dvâpara and kali.* In classical times, the ages are associated with the symbolism of metals, giving the "golden age," "silver age," "bronze age," and "iron age." The same symbolic pattern—which in itself is an interpretation—is found in the famous dream of Nebuchadnezzar (Daniel 2) as well as in the figure of the "Old Man of Crete" in Dante's *Commedia* (*Inferno,* XIV. 94–120). Progress from the purest metal to the most malleable—from gold to iron—implies involution. For this reason, René Guénon comments that the successive ages, as they "moved away from the Beginning," have brought about a gradual materialization. And for this reason, too, William Blake observed that "progress is the punishment of God." So that progress in life—in an individual's existence—is tantamount to gradual surrender of the golden values of childhood, up to the point in which the process of growing old is terminated by death. The myths concerning the "Golden Age" find their origin, according to Jung, in an analogy with childhood—that period when nature heaps gifts upon the child without any effort on his part, for he gets all he wants. But in addition, and in a deeper sense, the Golden Age stands for life in unconsciousness, for unawareness of death and of all the problems of existence, for the "Centre" which precedes time, or which, within the limitations of existence, seems to bear the closest resemblance to paradise. Ignorance of the world of existence creates a kind of golden haze, but with the growing understanding of concepts of duty, the father-principle and rational thinking, the world can again be apprehended.[14]

Toward the end of his book the author of *The Social History of Art* writes that the purpose of any historical research is the understanding of the present. Such a statement is quite inadmissible for a historian. To a Marxist historian, to whom progress is an axiom, that is, an established principle and a self-evident truth, the Golden Age, the social ideal, the utopian condition of man in general could not have been realized in the past but will be the triumph of the future. The belief, voiced in various places in the book, that we shall arrive at a rational solution of our own cultural difficulties if we visualize the factual developments of the role which art and poetry have played in the history of mankind, instead of clinging to a purely idealistic and romantic interpretation of these facts, leaves us wondering. A state-dictated art eliminates itself. Perhaps this may be called a "rational" solution of our cultural difficulties.

The position of the artist in the highly industrialized society in which we live is one of the strangest phenomena of our time. The modern artist began by proclaiming himself to be completely free in the exercise of his special gifts (*l'art pour l'art*).[15] He refused to paint landscapes, Madonnas, and portraits, the typical commissions of previous times. As private patronage was fading owing to changes in the social order and the economy, and public patronage had not yet had time to crystallize, the modern artist at the beginning of the century was seriously advised by Oswald Spengler, and in the middle of the century by Herbert Read, to give up art and to turn to more profitable professions to enable him to live.[16] The "absolute" freedom of creation which was finally achieved during the first decade of this century led the artist de facto into an insupportable isolation. He could not live without society, but society, having accepted the fact of his noble ivory tower, could only by a great effort understand what the nonacademic artist of the present day was aiming at. Often no effort was made, and the rupture between a technologically organized nation and its artists was complete.[17] This is, in short, the social aspect of the birth of modern art. Today the international commercialization of modern art and certain facets of public-taxation policies (for instance in the United States), the efforts of State organizations such as the Swedish Statens Konstråd, the Arts Council of Great Britain, and the British Council, among others, and the attitude of industry and big business toward commissioning modern works of art have completely changed the scene. In Soviet Russia the integration of the artist into society has been achieved, but at the price of art itself. There must be an inner con-

sensus between society and art, an organic growth which, in spite of the commercialization of art, is lacking in our time, to the great distress of modern humanists. No one has better formulated the causes of our cultural failures than Alfred North Whitehead in his Lowell lectures delivered in 1925, *Science and the Modern World*.[18] In these the utilitarian ideals of the Victorian Age are blamed for the lack of reverence for the arts, for the disappearance of beauty from the senses and the minds of modern man. Whitehead sees art as the only salvation from a technological nightmare, its function to add fantasy to a life which, limited to a mechanistic and materialistic world view, is like a prison from which the soul cries for release.

What was the position of the artist in former times? we ask; what functions did art fulfill? Were there ups and downs in the appreciation of art? Was the artist always considered to be a "crank" or an "outlaw," an anarchistic member of society, an "eccentric," a "bohemian," a "dandy," an exception to the rule of respectability; an "entertainer" or a craftsman in the service of publicity agencies, of mass production, a mere designer for industrial products, the aesthetic component in a high-powered salesmanship—for this is his well-paid position now. And what, on the other hand, were the characteristics of the ages when the artist was not called an artist but produced works of art, or when he stood at the top of the social ladder, honored by rulers as their equal or even superior, the master in the realm of human genius? The social history of art can give some answers to these questions.

The naturalistic animal drawings of the Old Stone Age were made by hunters. Their main aim was magic, their main purpose was to provide food. The animal depicted as pierced by spears or arrows on the dark walls of the caves was considered to be already slain before it was even hunted, an idea which strengthened Paleolithic man's confidence in himself, in the hard conditions under which he lived. These "artists," it is assumed, were not exempted from the duties of providing food. Research has only recently established that many of the animal drawings are sketches, rough drafts, and corrected pupil drawings, making it highly probable that there was an organized educational activity at work. The artist-magician seems to be the first representative of specialization and the division of labor. At any rate, he emerges from the undifferentiated mass, alongside the ordinary magician and medicine man, as the first professional. As the possessor of special gifts, he is the harbinger of the priestly class which will later lay claim not only to exceptional abili-

ties and knowledge but also to a kind of charisma and will abstain
from all ordinary work. Here, then, in the oldest examples of artistic
activity in Europe, the artist has a privileged position as magician
and priest, but his profession is not free. It stands in the service of
the primary needs of life, as Hauser points out. In such sociological
and economic reasoning what is not explained is the aesthetic quality
of the works produced. Understanding the inner link between the
primary motive of the animal drawings, that is, to work magic, and
the loving skill required to execute works of a beauty and sensi-
tivity which are extraordinary even when measured by high stan-
dards of art requires a philosophy of art and a sincere humanism
such as is exemplified in Siegfried Giedion's *The Eternal Present*.[19]

There is another aspect to consider. How far back can we trace,
at least in the cultural history of Europe, the conception of the artist
not as enjoying a special status but *purely as a craftsman* "carving
sculptures, painting pictures, shaping vessels, just as others make
axes and shoes," a craftsman who is hardly more highly esteemed
than the smith or the shoemaker? This happens in the age when he
is no longer an inspired magician but a maker of pictures of spirits,
gods, and men, of decorated utensils and jewels, who, in conse-
quence of an increased division of labor, has to satisfy more varied
needs for trade products. At the end of the Neolithic Age, which is
marked by a reorientation of life in all realms, by the transition from
mere consumption to production, from parasitic to creative economy,
cities and markets come into being and with them the agglomera-
tion and differentiation of the population. The first and only em-
ployers of artists were the priests and princes, and their workshops
were in temples and palace households. The compulsion under which
the artists had to work in this society is described as so relentless
that, according to the theories of modern liberal aestheticians, all
genuine cultural achievement should have been fundamentally im-
possible from the outset. And yet some of the most magnificent works
of art originated in the ancient Orient under the most dire pressure
imaginable. They seem to prove that there is no direct relationship
between the personal freedom of the artist and the aesthetic quality
of his work. But they prove that there is, of necessity, a connection
between the quality of the work of art and the ideas in the service
of which it was executed, whether religious or hierarchical, in other
words, a creed, a belief strong enough to give birth to a formative
imagination. This, too, is inexplicable in terms of sociology. The
above-mentioned historical facts, seen from our viewpoint, mark a

decline in the social status of the artist. Although the names of master-builders and master-sculptors are known in ancient Egypt, on the whole the artist remains an undistinguished craftsman. Our thoughts are here directed to the well-known fact that the artist and the educated man, the private tutor, the poet, and the philosopher, in ancient Rome for instance, were to a great extent slaves, and that, even in Gothic times, the conception of the artist-craftsman prevailed with all that follows from it, the status of anonymity and the low social standard. What remains is the miracle, practically inconceivable today, of the high degree of artistic and spiritual quality in their work.[20]

In Greece in the seventh century B.C. a new conception of art arises. The art produced at the courts of the tyrants is no longer a means to an end, but an end in itself. All hieratic connections seem to have been shaken off; art stands in a merely external relationship to religion. The aim and objective of the work of art is to achieve the perfect representation of the human body, the interpretation of its beauty free of all magical or symbolic implications. Although it is the temples which now begin to be filled with sculptures, the artist is no longer dependent upon the priests, is not under their tutelage, and does not receive commissions from them; his patrons are now the cities, the tyrants, and, for less expensive works, wealthy private individuals as well. The Greeks are the first people to complete the transition from the "instrumental" to the "autonomous" form of art activity, Hauser notes. This is generally considered to be the most tremendous change that has ever occurred in the whole history of art. Our present time has brought us a step beyond this. The conception of *l'art pour l'art* in the nineteenth century was an expression both of the artist's pride—he did not need to be understood and appreciated—and of his isolation: society did not care what the artist produced, did not take art as a serious business, gave it only a snob value, the status of an interesting hobby. But in contrast to old Greek culture, we must say that whereas our technological age can be visualized without art altogether, Greek culture is unthinkable without its artists and poets. The reason for the "autonomy" of art in Greece is explained in *The Social History of Art* as, first, an effect of colonization. This is a point which is difficult to accept, for how can it be proved that it was the foreigners surrounding the Greeks on all sides in Asia Minor that made them conscious of their own native genius and led them to spontaneity and autonomy in art? Second, Hauser points to economic considerations, explaining that

art becomes independent of magic and religion only when the master caste can afford the "luxury" of paying for "purposeless" art to be produced. This is an explanation which may prove to be totally wrong. For have we not witnessed in our lifetime the fact that a "purposeless," even an "abstract," art has been produced not because there was a master caste which could afford it, but has been produced contrary to the taste, the sympathy, and the support of such a master caste, in extreme opposition to the understanding of its contemporary surroundings?

In the philosophy of art the development toward autonomy has been thoroughly documented, but the explanations given for it are based on different criteria. From the Greek *mousike techne* (*techne*, art as useful skill in general, *mousikos*, of the Muses, fine art devoted to the Muses) we are led by way of the conceptions of Plato and Aristotle to Plotinus. And it is only in Plotinus' philosophy that the concept of fine art purged of all moral content and the concept of art as the externalization of beauty, that is, the doctrine of fine art as the expression of an absolute value, Beauty, is consistently developed.[21]

In classical Athens, in spite of the enormous importance which works of art came to have in displaying the power of their proud, victorious city, the social position of the artist was not at all satisfactory. Art was looked upon even here as a mere handicraft, the artist as an ordinary artisan. He was ill paid, without secure abode, and led a wandering life. *The Social History of Art,* in underlining such facts, implies a notion of art which was unknown to antiquity. We witness in classical Greece the paradoxical situation—to refresh the memory of those who may have forgotten the fate of Socrates and Phidias, the philosophical safeguards and prejudices of Plato— that the ancient world revered the creation while not honoring the creator of the work of art.[22]

In old Byzantium we find a tendency which is directed not against the artist but against visual art itself, or rather against pictures of religious content. We allude here to the phenomenon of iconoclasm. In consequence art was conceived of as having a purely decorative function. The immediate reasons for this tendency may have been political. The military successes of the Arabs, whose Mohammedanism recognized no image worship, following therein the old Jewish doctrine, provided one of the factors. Hauser points out that the foundation of a strong military state was hindered by the Church and the monasteries, which were among the biggest landowners,

and the emperor, by forbidding the worship of images, seems to have deprived them thus of their most effective means of propaganda. More decisive than the political reasons, however, were the "inner, the religious reasons: the aversion to idolatry and the early Christian refusal to accept the sensual-aesthetic culture of classical Antiquity." That is to say, the prime mover was not the emperor but the Church itself. The status of the artist could not profit from such a movement.[23]

One of the strong reasons for the present-day lack of aesthetic appreciation is the Industrial Revolution. It took place in a country which through its puritanical-rationalistic inclinations was in full agreement with Plato (and later on with Tolstoi)[24] in its enmity against the "frivolities" of art. Art, however, can never be outlawed entirely; mankind cannot live without it. In the monasteries of the Middle Ages art retained its place beside all the practical and spiritual activities strictly necessary for worship and flourished especially in the realm of church architecture and the production of illuminated manuscripts, mosaics, and stained glass.[25]

The period of the late Middle Ages is defined in *The Social History of Art* as a middle-class period. The mason's lodge of the twelfth and thirteenth centuries was a cooperative organization of the artists and artisans engaged in the building of a cathedral, establishing strict regulation of the work, precise rules regarding the taking on, payment, and training of workers, the hierarchy of architect, mastercraftsmen, and journeymen, special restrictions on the members' rights of intellectual property in their own work, and unconditional subordination of the individual to the artistic requirements of the common task.[26] All this shows quite a "modern" spirit in "organizing labor." In our time only the working class is organized in the strict sense of the word, whereas the other classes are rooted in old rights and privileges or economic practices, ensuring them their respective standards. The modern artist in the West still lives as if in a liberal age with all the liberal assumptions, but without the economic rewards and securities. Dictatorial states have tried to solve the problem of artistic production in our time by adopting the medieval-guild principle. England engaged artists for cultural services only during the two world wars. Where systematic attempts were made for the creation of public patronage, as in Sweden, the artists had to organize themselves into a trade union (former times saw the parallel drawn between artist and artisan, our time between artist and worker) whose representatives make suggestions to the

government. In spite of this trend toward public patronage no great art has been created under these auspices. This shows clearly that the quality of art represents foremost a spiritual, not a social, value and that there cannot be any sociological explanation for artistic merit.

The social status of the Renaissance artist has been the subject of detailed studies by many authors throughout the centuries. Leonardo's essay "Paragone" on the question of which art is to be considered the noblest brings us *in medias res*. The problem was well known in all its details even to classical antiquity. From the beginning to the end of the Greco-Roman epoch the point of view from which the plastic artist is judged and valued in comparison with the poet is much in evidence. We read:

> The sculptor or painter works for reward and makes no attempt to hide the fact, whereas the poet is looked upon as the guest-friend of his patron. . . . The sculptor and the painter have to work with dirty materials and tools, whereas the poet goes out with clean clothes and hands. The sculptor and painter are obliged to be doing manual work that involves bodily effort, while the labours of the poet are certainly not obvious to the eye.[27]

In the Renaissance, painters, sculptors, and architects had to fight hard to raise their status as compared with the "humanists," and they worked for it by emphasizing the scientific, theoretical approach in their art. At last they obtained recognition as educated men, as members of humanist society. Painting, sculpture, and architecture were accepted as liberal arts, all differing fundamentally from the manual crafts. The idea of the fine arts comes into existence in this way.[28]

It is revealing to know of Masaccio (who died poor and in debt) that he could not even pay his apprentice, and Paolo Uccello in his old age complains that he owns nothing, cannot work any longer, and has a sick wife.

The social ascent of the artists in the Renaissance is reflected in the fees they receive. In the last quarter of the fifteenth century relatively high prices begin to be paid in Florence for fresco paintings. In 1480 Giovanni Tornabuoni agrees to pay Ghirlandajo a fee of 1,100 florins for painting the family chapel in Santa Maria Novella. For his frescoes in Santa Maria sopra Minerva in Rome, Filippino Lippi receives 2,000 gold ducats. Michelangelo receives 3,000 ducats

for the paintings on the ceiling of the Sistine Chapel. Toward the end of the century several artists are already doing well financially; Filippino Lippi even amasses a considerable fortune. Perugino owns houses, Benedetto da Majano an estate. Leonardo draws an annual salary of 2,000 ducats in Milan and in France he receives 35,000 francs a year.[29]

The most fundamental change in the status of the artist occurs at the beginning of the Cinquecento. From then onwards the famous masters are no longer the protégés of patrons but great lords themselves. According to Vasari, Raphael leads the life of a grand seigneur, not that of a painter; he resides in his own palace in Rome, associates with princes and cardinals as equals. Titian climbs even higher up the social ladder. His reputation as the most sought-after master of his time, his way of life, his rank, his titles bring him into the highest circles of society. The Emperor Charles V appoints him a Count of the Lateran Palace and a member of the Imperial Court, makes him a Knight of the Golden Spur, and it is well known that Charles once picked up Titian's brush for him, considering it unsuitable for a genius to do it for himself. But it is Michelangelo whom we consider to have risen to absolutely unprecedented heights. His supremacy was so obvious that he could afford wholly to forgo all public honors, titles, and distinctions. He scorned the friendship of princes and popes; he dared to be their opponent. He was neither a count nor a state councillor nor a papal superintendent, but he was called the Divine. He did not wish to be described as a painter or sculptor in letters addressed to him: he was simply Michelangelo Buonarroti.[30]

Many a great artist has since then achieved social esteem, position, and wealth. Rubens in the Baroque period, Le Brun, *"le premier peintre du roi"* Louis XIV, David, the painter of the French Revolution and of Napoleon. But none of them possessed Michelangelo's demon. Only Goya can be compared to him in this respect. Rembrandt, with all the tragic implications which his fate reserved for him in his old age, is an example of how a genius in pursuit of high artistic ideals can be bereft of the appreciation of his social surroundings and die practically unknown. Only centuries later did his name rise like a star of the first order on the horizon. Was Dürer's fate much different? These names are taken from among the greatest of mankind.

What can we learn from the conditions under which the artists lived in the Holland of the sixteenth century? About 1560, so it is

related, there were in Antwerp 300 artists, when the city had only 169 bakers and 78 butchers. It happened for the first time in the history of Western art that the existence of a surplus of artists and of a proletariat in the art world could be established. Most of the painters in wealthy, middle-class, Protestant Holland lived in such miserable circumstances that many of them were forced to turn to another source of income outside the artistic profession. Thus van Goyen traded in tulips, Hobbema was employed as a tax-collector, Willem van der Velde was the proprietor of a linen business, Jan Steen and Adriaen van der Velde were innkeepers. Hals was never particularly popular and never received the prices which were paid, for example, for the portraits of a van der Helst. Vermeer is known to have had great financial difficulties. Some painters became art dealers, selling not only their own works, but selling and buying the works of others. Prices on the art market were low. A good portrait cost 60 guilders, for example, when the price of an ox was 90. Jan Steen once painted three portraits for 27 guilders. The case of Isaac van Ostade, who in 1641 supplied an art dealer with 13 pictures for 27 guilders, shows the kind of starvation wages with which famous painters had to content themselves. The indication that in the Netherlands the profession of art was taken up exclusively by members of the middle and lower sections of the middle class can be a satisfactory explanation of this state of affairs. We have already mentioned that art in our own time has become commercialized. There are worldwide speculations in works of art, and the need for investment in safer values than money has become obvious. Enormous prices are paid for works of the early modern masters, the Impressionists, van Gogh, Gauguin, Bonnard, or the still-surviving masters of the avant-garde, Kokoschka, Picasso, Miró, to name only a few. It is often only a short time from the day an artist has died in poverty until high prices are achieved in the art market for his works. Some modern artists, again, have been paid good prices for everything they have produced even in their lifetime, owing to art monopolies. A kind of financial upper class has been created among artists which is surrounded by an artistic middle class and proletariat.[31] The contemporary artist enjoys in one part of the world the freedom to produce what he wants and the chance to become rich and famous, but no guaranteed security, and in the other part of the world security without the freedom necessary for creation.

Our present cultural situation is as uncertain as the lives of the artists. It has been called "exhibitionist," because of the extraordi-

nary number of exhibitions organized year in and year out all over the world, but also because of its lack of the basic preconditions, peace and leisure, and above all the lack of the *consensus omnium* in spiritual matters so essential for every genuine culture.

NOTES

1. (New York, 1951).
2. Sombart, *Der moderne Kapitalismus*, 2d ed. (Munich, 1916), and other works; Weber, *Kulturgeschichte als Kultursoziologie* (Leiden, 1950).
3. An attempt was made to produce a psycho-historical theory based on relations between the arts, psychology, and the social sciences. See Walter Abell, *The Collective Dream in Art* (Cambridge, Mass., 1957).
4. *Weltanschauung und Analyse der Menschen Seit Renaissance und Reformation* (Stuttgart, 1957), and other works.
5. *Florentine Painting and Its Social Background* (London, 1947).
6. See Alfred Fabre-Luce, *Six Milliards d'insectes: Les Hommes de l'an 2000* (Paris, 1962).
7. Bertrand Russell, *The Scientific Outlook* (London, 1931).
8. *Journal (1889–1939); Journal (1939–1949)* (Paris, 1939 and 1954).
9. *Les Voix du silence* (Paris, 1951).
10. 2 vols. (London, 1935).
11. *Der Untergang des Abendlandes*, 2 vols. (Munich, 1922).
12. *Das Tragische Lebensgefühl (Del Sentimento Trágico de la Vida,* 1913) (Munich, 1925).
13. (Zurich, 1951).
14. E. Cirlot, *A Dictionary of Symbols (Diccionario de Simbolos Tradicionales)* (London, 1962).
15. Albert Cassagne, *La Théorie de l'art pour l'art en France chez les derniers romantiques et les premiers réalistes* (Paris, 1959).
16. Spengler, *The Decline of the West* (see n. 11); Read, *Art and Society* (London, 1937).
17. See Herbert Read, *Art and Alienation: The Role of the Artist in Society* (London, 1967).
18. (Cambridge: At the University Press, 1926).
19. The A. W. Mellon Lectures on the Fine Arts, 1957 (London, 1962). See also Abbé H. Breuil, *Four Hundred Centuries of Cave Art* (Montignac, 1952).
20. See Erwin Panofsky, *Gothic Architecture and Scholasticism* (London, 1957); Hans Sedlmayr, *Die Entstehung der Kathedrale* (Zurich, 1959); Otto von Simson, *The Gothic Cathedral* (London, 1956).

21. Thomas Munro, *The Arts and Their Interrelations* (rev. and enl. ed., Cleveland, 1967).

22. See André Bonnard, *Greek Civilization* (London, 1957, 1959, 1961); Jacob Burckhardt, *Griechische Kulturgeschichte*, 3 vols. (Leipzig, n. d.).

23. N. H. Baynes and H. St. L. B. Moss, *Byzantium: An Introduction to East Roman Civilization* (Oxford, 1948); O. M. Dalton, *Byzantine Art and Archaeology* (New York, 1961); P. A. Michelis, *Esthetique de l'art Byzantin* (Paris, 1959).

24. *The Republic of Plato*, trans. B. Jowett (Oxford, 1881); Leo Tolstoi, *What Is Art?* and *Essays on Art* (Oxford, 1930).

25. Henri Focillon, *Art d'Occident, le Moyen Âge Roman et Gothique*, 3d ed. (Paris, 1955); Émile Mâle, *Art et artistes du Moyen Âge* (Paris, 1947); Jean Decarreaux, *Monks and Civilization* (London, 1964).

26. Jean Gimpel, *The Cathedral Builders* (London, 1961). See also *The Sketchbook of Villard de Honnecourt*, introduction, ed. Theodore Bowie (New York, 1959).

27. *Literary Sources of Art History*, ed. Elizabeth Gilmore Holt (Princeton, 1947).

28. Anthony Blunt, *Artistic Theory in Italy, 1450–1600* (Oxford, 1940).

29. Giorgio Vasari, *The Lives of the Painters, Sculptors and Architects*, 8 vols. (London, 1900).

30. *The Divine Michelangelo*, The Florentine Academy's Homage on His Death in 1564, ed. and trans. Rudolf and Margot Wittkower (London, 1961).

31. Today it is the international auction catalogue which reflects the "economic" status of the artist.

3 • THE MUSEUM AND MODERN ART
The Mission of the Museum in Our Time

The masterpiece is a symphony played upon our finest feelings.

<div style="text-align: right">KAKUZO OKAKURA</div>

WE PREFER TO SPEAK TODAY OF THE RAISON D'ÊTRE OF A MUSEUM RATHER than its function, and of its mission rather than its raison d'être. What actually is this mission? Like the cult of the ceremonial tearoom in fifteenth-century Japan, it is best described as the offering of an opportunity for the admiration of the beautiful among the sordid facts of everyday life.[1] In our technical and democratic civilization, an art museum opens a door to those who feel a need for the admission of the significant, for the inclusion of aesthetic values in this impoverished and hasty existence of ours.

Have not the best writers mused over our heritage of dignity, beauty, and skill? Have they not studied with grateful hearts the treasures handed down to us which alone give us a measuring rod for the possible greatness in man? Have they not filled their minds with the sweetness and the bitterness of living which is enshrined in art and ennobled in a harmonious, meaningful unit? Listen to the words of Rilke, speaking of Rodin as blessed with *"la grâce des grandes choses"*:

There was the Louvre with its many luminous objects of the antique, suggestive of southern skies and the proximity of the sea, and behind these rose other, heavy things in stone, lasting from incredibly distant civilizations into ages which were still to come. There were stones asleep, and one felt that they would

<div style="text-align: right">317</div>

awaken at some Judgment Day, stones which had nothing mortal
about them, and others embodying a movement, a gesture, which
had retained such freshness that it seemed to be preserved here
only until some passing child should receive it one day as a gift.
And not only in the famous works of art and in those visible
from afar did this quality of life exist; the unnoticed, the small,
the nameless, and superfluous were no less filled with this deep
inner vitality, with the rich and amazing restlessness of life.
Even the tranquility, where there was tranquility, was composed
of hundreds upon hundreds of moments of motion keeping each
other in equilibrium. . . .[2]

How well writers and poets have known the secret of meditating
on the greatness of the work of art. We hear Hugo von Hofmannsthal
saying:

Each work of art is lonely by its very nature: is silent, wrestling,
a magical power over the world. Claudel once said of the dead
that they were *plus mornes que les poissons*—thus the individual
works of art stand next to one another, gloomy, like mute fish
standing in the depth of the water, comparable to the dead,
without magnanimity, possessed, each one, of its uniqueness.[3]

And the young Gustave Flaubert, did he not learn in the museums
to weigh the merits of the painters against those of the writers?

What enchanted him most deeply with these masters of art
was the union of passion and inventive genius; the most indi-
vidualistic and personal poets showed less fire, less fullness of
life and even *naïveté* in the portrayal of the one feeling which
constituted their greatness, than those others proved to possess
in the manifoldness of feelings which they depicted; subsequent
literatures, however, with all their acquired tricks and contrived
artificiality, have not achieved anything that can reach up to
the wise harmony which with those masters is found in its most
natural and perfect state as their source and origin.[4]

To Marcel Proust the famous paintings did not always offer that
code of refinement and rare manners which he, a true heir of Castig-
lione's *cortegiano*, would have liked them to radiate:

It happens that the salon which, in public galleries, gives the
greatest impression of elegance in great paintings of the Renais-
sance and onwards, is that of a little ridiculous bourgeoise
whom after seeing the picture, I might, if I had not known her,

have yearned to approach in the flesh, hoping to learn from her precious secrets that the painter's art did not reveal to me in his canvas, though her majestic velvet train and laces formed a passage of painting comparable to the most splendid of Titians. . . . The awakening of love of beauty in the artist who can paint everything may be stimulated, the elegance in which he could find such beautiful motifs may be supplied, by people rather richer than himself—at whose houses he would find out what he was not accustomed to in his studio where as an unknown genius he sold his canvas for fifty francs. . . .[5]

But could he ever be without the splendor which the museums so generously displayed? "Take," he said,

a young man of modest means and artistic tastes sitting in the dining room at that banal and dismal moment just after lunch, when the table has not yet been completely cleared. With his mind full of the glories of museums and picture galleries, of cathedrals, of the sea and mountains, it is with a feeling of discomfort, of boredom, of something approaching disgust, of melancholy, that he looks at the last knife lying on the crumpled tablecloth which dangles on the floor near the remains of a cutlet cold and half raw. . . . He curses the surrounding ugliness and, ashamed of having spent a quarter of an hour savouring, not exactly the shame, but the disgust and even the fascination of it, he stands up and, if he cannot take the train for Holland or Italy, he goes to the Louvre to look for the visions of palaces of Veronese, the Princes of van Dyck or the seaports of Claude Lorrain, visions which this evening will come anew to tarnish and disenchant his return to the familiar scene of everyday life. . . . If I knew this young man I should not try to dissuade him from going to the Louvre. Instead, I would accompany him; but I would lead him into the Lacaze gallery and into the galleries of the French 18th Century painters, or into the Rubens gallery, or into some other French Gallery, and there I would stop him in front of the Chardins.[6]

How many fine poems have not been inspired by the masterpieces in those cloisters of repose and contemplation which our museums are:

The Body is not fallen like the soul:
For these are godlike, being
Creatures of Flesh, and in that being whole. . .[7]

And what a serene vision of Brueghel's *Icarus* in W. H. Auden's poem "Musée des Beaux Arts":

> About suffering they were never wrong,
> The Old Masters: how well they understood
> Its human position; how it takes place
> While someone else is eating or opening a
> window or just walking dully along;
> In Brueghel's Icarus, for instance: how everything
> turns away
> Quite leisurely from the disaster; the ploughman may
> Have heard the splash, the forsaken cry,
> But for him it was not an important failure; the sun shone
> As it had to on the white legs disappearing into the green
> Water; and the expensive delicate ship that must have seen
> Something amazing, a boy falling out of the sky,
> Had somewhere to get to and sailed calmly on.[8]

There is a shade of skepticism and uneasiness in William Empson's fortissimo in "Homage to the British Museum":

> Attending there let us absorb the cultures of nations and dissolve into our judgment all their codes. . . . Let us stand here and admit that we have no road. Being everything, let us admit that is to be something. Or give ourselves, the benefit of the doubt: Let us offer our pinch of dust all to this God, and grant his reign over the entire building.[9]

A similar, somewhat tired, precious attitude was adopted by Paul Valéry:

> I am not overfond of museums. Many of them are admirable, none are delightful. Delight has little to do with the principles of classification, conservation, and public utility, clear and reasonable though these may be. . . . Dreariness, boredom, admiration, the fine weather I left outside, my pricks of conscience, and a dreadful sense of how many great artists there are, all walk along with me. . . . Only an irrational civilization, and one devoid of the taste for pleasure, could have devised such a domain of incoherence. This juxtaposition of dead visions has something insane about it, with each thing jealously competing for the glance that will give it life. . . . But our heritage is a crushing

burden. Modern man, worn out as he is by the immensity of his technical resources, is also impoverished by the sheer excess of his riches. . . . The museum exerts a constant pull on everything that men can make. It is fed by the creator and the testator. All things end up on the wall or in a glass case. . . . I cannot but think of the bank at a casino, which wins every time. . . .

But I shall go further, says the young and powerful voice of André Malraux, who, in our age, has expressed perhaps the most invigorating and fertile thoughts on the idea of the museum. Already in his first essay on art, he realized the miracle which is hidden in the true application of the work of art:

> Every work of art is created to satisfy a need . . . a need sufficiently urgent to give it birth. Then the need ebbs from the work like blood from a body, and the work itself begins its mysterious process of transfiguration. It enters the region of shadows. Out of this region only our own need, our own desire can rescue it. Until that time it will remain like a great statue with white, sightless eyes, before which will pass a long procession of the blind. And the same necessity that directs one of the blind to approach the statue will cause both at the same time to open their eyes. . . . Art, thought, poetry, all the ancient dreams of man: if we need them in order to live, they need us in order to re-live. They need our passion, they need our desire, they need our will. . . .[11]

This idea grew for Malraux into a conception of the museum as harboring in its big halls all over the world the evolving image of mankind, offering it to modern man as he stands at the threshold of a new world filled to the brim with new, powerful visions, in order to enable him to realize what he has been, so that he will know what he is and where to go:

> The part played by museums in our relationship to the arts is so great that we are hard put to it to imagine a world without them, or to realize that in fact museums never existed where European civilization is or was unknown, or that, even here, museums have been in existence for no more than two centuries. The nineteenth century lived on them; we live on them still, and we forget that they have imposed on the visiting spectator an entirely new attitude toward works of art. They have helped to relieve of their functions the works of art they have

gathered together; they have transformed even the portrait into a picture. . . . The museum no longer knew anything of palladium, of saint, of Christ, of objects of veneration, of resemblance or imagination, of décor or possession, but it did know of the images of things themselves and having their raison d'être in just that specific difference. . . . The museum separates the work of the "profane" world and associates it with work opposed or rival to it. It is a confrontation of metamorphoses. . . . The first universally artistic culture . . . was not an invasion but one of the supreme conquests of the Occident. Whether we like it or not, nothing can give light to Western man except the torch which he himself holds, even if he burns his hand with it; and what that torch tries to throw light upon is everything that may increase the power of man. How could an agnostic civilization dispense with an appeal to something that surpasses it and often ennobles it? If the quality of the world is the material of every culture, the object of all culture is the quality of man; and it is that, and not the sum of his knowledge, that makes him heir to greatness. And who knows if our own artistic culture may not limit itself to the most subtle refinements of sensibility, touching its way among the figures, savoring the songs and the poems which are the heritage of the oldest nobility of the world—and that because today it finds itself sole heir to that heritage.[12]

This, then, is truly an active force invading the domain of everyday values with a powerful thrust, penetrating it with that otherness which makes life worth living. A concert in a museum, chamber music, people strolling about in the intervals among works of art; a poetry-reading, people listening to the voice of a poet, their gaze fixed on a tapestry or the enigmatic colors of a Venetian painting—have we not built the same sanctuaries to beauty in everyday life as the Japanese? And we are strengthening them with the mighty conception of a universal culture based on science and the veneration of old traditions. We are far from the notion of the eighteenth century which already, in the idea of the museum as a sacral building with a temple front and the main hall as a sanctuary containing the most precious treasures of meditation, was creating a hierarchical barrier between the highest ideals on the one hand and everyday life on the other. This conception is based on an idealistic view voiced by Goethe, especially in his *Aus Meinem Leben, Dichtung und Wahrheit*,[13] by the Romantics F. D. Schleiermacher and W. H. Wackenroder ("Art must become a religious love or a loved re-

ligion"), and particularly by Hölderlin and his notion of an aesthetic church (*ästhetische Kirche*).[14] These ideas of an aesthetic church and of the artist as the highest among human beings, a priest of art, are rooted in the writings of England's pantheistic Anthony Ashley Cooper, third Earl of Shaftesbury, which were collected under the title *Characteristics of Men, Manners, Opinions, Times, etc.*[15] This book of essays, especially "A Letter Concerning Enthusiasm and Soliloquy or Advice to an Author," had no influence at all in England but created, together with the concept of the English garden, a definite spiritual climate on the Continent, influencing Herder, Goethe, the German Romantic school, Diderot, Rousseau, and others. Hegel's *Aesthetics*, in fact, gave its blessing to this historicizing, idealistic movement in stating that art belongs to the past, a point of view which no art historian of today can share: "But we no longer feel the absolute need to express content in the form of art. For us, art in the highest sense of its mission is a thing of the past. . . ."[16]

We enter a museum, weary perhaps from the hectic rhythm of our day, we rediscover the need for meditation, we are enhanced in our belief that we, too, are building a world equal in its greatness to that of the old cultures. And all this because "a magic touch of the beautiful, the secret chords of our being are awakened, we vibrate and thrill in response to its call. Mind speaks to mind. We listen to the unspoken, we gaze upon the unseen."[17]

THE INTERPRETATION OF MODERN ART

> Non sole le opere degli artisti viventi ma
> anche quelle degli artisti fioristi dal principio del secolo XIX.
>
> PALMA BUCARELLI, 1951

We have touched on what the museum means to the poet and the average person. The world which it represents for the art historian, the aesthetician, and the restorer has not been mentioned; to do so would lead us too far afield. Whoever is interested may, with profit, read Sir William Flower's encyclopedia article on museums and become informed on what the author calls "the new museum idea," concerning museum administration and development.[18] The chapter "Denkmalpflege und Musealkunde" in Hans Tietze's work *Die Methode der Kunstgeschichte* will provide further material.[19] Some important critical thoughts are developed in the chapter "Sam-

melwesen (Museen)" in Josef Strzygowski's *Die Krisis der Geistes-
wissenschaften: Vorgeführt am Beispiele der Forschung über Bil-
dende Kunst.*[20]

To the artists the museum is the air they breathe. Ambroise Vol-
lard speaks of Cézanne's constant association with the Louvre,

> his zeal for the study of the masters, his fever of work. . . . Cé-
> zanne held that a painter could gain from looking at the canvases
> of other painters; but what he meant when he said "the other
> painters" was the old masters and his own rue Lafitte, that was
> the Louvre. When he had spent an afternoon drawing from
> Greco, Delacroix or any "other" of his favourites, with what
> pride he would say: "I think I have made some progress to-
> day!"[21]

And of Henri Rousseau:

> One afternoon Rousseau arrived at my shop in an open fiacre.
> He had in front of him a canvas two metres high. I can see
> him still, struggling with the wind. When he had put his can-
> vas down in the shop he began to contemplate it with a sort
> of devotion.
> "You seem to be pleased with your work, Monsieur Rous-
> seau," I said to him.
> "And you, Monsieur Vollard?"
> "That's for the Louvre, that is!"
> His eyes shone . . .[22]

And listen to the cautious voice of Fantin-Latour. Vollard recalls:
"I remember one day in his studio, when I told him that I intended
going to the Louvre to compare a still life by Cézanne with one by
Chardin, the painter turned and said brusquely, 'Don't play any
games with the Louvre, Vollard.' "[23]

"When I was a young teacher at the art school," Henry Moore
once said to me, "there was not one day that I would miss going to
the British Museum."

Van Gogh's letters to his brother contain innumerable mentions
of visits to museums and the way in which they challenged and en-
riched the mind of his worrying genius. Picasso called Derain iron-
ically *"le guide de musées,"* and in his criticism is contained the nu-
cleus of the wisdom which Cézanne communicated to Camoin:

Since you are now in Paris and the Masters of the Louvre are attracting you, make, if you feel like it, some studies after the great decorative masters, Veronese and Rubens, but just as you would do after nature—a thing I was only able to do incompletely myself. But you do well to study above all from nature.[24]

There is hardly a month in the journal of Delacroix from 1822 to 1863 which does not contain a reference to a visit to a museum. What a wealth of observation, of critical thought, of inspiration did the visits not bring to life!

In addition to their permanent collections and their frequent special exhibitions, museums nowadays develop an educational activity of wide scope. In the Galleria Nazionale d'Arte Moderna in Rome, to give one example, this activity covered, during 1955, two large series of illustrated lectures, one on painting at the beginning of the eighteenth century in France, Italy, England, Germany, and the United States, the other on the movements in modern art in Europe at the end of the nineteenth and the beginning of the twentieth century: *Art nouveau* and the "Sezession," Expressionism, Kandinsky and the beginnings of abstract art, Klee, Fantastic art, Mondrian and the pure plastic art, Gropius and the Bauhaus, the rational movements in European architecture, Surrealism, Miró, Juan Gris. In addition to these lectures, the following films were shown: *The French Impressionists* by Emilio Lavagnino, *Il Surrealismo e il Sacro* by Enrico Castelli Gattinari, and films on individual artists such as *Scipione,* for which Palma Bucarelli wrote the text, and *La Donna e la Luna* from the Cavellini Collection, written by Gattinari. Educational exhibitions of color reproductions of works of Degas, Braque, and Cubist painters were also organized. The entire educational program—including the usual guided tours of the museum for students and a wider public, held also in French and English for foreign visitors—was rounded off by exhibitions of what is there called *"opere del giorno,"* that is, new acquisitions. These exhibitions are well documented by photographs, notes, and talks.

This rich program, behind which we sense a systematic approach to the problems of modern art, leads us to speculation of various kinds. Why, we ask, a series on eighteenth-century art combined with one on modern art in the more specific sense of the term? The

answer may be that a museum which contains works of sculpture starting with Antonio Canova (1757–1821), Pietro Tenerari (1789–1869), and Lorenzo Bertolini (1777–1850) and moving to present-day sculptors such as Medardo Rosso, with a beautiful collection of Amedeo Modigliani, Marino Marini, Giacomo Manzú, Arturo Martini, Emilio Greco, Mirko Basaldella, and others; which has a collection of paintings beginning with Teodoro Matteini (1754–1831), Gaspare Laudi (1756–1830), Natale Schiavoni (1777–1858), and Francesco Hayes (1791–1882) and displaying all the then "modern" trends such as Classicism, Romanticism, and *genre* and historical painting, to be followed by Realism, Pleinairism, and Impressionism and leading to Umberto Boccioni, Giorgio de Chirico, Carlo Carrá, Giorgio Morandi, Philippo de Pisis, Massimo Campigli, Scipione, Felice Casorati, Renato Guttuso, to name only a few—such a museum must favor not only the extreme modernists. But there is a deeper reason hidden in this obvious fact. In a country in which tradition is as living a force as it is in Italy—and this not only because of its collections but also owing to the venerable presence of cities which connect the past with the present and history with modern existence —contemporaneity began immediately after the Baroque had spent its genius. The Baroque, which must formally be seen as a powerful unfolding of the Renaissance trend, has put Italy into a privileged position. For where in the whole world is there another country which has produced such a majestic line of new developments in all the arts, and that in an unbroken sequence from the fourteenth to the end of the seventeenth century, thus giving a great example to mankind? Paris in its historic parts can rightly be called a Gothic town. But what is alive in Paris is not the Gothic and the Romanesque! These are restricted to a few churches and uninhabitable narrow streets. The spirit of Paris is a daughter of the Italian spirit insofar as François Villon and Clement Marot may be said to be disciples of the Renaissance spirit of a Boccaccio and a Petrarch, and the Rococo of the French kings and nobles to be a playful variant of the Italian Baroque. Prague is a Baroque city in spirit, but it did not play a leading part in paving the way for a European art development. One feels, however, the consciousness of such greatness and tradition in Italy and, what is more remarkable, one finds a very positive attitude also to new developments. It was Italy which in the second half of the nineteenth century started the international Biennale exhibitions in Venice, and from 1909 on, the Galleria Nazionale d'Arte Moderna also began to acquire works by foreign artists at

the international Biennales in Venice.[25] Italy did not experience the break between the old and the new civilization as strongly as England did. There is continuity in creativeness, and the Italian artist will accentuate tradition rather than neglect it. He will thus find a valid formula for today. This was the case of Medardo Rosso, who decisively influenced Rodin. It is true of the new Italian sculpture beginning with Arturo Martini and Marino Marini and confronting the more cerebral approach in the North of Europe and in America with the eternal values of beauty and of the figurative in its graceful aspects; of Modigliani and of de Chirico! The Pittura Metafisica is unthinkable without the impact of tradition. Hence, too, the violent antitraditionalist tendency of Futurism which only proves the rule to any psychologist and aesthetician. The continuity of creativeness in Italy is also the reason for a phenomenon like Lionello Venturi, a professor of art history who, after having devoted his studies to the origins of Venetian painting, to Giorgione and Giorgionism, undertakes a standard work on Cézanne, a major study on Chagall, and defends that most advanced trend of the abstract movement, Tachism. In England, by contrast, Cézanne was still criticized during the fifties from the prejudiced academic point of view.[26] Only after 1950 did Professor Anthony Blunt of the Courtauld Institute of London University, in giving five lectures on Picasso, reconcile academic circles with the extreme development in modern art embodied in this artist. There is no break in Italy between the past and the present in art; there is a direct line from the eighteenth century to Abstract Expressionism.

Nevertheless, the customary interpretation of modern art (which starts with Courbet, with one predecessor only in the person of Goya —twenty years too early to be a direct influence on Manet) is problematic even in Italy. Thus we find a great emphasis laid on it in the educational program of the Galleria Nazionale d'Arte Moderna. Let us investigate this problem more closely.

Why is the interpretation of modern art so complicated? Because of the bewildering chaos of isms and the frequent change of styles, techniques, and aims, so different from anything else apparent in art before our time. That would be the answer given by the average layman. There must be, however, one and not several reasons for these changes, and perhaps in detecting it we may simplify the seemingly confusing image which modern art produces in the beholder by showing up a few principles which govern it all. That it is a real problem is evident alone from the fact that we are unable

to find a nomenclature for our artistic strivings, for our style. The
terms *contemporary* or *modern* cannot replace it; they only point to
the actual existence of the problem.

Since the seventeenth century, modern science, in its powerful
drive, has caused a disruption of a unified world view in the Western
Hemisphere, as all authors, both scientific and philosophic, agree.
I quote Alfred North Whitehead: "The 16th century of our era saw
the disruption of Western Christianity and the rise of modern sci-
ence . . . in the 17th century, the birth of modern science. . . ."[27] Er-
win Schrödinger speaks of our age as being "possessed by a strong
urge towards the criticism of traditional customs and opinions," of a
new spirit which demands "rational thought on every subject."[28] A
most complicated situation has arisen from the fact that science has
refrained from aiming at a "total view of the world."[29] Any phi-
losophy worthy of its name, therefore, has to aim forthwith toward
the acknowledgment of science but, in acknowledging it, has to de-
fine its limits and the ineffable quality, the *chiffre* of Being.[30] The
chiffre of Being is also the essence of art. In adopting scientific view-
points, in making discoveries like those of any specialized scientist,
in following a certain idea or trend to its extreme—in all this, the
modern artist has either paralleled the scientific development or
has been influenced, as all of us have been influenced, by the pro-
found changes that scientific thought and its practical application
in technology have made in our lives. So when we ask why the
concept of contemporary art deviates so essentially from the tradi-
tional concept of art, we have to ascertain first whether in the litera-
ture on contemporary art the question is answered from a unified
point of view, taking into account the influence of scientific method
and thought. This approach will reveal itself to be the one to pro-
vide us with a satisfactory answer. The influences of scientific method
and thought on art show themselves to be:

(a) direct—when scientific methods and ideas are directly taken
 over into the practice of the artist; and

(b) indirect—through the changes brought about by science in in-
 dustrial society and in the whole outlook on life and art.

Without a study of these questions one cannot arrive at an under-
standing of the spiritual crisis of our time.[31] And on this understand-
ing a valid interpretation of the contemporary art is dependent. There
has been only sporadic work done on special problems in this field.
Parallels between the theories of contemporary artists (from Courbet
onward) have been drawn tentatively, and influences of science have

been mentioned to some extent in new literature. We realize also that a new metaphysical approach in painting (de Chirico, Klee, Miró) showed itself to have anticipated some trends in the contemporary philosophy of science, especially the reconsidering of the problem of metaphysics (E. A. Burtt, Max Born, and Erwin Schrödinger, among others). We can, however, also see the trend of these painters as a continuation of the Symbolist movement, which constitutes a parallel to Bergson's antirationalist philosophy. Such studies may lead to a simplification of the whole picture and to a new interpretation and definition of modern art. In rendering in perspective the intermediate cultural period through which we are going and in which the old religious, philosophic, and moral concepts are in a state of dissolution, the birth of new concepts and form values, a new myth and a new world view in progress, will be made more comprehensible.

When J. J. Winckelmann, who for the first time focused European interest on the art monuments of the old world, wrote in the preface to his study *Von der Kunst unter den Griechen*: "When I further realized that many antique works of art were either not known or not understood, I sought to combine scholarly learning with art," he was mainly concerned with information.[32] The interpretation was a secondary matter; even when measured by their different ideologies, stylistically speaking there is one unbroken line of development in both Christian art and the art of antiquity.[33] We understand why with the advent of modern science our task is so essentially different. This is amply acknowledged in the educational program of the Galleria Nazionale d'Arte Moderna in Rome. There is, however, yet another aspect of the problem.

ART AND EDUCATION

That modern art has been attacked and that the attacks are still continuing is well known. The history of modern art criticism, in creating martyrs and saints among artists, such as van Gogh, Cézanne, Edvard Munch, Modigliani, Ernst Josephson, and many others, has written a black chapter in its annals. Oswald Spengler openly says:

An artificial art is incapable of any organic development. It signifies the end. The conclusion to be drawn from this—a bitter admission—is that occidental art is irrevocably finished. . . . What is today being carried on as art is impotence and false-

hood, and this is as valid for music since Wagner as it is for painting since Manet, Cézanne, Leibl or Menzel.[34]

The term "the dehumanization of art" was coined by José Ortega y Gasset. In their attacks on contemporary art, those led by religious considerations have written most consistently indeed—for example, Bernard Champigneulle, Wladimir Weidlé, Nicholas Berdyaev, Vladimir Soloviev, and, more recently, Hans Sedlmayr. J. Huizinga and P. A. Sorokin are both skeptical about the modern developments in art. So is C. G. Jung. Violent attacks on modern art have been made by de Chirico, by Bernard Berenson, by Wyndham Lewis, and by many other writers in different countries. Under such circumstances, a conscientious and penetrating interpretation of modern art is an act of ethical necessity. As many of these writers treat their subject from a "Catholic" point of view, it is obvious that the importance of having a serious podium for polemics and a genuine source of information on modern art in Rome itself is unquestionable. That the main purpose of such educational activity is to enlighten the public and inform the art student none will doubt, nor that it is the very essence of an art museum's activities to give inspiration and enlightenment to the artist himself. In a time, however, when particularly in the initial stages of industrialism so much damage was done to all aesthetic values,[35] there is still another aspect to the problem of art and education. The soul cries out in the desert in which scientific thinking has left us, and it is for this reason that Whitehead claims that the "fertilization of the soul is the reason for the necessity of art," that the "importance of living art . . . can hardly be exaggerated."[36] It is the cautious leading-back on the path toward the sound imaginative powers in all men which have been destroyed by our civilization that is and must be the ultimate goal of all art education. A public which will be conscientiously educated toward new aesthetic values is a public which ultimately will also conscientiously take part in the building up of a meaningful modern civilization. In the middle of the century, however, we seem to have reached another crisis, this time one in the very center of the modern art movement. When analyzing Pop art, Herbert Read wrote:

> To what extent are we critics responsible for the present nihilistic phase of art? Is it a logical consequence of all we have striven for in the past fifty years? Does the movement that began with Cézanne and his resolve to wrest the secret of being

from the visible universe lead logically and inevitably to the present disintegration of the visual image? I would wear sackcloth and ashes if I thought so. . . . The social conditions that determine the emergence of such a kind of anti-art are not ephemeral: they are with us in increasing and frightening intensity. Until we can halt these processes of destruction and standardization, of materialism and mass communication, art will always be subject to the threat of disintegration. The genuine arts of today are engaged in a heroic struggle against mediocrity and mass values, and if they lose, then art, in any meaningful sense, is dead. If art dies, then the spirit of man becomes impotent and the world relapses into barbarism.[37]

NOTES

1. See Kakuzo Okakura, *The Book of Tea: A Japanese Harmony of Art, Culture and the Simple Life* (Edinburgh and London, 1919).
2. Rainer Maria Rilke, *Auguste Rodin*, in *Selected Works: Prose*, trans. G. Craig Houston (London, 1954).
3. *Handzeichnungen alter Meister*, in *Prosa III* (Frankfurt am Main, 1952).
4. Gustave Flaubert, *Éducation Sentimentale* (Paris, 1912).
5. *Time Regained*, Vol. 12 of *Remembrance of Things Past*, trans. Stephen Hudson (London, 1941).
6. Marcel Proust, "Chardin," in *By Way of Sainte-Beuve*, trans. Sylvia Townsend Warner (London, 1958).
7. Anne Ridler, "Piero della Francesca," in *Golden Bird* (London, 1947).
8. *Collected Shorter Poems 1927–1957* (London and New York, 1945).
9. Quoted from *The Faber Book of Modern Verse*, ed. Michael Roberts (London, 1947).
10. Paul Valéry, "The Problem of Museums," in *The Collected Works of Paul Valéry*, Vol. 12, ed. Jackson Mathews, trans. David Paul (Princeton, 1960).
11. "L'Oeuvre d'art," in *Combat* (Paris, 1934).
12. *Museum Without Walls* (New York and London, 1953). See also André Malraux, "Le Problème fondamental du musée," paper read at the Congress of Art and Archaeology, New York, January 1954, and published in *La Revue des Arts* (Paris), No. 1, 1954.
13. *Goethes Autobiographische Schriften*, Vol. 1 (Leipzig, 1922).
14. *Sämtliche Werke*, Vol. 1, ed. Hellingrath, Seebass, and Pigenot (Berlin, 1923).

15. 3d ed., 2 vols., ed. John M. Robertson (London, 1900).
16. *Werke*, Vol. 1: *Vorlesungen über Ästhetik* (Berlin-Leipzig, 1837–87).
17. Okakura, *The Book of Tea*.
18. *Encyclopedia Britannica*, 11th ed.
19. (Leipzig, 1913).
20. (Vienna, 1923).
21. *Souvenirs d'un marchand de tableaux* (Paris, 1948).
22. Ibid.
23. Ibid.
24. John Rewald, *The Ordeal of Paul Cézanne* (London, 1950).
25. Museum publication, La Galleria Nazionale d'Arte Moderna.
26. Thomas Bodkin, *The Approach to Painting* (London, 1945).
27. *Science and the Modern World* (Cambridge, 1945).
28. *Science and the Human Temperament* (London, 1935).
29. Werner Heisenberg, *Philosophic Problems of Nuclear Science* (London, 1952).
30. Karl Jaspers, *Philosophie*, 2d ed. (Berlin-Göttingen-Heidelberg, 1948).
31. Linguistically, the word *crisis* (from the Greek *krisis*, "decision") is appropriate. For new facts and ideas have occurred which compel us to take up a definite position on essential questions.
32. Quoted in Johann Joachim Winckelmann, *Ausgewählte Schriften und Briefe* (Wiesbaden, 1948).
33. See Max Dvořak, "Katakombenmalereien, Die Anfänge der Christlichen Kunst," in *Kunstgeschichte als Geistesgeschichte* (Munich, 1924).
34. *Der Untergang des Abendlandes* (Munich, 1922).
35. See the quotations from John Ruskin, William Morris, Eric Gill, and others in J. P. Hodin, "Herbert Read's Philosophy of Art," in *The Dilemma of Being Modern* (London, 1956).
36. *Science and the Modern World*.
37. *The Origins of Form in Art* (London, 1965).

MODERN ART—
A HISTORICAL OUTLINE

MODERN ART—A HISTORICAL OUTLINE

THE EARLY PHASE

REALISM-NATURALISM (Pleinairism from 1836 until the emergence of objective Realism; 1855, first Manifesto of Courbet and exhibition in his own Pavillon du Réalisme).

The School of Barbizon or of the Forest of Fontainebleau, Pleinairism (*Paysage intime*). *Forerunners*: John Constable (1776–1837). R. P. Bonnington (1801–28). *Masters*: Théodore Rousseau (1812–67). Narcisse Diaz (1808–73). Jean François Millet (1814–75). Charles François Daubigny (1817–78). The objective Realism of Gustave Courbet (1817–77). The School of Courbet. *In Germany*: Wilhelm Leibl (1884–1900). Wilhelm Trübner (1851-1917). *In Italy*: Giovanni Segantini (1858–99). *In Spain*: Ignacio Zuloaga y Zabaleta (1870–1945). *In England*: Augustus John (1878–1961). *In Sweden*: Anders Zorn (1860–1920). *In Belgium*: Jozef Israëls (1824–1911). *In Denmark*: P. S. Krøyer (1851–1909).

SUBJECTIVE REALISM

Edouard Manet (1832–83), listed under "The Great Independents"; Renoir said of Courbet that he is still tradition, whereas Manet is the truly new. Edgar Degas (1834–1917). Henri de Toulouse-Lautrec (1864–1901). Leading to and as a parallel development of

IMPRESSIONISM (1874–86)

Forerunner: William Turner (1775–1851). *Masters*: Claude Monet (1840–1926). Auguste Renoir (1841–1919); his later development

335

listed under "La Renaissance du Sentiment Classique."[1] Camille Pissarro (1830–1903); later becomes Pointillist. Alfred Sisley (1840–99). Berthe Morisot (1841–95). Also Paul Cézanne (1839–1906), temporarily: "Faire de l'Impressionisme quelque chose de solide et de durable comme l'art des musées." Paul Gauguin (1848–1903) in his beginnings. *Also*: J. F. Bazille (1841–70), Mary Cassatt (1855–1927), Eugène Boudin (1824–98), J. B. Jongkind (1818–91), G. Caillebotte (1848–94), J. B. A. Guillaumin (1841–1927), and others.

1st Impressionist Exhibition, 1874: Pissarro, Monet, Renoir, Cézanne, Sisley, Guillaumin, Berthe Morisot, Degas, Boudin, Henri Rouart, Braquemond, and de Nittis

2nd Impressionist Exhibition, 1876: Degas, Renoir, Pissarro, Monet, Sisley, Berthe Morisot, Gustave Caillebotte, and others

3rd Impressionist Exhibition, 1877: Monet, Renoir, Caillebotte, Pissarro, Sisley, Guillaumin, Berthe Morisot, Cézanne, Degas, and others

4th Impressionist Exhibition, 1879: Degas, Pissarro, Monet, Mary Cassatt, Forain, and others

5th Impressionist Exhibition, 1880: Pissarro, Caillebotte, Berthe Morisot, Raffaeli, Gauguin, Mary Cassatt, Forain, Degas, Braquemond

6th Impressionist Exhibition, 1881: Monet, Guillaumin, Gauguin, Mary Cassatt, Degas, Berthe Morisot, and others

7th Impressionist Exhibition, 1882: Renoir, Pissarro, Monet, Sisley, Guillaumin, Caillebotte, Berthe Morisot, Gauguin

8th Impressionist Exhibition, 1886: Degas, Mary Cassatt, Forain, Berthe Morisot, Gauguin, Odilon Redon, and others; and the Divisionists Seurat, Pissarro, Signac, and Emil Schuffenecker[2]

In Germany: Max Liebermann (1847–1935), Max Slevogt (1868–1932). *In England*: Walter Richard Sickert (1860–1942), Lucien Pissarro (1863–1944). *In the United States*: James Whistler (1834–1903).[3]

NEO-IMPRESSIONISM, also called POINTILLISM or DIVISIONISM (1882–91)

Georges Seurat (1859–91), Paul Signac (1863–1935), Henri-Edmond Cross (1856–1910), Maximilian Luce (1858–1941), Charles Angrand (1854–1926), Albert Dubois-Pillet (1854–90), H. Petitjean (1854–1929), and Lucie Cousturier (1870–1925). *Also*: Theo van Rysselberghe (1862–1926), Henri Van de Velde, Leo Gausson, and Louis Hayet.

SYMBOLISM (1885–1900)

Forerunners: Gustave Moreau (1826–98), the teacher of Matisse, Rouault, Marquet, and Jean Puy; Puvis de Chavannes (1824–98), Eugène Carrière (1848–1906), and Odilon Redon (1840–1916). *Masters*: Félicien J. V. Rops (1833–98), The "Rose-Croix Painters," The "Nabis" Pierre Bonnard (1867–1947) and Edouard Vuillard (1868–1940) in their beginnings. K. Xavier Roussel (1867–1944), Maurice Denis (1870–1943), Paul E. Ranson (1862–1909), Felix Vallotton (1865–1925), Paul Sérusier (1863–1927), "The School of Pont-Aven" (Synthétisme and Cloisonnism): Paul Gauguin (1848–1903) for a period. Emile Bernard (1868–1941), Louis Anquetin (1861–1932), Armand Seguin (1869–1903), Henry Moret (1856–1913), M. E. L. Maufra (1861–1918). *Also*: Charles Laval, Charles Filiger, E. P. de Chamaillard, and others.

THE GREAT INDEPENDENTS

Paul Gauguin (1848–1903). The return to Primitivism. Links Symbolism and Fauvism.

Vincent van Gogh (1853–90), whose late art is the beginning in France of Expressionism.

Auguste Renoir (1841–1919), because of the classic development in his mature style. Pierre Bonnard (1867–1947), and also to some extent Edouard Vuillard (1868–1940), the masters of the *réalité poétique,* of *Intimism.* (Bonnard's "touche" found a new development in Tachism.)

Paul Cézanne (1839–1906), whose style and theories gave the initiative to the rise of Cubism. With him ends the early phase of modern painting.

The developments of Seurat and his friends, of Symbolism, of Gauguin, van Gogh, Cézanne, and Bonnard, are often called comprehensively *Post-Impressionism*. This term bears no stylistic implication and is to be considered only as a designation of a period, that is, the time after Impressionism.[4] Manet, Gauguin, van Gogh, Renoir, Bonnard, and Cézanne we call the Great Independents because they are pioneers of future developments.

THE PHASE OF RADICALISM

Fauvism (established between 1905–7). Its great master is Henri Matisse (1869–1954). Adherers to the Fauvist movement were Kees van Dongen (b. 1877), Louis Valtat (1869–1952), and the members of three groups. The group of the Atelier Gustave Moreau and the Académie Carrière: Albert Marquet (1875–1947), Henri Charles Manguin (1874–1943), Charles Camoin (1879–1965), and Jean Puy (1876–1960); the group of Chatou: André Derain (1880–1954) and Maurice Vlaminck (1876–1958); the group of Le Havre: Othon Friesz (1879–1949), Raoul Dufy (1877–1953), and Georges Braque (1882–1963), the latter only for a short time.[5]

CUBISM

Founders: Pablo Picasso (b. 1881) and Georges Braque (1882–1963). *The School of Cubism*: Albert Gleizes (1881–1953), Jean Metzinger (1883–1956), Juan Gris (1887–1927), Robert Delaunay (1885–1941), Fernand Léger (1881–1956), Louis Marcoussis (1883–1941), Roger de la Fresnaye (1885–1925); Francis Picabia (1879–1953), temporarily; also Le Fauconnier (1881–1946), Jean Souverbie (b. 1891), Léopold Survage (b. 1879), Jean Lurçat (1892–1966), Henri Hayden (b. 1883; now a figurative Realist), René Auberjonois (1872–1957), and others.

The beginnings of Cubism, 1906–8 (influence of Cézanne-Seurat and Negro sculpture). *Analytical Cubism*, 1909–12. In 1910 Picasso reaches a stage in his development which is near abstraction. The collages of 1914 are practically abstract.

Section d'Or group founded in 1912. *Members*: Gleizes, Metzinger, Jacques Villon (1875–1963), Frank Kupka (1871–1957), Picabia, Marcoussis, André Lhote (1885–1962), and others.

Collage technique developed between 1912–14. Picasso's use of new textures still influences the art of after 1950. Cubist constructions developed between 1912–13. *Decorative* (enriched) *Cubism*,

1914–15. *Synthetic Cubism,* 1912–22. Principles of simultaneism, of superimposition and transparence applied; that is, the cumulative rendering of the object viewed from different points. The term *Orphism* was used by Guillaume Apollinaire in 1912 to designate the art of Robert Delaunay. *Curvilinear Cubism,* 1923–26. Surrealist convulsive element merges with Cubism in the years 1925–27.[6]

The entire work of Picasso (with the exception of his various temporary returns to classic concepts) is "Cubist" in its spirit, that is, it is carried by a recreative revolutionary *élan.* From 1908–14 Braque and Picasso worked inseparably. From 1917 on Braque developed a personal style. Léger was Cubist as early as 1910/11 and from 1917 on developed a personal style. Picabia was Cubist during the years 1910–13. In 1913 he turned Dadaist.

FUTURISM (early phase, 1909–14)

1909: F. T. Marinetti's first Futurist Manifesto. 1914: publication of Umberto Boccioni's *Pittura Scultura Futuriste.*

Founder: the poet F. T. Marinetti (1876–1944); its most important painter, Umberto Boccioni (1882–1916).

Members: Carlo Carrà (b. 1881), Luigi Russolo (1885–1947). Giacomo Balla (1874–1958) and Gino Severini (1883–1966) join the movement in 1910. Other Futurist artists, temporarily: Ardengo Soffici (b. 1879), Ottone Rosai (1895–1957), Mario Sironi (b. 1885), Emilio Pettoruti (b. 1895).[7]

PURISM (1915–25)

Founders: Amedée Ozenfant (1886–1966) and Charles-Edouard Jeanneret—alias Le Corbusier (1887–1965).

In 1915 appears the *Revue l'Élan*; in 1918, publication in Paris of Ozenfant's and Jeanneret's book *Après le Cubisme,* and in 1925, of their volume *La Peinture moderne. Revue l'Esprit Nouveau,* Paris, 1920–25, propagates Purist ideas.[8]

DADAISM (1911–22)

Forerunners: The Cubist disintegration of natural forms, the Futurist rebellion against the notions of harmony and good taste (1910). The paintings of de Chirico (b. 1888) from 1910 on. The early abstract improvisations of Kandinsky (1910–14). Chagall's work, the style of which was described by Guillaume Apollinaire (1880–1918) in 1910 as *Sur-naturalisme.* Marcel Duchamp's (b. 1887) anti-Cub-

ist pictures from 1911 on. The Cubist *papier collé*, in which bits of pasted newspaper, wallpaper, etc., were used. Glass, wood, cardboard, cement, horsehair, mirrors, etc., were recommended in 1913 as new materials by Umberto Boccioni (1882–1916). Picasso's relief constructions of odds and ends of wood, paper, sackcloth, etc. Francis Picabia's (1879–1953) Dadaist *Catch as Catch Can* and *Amorphism* (1913). Duchamp's first ready-made, Paul Klee's (1879–1940) *Little World* (1914). Dada works exhibited in New York at the Armory Show in 1913 and by the Stieglitz Gallery up to 1915. The *Review 291* founded in 1915 by Alfred Stieglitz (1864–1946) and Agnes Ernst Meyer.

Founding of the Cabaret Voltaire in Zurich, 1916, by Hugo Ball.

Development: The first organized Dadaists were Tristan Tzara (b. 1896), Hans (Jean) Arp (1887–1966), Marcel Janco (b. 1895), Hugo Ball (1886–1927), and Richard Hülsenbeck (b. 1892). Other early contributors to Dadaist publications: Guillaume Apollinaire, Blaise Cendrars (b. 1887), Benjamin Peret (1899–1959), E. Hennings (1885–1948), Jakob van Hoddis (b. 1884), F. T. Marinetti (1876–1944), Pierre Reverdy (b. 1889), Max Jacob (b. 1876), André Breton (1896–1966), Philippe Soupault (b. 1897), Louis Aragon (b. 1897), Wassili Kandinsky (1886–1944), Paul Dermée (1886–1957), Pierre Albert-Birot (1885–1967), Marcel Slodki (1892–1942).

1916: The first Dada manifesto by Tzara. Zurich Dada art, 1916–18. Arp, Christian Schad (b. 1894), Otto van Rees (b. 1884), Arthur Segal (1875–1944), Picasso, Modigliani, and others.

1916–17: Man Ray's *Theatre* in New York, publication *Sic* in Paris, and *Nord-Sud* propagate Dada spirit. Marcel Duchamp brings out in New York the review *The Blind Man,* and *Wrong-wrong.* Francis Picabia and Walter C. Arensberg publish *Review 391.* Picabia arrives via Barcelona in Zurich to join Tzara.

Dada 1 and *Dada 2* published in Zurich, 1917.

Berlin: Hülsenbeck organizes Dada movement. *Members*: John Heartfield, Hanna Höch (b. 1889), George Grosz (1893–1959), Raoul Hausmann (b. 1886), Franz Jung, Johannes Baader. Hülsenbeck publishes periodicals *Club Dada* and *Der Dada* in 1917.

Dada 3 appears in Zurich, 1918.

Cologne, 1918: Max Ernst (b. 1891), Johannes T. Baargeld, and Hans Arp are leaders of the Dadaist movement there.

Zurich, 1919: Tristan Tzara published *25 Poèmes* with woodcuts by Arp.

Dada 4 and *5* appear under the title *Anthologie Dada.*

Paris, 1919: *Littérature* founded by Breton, Soupault, and Aragon, with the collaboration of Paul Eluard (1895–1952), devoted to Dadaism. Arrival of Tristan Tzara in Paris.

Cologne, 1919: J. T. Baargeld publishes Dada newspaper *Ventilator*. Arp and Ernst bring out the *Fatagaga* series of collages.

Hanover, 1919: Kurt Schwitters (1887–1948) introduces *Merz*, a term analogous to Dada.

Paris, 1920: Public demonstration of Dada (Palais des Fêtes). First number of *Proverbe* published by Paul Eluard. Last number of *Dada* appears under title *Dadaphone*. Picabia brings out review *Cannibale*. *Littérature* publishes twenty-three Dada manifestos. One-man exhibitions of: Picabia, Max Ernst, Georges Ribemont-Dessaignes (b. 1884), Man Ray (b. 1890), Giorgio de Chirico (b. 1888). Arp arrives in Paris. Climax of movement in Paris: Dada Festival at Salle Gaveau (Dermée, Eluard, Picabia, Tzara, Breton, Soupault, Ribemont-Dessaignes, Aragon).

Berlin, 1920: International Dada Exhibition. Peak and end of Dada in Berlin.

Cologne, 1920: Periodical *Die Schammade* founded.

Paris, 1921: *The Magnetic Fields* published by Breton and Soupault.

New York, 1921: Marcel Duchamp and Man Ray publish *New York Dada*.

Paris, 1922: International Dada Exhibition. Disintegration of Dada in Paris 1921–23. End of Dadaism in France.[9]

Surrealism (1924–36)

Forerunners: those of Dadaism, and Dadaism itself. *Founder*: the author and psychoanalyst André Breton (1896–1966). *Masters*: Max Ernst (b. 1891), Salvador Dali (b. 1904), André Masson (b. 1896), Joan Miró (b. 1893), Yves Tanguy (1900–1959), Hans Arp (b. 1887), Pierre Roy (1880–1950), Man Ray (b. 1890), René Magritte (1898–1967), Paul Delvaux (b. 1897), Marcel Duchamp (b. 1887), Francis Picabia (1879–1953); also Oscar Dominguez (b. 1906), Wolfgang Paalen (1905–59), and others.

New techniques: Frottage (Max Ernst); exquisite corpse—*cadavre exquis* (collective); Rayograph (Man Ray); decalcomania (O. Dominguez); smoke pictures (Wolfgang Paalen); use of double images, *objets trouvés*, metamorphoses, dream pictures, Surrealist objects, etc.

Paris, 1924: First manifesto of Surrealism by André Breton. Peri-

odical *La Révolution Surréaliste* published by Pierre Naville (b. 1903) and Benjamin Péret (b. 1899). Masson exhibition.

Paris, 1925: First collective exhibition of Surrealism (Picasso, Man Ray, Arp, Klee, Masson, Ernst, Miró, Pierre Roy, de Chirico). Miró exhibition. Adherence of Surrealism to Communism (*La Révolution Surréaliste*, No. 5).

Paris, 1926: Second Surrealist exhibition includes also Marcel Duchamp (Rrose Sélavy) and Francis Picabia. Max Ernst exhibition. Man Ray exhibition.

Paris, 1927: One-man exhibitions by Arp, Max Ernst, Man Ray, Tanguy; de Chirico exhibits in New York.

Paris, 1928: Breton publishes *Le Surréalisme et la peinture*. Group exhibition by Arp, de Chirico, Max Ernst, Malkine, Masson, Miró, Picabia, Roy, Tanguy. One-man exhibitions: Ernst, Miró, de Chirico. Arp exhibits in Brussels, Miró in New York.

Paris, 1929: Surrealist film *Le Chien andalou*, by Dali and Buñuel. One-man exhibitions: Arp, Dali, Masson, Man Ray. Miró exhibits in Brussels, Ernst in Berlin. Founding by G. Ribemont-Dessaignes of the review *Bifur* (1929–31).

Paris, 1930: Breton publishes second manifesto of Surrealism. *Le Surréalisme au service de la révolution* edited by Breton. Dali's paranoiac method of criticism introduced (published subsequently in *La Femme Visible*). One-man exhibitions: Dali, Ernst, Miró. Exhibition of Surrealist collages: Arp, Braque, Dali, Duchamp, Ernst, Gris, Miró, Magritte, Man Ray, Picabia, Picasso, Tanguy. Preface to Catalogue by Aragon: *La Peinture au défi*. Automatic texts by Breton and Eluard: *L'Immaculée Conception*. Klee exhibits in New York.

Paris, 1931: Surrealist film *L'Age d'or*, by Dali and Buñuel. Dali introduces the "Surrealist object" in *Le Surréalisme au service de la révolution*. First purely Surrealist exhibition in the United States (Dali, de Chirico, Ernst, Miró, Picasso, Roy, Survage, Masson).

Paris, 1932: Breton publishes *Les Vases communiquantes*. Exhibitions: Dali, Ernst, Masson, Miró. Arp exhibits in Basle. Surrealist group exhibition in New York.

Paris, 1933: The Surrealists take part in general exhibitions. Dali, Miró, and Masson exhibit in New York, Ernst and Miró in London.

Paris, 1934: One-man exhibitions of Ernst and Victor Brauner. Arp, Giacometti, Dali exhibit in New York. Dali exhibits in London and Barcelona. General exhibition of Arp, Ernst, Giacometti, Miró in Zurich.

Paris, 1935: Exhibitions and other activities in Central Europe, Scandinavia, Tenerife, Yugoslavia, Japan. General exhibitions of Surrealists and one-man exhibitions of Tanguy, Ernst, and Miró in Paris. Miró, Masson, Dali exhibit in New York.

Paris, 1936: Paris exhibition of Surrealist objects. International Surrealist exhibition in London. Dali, Tanguy, Magritte, Ernst, de Chirico, Miró exhibit in New York. Decline of Surrealist impetus.[10]

ABSTRACT ART (from 1910 until about 1930)[11]

Forerunners: Cubism (influence on Kupka, Mondrian, and others). Fauvism (influence on Kandinsky). Expressionism (influence on Kandinsky, Klee). Tchurlianis (1906–7), Picasso's and Braque's near-abstractions (1910–14).

Some of Juan Gris' and also of Léger's "contrasting forms," 1913–14, are near-abstract.

The first masters: Wassili Kandinsky (1866–1944). Phase of Abstract Expressionism from 1910, and subsequent development.

Michael Larionow (1888–1964) and Nathalia Gontcharova (1881–1962): *Rayonism* (*Lutchism*), 1911.

Frank Kupka (1871–1957) from 1911 on. Francis Picabia (1879–1953) between 1912–13.

Robert Delaunay (1885–1941): *Simultaneism*, 1912 (called by Apollinaire *Orphism*). Sonia Delaunay-Terk (b. 1885).

Morgan Russell (1886–1953) and Stanton MacDonald-Wright (1890–1966): *Synchronism*, 1913 (related to Simultaneism).

Piet Mondrian (1872–1944): First abstract paintings in 1913. *Neo-Plasticism*, 1920. Member of the de Stijl group, founded in 1917. Also a few works by Franz Marc (1880–1916), August Macke (1887–1914) from 1913 and 1914, and Paul Klee (1879–1940), from 1914, 1917–18, etc., are abstract.

Casimir Malevitch (1878–1935): *Suprematism*, 1913. Vladimir Tatlin (1885–1953); works from 1913–17; Naum Gabo (b. 1890) and Antoine Pevsner (1886–1962); works from 1915–17: *Constructivism*.

Patrick Henry Bruce (1880–1937), from 1913 on. Giacomo Balla's (1871–1958) and Gino Severini's (1883–1966) abstract compositions of 1913. Also a few works of Carlo Carrà (b. 1881), Umberto Boccioni (1882–1916), Ardengo Soffici (1879–1964), and later on of Enrico Prampolini (1896–1956) are abstract. Emilio Pettoruti (b. 1895), first abstract works, 1914. Hans (Jean) Arp (1887–1966) and Alberto

Magnelli (b. 1888) make abstract compositions in 1915. Sophie Taeuber-Arp anticipates Neo-Plasticism (reduction of actual forms into geometric patterns) in 1916. Victor Servranckx (1897–1965), works since 1917. Theo van Doesburg (1883–1931). Geometricizing of natural forms since 1916. *Elementarism*, 1925. Member of the *de Stijl* group, together with the painters Bart van der Leek (1876–1958) and Vilmos Huszar (1884–1960), the sculptor Georges Vantongerloo (1886–1965), the architects Oud and van't Hoff, and the poet Kok.

Alexander Rodchenko (1891–1956): *Non-Objectivism*, 1917. El Lissitzky's (1890–1941) compositions called *Proun*, 1919. Marcel Janco (b. 1895), works from 1917–19. Viking Eggeling (1880–1925), abstract films since 1917. Hans Richter (b. 1888), abstract from 1917; abstract films from 1919. (In 1923 Man Ray also made an abstract film, and in 1924 Léger.)

Friedrich Vordemberge-Gildewart (1897–1962), abstract from 1919 on. Otto Freundlich (1878–1934), abstract from 1919 on. Pevsner, Gabo, and Lazslo Moholy-Nagy (1895–1946) propagate Russian Suprematism and Constructivism at the *Bauhaus* (1919–33) in Germany. Moholy-Nagy creates *Photograms*; abstract photography made also by Man Ray and Francis Bruguière. The Bauhaus painters and graphic artists were: Paul Klee (1879–1940), Lyonel Feininger (1871–1956), Oskar Schlemmer (1888–1943), Wassili Kandinsky (1866–1944), Josef Albers (b. 1888), Herbert Bayer (b. 1900), Johannes Itten (1888–1967), Georg Muche (b. 1895), Lothar Schreyer (1886–1966), Moholy-Nagy; also the sculptor Gerhard Marcks and the architects Walter Gropius and Marcel Breuer.[12] In 1937, Moholy-Nagy founded a new Bauhaus, the Institute of Design, in Chicago. Hans Hartung's (b. 1904) early abstract work, 1922.

Cesar Domela (b. 1900), abstract from 1923. Joins the de Stijl group in 1924. Ben Nicholson (b. 1894). First abstract work, 1923–24. Sergei Charchoune (b. 1888), works between 1925-35. "L'Art d'Aujourd'hui" exhibition, Paris, 1925. The "Cercle et Carré" exhibition, Paris, 1930. Jean Helion (b. 1904), abstract since 1930, member of the *Abstraction-Création* group, founded 1932–36 by Georges Vantongerloo (b. 1886) and Auguste Herbin (1882–1960).

Other abstractionists: Joseph Albers (b. 1888); Rudolph Bauer (1889–1954), abstract since 1929; Willi Baumeister (1889–1955), member of the *Cercle et Carré* group in 1930 and of the Abstraction-Création group in 1932; Alfred Reth (1884–1967), formerly Cubist;

member of the Abstraction-Création group in 1932; Kurt Schwitters (1887–1948), member of the Cercle et Carré group in 1930 and of the Abstraction-Création group in 1932.

EXPRESSIONISM

The later van Gogh (from 1889 on), Edvard Munch (1863–1944), Louis Corinth (1858–1925). Ferdinand Hodler (1853–1918) and James Ensor (1860–1949) to some extent. Oskar Kokoschka (b. 1886); the group *Die Brücke* (1905–13): Ernst Ludwig Kirchner (1880–1938), Erich Heckel (b. 1883), Karl Schmidt-Rottluff (b. 1884), Emil Nolde (1867–1956), member for a short time only; Otto Mueller (1874–1930), Fritz Bleyl (b. 1880), Max Pechstein (1881–1955), Cuno Amiet (1868–1961), Axel Gallen-Kallela (1865–1931).

Georges Rouault (1871–1958), Chaim Soutine (1894–1943), Ludwig Meidner (1884–1966).

A position between Expressionism-Fauvism (the early Kandinsky, the early Jawlensky) and the post-Cubist movement is taken up by the group *Der Blaue Reiter*, founded at the end of 1911 and developed out of the Neue Künstler-Vereinigung in Munich, of which the most important members were: Paul Klee (1879–1940), Wassili Kandinsky (1866–1944), Franz Marc (1880–1916), August Macke (1887–1914), Alexej Jawlensky (1864–1942), Heinrich Campendonck (1889–1957), and Gabriele Münter (1877–1962).[13]

FANTASTIC ART

The term *fantastic* was used by Baudelaire in *Curiosités esthetiques* to characterize the art of Goya.

Forerunners: Gustave Moreau and Odilon Redon (see "Symbolism"). Arnold Böcklin (1827–1906; influence on de Chirico), Adolphe Monticelli (1824–86), and Henri Rousseau (Le Douanier, 1884–1910; in his exotic scenes from 1904–8).

Masters: James Ensor (1860–1949), Marc Chagall (b. 1887), Giorgio de Chirico (b. 1888), and the *Metaphysical School—Scuola Metafisica* (1917–21): Carlo Carrà (b. 1881) and Giorgio Morandi (1890–1964).[14]

Also André Masson (b. 1896) and Joan Miró (b. 1893), with their Surrealist ancestry.[15]

Paul Klee (1879–1940).[16]

NEO-PRIMITIVISM or NAÏVISM

Maurice Utrillo (1883–1955) and *"les maîtres populaires de la réalité"* (term coined by Maximilian Gauthier. Wilhelm Uhde called them *"les maîtres primitifs,"* Raymond Escholier *"les peintres populaires,"* Maurice Raynal *"les peintres du dimanche,"* and Jean Cassou *"les primitifs contemporains"*).

Henri Rousseau (Le Douanier; 1844–1910), André Bauchant (1873–1958), Louis Vivin (1861–1936), Séraphine Louis (1864–1934), Camille Bombois (b. 1883), Dominique Peyronnet (1872–1943). Also Jean Eve, Déchelette, Maclet, and others. In the United States Louis Michel Eilshemius (1864–1941).[17]

NEO-REALISM

Called by Bernard Dorival *"protestation du bon sens,"* by René Huyghe *"retour au réel,"* by Lionello Venturi "return to nature"; also "Neo-Humanism," *"les traditions sensibles,"* and *"renovation d'un art complet"* (Huyghe). Since about 1930, as reaction against the cerebral tendencies rooted in Cubism.

André Derain's post-Fauvist development is also to be seen as a reaction against Cubist rigidity.

Neo-Realists: André Dunoyer de Segonzac (b. 1884), Henri de Waroquier (b. 1881), Charles Dufresne (1876–1938), Amedée de la Patellière (1890–1932), Jean Louis Boussingault (1883–1943), François Desnoyer (b. 1894). Also Luc-Albert Moreau (1883–1948), Maurice Asselin (1882–1947), Edmond Céria (1884–1955), Robert Lotiron (1896–1967), Paul-Elie Gernes (1888–1948), and others.

Neo-Humanists (and related trends): Maurice Brianchon (b. 1899), R. Chastel (b. 1897), Raymond Legueult (b. 1898), Roland Oudot (b. 1897), André Planson (b. 1898), Maurice Albert Loutreuil (1885–1925), Maurice L. Savin (b. 1894), Jacques Thévenet (b. 1891), Jean Pougni (1894–1956), Eugène Zak (1884–1926), Constantin Terechkovitch (b. 1902), J. C. Aujame (b. 1905), Christian Berard (1902–49), R. Chapelin-Midy (b. 1904), R. Bezombes (b. 1913); also: Ch.-H. Caillard, Jacques Grange, Poucelet, and others.

Franz Roh speaks of *"Nach-Expressionismus"* in his book of the same title, dealing with the reactions against Expressionism and the post-Expressionist development, with the exception of abstract art.

NEUE SACHLICHKEIT—*New Objectivity; Idealer Realismus, Verismus, Luminismus, Neuklassizismus.*[18]

Max Beckmann (1884–1950) developed out of his Expressionist background a powerful stylized figural trend. Carl Hofer (1878–1945) painted lyrical, well-balanced figural compositions based on Cézanne. Alexander Kanold (1881–1939) and Georg Schrimpf (1889–1919) were representatives of the "new objectivity." The style of Otto Dix (b. 1891) is a dramatic Realism. Xaver Fuhr's (b. 1898) art oscillates between Expressionism, Neo-Primitivism, and Realism. Paula Modersohn-Becker (1876–1907) must also be mentioned here. Her Intimism is a *realisme poètique* comparable to Marie Laurencin's (1885–1957) style, but more expressive.

THE MIDDLE PHASE[19]

NEW DEVELOPMENTS IN REALISM SINCE THE EARLY THIRTIES

Social Realism was proclaimed the state formula for art styles in Soviet Russia and also in the satellite countries. Only Yugoslavia, followed later by Poland and Czechoslovakia, showed a freer development, being influenced by French taste and, to a lesser degree, by French Radicalism. Objective Realism with a Socialist tendency and popular appeal are the chief elements of Social Realism.[20] Social Realism also has representatives in other countries: André Fougeron (b. 1912) in France; Renato Guttuso (b. 1912), Carlo Levi (b. 1902), Guiseppe Zigaina (b. 1924) in Italy. (1945: Manifesto del Realismo in Italy.) Other Italian Realists: Ottone Rosai (b. 1895), Salvatore Bardi.

Realism in *Mexico*: Diego Rivera (1886–1957), David Alfaro Siqueiros (b. 1898), José Clemente Orozco (b. 1883), Antonio Ruiz (b. 1897); in *Sweden*: Albin Amelin (b. 1902); in *Norway*: Reidar Aulie (b. 1904).

In *France*: François Gruber (1913–48). *1937*: founding of the group *Forces Nouvelles*. *1948*: the group *L'Homme Témoin* exhibits in Paris: Bernard Lorjou (b. 1908), Bernard Buffet (b. 1928), Paul Rebeyrolle (b. 1926), André Minaux (b. 1923), Claude Venard (b. 1913), Mottet. Other Realists: Edouard Goerg (b. 1893), Balthus (b. 1911), Jean Commère (b. 1920), Roger Montané (b. 1916), Gi-

nette Rapp (b. 1928), Jean Vinay (b. 1907). Also Winsberg (b. 1929), Henry (b. 1924), Adnet (b. 1924), Ganne (b. 1931), Margotton (b. 1915), Paris (b. 1924), Pagava (b. 1920). The work of Buffet, Minaux, and others has in its humanism a tinge of Existentialist philosophy.

A similar tendency shows in *England*: John Bratby (b. 1928), Derrick Greaves (b. 1927), Edward Middleditch (b. 1923), Jack Smith (b. 1928). Other Realists: Stanley Spencer (1891–1959), Ruskin Spear (b. 1911). The portraits of Graham Sutherland (b. 1903), Edward Le Bas (b. 1904), Edward Burra (b. 1905), Claude Rogers (b. 1907), Lawrence Gowing (b. 1918), William Coldstream (b. 1908), H. E. du Plessis (b. 1894), Geoffrey Tibble (b. 1909).

In the *United States*: Edward Hopper (b. 1882), Ben Shahn (b. 1898), Yasuo Kunioshi (1893–1953), Maurice Prendergast (1859–1924; with Impressionist ancestry), Charles Burchfield (b. 1893; with a Surrealist tendency), Milton Avery (b. 1893), Sidney Laufmann (b. 1891; Romantic Realism), Walt Kuhn (b. 1880), P. Dickinson (1891–1930), W. Gropper (b. 1897), Morris Grave (b. 1910), Thomas Fransioli (b. 1906), Arbit Blatas (b. 1908), Andrew Wyeth (b. 1917), George Tooker (b. 1920), Philip Evergood (b. 1901), H. Sharrer (b. 1920). Also: Henry Koerner, Richard Haines, Breinin, and others.

In Germany: Friedrich Karl Gotsch (b. 1900), Paul Berger-Bergner (b. 1904), Ludwig Krebs (b. 1918), H. Pricking (b. 1930). Also: Huth (b. 1890), Eglan (b. 1917), Scheibe (b. 1914). In *Holland*: Leo Gestel, Jan Sluyters. In *Austria*: Pregartbauer (b. 1925). In *Spain*: Vaquero (b. 1900). In *Latin America*: P. Figari (1861–1938), A. Guido (b. 1892), F. Kablo (b. 1910).[21]

The Followers of Symbolism and Fantastic Art

Symbolic, Fantastic, Surrealist, and Abstract elements are often mixed in this period, as in the later work of Max Ernst.

The Cuban Wifredo Lam (b. 1902), the French Victor Brauner (b. 1903), the Chilean Roberto Matta Echaurren (b. 1912), the Austrian Fritz Hundertwasser (b. 1928) have a Surrealist ancestry. Also Alfred Aberdam (1894–1964) in France. Matta's and Hundertwasser's work have a strong bias toward abstraction. Abstract elements mixed with suggestions derived from the art of primitive peoples are also dominant in the work of the Mexican Rufino Tamayo (b. 1899) and of the American William A. Baziotes (1912–63).

In *Italy*: Followers of the Metaphysical School: Alberto Savinio (1891–1952), Salvatore Fiume (b. 1915), Arturo Nathan (1891–1944); also: Osvaldo Licini (b. 1894), Mario Sironi (b. 1885), Corrado Cagli (b. 1910), Enrico Baj (b. 1924; *Nuclear Movement*). In *Turkey*: Leone Minassian (b. 1905). In *England*: Alan Davie (b. 1920), Peter Kinley (b. 1926), Frank Avray Wilson (b. 1914) represent abstract Symbolism. In *Australia*: Sidney Nolan (b. 1917; with Primitivist-Surrealist elements). In *Belgium*: Louis Baretta (1866–1928), Henri Heerbrant (b. 1913), and others. In *Austria*: Wolfgang Hutter (b. 1928), Ernst Fuchs (b. 1930), Anton Lehmden (b. 1929), Franz Luby (b. 1902). In the *United States*: Pavel Tchelitschew (b. 1898), June Wayne (b. 1918), Dan Lutz (b. 1906), William G. Congdon (b. 1912), Inez Johnston (b. 1920). In *Germany*: Werner Gilles (b. 1894), Eduard Bargheer (b. 1901), Hanns Jaenisch (b. 1907). In *Latin America*: F. Ponce de Léon (b. 1895), J. Castellanos (1905–47), R. Anguiano (b. 1909).[22]

The Followers of Matisse and Fauvism and
The Followers of Picasso and Cubism

The influence of both these masters and schools spread wide and still reaches deep into the phalanx of the Abstract movement. In *France*: Marcel Gromaire (b. 1892), Edouard Pignon (b. 1905), Léon Gischia (b. 1903; abstract since 1948); André Marchand (b. 1907), Antoni Clavé (b. 1913).

In the *United States*: John Marin (1870–1953; Cubism-Fauvism), Lyonel Feininger (1871–1956; Cubism-Constructivism-Fauvism). Georgia O'Keefe (b. 1887; Fauvism-Realism); Nicholas Vasilieff (b. 1892; Fauvism), Karl Knaths (b. 1891; school of Picasso); Carl Zerbe (b. 1903; Cubism). Vaclav Vytlacil (b. 1892), Stuart Davis (b. 1894; Cubism); David Park (b. 1911), Robert Frame (b. 1924)—both Fauvists.

In *England*: Matthew Smith (1879–1959); Roderic O'Conor (1860–1940), Ivon Hitchens (b. 1893)—all Fauvists. Graham Sutherland (b. 1903; Fauvism, Picasso, de Chirico); J. Bornfriend (b. 1904; school of Matisse-Picasso-Chagall), Z. Ruszkowski (b. 1907; Cubism, Fauvism, Bonnard). Ceri Richards (b. 1903), Louis de Brocquy (b. 1917), Robert Colquhoun (1914–62), and Robert Macbryde (1913–1966), all school of Picasso.

In *Belgium*: Ferdinand Schirren (1872–1944). In *Austria*: Hans Robert Pippal (b. 1915), Karl Kruezberger (b. 1916). In *Germany*: Christian Rohlfs (1849–1938), Curt Georg Becker (b. 1904), Fried-

rich Stabenau (b. 1900), Alexander Camaro (b. 1901). In *Sweden*: Hilding Linnquist (b. 1891, Fauvism). In *Italy*: Filippo de Pisis (1896–1956; Impressionism-Fauvism), Bruno Cassinari (b. 1912; Cubism, Fauvism), Virgilio Guidi (b. 1892; school of Picasso), Felice Casorati (b. 1886; Realism disciplined by Cubism).

The Followers of Futurism

Through the organizing talent of F. T. Marinetti, the Futurist movement by 1930 grows in *Italy* to about 500 members. Most important: Enrico Prampolini (1896–1956; from 1930 onward abstract). Also: Armando Pizzinato (b. 1910), Fortunato Depero (b. 1892). Publication of *Archivi del Futurismo*, 1957.

In the *United States*: Joseph Stella (1877–1946), P. Blume (b. 1906). *English Vorticism*, founded in 1914 by Wyndham Lewis (1884–1956), Edward Wadsworth, and William Roberts (b. 1895), was based on Futurism and Cubism. Merlyn Evans (b. 1910).

The Followers of Purism

The spirit of the formal elements of Purism are to be found in the work of Ben Nicholson (b. 1894) in *England*. In the *United States*: Miles Spencer (1893–1952), Charles Sheeler (b. 1883), Attilio Salemme (b. 1911), Marvin Cone (b. 1891), Stephen M. Etnier (b. 1903). Also: John Heliker, Michael Frary, and others.

The Followers of Surrealism from 1936 Onward and the Decline of the Movement

1941: Breton publishes *Genèse et perspectives artistiques du Surréalisme*.[23]

1942: Surrealist exhibition in New York. Breton publishes his *Prolégomènes a un troisième manifeste du Surréalisme ou non*.

Paris, 1947: Last exhibition of Surrealism in its degenerate form. End of Surrealism as a movement.

1953: Breton publishes *Du Surréalisme en ses oeuvres vives*. In *Italy*: Guiseppe Viviani (b. 1898), Léonor Fini (b. 1908), Fabrizio Clerici (b. 1913), Stanislao Lepri (b. 1913). The Surrealist background of Wifredo Lam, of Victor Brauner, of Roberto Matta Echaurren, and of Fritz Hundertwasser is taken account of in "The Followers of Symbolism and Fantastic Art."

In *France*: Felix Labisse (b. 1905), Lucien Coutaud (b. 1904), P. Carzou, and others.

In *Germany*: R. Oelze (b. 1900), Edgar Ende (b. 1901), Mac Zimmermann (b. 1912), Wolfgang Frankenstein (b. 1918), Hans Thiemann (b. 1916), Heinz Trökes (b. 1913), Paul Wunderlich (b. 1927). In *Austria*: Rudolf Hausner (b. 1914), Rudolf Wacker (b. 1893), Gerhard Swoboda (b. 1923), Wolfgang Hutter, and others.

In *England*: Influence on Paul Nash, on Henry Moore, on Graham Sutherland; Francis Bacon (b. 1910), John Tunnard (b. 1900), Lucien Freud (b. 1922), Michael Ayrton (b. 1921).

In *Belgium*: Jean Mulder (b. 1897), Maurice Cantens (b. 1891), Maxime van de Woestijne (b. 1911), Jean Ransy (b. 1910), E. L. T. Mesens (b. 1903), Robert Geenens (b. 1896), Suzanne van Damme, Jane Gravenol, Rachel Baes, Octave Landuyt (b. 1922), and others.

In the *United States*: Eugene Berman (b. 1899), Peter Blume (b. 1906), Paul Cadmus (b. 1906), W. Quirt (b. 1902), Clarence H. Carter (b. 1904), J. Atherton (b. 1900), E. Donati (b. 1909), Helen Lundeberg (b. 1908), Herbert Saslow (b. 1920), Kurt Seligman (b. 1900), Leo Manso (b. 1914), Charles Rain, (b. 1911), Kelly Fearing (b. 1918), John Wilde (b. 1919), Irving Norman (b. 1910), Aaron Bohrod (b. 1907); also: Alexander Brook, Dong Kingman, Bernard Perlin, Leonid, Ivan Albright.

In *Latin America*: C. Egas (b. 1899), M. Carreno (b. 1913), and others. In *Sweden*: Founding of the Halmstad group in 1929: Stellan Mörner (b. 1896), Sven Jonsson, Waldemar Lorentzen, Axel and Erik Olsson, Essaias Thorén.

THE FOLLOWERS OF EXPRESSIONISM

Most of the East European artists of Jewish origin living in Paris are Expressionists: P. Kremegne (b. 1890), M. Kikoine (b. 1892), Max Band (b. 1900), A. Feder (b. 1886), Mané-Katz (b. 1894), Lasar Segall (b. 1890), Z. Menkes (b. 1896).

Similarly in the *United States*: Max Weber (b. 1881), Hyman Bloom (b. 1913), Jack Levine (b. 1915), Abraham Rattner (b. 1895). Also: Franklin C. Watkins (b. 1894), Rico Lebrun (b. 1900), Roger Kuntz (b. 1926), Wolf Kahn (b. 1927), Stephen Green (b. 1918), Jonah Kinigstein (b. 1923), Nicolas Carone, and others.

In *Germany*: Rolf Nesh (b. 1893), Karl Kluth (b. 1898), Wenk-Wolff (b. 1929), Cuneo (b. 1889), and others. In *Holland*: Willem Paerels (b. 1878).

In *Belgium*: The School of Laethem-Saint-Martin: Gustave van de Woestyne (1881–1947), Constant Permeke (1886–1952), Gustave de Smet (1877–1943), Fritz van den Berghe (1883–1939), Albert Ger-

vaes (b. 1873). Also: Hippolyte Daeye (1873–1952), Paul Maas (b. 1890), Frans Masereel (b. 1889), Henri-François Ramah (Raemaker) (1887–1947).[24]

In *Italy*: Toti Scialoja (b. 1914), Giovanni Stradone (b. 1911), Fausto Pirandello (b. 1899), Gino Bonichi Scipione (b. 1904), Mario Mafai (b. 1902).[25]

In *England*: Erich Kahn (b. 1904), Marie Louise Motesiczky (b. 1906). In *Ireland*: Jack B. Yeats (1871–1957). In *Sweden*: Ivan Ivarson (1906–39).

The Followers of Neo-Primitivism

Here the *maîtres populaires* must be distinguished from those artists who follow a more archaic primitive line.

In *England*: Alfred Wallis (1855–1942), Christopher Wood (1901–30), C. S. Lowry (b. 1887), F. N. Souza (b. 1924).

In the *United States*: Joseph Pickett (1848–1918), John Kane (1860–1934), Morris Hirschfield (1872–1946), Horace Pippin (1888–1946), Patrocino Barela (b. 1908), José Dolores Lopez (1880–1939), Clara McDonald Williamson (b. 1875), Anna Mary Robertson Moses (1860–1961), Caroll Cloar (b. 1913). In *Cuba*: Rafael Moreno (b. 1887). In *Brazil*: Candido Portinari (b. 1903).

In *Italy*: Massimo Campigli (1895–1971), Antonio Donghi (b. 1897). In *Germany*: Werner Heldt (b. 1904). In *Belgium*: Edgard Tytgat (b. 1879), Floris Jespers (b. 1889), Van den Abeele, and others. In *Sweden*: Sven Erixson (1899–1970), Olle Olsson (b. 1904). The most comprehensive material on this trend is contained in *De Lusthof der Naïeven*.[26]

L'Art Brut

Trend developed and theoretically founded by Jean Dubuffet (b. 1901).[27] Exhibition at the Drouin Gallery, Paris, 1944, established the name of the artist. Dubuffet's collection of *l'art brut* (several thousand pieces) has been since 1952 deposited in the United States in the residence of the painter Alfonso Ossorio. Also: Jean Fautrier (b. 1898), Glasco, Réné Guiette (b. 1893), and others.

The concepts of Karel Appel (b. 1921) and his dynamic *Color-Primitivism*, of Asger Jorn (b. 1914), and the figural work from 1950 onwards of Willem de Kooning (b. 1904) have much in common with *l'art brut*.

1948: founding of the COBRA group, uniting the Danish *Host*, the Belgian *Surrealiste-Revolutionnaire,* and the Dutch *Reflex* groups into one (*CO* for Copenhagen, *BR* for Brussels, and *A* for Amsterdam). Lasted till 1951. The main artists: Asger Jorn, Carl-Henning Pedersen, and Ejler Bille of Denmark; Karel Appel, Constant, and Corneille of Holland; Christian Dotrement of Belgium, and others.

UNFOLDING OF ABSTRACT ART[28]

The Société Anonyme (founded in 1920 by Katherine Dreyer, Marcel Duchamp, and Man Ray) organized in 1926 the first traveling exhibition of abstract art in the United States (Brooklyn Museum).

Publication of *Art concret* (1929–30), by Theo van Doesburg (1883–1931), Jean Hélion (b. 1904), Otto G. Carlsund (1897–1948), and Tutundjian. Founding by Henry Valensi (b. 1883) of the Association des Artistes Musicalistes, 1932.

Exhibition of American abstract art at the Whitney Museum in 1935. The Museum of Living Art (A. E. Gallatin Collection), founded in 1927, has had since 1935 great importance for the propagation of abstract art. Alfred H. Barr, Jr., published *Cubism and Abstract Art* in 1936. Founding of the American Abstract Artist's Society in New York, 1936.

Founding by Leo Léuppi (b. 1893) of the Swiss abstract group *Die Allianz* in 1936.

The Museum of Non-Objective Painting (later the Solomon R. Guggenheim Museum) founded in New York in 1937.

The new premises of the Museum of Modern Art in New York, founded in 1939, of major importance for the development of abstract art.

"Art Concret" exhibition at the Drouin Gallery in Paris, 1945 (Kandinsky, Herbin, Magnelli, Gorin, Pevsner, Freundlich, Domela, Robert and Sonia Delaunay, Arp, Sophie Taeuber-Arp, Mondrian, and van Doesburg).

Salon des Réalites Nouvelles inaugurated in 1946. Exhibition of Alberto Magnelli, Drouin Gallery, Paris, 1947.

1949: Founding in Milan of group *Arte Concreta* by Gillo Dorfles (b. 1910), Bruno Munari (b. 1907), and Gianni Monnet (b. 1912). In the same year founding of the review *Art d'aujourd'hui* (Léon Dégand and Charles Estienne). Also: "Les Premiers Maîtres de l'art abstrait, I/II" exhibition organized by Michael Seuphor at the Maeght Gallery in Paris.

1950: Maeght publishes Seuphor's book *L'Art abstrait*. Founding in Paris of the group *Espace*, 1950, by Del Marle and André Bloc (in 1954 sections are founded in Switzerland, Great Britain, Italy, and Sweden).

Rome, 1951: exhibition of "Arte Astratta e Concreta in Italia."

Exhibition of abstract art and the publication of Andrew Ritchie's book *Abstract Painting and Sculpture in America* at the Museum of Modern Art, New York.[29]

Cimaise: Revue de l'art actuel founded in 1953 by I. Alvard, H. Wescher, and L. V. Gindertael. Michel Tapié publishes in the same year *Un Art autre ou il s'agit de nouveaux dévidages du réel*.[30] Exhibition "Nouvelles Propositions de Réel" organized by Charles Estienne at the Gallery Craven, Paris, 1953.

Michel Seuphor organizes in 1957 the exhibition "50 Ans de Peinture Abstraite" and brings out at the same time his *Dictionnaire de la peinture abstraite*. Publication in 1957 of *The World of Abstract Art*, edited by The American Abstract Artists.

Some established names of abstract artists in *France* (from about 3,000 now living and working there): Roger Bissière (1888–1964) and his followers: Alfred Manessier (b. 1911), Jean Bertholle (b. 1909), Jean Le Moal (b. 1909), Gustave Singier (b. 1909), Jean Bazaine (b. 1904), Maurice Estève (b. 1904), Charles Lapique (b. 1898); all from the group *Témoignage* (*abstraction lyrique*). Hans Hartung (b. 1904), Pierre Tal Coat (b. 1905), André Lanskoy (b. 1902), Pierre Soulages (b. 1919), Nicholas de Staël (1914–55), Jean-Paul Riopelle (b. 1923), Maria Helena Vieira da Silva (b. 1908), Claude Idoux (b. 1915), Bram van Velde (b. 1895), Geer van Velde (b. 1898), Jean Degottex (b. 1918), Jules Chaporal (1919–51), Roger Chastel (b. 1897), Alexandre Garbell (b. 1903), Marius Honoré Bérard (b. 1896). Jean Atlan (b. 1913), Zao-Wou-Ki (b. 1920), Philippe Hosiasson (b. 1898), Gérard Schneider (b. 1895), Jacques Germain (b. 1915).

Geometric style (called by Charles Estienne *"abstrait froid"*): Victor Vasarely (b. 1908), leading artist of the *kinetic* movement; Jean Dewasne (b. 1921), Edgar Pillet (b. 1912), Jean Piaubert (b. 1900), Sergei Poliakoff (b. 1906), Pablo Palazuelo (b. 1916), Alberto Magnelli (b. 1888), Emilio Pettoruti (b. 1895).

Pure color tectonic (called by Charles Estienne *"abstrait chaud,"* also *"abstraction lyrique,"* and developed initially by de Staël, Tal-Coat, Bissière, Manessier, Bazaine, and others: Gérard Vulliamy (b. 1909), S. Kolos-Vary (b. 1899), Pierre César Lagage (b. 1911), Olivier Debré (b. 1920), Georges Van Haardt (b. 1907), Francis Bott

(b. 1904), Arpad Szenès (b. 1900), John H. Levee (b. 1924), and others.

In *Belgium*: Jo Delahaut (b. 1911), Pol Bury (b. 1922), Jan Saverys (b. 1924), Louis van Lint (b. 1909), Anne Bonnet (b. 1908), Kurt Lewy (b. 1898), Rudolf Meerbergen (b. 1908), Marc Mendelson (b. 1915), Gaston Bertrand (b. 1910). Also: Joseph Peeters (abstract since 1920), Karel Maes, Edmond van Dooren, Prosper de Troyer, Jos Leonard, Paul Joostens.

Belgians in Paris: Engel-Pak (b. 1885), Henri Closon (b. 1888), Rodolphe Raoul Ubac (b. 1919), Guillaume Hoorickx (b. 1900), Pierre Alechinsky (b. 1927), Lempereur-Haut, Orix, and others.

In *Holland*: W. F. Sinemus (b. 1903), André van der Vossen (b. 1893), Frieda Hunziker (b. 1908), P. Ouborg (1893–1956), Willy Boers, Roosdens, Will, Alkema, and others.

In *Germany*: Willi Baumeister (1899–1955), Rolf Cavael (b. 1898), Fritz Levedag (1899–1951), Conrad Wespfhal (b. 1891), Willi Müller-Hufschmid (b. 1890), Otto Ritschl (b. 1885), Theodor Werner (b. 1886), Julius Bissier (1893–1965; in some of his works abstract), Ernst W. Nay (b. 1902), Fritz Winter (b. 1905), Georg Meistermann (b. 1911), Alexej Jawlensky (1864–1941; from 1934 onwards abstract), Josef Fassbender (b. 1903), Karl Otto Götz (b. 1914), G. K. Schmelzeisen (b. 1900), Hubert Berke (b. 1908), B. Schultze (b. 1915), K. R. H. Sonderborg (b. 1923), Albrecht Schilling (b. 1929), Gerhard Fietz (b. 1910), Arnold Fiedler (b. 1910), Fritz Grasshoff (b. 1913); also: Manfred Bluth, Fath Winter, Karl F. Brust, Herbert Spangenberg, and others.

In *Scandinavia*: Otto G. Carlsund (1897–1948), Fransiska Clausen (b. 1899), Aagard Andersen (b. 1919), Richard Mortensen (b. 1910), Olle Baertling (b. 1911), Endre Nemes (b. 1909), Eric H. Olsen (b. 1909), Olle Bonnier (b. 1925), Anna-Eva Bergman (b. 1909), Thorvaldur Skulason (b. 1906), Svavar Gudnason (b. 1909), Valtyr Petursson (b. 1919), Nine Tryggvadottir (b. 1913).

In *England*: Ben Nicholson (b. 1894), S. W. Hayter (b. 1901), Victor Pasmore (b. 1908; late work Constructivist), Alva (b. 1901), Anthony Hill (b. 1930), Terry Frost (b. 1915), Adrian Heath (b. 1920), Donald Hamilton Frazer (b. 1929; later tendency to figuration), William Gear (b. 1915), William Scott (b. 1913; later figural development in the style of de Staël, Dubuffet, music), Edvardo Paolozzi (b. 1924), Roger Hilton (b. 1911), Sandra Blow (b. 1925), Peter Lanyon (1918–65), John Wells (b. 1907), Patrick Heron (b. 1920), Bryan Wynter (b. 1916), Wilhelmina Barns-Graham (b. 1912), and others.

In *Italy*: Basaldella Afro (b. 1912), Alberto Burri (b. 1915), Guiseppe Capogrossi (b. 1900), Mario Radice (b. 1900), Atanasio Soldati (1887–1953), Guiseppe Santomaso (b. 1907), Giulio Turcato (b. 1900), Emilio Vedova (b. 1919), Mino Guerrini (b. 1927), Silvano Bozollini (b. 1911), Angelo Savelli (b. 1911), Ninodi Salvatore (b. 1924), Piero Dorazio (b. 1927), Renato Righetti (b. 1916), Mauro Reggiani (b. 1897), Roberto Crippa (b. 1921), Mattia Moreni (b. 1922), and others.

In *Switzerland*: Max Bill (b. 1908), H. Eichmann (b. 1915), Lili Erzinger (b. 1908), Camille Graeser (b. 1892), R. P. Lohse (b. 1902), Walter Bodmer (b. 1913). Also: Eble, Tiravanti, Fischli, Vreni Loewensberg, Hintereiter, and others.

In *Argentina*: Alfredo Hlito (b. 1923), Miguel Ocampo (b. 1922), V. Villalba (b. 1925), Juan N. Mele (b. 1923), G. Vardanega (b. 1923), Tomas Maldonado (b. 1922), Gyula Kosice (b. 1924; later kinetic trend), and others. In *Uruguay*: The *Madi* group in Paris (Abstract Primitivist trend). Carmelo Arden-Quin (b. 1913), Rid Rothfuss (b. 1920). In *Cuba*: Sandu Darie. In *Brazil*: The Flexor Studio in São Paulo (School of Abstract Painting). In *Mexico*: Gunther Gerzso. In *Australia*: Grace Crowley (b. 1895), Ralph Balson (b. 1890). In *South Africa*: Nel Erasmus (b. 1928). In *Yugoslavia*: Ivan Picelj (b. 1924), Krist, Rasica, and others. In *Spain*: Canogar, Delgado, Feito (b. 1929), Luque, Rodriguez Zambrana, Luiz de la Orden. In *Japan*: S. Morita (b. 1912), Y. Sekiya (b. 1920), T. Shinoda (b. 1912), F. Tsuji (b. 1925), B. Nakamura (b. 1916), G. Osawa (1890–1953), S. Eguchi (b. 1919), Inone, and others.

In *Austria*: Josef Mike (b. 1929), Carl Unger (b. 1915), Johann Fruhmann (b. 1928), Friedrich Riedl (b. 1923), Johanna Schidlo (b. 1923).

In the *United States*: Mark Tobey (b. 1890), Franz Kline (b. 1910), Bradley Walker Tomlin (1899–1953), Adolph Gottlieb (b. 1903), Robert Motherwell (b. 1915), Fritz Glarner (b. 1899), Arshile Gorky (1904–48), Loren MacIver (b. 1909), Rice Pereira (b. 1907), Hilla Rebay (b. 1890), Jean Xceron (b. 1890), Buffie Johnson (b. 1912), Hedda Sterne (b. 1915), Suzy Frelinghuysen (b. 1912), Ronnie Elliott (b. 1916), A. Friedman (1879–1946), Stuart Davis (b. 1894), M. Graves (b. 1910), Alice T. Mason (b. 1904), Lee Mullican (b. 1919), Charmion van Wiegand (b. 1900), Pearl Fine (b. 1908), Max Gordon Onslow-Ford (b. 1912), Tom Benrimo (b. 1887), John Ferren (b. 1905), Edith Smith (b. 1925), Kyle Morris (b. 1918), Robert Jay Wolff (b. 1905), Victor Candell (b. 1903), Hans Hofmann (b. 1880), Carl Morris (b. 1911); also: Rudolf Ray, John

Beauchamp, Boris Margo, Keith Finch, Walter Munch, and others. Some American abstractionists in Paris: Bernard Pfriem (b. 1916), Bernard Childs (b. 1910), T. J. Malina (b. 1912), and others.

Influence of Eastern calligraphy on Tobey, Kline, Tomlin, Alcopley (b. 1910) in the *United States*; on Hartung, Soulages, Schneider, Mathieu, Alechinsky in *France*; on Götz, Bissier in Germany.

TACHISM-ACTION PAINTING–*Art Autre*, SINCE ABOUT 1945

In *France*: The first masters: Henri Michaux (b. 1899), Wols (Wolfgang Schultze; 1913–51), Camille Bryen (b. 1907), Sam Francis (b. 1923), Georges Mathieu (b. 1921). Impact of the work of Hans Hartung, Pierre Soulages, and Jean-Paul Riopelle on the movement. Oscar Chelimsky (b. 1923), Robert Lapoujade (b. 1921), François Willi Wendt (b. 1909), Alexander Istrati (b. 1915), Louis Nallard (b. 1918), Greta Sauer (b. 1909), Bram Bogart (b. 1921), Jaroslav Serpan (b. 1912), Roger Edgar Gillet (b. 1924), Thanos Tsingos (b. 1914), François Arnal (b. 1924), Guy Debord (*Situationism*), and others.

In the *United States*: Mark Tobey (b. 1890; influence on Jackson Pollock). Jackson Pollock (1912–56), Mark Rothko (b. 1903), Clyfford Still (b. 1904; The Pacific or West Coast School of Painting– *Hard edge*), Paul Jenkins (b. 1923), Lee Hersch (1896–1953), Lawrence Kupfermant, Ruth Francken, and others.

In *Germany*: Berhard Schulze (b. 1915). In *England*: Ralph Rumney (b. 1924), Paul Feiler (b. 1918), Derek Middleton (b. 1921), Dennis Bowen (b. 1921), Rodrigo Moynihan (b. 1910), Robin Denny (b. 1930), Dorothy Bordass (b. 1905), and others. In *Italy*: Renato Birolli (1906–59), Antonio Corpora (b. 1909), Edmondo Bacci (b. 1913), Guiseppe Ajmone (b. 1923), Enzo Brunori (b. 1924), Alfredo Chighine (b. 1914), Gianni Dova (b. 1925), Lucio Fontana (b. 1899; late tendency *l'art brut*), Ennio Morlotti (b. 1910), Gino Morandi (b. 1915). Lucio Fontana's *Manifesto Blanco*, 1946 (Buenos Aires); first manifesto of *Spazialismo*, 1947, published in Milan in 1957. In *Spain*: Antonio Tàpies (b. 1923) and his school. In *Greece*: Mario Prassinos (b. 1916), Jannis Spyropoulos (b. 1912).

TENDENCIES UP TO 1970

Combinations and further development, variations and interrelation of the previous tendencies. A marked trend toward a new "content" in art and a revival of figurative painting in a new and original

manner based on the European stylistic heritage. The artists represented at the First Gaetano Marzotto Prize competition and exhibition in 1967 were: Edward Burra (b. 1905), Z. Ruszkowski (b. 1907), and Leroy de Maistre (b. 1894) from England; Fabrizio Clerici (b. 1913), Leonardo Cremonini (b. 1925), Fernando Farulli (b. 1923), Carlo Mattioli (b. 1911), and Renzo Vespignani (b. 1924) from Italy; Friedrich-Karl Gotsch (b. 1900), Richard Oelze (b. 1900), and Paul Wunderlich (b. 1927) from Germany; Léon Golub (b. 1922), an American living in Paris; Antonio Guansé (b. 1926) and Orlando Pelayo (b. 1920) from Spain; Octave Landuyt (b. 1922) and Pol Mara (b. 1920) from Belgium; Vladimir Velickovic (b. 1935) and Gabriel Stupica (b. 1913) from Yugoslavia; Bengt Lindström (b. 1925) from Sweden; Antonio Segui (b. 1934) from Argentina; Sarai Sherman (b. 1922) from the United States.

The decline of Paris as an art center, the rise of New York as a source of inspiration mark the mid-century. American influence on English art starts about 1945 (Hard-edge, Rothko, A. Gottlieb, American Pop, Minimal art). Two main tendencies emerge: *Kinetic Art* (based on early researches of the Bauhaus) and *Pop Art* (based on Dada influences, Cubist collage, "folk" art, the mentality of advertisements, films, comic strips, etc.). Paris retains the lead in kinetic art (Vasarely and the group around the Denise Renée Gallery). Pop art is taken seriously by critics such as Leo Steinberg, Pierre Restany, Lawrence Alloway, Nicolas Calas, Nancy Marmer, Lucy R. Lippard, Alan Solomon. Defended in Gregory Battcock's *The New Art*, Lucy R. Lippard's *Pop Art*, Gillo Dorfles' *Nuovi Riti, Nuovi Miti*, and John Russell and Suzi Gablik's *Pop Art Redefined*. Attacked by critics such as Herbert Read in his book *The Origins of Form in Art*.

A general survey of the present tendencies in art is given in Gillo Dorfles' *Ultime Tendenze nell'Arte d'Oggi*, in the same author's major book, *Simbolo, Communicazione, Consumo*, in *Art Since 1945* and *Art of Our Time*, edited by Will Grohmann, and in *Since 45*, edited by Ernst Goldschmidt. See also: *Dalla Natura all' Arte*, 1960, and *Arte e Contemplazione*, 1961 (both Palazzo Grassi, Venice) and: Catalogues of the Documenta I, 1955; Documenta II, 1959; Documenta III, 1964 (Kassel). Frank Popper analyzes kinetic art in a historical survey, reaching as far back as 1860 in: *Naissance de l'art cinétique* (Paris, 1967). See also by the same author: *Kinetic Art, Yesterday, To-day and To-morrow* (London, 1966). The *Vitalist* (Expressionist) trend is still strongly in evidence. See: *Vitalità nell' Arte* (Venice, 1959); *Campo Vitale*, 1967 (Catalogues of the Palazzo Grassi, Venice).

The attitude against art as expression and for art as an activity for the production of objects with only a limited aesthetic meaning becomes quite definite. *Emballage* enters the scene, as do *Minimal Art, Poor Art,* etc.[31] Art becomes a means for the radical political change of society, the means of protest and rebellion symbolic of a deep discontent with the state of human affairs.[32] The situation leads to a climax in which the question of the future of art is seriously posed.[33]

Formation of new groups. *Spur* (Vitalist) 1957 in Munich (see "Momenti" 3, Palazzo Grassi, Venice, 1966); *Syn* (Abstract): Program in Catalogue, Wiesbaden, 1967.

Activity and fame of Jean Dubuffet reach a climax. A twenty-volume catalogue of his work is being produced in Paris. Francis Bacon becomes the leading painter of the Existentialist-Nihilist trend of twentieth-century humanism.[34]

FURTHER CLASSIFICATION

The English like to add to the established isms that of *English Neo-Romanticism*, with its beginnings in the nineteen-thirties. In fact, the Romantic trend has never died out in English art since the nineteenth century.[35] Among the artists adhering to this traditional taste can be named Graham Sutherland (b. 1903), John Piper (b. 1903), Paul Nash (1889–1946), John Minton (b. 1917), Keith Vaughan (b. 1912), Frances Hodgkins (1871–1947), John Craxton (b. 1922), Michael Rothenstein (b. 1908), and others.

After the collapse of Futurism in 1915 and of the Metaphysical School about 1921, an anti-modernist movement entered the Italian scene, the *Novecento*, founded in 1926 by Margherita Sarfatti. Its character was based on idealization, the revival of more traditional subject matters and techniques, and the return to the Realism of the nineteenth century. Among the artists adhering to this movement were Achille Funi (b. 1890) and Piero Marussig (1879–1937), both Neo-Classicists; Mario Sironi (b. 1885), a romantic Expressionist; Arturo Tosi (b. 1871) and Pio Semeghini (b. 1878), Impressionists; also Virgilio Guidi (b. 1892), an Impressionist and Neo-Classicist, recently abstract, and Pompeo Borra (b. 1898), a traditionalist after having been abstract during the thirties.

As an opposition to the Novecento, the "Roman School" (1904–33) was founded by Cino Bonichi Scipione (b. 1904), an Expressionist, and Mario Mafai (b. 1902), an impulsive Neo-Romantic Realist. Among the artists influenced by the Roman School are the Expressionists Giovanni Stradone (b. 1911) and Toti Scialoja (b. 1914);

also Renzo Vespignani (b. 1924) and Marcello Muccini (b. 1925), both Neo-Romantic Realists.

The short-lived *Corrento* movement founded in Milan in 1939 by Renato Birolli (1906–59) had as its aim to go beyond the program of the Roman School to regain the lost progressive momentum. Among its members were Bruno Cassinari (b. 1912), Enno Morlotti (b. 1910), Emilio Vedova (b. 1919), and others. In 1946, Renato Birolli founded the *Nuova Secessione Artistica Italiania*, with a manifesto signed by himself and by Bruno Cassinari, Antonio Corpora (b. 1909), Renato Guttuso (b. 1912), Enno Morlotti, Armando Pizzinato (b. 1910), Guiseppe Santomaso (b. 1907), Giulio Turcato (b. 1912), Emilio Vedova, and the sculptors Viano and Leoncillo. In 1947 the name of the movement was changed to *Fronto Nuovo delle arti* (with Cassinari leaving and the sculptors Fazzini and Franchina entering the group).[36]

The French like to list as one group the painters of Montmartre: Henri de Toulouse-Lautrec (1864–1901), Jean-Louis Forain (1852–1931), Suzanne Valadon (1865–1938), Maurice Utrillo (1883–1955), and also the painters who exhibited in the Salon d'Automne, the Salon des Artistes Indépendants, the Salon des Surindépendants, etc.[37] From the stylistic point of view, such a distinction has little justification. Sheldon Cheney also speaks of the "Bohemians of Montmartre.[38] He also concerns himself separately with the "École de Paris"—a confusing term, because it cuts across all schools. By École de Paris is meant in the early literature on the subject either only the small group of Jewish painters, Marc Chagall (b. 1887), Amadeo Modigliani (1884–1920), Moise Kisling (1891–1953), Chaim Soutine (1894–1943), and Jules Pascin (1885–1930)—the term *"peintres maudits"* has also been used in this connection[39]—or all foreign painters working in Paris in the first decade of this century, such as Picasso, Juan Gris, and other Cubists as well as the pupils of the Académie Matisse (since 1906), among whom were the Germans Hans Purrmann (b. 1880), Rudolf Levy (1875–1943), and Eugen Spiro (b. 1874); the Norwegians Axel Revold (1887–1962), Henrik Sørensen (1882–1962), and Jean Heiberg (b. 1884); the Swedish artists who formed the group *1909 Års Män* ("the Men of 1909"), with Isaac Grünewald (1889–1946), Sigrid Hjertén (1885–1948), Einar Jolin (b. 1890), and others.[40] Later Jean Cassou used the term École de Paris in a much wider and, historically seen, comprehensive and final sense, to include Impressionism followed by Nabism, Fauvism, Cubism, and Surrealism, with all the great foreign names listed side by side with

the French ones. Raymond Nacenta includes also Neo-Realists and abstractionists. In these broader interpretations the École de Paris becomes synonymous with the modern movement in art as far as it was based in Paris.[41] After 1950 the term "La Jeune École de Paris" came into being,[42] or sometimes "La Nouvelle École de Paris,"[43] and it was this new School of Paris which formed the cadre of exhibitors in the first Paris Biennale in 1957.[44]

NOTES

1. Robert Rey, "La Renaissance du sentiment classique," in *La Peinture française à la fin du XIXe siècle* (Paris, 1931).
2. John Rewald, *The History of Impressionism* (New York, 1946); Lionello Venturi, *Les Archives de l'impressionisme*, 2 vols. (Paris and New York, 1939).
3. Richard Muther, *Geschichte der Malerei*, Vol. 3 (Berlin, 1926); Joseph Pijoan, *History of Art*, Vol. 3 (London, 1933); A. H. Springer, *Kunstgeschichte*, Vol. 5 (Leipzig, 1923–29); Karl Woermann, *Geschichte der Kunst*, Vol. 6 (Leipzig and Vienna, 1915–22); Edouard Joseph, *Dictionnaire biographique des artistes contemporains, 1910–1930* (Paris, 1931–34), and *Supplément au dictionnaire biographique des artistes contemporains* (Paris, 1937); *Dictionnaire de la peinture moderne*, ed. Robert Maillard (Paris, 1954).
4. Rewald, *Post-Impressionism: From van Gogh to Gauguin* (New York, 1956); René Gaffé, "Le Neo-Impressionisme," "Le Post-Impressionisme," and "Les Fauves et quelques autres," in *Introduction à la peinture française: De Manet à Picasso* (Paris, 1954).
5. Georges Duthuit, *The Fauvist Painters* (New York, 1950); Alfred H. Barr, Jr., *Matisse: His Art and His Public* (New York, 1951); Jean Leymarie, *Fauvism* (Paris, 1959).
6. Alfred H. Barr, Jr., *Cubism and Abstract Art* (New York, 1936; new ed., 1967), and *Picasso: Fifty Years of His Art* (New York, 1946); Wilhelm Boeck and Jaime Sabartès, *Picasso* (London, 1955); Jean Paulhan, *Braque le patron* (Geneva-Paris, 1946); Henri Kahnweiler, *Juan Gris: Sa Vie, son oeuvre, ses écrits* (Paris, 1946).
7. Barr, *Cubism and Abstract Art*; Marco Valsecchi and Umbro Apollonio, *Panorama dell'Arte Italiana* (Torino, 1950–51); *Archivi del Futurismo* (Rome, 1957); Venturi, "I Futuristi Italiani," in *Lezioni di Storia dell'Arte Moderna* (Rome, 1954-55).
8. Amedée Ozenfant, "Evolution of Purism," in *Foundations of Modern Art* (New York, 1952).

9. Barr, *Fantastic Art, Dada, Surrealism* (New York, 1936); Robert Motherwell, ed., *The Dada Painters and Poets* (New York, 1951); Georges Hugnet, *L'Aventure Dada (1916–1922)*, Introduction by Tristan Tzara (Paris, 1957); Willy Verkauf, *Dada: Monograph of a Movement* (London, 1957).

10. Barr, *Fantastic Art, Dada, Surrealism*; André Breton and Paul Eluard, *Dictionnaire abrégé du Surréalisme* (Paris, 1938); Breton, *Premier manifeste du Surréalisme* (Paris, 1924), *Le Surréalisme et la peinture* (Paris, 1928), *Second manifeste du Surréalisme* (Paris, 1930), *Les Manifestes du Surréalisme suivi de Prolégomènes à un troisième manifeste du Surréalisme ou non, du Surréalisme en ses oeuvres vives et d'ephémérides Surréalistes* (Paris, 1955), and *Les Vases communiquants* (Paris, 1932); J. P. Hodin, "La Biennale et l'avenir du Surréalisme," *Les Arts Plastiques* (Brussels), Numéro Spécial: La XXVIIe Biennale de Venice, October 1954, pp. 5–21.

11. Barr, *Cubism and Abstract Art*; Michel Seuphor, *L'Art abstrait: Ses origines, ses premiers maîtres* (Paris, 1950), *Abstract Painting from Kandinsky to the Present* (London, 1962), and *A Dictionary of Abstract Painting* (London, 1957); H. L. C. Jaffé, *De Stijl, 1917–1931* (Amsterdam, 1956).

12. Herbert Bayer, Walter Gropius, and Ise Gropius, eds., *Bauhaus, 1919–1928* (Boston, 1952).

13. Ludwig Justi, *Neue Kunst: Ein Führer zu den Gemälden der sorgenannten Expressionisten in der Nationalgalerie* (Berlin, 1921), and *Von Corinth bis Klee* (Berlin, 1931); Sheldon Cheney, *Expressionism in Art* (New York, 1934); *German Contemporary Art* (Offenburg, 1952); Umbro Opollonio, *Die Brücke e la Cultura dell'Expressionismo* (Venice, 1952); Ludwig Grote, *Deutsche Kunst im 20. Jahrhundert* (Munich, 1954); Nell Walden and Lothar Schreyer, *Der Sturm* (Baden-Baden, 1954); J. P. Hodin, "The Expressionists," in *The Dilemma of Being Modern*; B. S. Myers, *Expressionism* (London, 1957); Peter Selz, *German Expressionist Painting* (Berkeley and Los Angeles, 1957); L. G. Buchheim, *Die Künstlergemeinschaft Brücke* (Feldafing, 1956); Max Sauerland, *Die Kunst der letzten Dreissig Jahre* (Hamburg, 1948).

14. Barr, *Fantastic Art, Dada, Surrealism*; Charles Baudelaire, *Curiosités esthétiques*; "James Ensor," *Les Arts Plastiques* (Brussels), No. 1, January 1950; Paul Haesaerts, *James Ensor*, Les Maîtres de l'Art Belge (Brussels, 1957); Venturi, *Marc Chagall* (New York, 1945); Jacques Lassaigne, *Chagall* (Paris, 1957); J. T. Soby, *Giorgio de Chirico* (New York, 1955); Franz Meyer, *Marc Chagall* (London, 1964).

15. Michel Leiris and Georges Limbour, *André Masson and His Universe* (Geneva-Paris-London, 1947); Clemens Greenberg, *Joan*

Miró (New York, 1948); Jacques Dupin, *Miró* (London, 1962); Felix and Paul Klee, *Leben und Werk in Dokumenten* (Zurich, 1960).

16. Carola Giedion-Welcker, *Paul Klee* (London, 1952); Will Grohman, *Paul Klee* (London, 1954); Haftmann, *The Mind and Work of Paul Klee* (London, 1954); Paul Klee, *The Thinking Eye*, ed. Jürg Spiller (London, 1961).

17. Wilhelm Uhde, *Fünf primitive Meister* (Zurich, 1947); Barr, *Painting and Sculpture in the Museum of Modern Art* (New York, 1948).

18. Bernard Dorival, *Les Étapes de la peinture française contemporaine*, Vol. 3: *Depuis le Cubisme, 1911–1944* (Paris, 1946); Huyghe, "Le Retour au réel" and "Les Tendences actuelles," in *La Peinture française*; Venturi, *Pittura Contemporanea*; Franz Roh, *Nach-Expressionismus* (Leipzig, 1925). See also *Figuratie En Defiguratie: The Human Figure Since Picasso*, Catalogue, Ghent Museum, 1964.

19. *Dictionaries*:
Dictionnaire de la peinture moderne; Emmanuel Benezit, *Dictionnaire critique et documentaire des peintres, sculpteurs, dessinateurs et graveurs*, 8 vols. (Paris, 1849–1955); Ugo Galetti and Ettore Camesasca, *Enciclopedia della Pittura Italiana*, 2 vols. (Milan, 1950); *Svenskt Konstnärs Lexikon*, 2 vols. (Malmö, 1952–53); *Weilbachs Kunstnerleksikon*, 3 vols. (Copenhagen, 1947–52); T. Strand, *Illustrert Norsk Kunstnerleksikon* (Oslo, 1944); D. Trowbridge Mallett, *Mallett's Index of Artists, International-Biographical* (New York, 1935; Supplement, 1948); H. Vollmer, *Allgemeines Lexikon der Bildenden Künstler des XX. Jahrhunderts*, 2 vols. (Leipzig, 1953–55).
Catalogues:
Catalogues of La Mostra Biennale Internazionale d'Arte, Venice, from 1948 onward. Catalogues of art exhibitions in different towns of Europe and the U.S.A., the Sao Paulo Biennale, etc. *Les Sources du XXe Siècle: Les Arts en Europe de 1884 à 1914*, Introduction by Jean Cassou, Musée National d'Art Moderne (Paris, 1960/1961).
Books:
Alfred H. Barr, Jr., ed., *Masters of Modern Art* (New York, 1954); John Rothenstein, *Modern English Painters, Sickert to Smith*, (London, 1952), and *Modern English Painters, Lewis to Moore* (London, 1956); A. C. Ritchie, *Masters of British Painting, 1800–1950* (New York, 1956), and *The New Decade: 22 European Painters and Sculptors* (New York, 1955); C. G. Laurin, *Nordisk Konst* (Stockholm, 1925); Rudi Blesh, *Modern Art USA: Men, Rebellion, Conquest, 1900–1956* (New York, 1956); Nathaniel Pousette-Dart, ed., *American Painting Today* (New York, 1956);

A. S. Weller, ed., *Contemporary American Painting and Sculpture* (Urbana, 1957); J. T. Soby and Alfred H. Barr, Jr., *Twentieth-Century Italian Art* (New York, 1949); Raffaele Carrieri, *Pittura Scultura d'avanguardia in Italia, 1890–1910* (Milan, 1950); Gerhard Händler, *German Painting in Our Time* (Berlin, 1956); H. K. Röthel, *Moderne Deutsche Malerei* (Wiesbaden, 1956); A. C. Ritchie, ed., *German Art of the Twentieth Century* (New York, 1957); Jean Cassou, *Panorama des arts plastiques contemporains* (Paris, 1960).

20. Michal A. Alpatov, *The Russian Impact on Art* (New York, 1950); Hodin, "The Soviet Attitude to Art," *Contemporary Review* (London), No. 1050 (1953), pp. 346-350; Alexander Kamensky, "L'Art contemporain en U.S.S.R.," *Encyclopedie, L'Art international contemporain* (Paris, 1958).

21. Niels von Holst, *Moderne Kunst und Sichtbare Welt* (Berlin-Göttingen-Heidelberg, 1957); Catalogue of the Gaetano Marzotto Prize for Figurative Painting, 1967; *Encyclopedie, L'Art international contemporain.*

22. Herbert Read, *Contemporary British Painting* (London, 1951); "Le Fantastique dans l'art Belge: De Bosch à Magritte," *Les Arts Plastique* (Brussels), Numéro Special (1954), pp. 3–60; Lloyd Goodrich and John I. H. Baur, *American Art of the 20th Century* (London, 1962); John Rothenstein, *British Art since 1900* (London, 1962); Edward B. Henning, *Fifty Years of Modern Art* (Cleveland, 1966); Raymond Nacenta, *School of Paris* (London, 1960); Werner Hofmann, *Modern Painting in Austria* (Vienna, 1965); *Encyclopedie, L'Art international contemporain.*

23. Breton, *Le Surréalisme et la peinture* (New York, 1945); "Prolégomènes à un troisième manifeste du Surréalisme ou non," and "Du Surréalisme en ses oeuvres vives," in *Les Manifestes du Surréalisme* (Paris, 1952–53); Alain Bosquet, ed., *Surréalismus, 1924–1949* (Berlin, 1950); "André Breton (1896–1966) et le mouvement Surréaliste: Hommages," *La Nouvelle Revue Française* (Paris), April 1, 1967.

24. Emile Langui, "Introduction," *Origines et aboutissements de l'Expressionisme Belge*, Catalogue Palais des Beaux-Arts, Brussels, 1952.

25. Guido Perocco, *Artisti Del Primo Novecento Italiano* (Turin, 1965).

26. Museum Boymans (Rotterdam, 1964). See also Hodin, *Sven Erixson* (Stockholm, 1940); Michel Tapié, *Hautes Pates de J. Dubuffet* (Paris, 1946).

27. Jean Dubuffet, *L'Art brut préféré aux arts culturels* (Paris, 1949); Limbour, *Tableau bon levain à vous de cuire la pate: L'Art brut de Jean Dubuffet* (Paris, 1953); Piero Dorazio, "I nomi e le tend-

enze piú attuali," and "L'Arte d'avanguardia in Italia," in *La Phantasia dell' Arte Nella Vita Moderna* (Rome, 1955).

28. Marcel Brion, "Les Grands Courants de la peinture abstraite," in *Art abstrait* (Paris, 1956); Jean Bouret, "Le Présent abstraite," in *L'Art abstrait: Ses Origines, ses luttes, sa présence* (Paris, 1957); J. Poensgen and L. Zahn, *Abstrakte Kunst eine Weltsprache* (Baden-Baden, 1958).

29. (New York, 1951).

30. (Paris, 1952); *Morphologie autre*, 2 vols. (Torino, 1960–61).

31. Harold Rosenberg, *The Anxious Object* (New York, 1964), and *Artworks and Packages* (London, 1969); *Minimal Art*, ed. Gregory Battcock (London, 1969).

32. André Stephane, *L'Univers contestationnaire étude psychanalytique* (Paris, 1969); Hélène Parmelin, *L'Art et les anartistes* (Paris, 1969).

33. Werner Schmalenbach, *Kunst und Gesellschaft Heute* (Frankfurt am Main, 1969); Werner Haftmann, *Das Museum in der Gegenwart* (Frankfurt am Main, 1970).

34. John Rothenstein and Ronald Alley, *Francis Bacon* (London, 1964).

35. John Piper, *British Romantic Artists* (London, 1942); Read, *Contemporary British Painting* and *A Concise History of Modern Painting* (London, 1959).

36. Soby and Barr, *Twentieth-Century Italian Art.*

37. Dorival, "Les Peintures de Montmartre," in *Les Étapes de la peinture française contemporaine*; Reynal, "The Salon d'Automne," in *History of Modern Painting: Matisse, Munch, Rouault* (Geneva, 1950).

38. *The Story of Modern Art.*

39. Florent Fels, *L'Art vivant*, Vol. 2; G. di San Lazzaro, "Looking Around: Quotations from Elie Faure and Waldemar George," in *Painting in France, 1895–1949.*

40. Hodin, "Paris," in *Isaac Grünewald* (Stockholm, 1949); Barr, "Matisse's School, 1908–1911," in *Matisse, His Art and His Public.*

41. Jean Cassou, Introduction to the Catalogue, *L'École de Paris, 1900–1950*, Royal Academy of Arts, London, 1951; Nacenta, *School of Paris.*

42. Hubert Juin, *Seize Peintres de La Jeune École de Paris* (Paris, 1956).

43. Limbour, "La Nouvelle École de Paris," *L'Oeil* (Paris), No. 34, (October 1957), pp. 58–71.

44. *Biennale 57–Jeune Peinture, Jeune Sculpture*, Catalogue of the Musée des Arts Decoratifs, Palais du Louvre, Pavillon de Marsan, Paris, 1957.